THE MAKING OF A COLLECTION

THE MAKING OF A COLLECTION

PHOTOGRAPHS FROM
THE MINNEAPOLIS
INSTITUTE OF ARTS

BY CARROLL T. HARTWELL

APERTURE

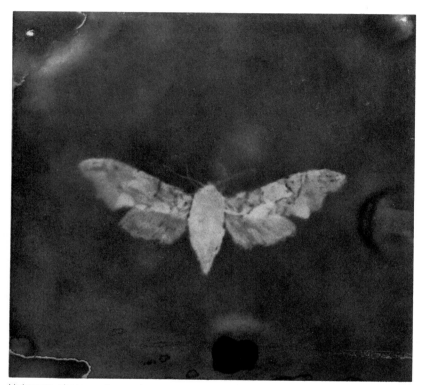

Unknown photographer, n.d.

THIS BOOK IS DEDICATED TO
THE MEMORY OF ANTHONY MORRIS CLARK
WHOSE EXAMPLE AND GUIDANCE CONTINUE AS THE MOST
PERSISTENT FORCE IN MY PROFESSIONAL LIFE.

THE MAKING OF A COLLECTION
CARROLL T. HARTWELL

It has almost become a cliché to say that the most interesting collections have been formed along lines that, like their creators, are predisposed to specific tastes or concerns and are, as a result, more or less "eccentric." An obvious extension of this value judgment suggests that a collection would be diminished in character or thrust if it lacked these subjective features, if the personality of the collector, per se, were missing. The history of photography, in particular, is rich with instances where the intelligence and cleverness of the individual collector have given substance to our understanding of the beauty and singularity of the medium.

During the last thirty-five years, the collecting of photographs has been, it seems, legitimized through the sanction and endorsement of the Art Institute of Chicago, the Boston Museum of Fine Arts, The Museum of Modern Art, and, even earlier, the Metropolitan Museum of Art and the Albright-Knox Art Gallery. More recently, New Orleans, Houston, Detroit, and Minneapolis have followed similar patterns of acquisition. In each instance, these collections have almost always been the result of the decisions and convictions of a single person, usually a curator. And most importantly, the creators of these younger collections have all had the advantage of being able to look at four key people in the field whose aesthetic insight and art historical acumen have been exemplary: Beaumont Newhall of George Eastman House, John Szarkowski of The Museum of Modern Art, Hugh Edwards of the Art Institute of Chicago, and, of course, Alfred Stieglitz himself, the father of modern photography, whose collection of American and European photographs was the basis for the Metropolitan's holdings.

The pattern of autonomy that any one of these curators exercises is as real and important as that which exists for a private collector. Trustee committees and influential donors not withstanding, these museum professionals shape, guide, exhibit, and publish their assemblages according to their own judgments and proclivities. For better or worse, the photography collection at The Minneapolis Institute of Arts has been formed according to one individual's knowledge and biases—my own.

A certain misreading of this institution's historical flirtation with photography has resulted from Minneapolis's failure to publicly trace its origins. As early as 1903, the Minneapolis Photographic Salon published and exhibited works by its members together with those by invited photographers of national and international repute. Indeed, it is a matter of record that one of the first loan exhibitions organized by Alfred Stieglitz of his New York-based Photo-Secessionists was created expressly for Minneapolis and shown alongside 250 works done in the same impressionistic spirit by photographers of the Minneapolis area. This event signaled the beginning of what later became an ongoing exhibition program conducted by the Minneapolis Camera Club, which continued well into the mid–1950s.

But curiously, it was not until 1983 that any examples from these early exhibitions were to enter the museum's permanent collection. This is not to disparage or impute the judgment of the Institute's staff at the time, but merely to suggest that photography—as a highly popular craft and diversion with no true history as art—was not considered an appropriate medium to accession. While The Minneapolis Institute of Arts, along with most American museums in the 1930s and '40s, exhibited photographs—usually loan exhibitions from local camera clubs—it had no in-house collection of them. It seems probable that photography, lacking the scholarly, art historical, and museological underpinnings that painting and sculpture already possessed, simply was not considered worthy.

Without pressing the point too far and not to make

Minneapolis appear exceptional in its failure to collect photographs during these years, it should be noted that in 1910 the Albright Gallery in Buffalo, New York (later to become the Albright-Knox) mounted the largest display of photographic art to date. Curated by Stieglitz, it occupied all of the museum's galleries and included 479 framed items. Writing at the time to an amateur photographer in Germany, Stieglitz stated:

> The exhibition made such a deep artistic impression that the trustees bought twelve pictures for very good prices, and even set apart a gallery for them. This space will remain a permanent home for pictorial photography. The dream I had in Berlin in 1885 has finally become a reality.[1]

But while the museum did not keep its promise to provide a permanent exhibition space for photography, it had indeed purchased original prints by Edward Steichen, Clarence H. White, Gertrude Käsebier, and Heinrich Kuehn, as well as by such lesser known names as the Scottish photographers David Octavius Hill and Robert Adamson.[2] Moreover, another fourteen years would elapse before the next notable acquisition of photographs would be made by a major American museum. This was in 1924 when Ananda Coomaraswamy accepted a gift of twenty-seven photographs from and by Alfred Stieglitz for the Boston Museum of Fine Arts.

During the first months of 1963, the loan requests for Carl Weinhardt's "Four Centuries of American Art" were sent out and began to form what proved to be an immensely popular and substantial exhibition, which opened at the Institute that November and lasted through the middle of January 1964. As museum photographer, I was responsible for making object photographs for the accompanying catalogue. The exhibition's paintings, sculpture, silver, and furniture—which so eloquently expressed an artistic and craft heritage that was distinctly American—provoked me to observe to Weinhardt, then the museum's director, that a serious gap was left by the omission of American photography. Were we, in our intended comprehensiveness, to ignore Alfred Stieglitz, Edward Steichen, Lewis Hine, Ansel Adams, Edward Weston, Walker Evans, W. Eugene Smith, and Robert Frank? I subsequently proposed that I be allowed to spend sufficient time, first in New York City at the Metropolitan and The Museum of Modern Art, then in Rochester, New York, at George Eastman House, and lastly in Chicago at the Art Institute, to enable me to study the photography collections held by these great museums. And—most audacious of all—that I be permitted to borrow from these collections to put together a corollary exhibition to Weinhardt's survey, which I called "A Century of American Photography."

It is impossible to construct a more privileged beginning for an aspiring curator of photography than to visit the Stieglitz Collection at the Metropolitan Museum of Art. The collection—580 photographs assembled by Stieglitz between 1894 and 1911 and given to the museum in 1933 as a gift and in 1949 as a bequest—represents, in Stieglitz's own words, "the very best that was done in international pictorial photography upwards of seventy-odd years"[3] and includes fifty Steichens, fifty Clarence Whites, and fifty Frank Eugenes. At the time of my visit, however, it was so little used that in several instances sequences of prints that I had arranged and then reshelved went virtually undisturbed for several months. I was able, therefore, to fully immerse myself in the material for the two weeks I spent there. This, coupled with frequent discussions with Hyatt Mayor, then the curator of prints and photographs, set the pattern and tone for my independent study, a study that next took me to The Museum of Modern Art.

The photography collection at The Museum of Modern Art covers the entire history of the medium and is particularly strong in the area of twentieth-century work. In 1963, John Szarkowski had been director of the department for nearly a year and Steichen was routinely present, offering his paternalistic insight into the collection. Grace Mayer's omniscient and patient custodianship as curator, too, helped to create an atmosphere of calm and order that was highly conducive to my becoming familiar with the many prints and their makers. Indeed, the advantages of working with three such original people and such a wealth of photographs can hardly be overstated.

As if these two experiences were not sufficient, I then moved on to Rochester for a week. The International Museum of Photography at George Eastman House, which opened in 1949 and is one of the primary research centers for photography in the world, possesses over 600,000 items documenting the history and aesthetics of photography and in addition to its collection of photographs holds

large numbers of photographic equipment, motion-picture films, and film stills. At the time, Beaumont Newhall was the director and Nathan Lyons the curator, and both were as supportive and encouraging as one could hope for and along with Robert Doty, then a graduate intern, provided guidance through the intricacies of that amazing collection.

My last stop was Chicago. A collection of photographs was initiated at the Art Institute in 1949 with a generous gift of 200 photographs from Georgia O'Keeffe—150 photographs and photogravures by her late husband Alfred Stieglitz and fifty prints by various members of his Photo-Secession. Over the next several years, by gift and purchase, works by Weston, Ansel Adams, and Harry Callahan were added to the collection as well as images by Henri Cartier-Bresson, Brassaï, and Weegee. In 1959, Hugh Edwards, who had worked at the museum since 1927, was appointed as curator of photography, and it was he who became my nearest and most frequent professional contact. Through a passionate flow of thought and reasoning, he led me to understand the visual and historical connections between Stieglitz and Minor White, Walker Evans and Robert Frank, Weston and Joseph Jachna. Hugh's inherent powers of discrimination, as well as his unswerving taste and judgment, continue to provide a model for the functioning of a proper curator and connoisseur.

The result of this brief, but intensive, study was the exhibition "A Century of American Photography 1860–1960," which opened at the Institute in November 1963. It consisted of 125 photographs drawn from the above-mentioned institutions and featured work by thirty-six photographers, including Thomas Eakins, Stieglitz, Alvin L. Coburn, Man Ray, Charles Sheeler, Lewis Hine, Evans, and Frank. An assortment of contemporary photographers—among them George Krause and Aaron Siskind—was included. In fact, the selection was as broad in historical scope and aesthetic type as could be reasonably hoped for in so limited a number of examples. Even now, as I review the checklist of the show, it occurs to me that with a bit of updating I would be altogether happy to do the same exhibition again today.

A second exhibition, utilizing loans from these same museums and artists, opened the following spring in the six main galleries of the museum. Entitled "The Aesthetics of Photography: The Direct Approach," it attempted to demonstrate systematically that in its unaltered and most basic technical application the photograph does provide a vehicle for personal artistic expression and as such can be said to have a distinct aesthetic character all its own.

These two shows, then, signaled the beginning of an exhibition program that has continued unabated since 1964. At first, starting with an installation of Tom Muir Wilson's solarized and toned images in December 1965, there was a series of one-person exhibitions that alternated between historical material (e.g., that of the Victorian photographer Charles Currier or of the Photo-Secession) and contemporary works produced by photographers working in Minneapolis (e.g., Danny Seymour, Elaine Mayes, Gary Hallman, Stuart Klipper, and Robert Wilcox). For much of the former, it was still possible with relative ease and little expense to draw upon the museum collections with which I had become acquainted.

At this point, however, The Minneapolis Institute of Arts still had no collection of photographs of its own. In the absence of funds for purchase and with no clear policy for the future, several acquisition opportunities were lost. One such opportunity arose during my visit in 1964 to Berenice Abbott's tiny East Village apartment to borrow prints for "A Century of American Photography." We sorted through many boxes of her work on top of and around an enormous crate situated in the middle of her living room. It took little encouragement for her to reveal that the crate was filled with prints and glass plates by Eugène Atget. Berenice asked, "Would your museum be interested in buying the entire collection?" But while I plead the case for Minneapolis purchasing all of this uncatalogued and relatively obscure French material, the Atget acquisition turned out to be a futile dream on my part. The material—now known as the Abbott-Levy Collection—was subsequently acquired by The Museum of Modern Art in 1968 where for the past fifteen years it has been organized, exhibited, and published with a thoroughness that would have been well beyond the Institute's capacity.

However, during that same trip, I also called the museum's director for permission to send a set of old photo magazines for consideration, which cost five hundred dollars. This set of Stieglitz's quarterly, *Camera Work,* had been listed in the Wehye Bookstore's periodical for more than a year and was evidently not all that coveted. But in truth, once the newspaper-wrapped set was in Minneapolis and duly presented to the director and staff, it was without

question a most defensible purchase. Here seemed to be Minneapolis's own modest version of the Stieglitz Collection, and I would employ it and its contents in much the same way as I had the Metropolitan's. It was possible, with this set of *Camera Work* as a foundation, to imagine the beginnings of a collection, for that same year the offer of a perfect Edward Weston *50th Anniversary Portfolio* came from a local photographer. An embarrassingly small sum consummated the transaction and along with the Ansel Adams *Portfolio Number Three* (1960), purchased from the Carl Siembab Gallery in Boston, we had a total of thirty photographic prints.

One afternoon in 1969, Julia Marshall, a Duluth resident and occasional professional portrait photographer, walked into my office, put several copies of *Camera Work* into my hands, and said, ''Do you know what these are?'' Her frustration at not being able to find a proper home for this treasure—which had been carefully stored away in her attic for almost fifty years—was immediately soothed when she learned that we not only knew what the material was, but would gratefully accept it as a gift to the museum. In fact, it could be said that the photography collection at The Minneapolis Institute of Arts was inspired by the abiding interest in the medium that Julia Marshall has had since her student days in New York in the '20s. Her teacher Clarence H. White was evidently the source for both her contact with Stieglitz and for her understanding of the crucial position that *Camera Work* held—and continues to hold—in the history of American art and photography.

These wonderful volumes, then, with their perfectly executed gravures of images by White, Käsebier, Joseph T. Keiley, A. L. Coburn, and Steichen, as well as by Stieglitz himself, were and remain the cornerstone of The Minneapolis Institute of Arts' collection of photographs. Not only was this gift an inspired and fortuitous beginning for the museum's collection, but its spirit and example (that of both Stieglitz and Julia) have been the touchstone and foundation for all of the photographs added since. In precisely the same way that Stieglitz used *Camera Work* and his galleries to present American photography as a vital aspect of the avant-garde, The Minneapolis Institute of Arts' collection and exhibition program have typically reflected a devotion to contemporary artists' work, ideas, and accomplishments. True to Stieglitz's practice of providing a historical base for his readers (e.g., issues featuring David Octavius Hill, Frederick H. Evans, and Julia Margaret Cameron), this collection, too, has been founded on the principle that contemporary photography is a valid addition to the aesthetic and technical development of the medium to the extent that it takes cognizance of and builds on its history.

Suddenly, then, with Julia's gift, we had two sets of *Camera Work.* It never once occurred to me, even with escalating market values, to consider selling off the first set. Instead, it became possible to keep it intact (except for 49/50) and from Julia's set to selectively remove and frame a substantial number of the gravures themselves. These then became the foundation for loan exhibitions that have traveled widely to places as diverse as Tempe, Arizona; Fort Dodge, Iowa; Vermillion, South Dakota; and Williamstown, Massachussetts.

For the next several years, *Camera Work* continued to be the center of our still-modest collection. In 1973, however, another unsolicited gift was offered, this time of Lee Friedlander's portfolio *Fifteen Photographs.* The anonymous donor could hardly have anticipated the significance of his gift and how it would prefigure in the collection's changing emphasis. Had he known that Friedlander's images would be the occasion for my reassessment of Stieglitz, Atget, and Walker Evans, as well as for what I thought about photographic picture making in general, he might have hesitated, but probably not. Such is the unforeseeable consequence of donations.

Soon thereafter, in 1974, the Robert Wilcox Collection was purchased, which contains virtually all of this Minnesota photographer's work. His career was halted abruptly by his tragic death in 1970, but we are able to trace its development over a period lasting more than a decade. Wilcox's photographs, often reminiscent of the work of Paul Strand or Walker Evans in their formal poise, are firmly rooted within the documentary tradition. The most extensive group is from his series on the ''Gateway Area'' of Minneapolis, the city's own version of ''skid row,'' which was torn down in the late 1950s and '60s during the first great wave of urban renewal.

By now, the philosophy and artistic polarization of the collection were becoming evident. With the 1975 acquisition of more than seventy photographs by Walker Evans, another primary dimension emerged. Once again, gifts to the collection had a crucial and formative effect. Arnold H. Crane from Chicago and D. T. Bergen from London, who was a former trustee of the Institute's, each made donations of Evans prints to the museum. These were judiciously selected to complement yet another group of Evans photographs that were purchased at about the same time.

Together, these acquisitions represented the largest single addition of photographs to the collection to date. Interestingly, the Evans pictures now stood within the collection as a type of bridge extending from Atget's images of the early 1900s through to Evans's own photographs of America in the '30s, and on to Friedlander's of the 1960s.

Remarkably, that same year the museum acquired a group of 5 x 7-inch contact prints by another great documentarian, Lewis W. Hine. Some seventy in number, they were literally rescued from the files of the National Child Labor Committee in Washington, D.C. The University of Maryland Baltimore County Library was given the entire Hine collection by the federal government with the understanding that duplicate prints could be sold. It was through this arrangement that we were able to buy our selection.

Over the past nine years, an extraordinary range of artists' work has been added by purchase and donation. Images by such masters as Atget, Steichen, Strand, and Minor White have been secured as well as prints by August Sander, Weegee, Diane Arbus, and Richard Avedon. Photographs by more contemporary workers have also been accessioned and include examples by William Christenberry, Reed Estabrook, Frank Gohlke, Richard Misrach, and Nicholas Nixon. Curiously, the most recent and spectacular acquisition—of two Stieglitz silver prints, *Equivalent* (1929) and *From the Shelton, West* (1935)—has brought the collection full circle to its origins in two sets of *Camera Work.*

Having quickly recounted the history of the collection's formation, I would like to offer some advice to would-be collectors of photographs, with, of course, a certain generosity toward amendment and exception.

Don't throw anything away. Stieglitz, the great private collectors André Jammes and Julien Levy, among many others, cite instances where, in a moment of precipitous orderliness or disregard, things were discarded that could have provided illumination or connection in ways realized only after they were gone. Save Bill Dane's photo-postcards as well as Gene Thornton's review of Cindy Sherman's last exhibition at Metro Pictures.

Look at and consider every image you can. If you assume that photographs made with a motorized Minolta can't be *Art,* there is as much risk of tunnel vision as if you were to conclude that all of Edward Weston's prints are by definition quintessential.

Consider everything. Gauge, speculate, and wait. There is a fair chance that the true value of a photograph will emerge, or that its ultimate rejection will proceed from its own inherent inadequacies.

Question the authoritative pronouncement. If Janet Malcolm seems correct, then how about Susan Sontag on the subject of Arbus or Avedon? If John Szarkowski's reading of William Eggleston's color pictures is sufficient, then what about his view on Irving Penn's platinum prints of cigarette butts? If Avedon is purported to be simply applying a commercially successful formula to his portraits, then what can be said of his absolutely galvanizing images of his father, Jacob Israel Avedon? And if Bruce Downes assigns Robert Frank's *Americans* to the category of misanthropic perversity, then how are we to interpret the effects of Frank's book on a generation of photographers and a world of photographically attuned and sensitive viewers?

One of the lures and dangers of being a curator or a collector is that it engenders a tendency toward compulsiveness, a truly insatiable appetite for the next picture, the next image that you simply must have and without which the collection will not be complete. For such a collector, it is always a new photograph, an unknown or unacknowledged artist, a reassessment of known but undervalued works, or a novel synthesis or juxtaposition of material that yields added insights and fresh desires. The mosaic that the collection already is will certainly be extended, but in defiance of the knowledge that a kind of completeness has already been achieved. Yet there is no stopping short of renouncing collecting altogether. This is not likely to be a satisfactory solution, however, and for the museum curator, it is not only contrary but fatal to the reasons for which one enters the museum field in the first place. For what Susan Sontag writes about the making of photographs could also be said about collecting them:

> The final reason for the need to photograph everything lies in the very logic of consumption itself. To consume means to burn, to use up—and, therefore, to need to be replenished. As we make images and consume them, we need still more images; and still more. But images are not a treasure for which the world must be ransacked; they are precisely what is at hand wherever the eye falls. The possession of a camera can inspire

something akin to lust. And like all credible forms of lust, it cannot be satisfied: first, because the possibilities of photography are infinite; and, second, because the project is finally self-devouring.[4]

To sidestep any dour inference from Sontag and to dispel the suspicion that collecting may be nothing more than a self-indulgent obsession, I'd like to relate a story about a very special collection and the people who created it: the Gale Collection of Japanese prints and paintings, which was received by the Institute in 1974.

As the museum's photographer, I had the special privilege of working with Dick Gale and his extraordinary wife Pete (née Isobel) at their farm in Mound, Minnesota, during the long and harsh winter of 1967, producing a complete and affectionate record of their collection of Ukiyo-e woodcuts and hanging scrolls. The color transparencies and black-and-white prints that came out of our labors took the form of a two-volume book by Jack Hillier that is both a testimony to the quality of the collection and, more importantly, a tribute to the passion and care with which it was assembled.

Thinking back to that special four-month project, I believe now that I have a better idea of how the experience entered into and materially conditioned both my attitude and sense of discrimination when it comes to collecting. Here, for the first time, I came across flesh-and-blood models whom I liked and respected, connoisseurs who interacted with the professional and scholarly community at large and added that expertise to their own. Most significantly, they were always reforming and redefining their collection, constantly trading up to eventually possess the very finest possible. As Dick would say, "It's all the same thing [collecting Japanese art or American photography]; trust your eyes and get it." Moreover, the example of this spirit introduced me to what is finally the best reason for collecting—the essential humbling and civilizing effect of the art itself as a consequence of the intelligence and skill of its maker.

An assemblage of work, objects, or things only becomes a collection by reason of the collector's knowledge, selectivity, and insight. To be touched by the spirit and grace of the object is surely the purpose of our desire to collect and its fulfillment. In both its individual parts and aggregate, the collection does justice to these motives and enthusiasms, reflecting them tangibly and usefully. It instructs and delights, is propitious and a pleasure.

What has seemed to be photography's most apparent and characteristic feature—its capacity to delineate appearances—has proven to be less than factually complete, yet more than mere record. That its technical foundations derive from chemical and optical sciences has, from the start, suggested authentic translation, verifiable depiction, and factual accuracy. The seductiveness of this notion, which satisfies our impulse to obtain a predictable reality, has always brought with it the awareness that beyond the surface "facts" are the poignancy and poetry of evocation. The photograph seems always to exceed the boundaries of its nominal subject and to attempt to unite the observer and the observed.

The earliest photographic pictures hold us by virtue of their distance in time, and the nostalgia and reminiscence that distance allows. They often function as icons of an aesthetically viable and archetypal past. By a direct, simple, and seemingly tentative means (technical and artistic), they speak of a wonderment and an allure that we assume was also embraced by the first photographers who, like us, believed in their veracity, authority, and fidelity as pictures. The idea that the photograph was a faithful recorder of reality is suggested by Julia Margaret Cameron's statement: "I longed to arrest all beauty that came before me, and at length the longing has been satisfied."[5]

In fact, the accommodations we make for the shortcomings of photography as an instrument of strict objectivity are the basis for its most useful application as metaphor and translation. Like vision itself, the photograph embodies our expectations and desires, our wished-for realities and illusions of fact.

Where photography surpasses itself is at the point where its subjects help us to better understand ourselves. Statement and meaning proceed from the photographer's attempts to isolate and portray salient visual features. But the photograph's ultimate relevance and cogency depend on the photographer's intentions and the limits placed on the subject. In photography, as John Szarkowski has written, "form and subject are defined simultaneously. Even more than in the traditional arts, the two are inextricably tangled. Indeed, they are probably the same thing. Or, if they are different, one might say that a photograph's subject is not its starting point but its destination."[6]

Several years ago, an enormous exhibition was mounted in Cologne: "The Imaginary Photo Museum: Fiction and Realization." Apart from the implicit contradiction in terms of its title, it suggested that the assembled pictures, if kept

together, would constitute the ideal and presumably exhaustive distillation of what photography has been, is, and even could be in the future. In that single exhibition, its history, its main artistic features, and its current trends were lucidly represented in photographs that had been drawn from many of the most substantial and highly esteemed collections, American and European, public and private.

Yet despite the scope of this valiant and seemingly all-encompassing enterprise, it possessed a major flaw. The ideal museum of photography could only be a magnificent emporium containing all of George Eastman House, The Museum of Modern Art, the several existing Stieglitz collections, Bill Larson's Moholy–Nagy collection, Jan Leonard's and Jerry Piel's Grand Tour photographs, and much, much more. For the ideal museum—the truly comprehensive collection—will always be an insatiable desire, an ambition beyond fulfillment.

The folly and fallacy of such an all-encompassing collection is that, if obtained (which in theory it cannot be), it would put an end to all of those profoundly human meanings that inform and give life to any artistic activity, including collecting. A collection never simply "is." All the bases can never be covered; the full results can never be in.

The intellectual and cultural crosscurrents that shape the knowledge, texture, and demeanor of an era are the same forces that flow through and enliven all that we value of that culture and by which our own age is formed and known. In collecting, the task is, of course, to decide what things to save. To put a finer, more personal point on this philosophy, I quote the following:

> Those of us who live by our eyes—painters, designers, photographers, girl-watchers—are both amused and appalled by the following half-truth: "What we see, we are"; and by its corollary: "Our collected work is, in part, shameless, joyous autobiography *cum* confession wrapped in the embarrassment of the unspeakable."[7]
>
> WALKER EVANS

> It is always the instantaneous reaction to oneself that produces a photograph.[8]
>
> ROBERT FRANK

The photography collection at The Minneapolis Institute of Arts represents one more entry on the subject of how photographs partake of such a cultural and personal consciousness and thereby mirror it.

I mean to encourage the reader of this book to consider these images and the order in which they occur as a provisional offering of subjective and suggestive intention. Phrased otherwise, understand them as a personal response and statement by one curator about an immensely complex and unsettled field of visual discourse and expression. And remember always that the proposition is open-ended.

The pictures in this catalogue are sequenced in a way intended to be provocative and emblematic. They take cognizance of a historical progression (but this is not primary) and allude to different kinds of photographs that are at once artistically sufficient in themselves yet stand relative to their antecedents visually, formally, and culturally. How each one fits into this scheme is to be discovered by the viewer. While the evidence is all there and each photograph is the receptacle and vehicle for this extrinsic relationship, the extent to which each person understands all of these levels is largely dependent upon his or her individual perception, generosity of spirit, and knowledge about the history of photography and the cultures that created it.

Finally, I would like to believe that the photography collection that I have been assembling for Minneapolis over the past two decades approximates what was once said about Hyatt Mayor's lectures: "[They] are constructed like the very best Parisian roasts—whose butchers slip pistachios into the veal—providing oblique, piquant perspectives, relishing the flavor of the past"[9] and, I might add, the present.

1. Quoted in Beaumont Newhall's essay "Museums and Photography" in Renate and L. Fritz Gruber, *The Imaginary Photo Museum* (New York: Harmony Books, 1982), p. 9.

2. *Ibid.*

3. Quoted in Weston J. Naef, *The Collection of Alfred Stieglitz: Fifty Pioneers of Modern Photography* (New York: The Metropolitan Museum of Art, 1978), p. 8.

4. Susan Sontag, *On Photography* (New York: Delta Publishing Co., 1973), p. 179.

5. *Ibid*, p. 183.

6. John Szarkowski, *William Eggleston's Guide* (New York: The Museum of Modern Art, 1976), p. 7.

7. Quoted in Beaumont Newhall, ed., *Photography: Essays & Images* (New York: The Museum of Modern Art, 1980), p. 312.

8. Quoted in Vicki Goldberg, ed., *Photography in Print: Writings from 1816 to the Present* (New York: Simon and Schuster, 1981), p. 401.

9. A. Hyatt Mayor, *Selected Writings and a Bibliography* (New York: The Metropolitan Museum of Art, 1983), p. 21.

The history of photography has been less a journey
than a growth. Its movement has not been linear
and consecutive, but centrifugal. Photography, and
our understanding of it, has spread from a center; it
has, by infusion, penetrated our consciousness. Like
an organism, photography was born whole. It is in
our progressive discovery of it that its history lies.

JOHN SZARKOWSKI, 1966

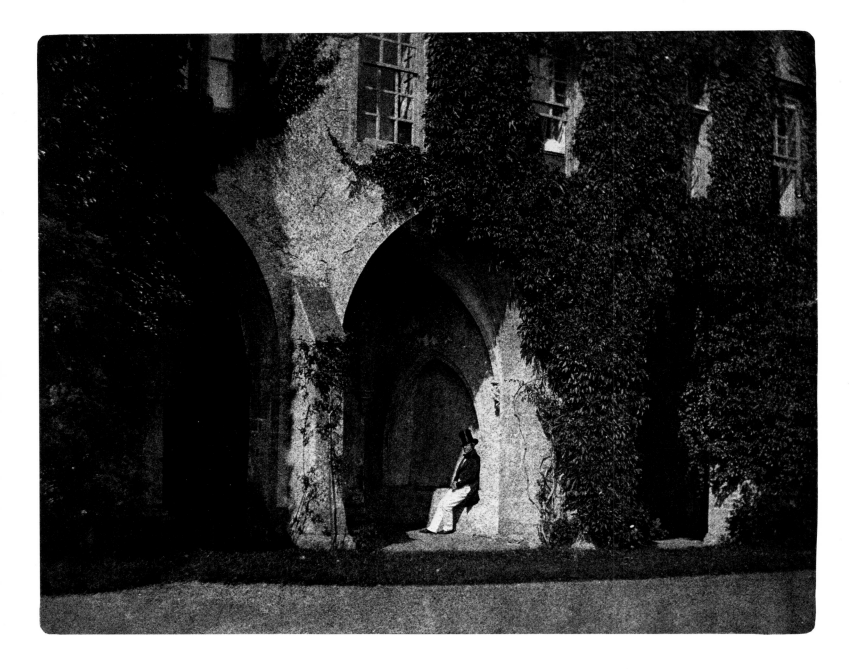

William Henry Fox Talbot, *Cloisters of Lacock Abbey,* 1844

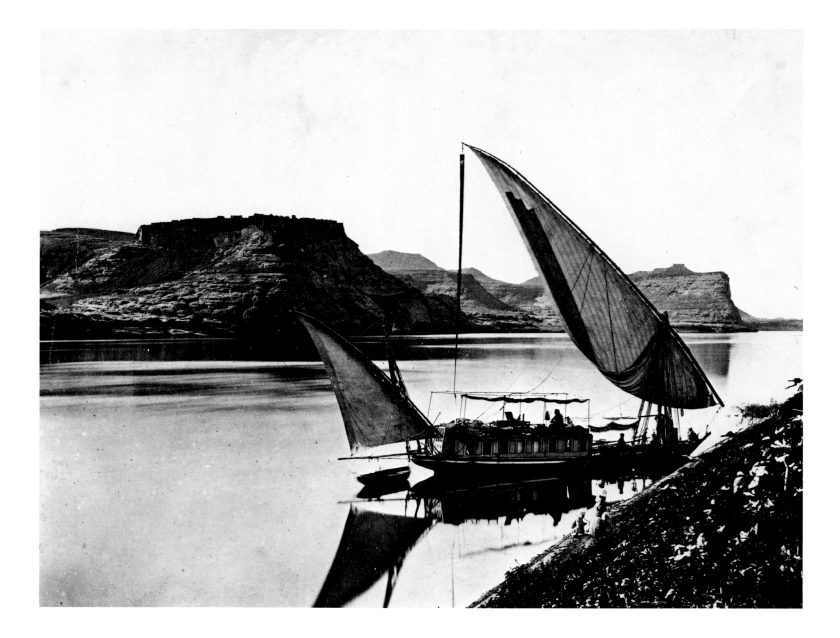

above: Francis Frith, *Travelers Boat at Ibrim,* c. 1860

opposite: David Octavius Hill and Robert Adamson,
The Reverend Robert Young, c. 1845

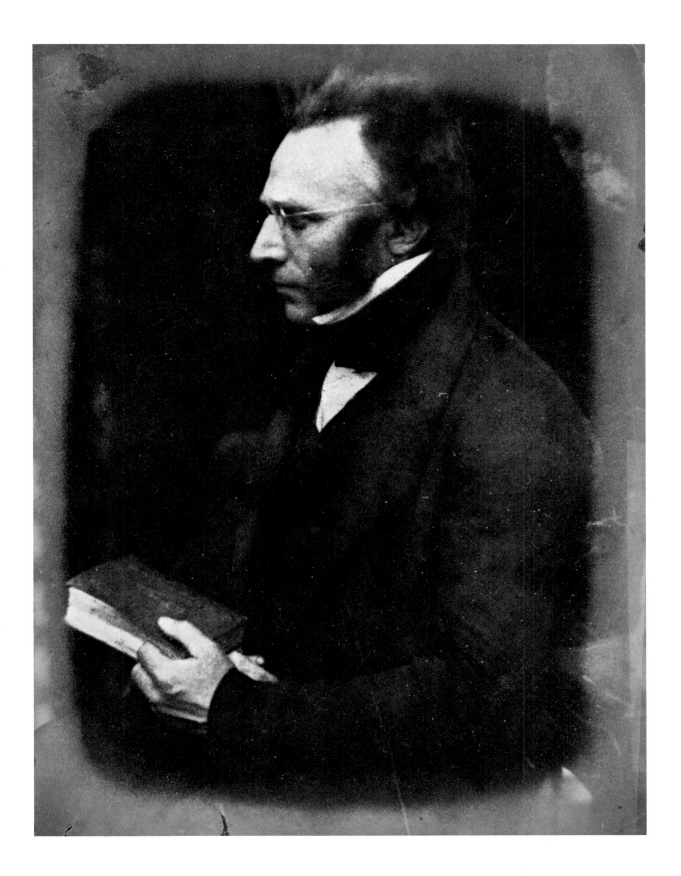

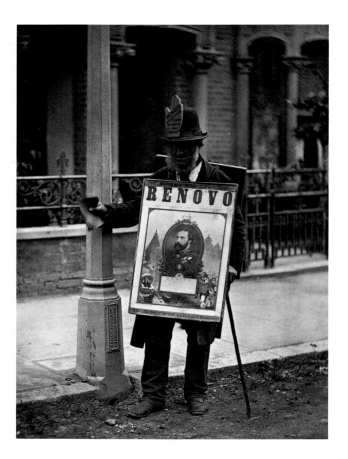

John Thomson, *The London Boardmen,* c. 1877

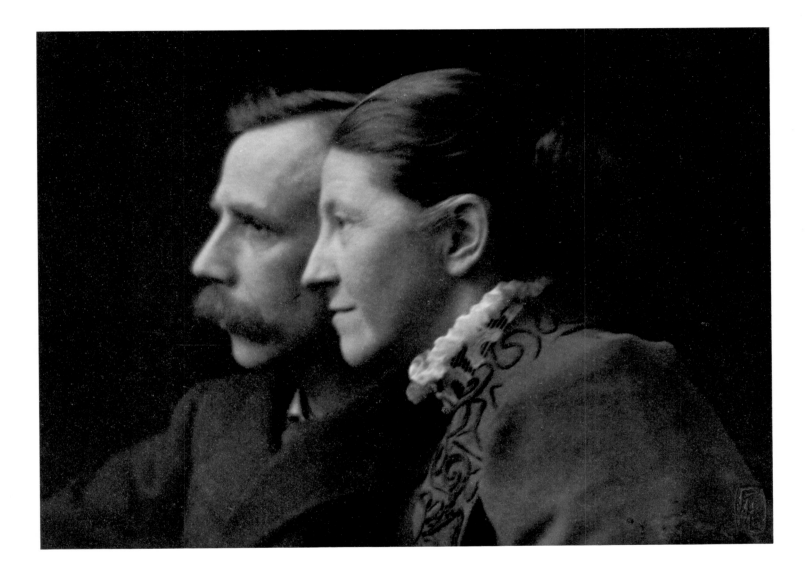

Frederick H. Evans, *Mr. and Mrs. S. Maudson Grant, Lincoln*, n.d.

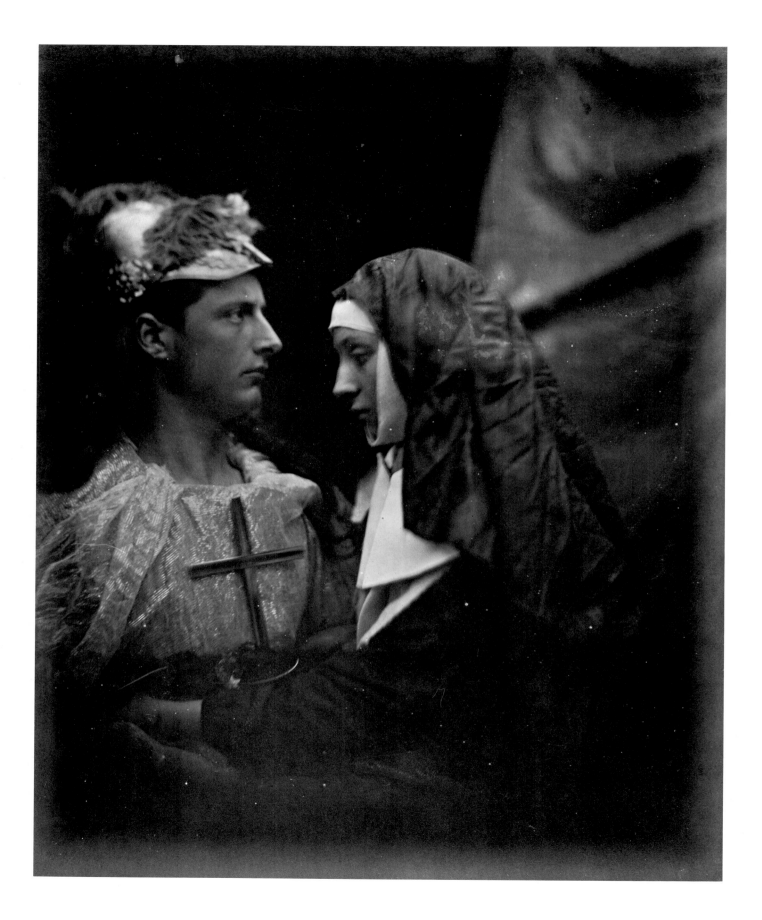

opposite: Julia Margaret Cameron, *Sir Gallahad and the Pale Nun,* c. 1870

top: Julia Margaret Cameron, *Kate Keown,* 1866

bottom: Julia Margaret Cameron, *The Spirit of the Spring,* c. 1870

opposite: Unknown photographer, untitled, September 4, 1852
top: Eugène Pirou, *Gustave Eiffel,* c. 1880
bottom: Emile Tourtin, *Sarah Bernhardt,* 1877

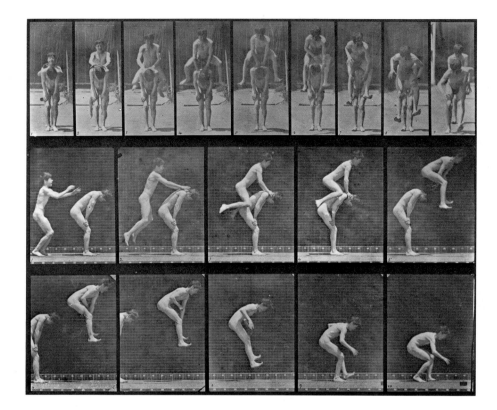

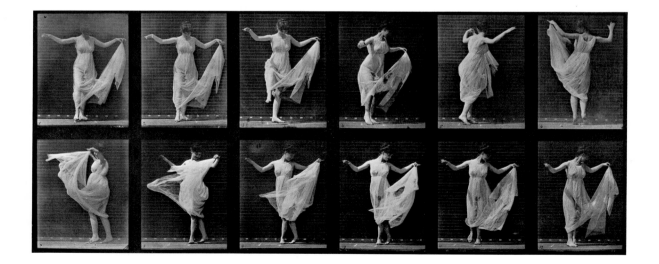

top: Eadweard Muybridge, *Animal Locomotion Plate 167*, 1887
bottom: Eadweard Muybridge, *Animal Locomotion Plate 187*, 1887

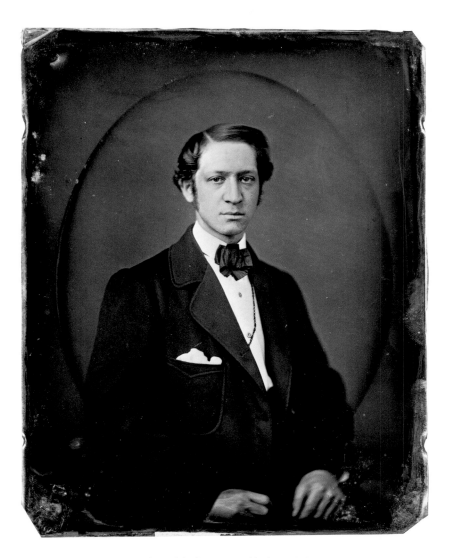

Jeremiah Gurney, untitled, c. 1852

The very invention that was born of a desire for the most detailed realism
not only discredited that realism by too quick and easy a satisfaction, but in time
stimulated art with undreamed-of revelations of form and action.

A. HYATT MAYOR, 1946

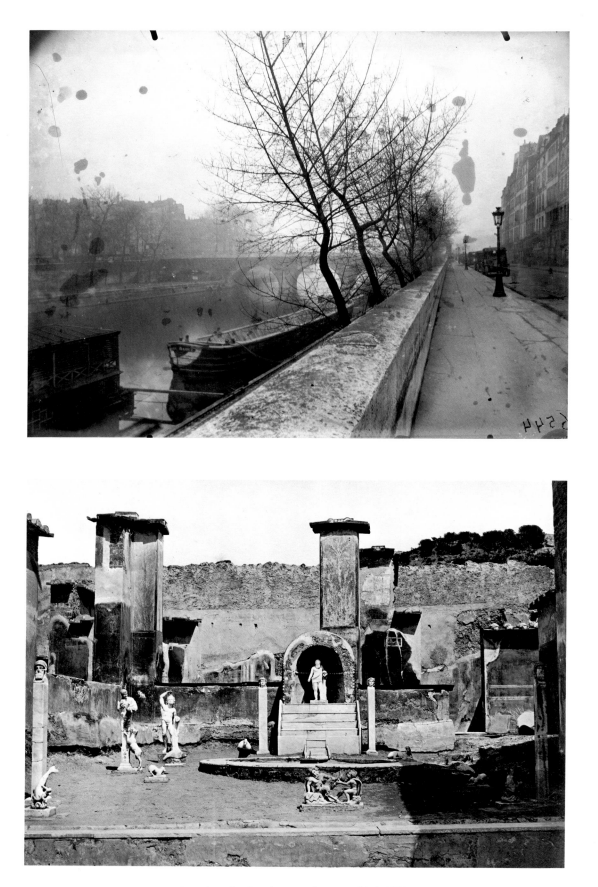

top: Jean-Eugène-Auguste Atget, untitled, 1925
bottom: Giorgio Sommer, *Casa di Marco Luerezio, Pompei*, c.1860

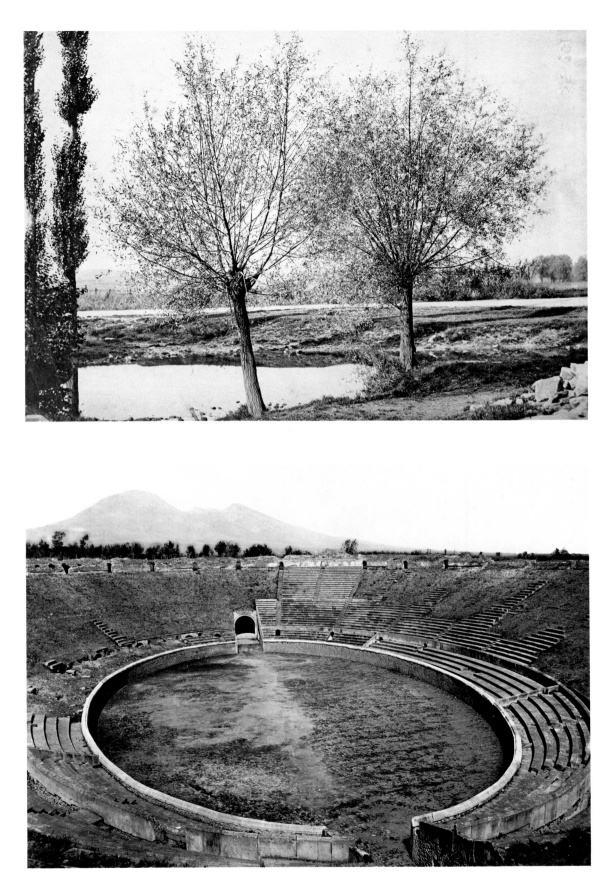

top: Unknown photographer, n.d.
bottom: Giorgio Sommer, *Anfiteatro, Pompei,* c. 1860

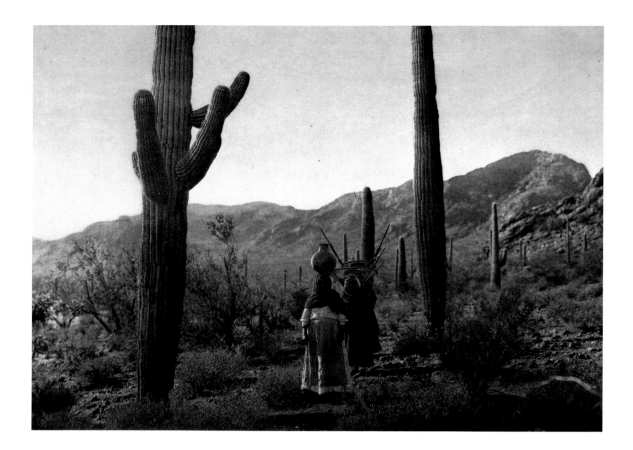

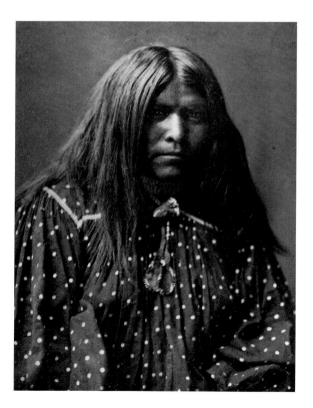

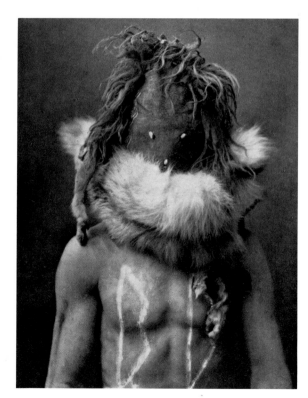

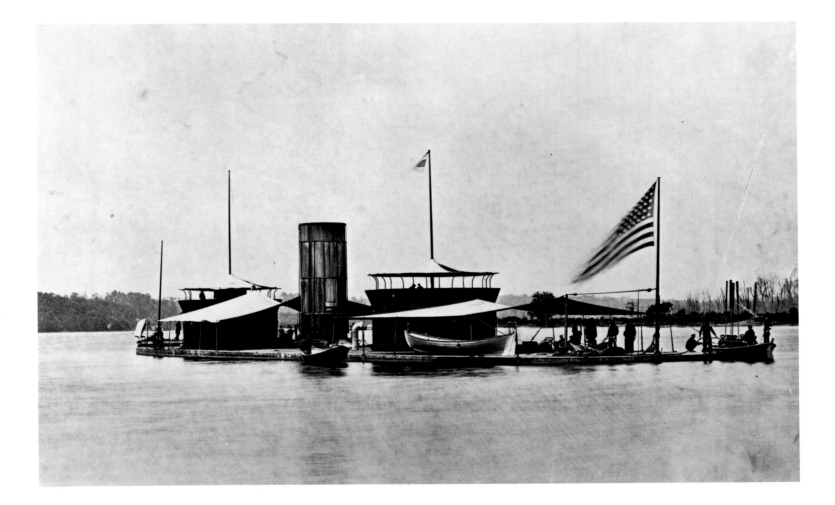

opposite, top: Edward S. Curtis, *Hasen Harvest, Oahatika,* c. 1907
left: Edward S. Curtis, *Nalin Lage, Apache,* c. 1906
right: Edward S. Curtis, *Nayenezgani, Navaho,* c. 1904
above: Unknown photographer, *The Monitor Onondaga,* n.d.

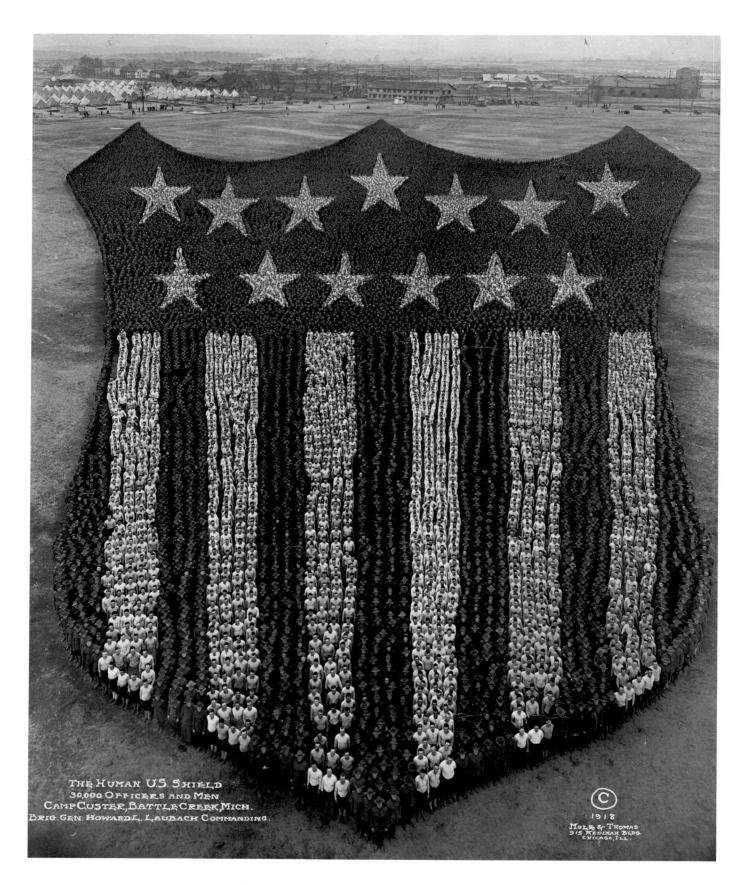

Arthur S. Mole and John D. Thomas, *The Human U.S. Shield,* 1918

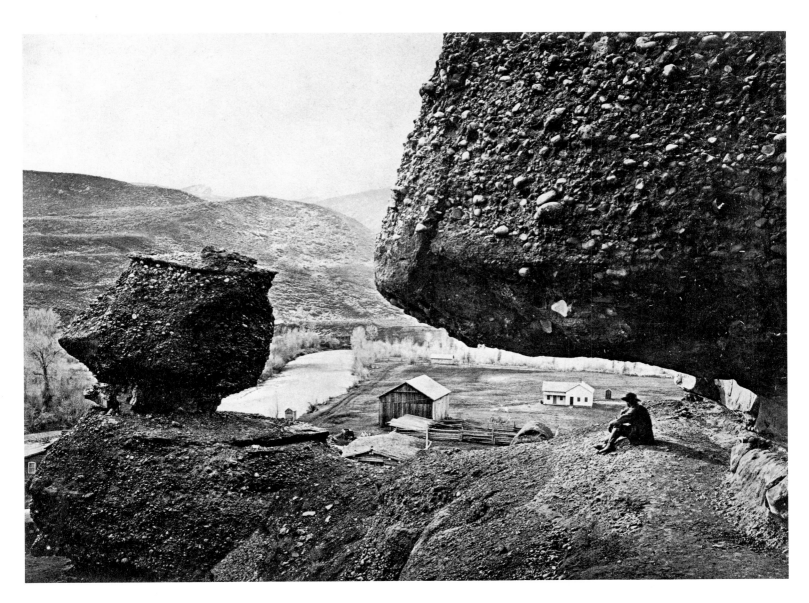

Andrew Joseph Russell, *Hanging Rock, Echo Canyon,* c. 1870

The eye of any age is so subtly yet inexorably a part of the mind of that age that one is tempted to wonder if photography could have been invented at any time before the 1830s in spite of the fact that the elements had been on hand for centuries. Certainly the photograph would have seemed a distraction of vicious curiosity to the mediaeval scrutiny of everything for possible symbolism and moral value.

A. HYATT MAYOR, 1946

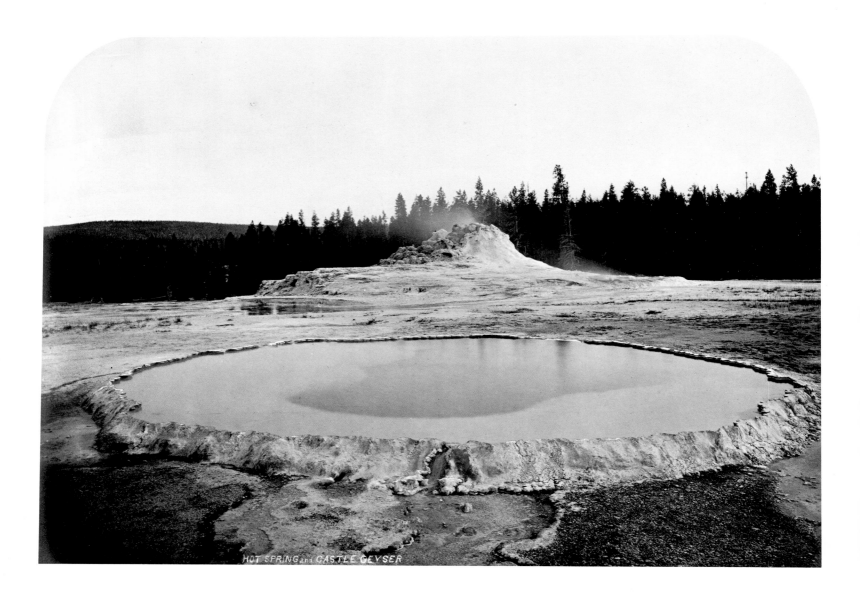

William Henry Jackson, *Hot Spring and Castle Geyser,* c. 1873

Carleton E. Watkins (attribution), [Pulpit Rock, Utah], c. 1870

Thomas Eakins, [Pennsylvania Academy of Fine Arts], c. 1880

top: Alvin Langdon Coburn, *New York, The Tunnel Builders*, 1908
bottom: Alvin Langdon Coburn, *Kensington Gardens*, n.d.

E. J. Bellocq, untitled, c. 1912

E. J. Bellocq, untitled, c. 1912

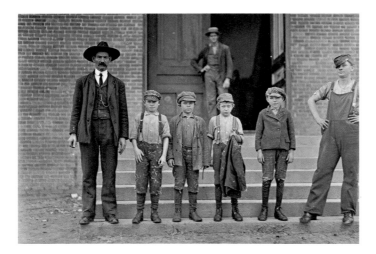

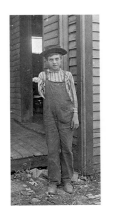

opposite, top left: Lewis W. Hine, [factory workers, Virginia], 1911
top right: Lewis W. Hine, [factory workers, North Carolina], 1908
bottom: Lewis W. Hine, [Macon, Georgia], 1909

left: Lewis W. Hine, [boy with one arm], 1907
bottom: Lewis W. Hine, [messenger boy, Waco, Texas], 1913

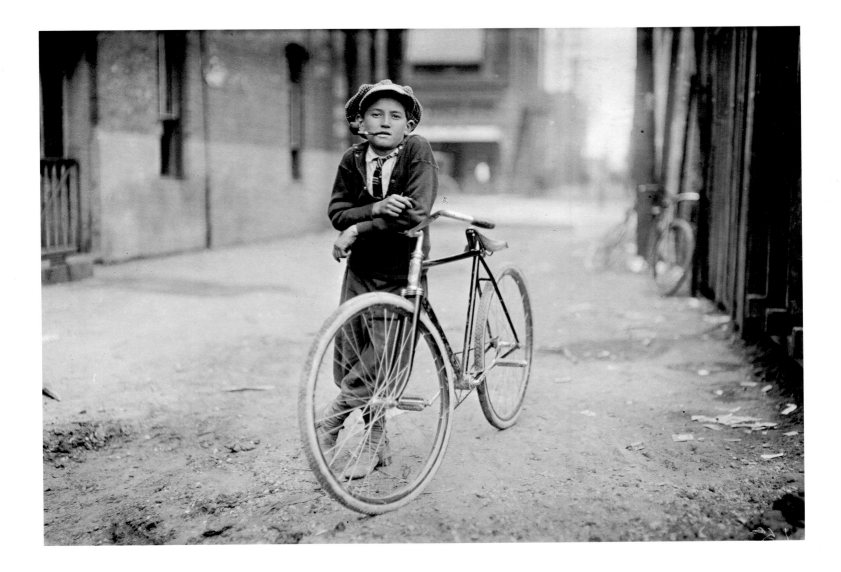

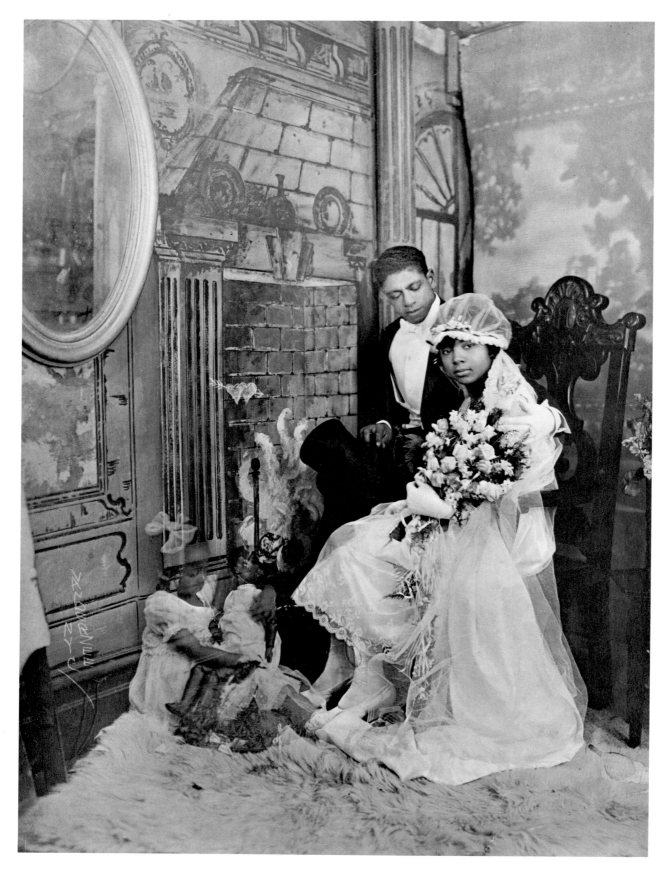

James Van DerZee, *Wedding Day, Harlem,* 1926

James Van DerZee, *Kate and Rachel Van DerZee, Lenox, Massachusetts,* 1909

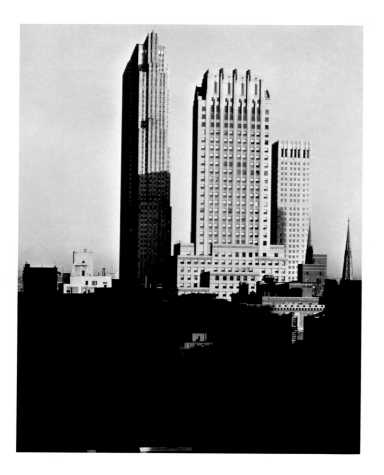

The subjects do not make the photographs. The vision of the photographer himself makes the subject.

FORBES WATSON, 1925

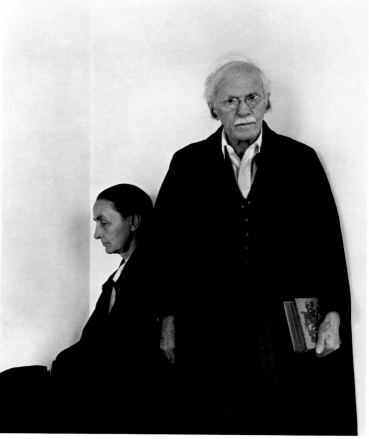

© Arnold Newman

top: Alfred Stieglitz, *From the Shelton, West,* 1935

bottom: Arnold Newman, *Stieglitz and O'Keeffe, An American Place,* 1944

opposite: Imogen Cunningham, *Alfred Stieglitz at An American Place,* 1934

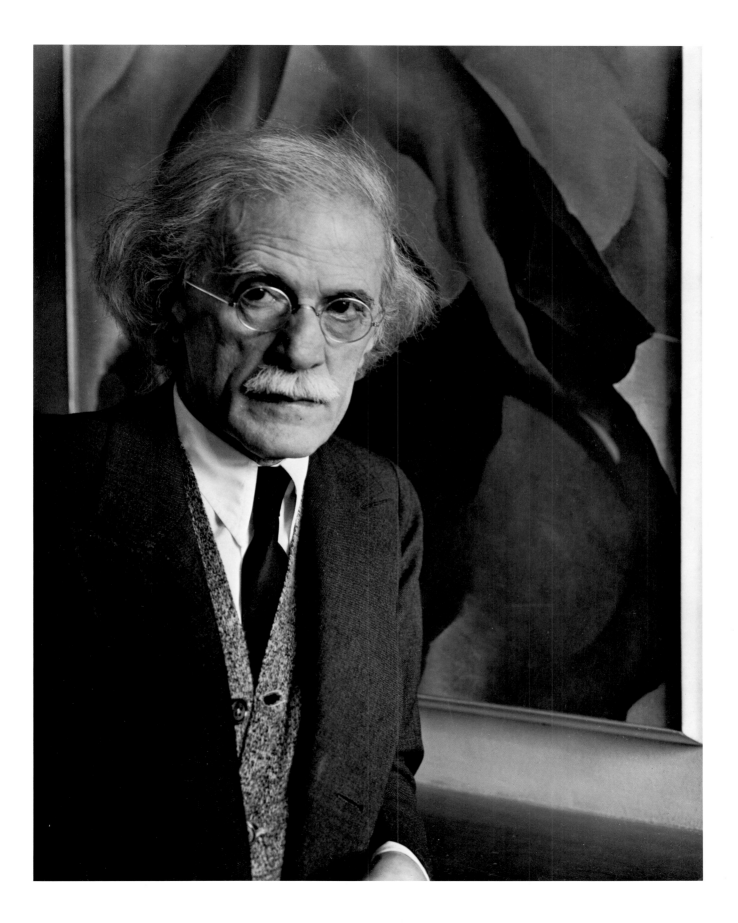

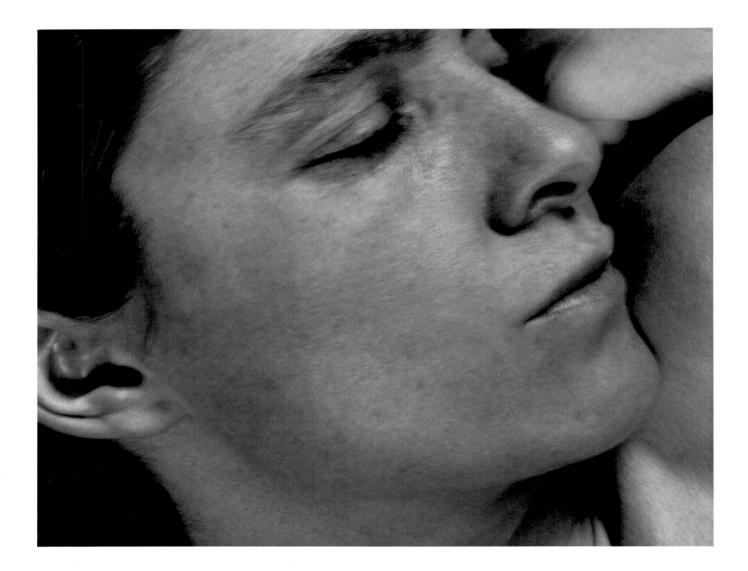

above: Paul Strand, *Rebecca Strand, New York City,* 1922
opposite: Paul Strand, *Window, Red River, New Mexico,* 1931

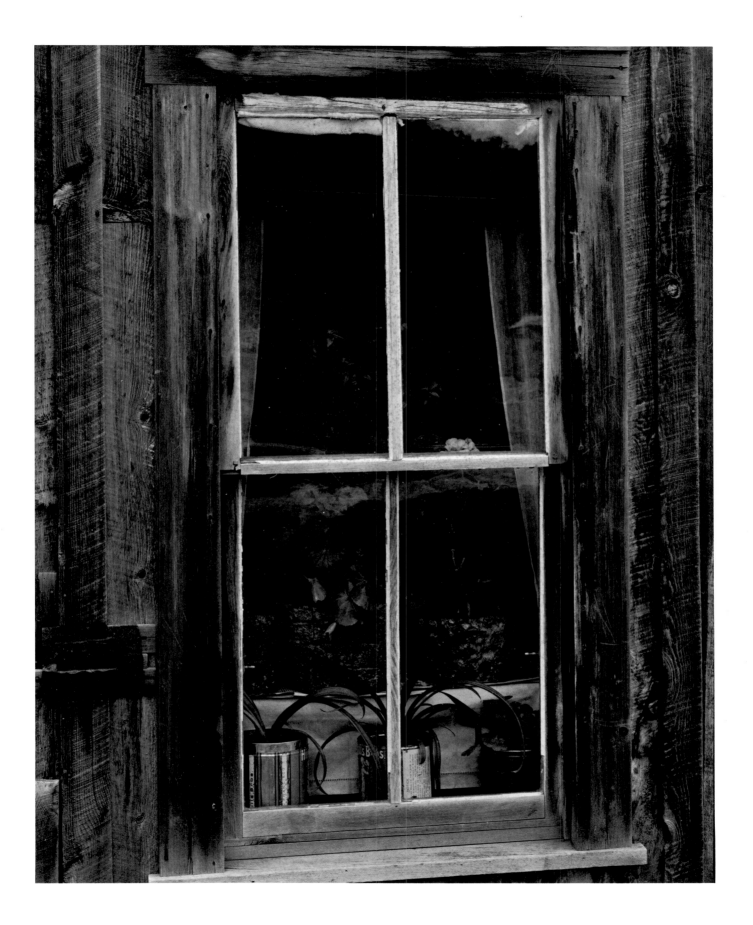

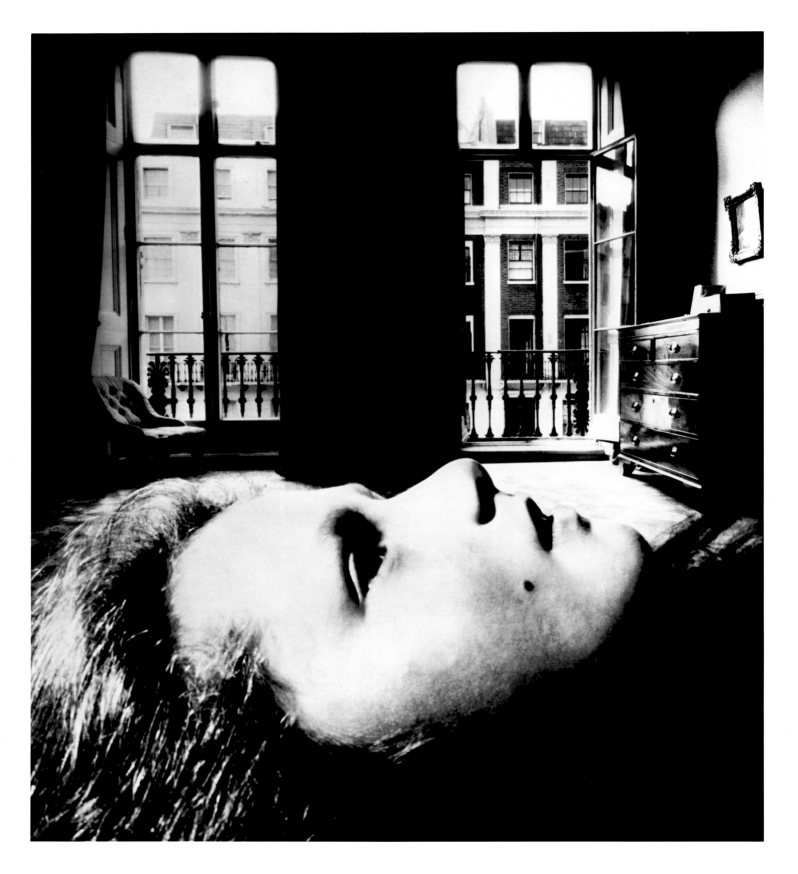

Bill Brandt, untitled, 1955

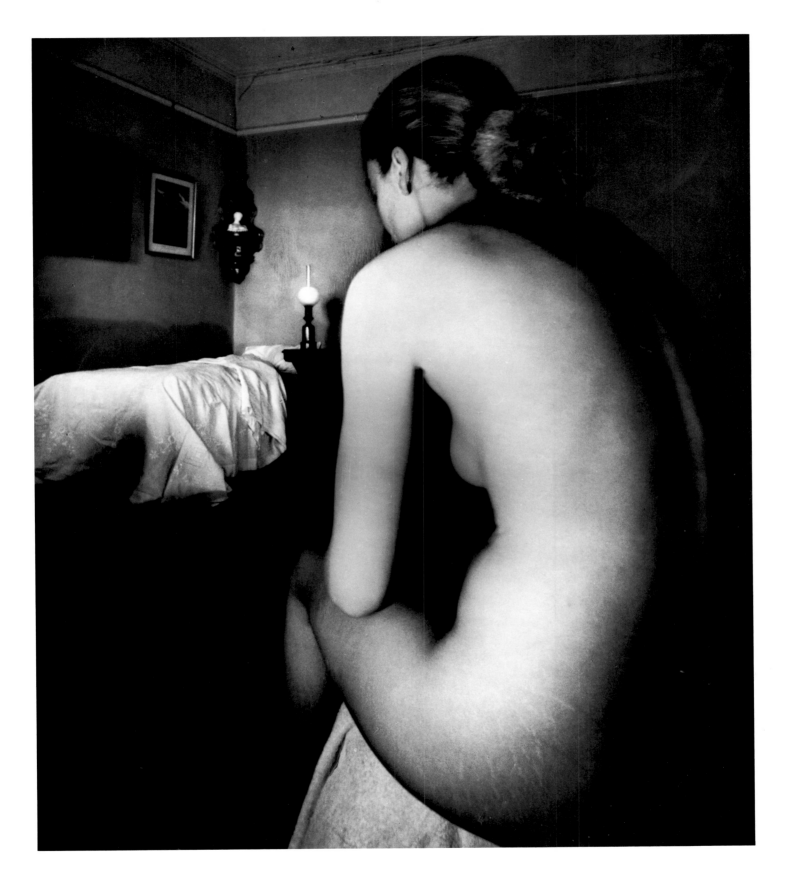

Bill Brandt, untitled, 1949

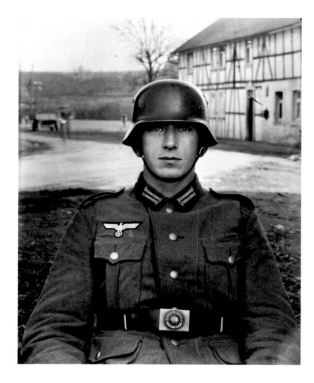

top left: August Sander, *Young Soldier, Westerwald*, 1945
lower left: August Sander, *The Wife of the Painter Peter Abelen, Cologne*, 1926
right: August Sander, *Farm Girls, Westerwald*, 1928
opposite: Val Telberg, *Fire in the Snow (The City No. 3)*, c. 1948

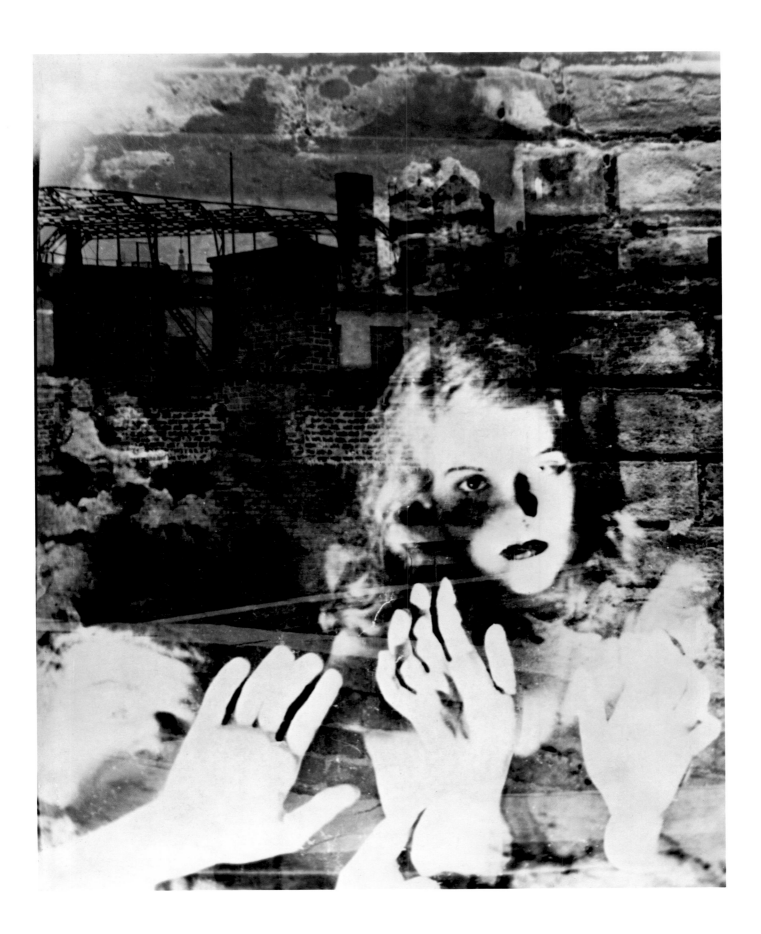

left: Manuel Alvarez Bravo, *Umbral (Threshold),* 1947

bottom: Manuel Alvarez Bravo, *Gorrión, Claro
(Skylight),* 1938 – 40

opposite: Manuel Alvarez Bravo, *Margarita de Bonampak,* n.d.

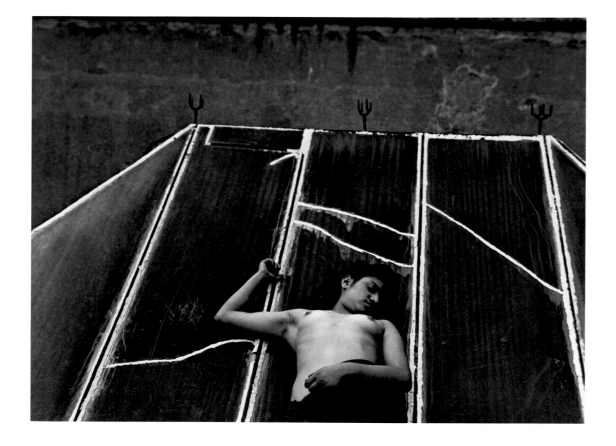

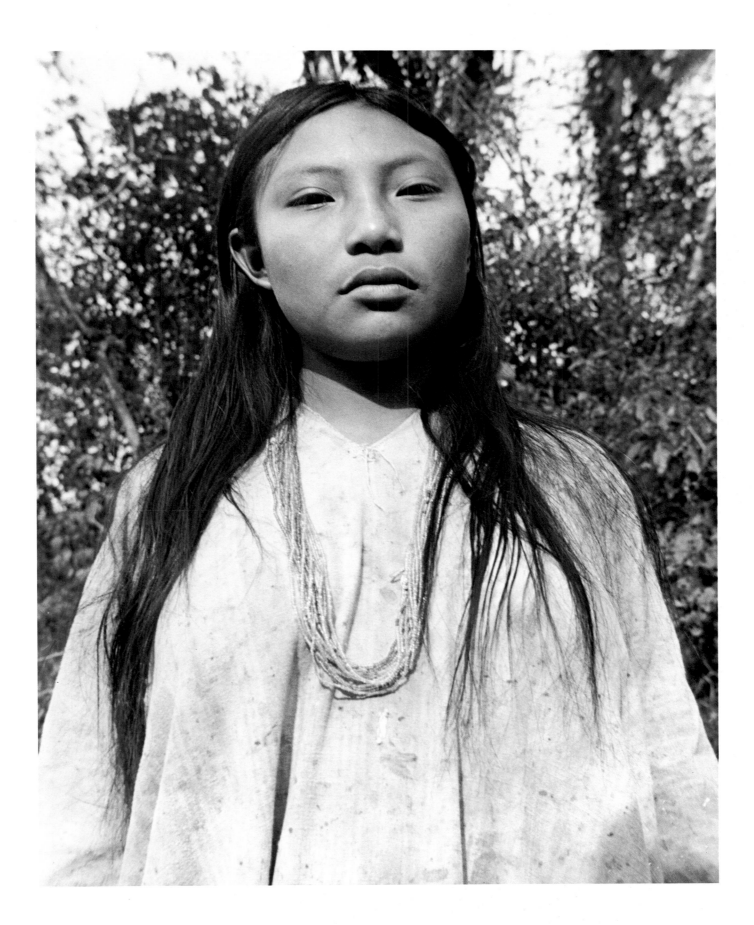

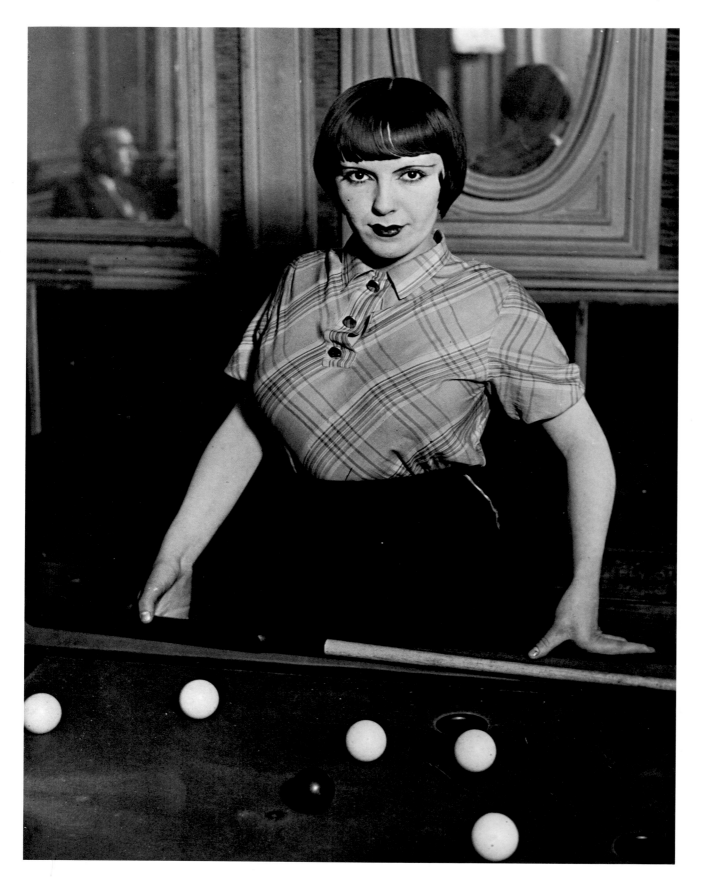

Brassaï, *La Fille au Billard Russe, Paris,* 1933

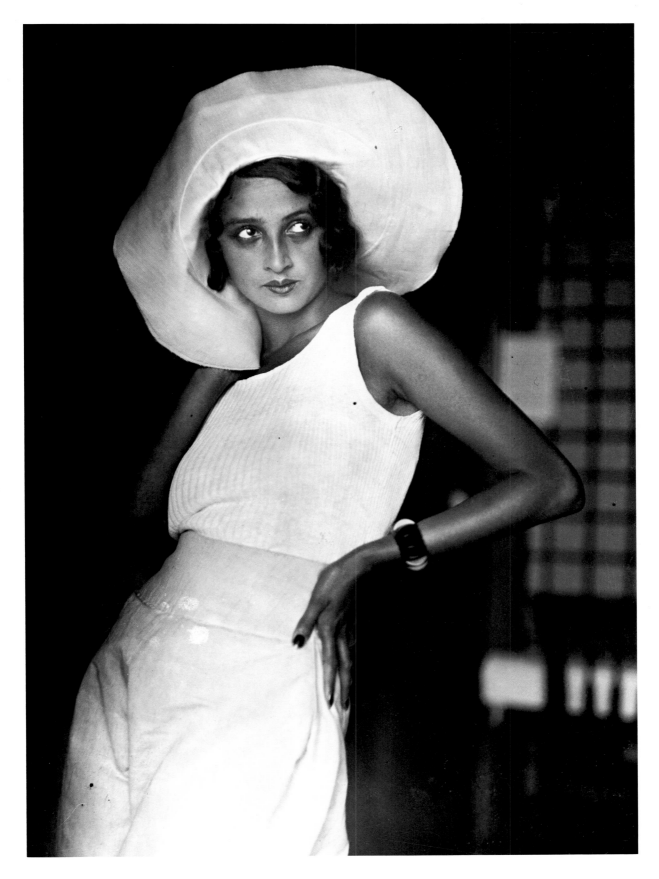

Jacques Henri Lartigue, *Renée (Perle),* 1930

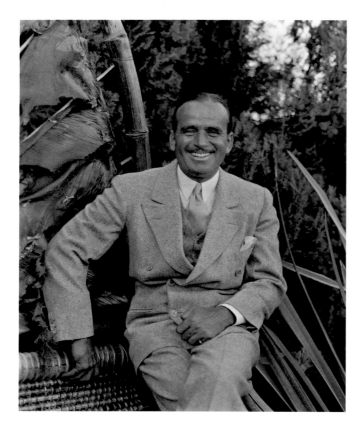

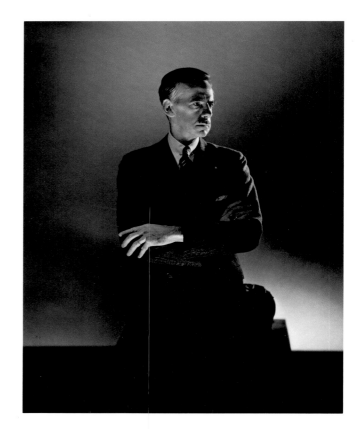

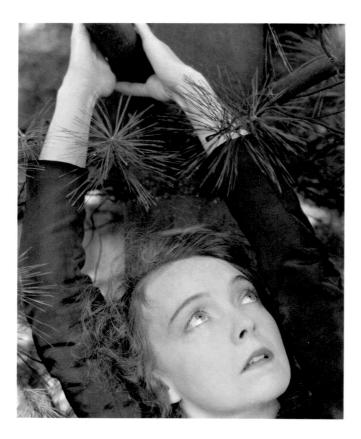

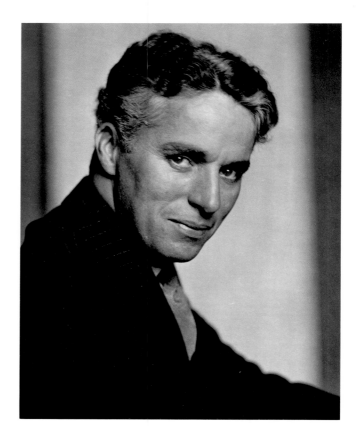

top: Edward Steichen, *Douglas Fairbanks,* c. 1928
bottom: Edward Steichen, *Lillian Gish in ''Within the Gates,''* 1934

top: Edward Steichen, *Eugene O'Neill,* c. 1933
bottom: Edward Steichen, *Charlie Chaplin,* c. 1925

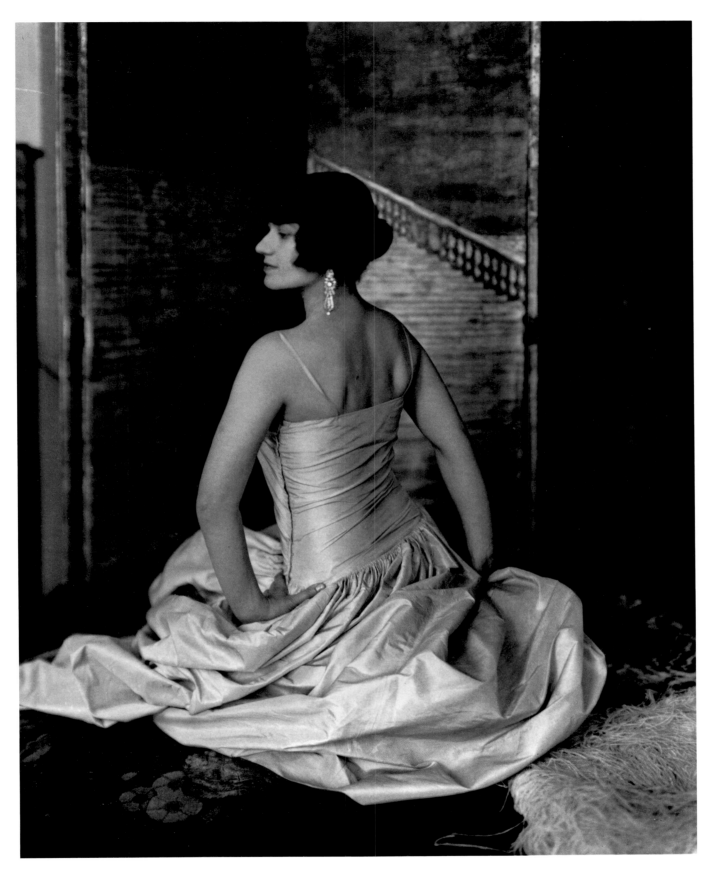

Edward Steichen, *La Duchesse de Gramont, Paris,* 1924

top: Berenice Abbott, *Ferry, West 23rd Street,* 1935
bottom: George Grosz, *Over the Rail,* 1932

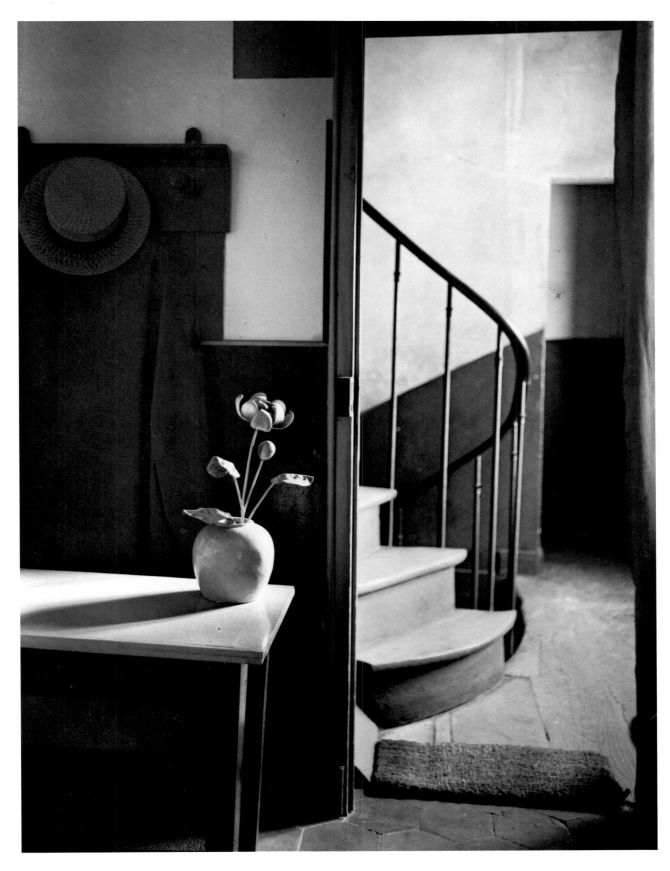

André Kertész, *Chez Mondrian, Paris,* 1926

left: Ralph Steiner, *Typewriter as Design,* c. 1922
bottom: Ralph Steiner, *Lollipop,* 1922

Albert Renger-Patzsch, untitled, n.d.

I'm an eye. A mechanical eye. I, the machine, show you a world the way only I can see it. I free myself for today and forever from human immobility. I'm in constant movement. I approach and pull away from objects. I creep under them. I move alongside a running horse's mouth. I fall and rise with the falling and rising bodies. This is I, the machine, maneuvering in the chaotic movements, recording one movement after another in the most complex combinations. Freed from the boundaries of time and space, I coordinate any and all points of the universe, wherever I want them to be. My way leads towards the creation of a fresh perception of the world. Thus, I explain in a new way the world unknown to you.

DZIGA VERTOV, 1923

Leaving aside the mysteries and the
inequities of human talent, brains, taste,
and reputations, the matter of art in
photography may come down to this: it is
the capture and projection of the delights of
seeing; it is the defining of observation
full and felt.

WALKER EVANS, 1969

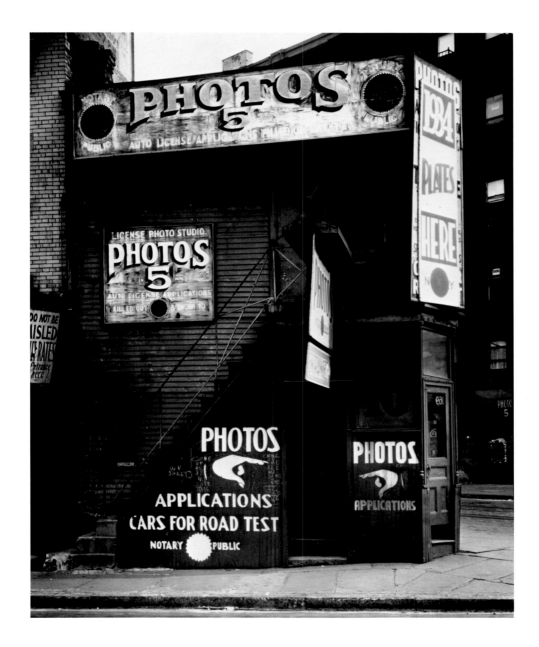

Walker Evans, *License Photo Studio, New York,* 1934

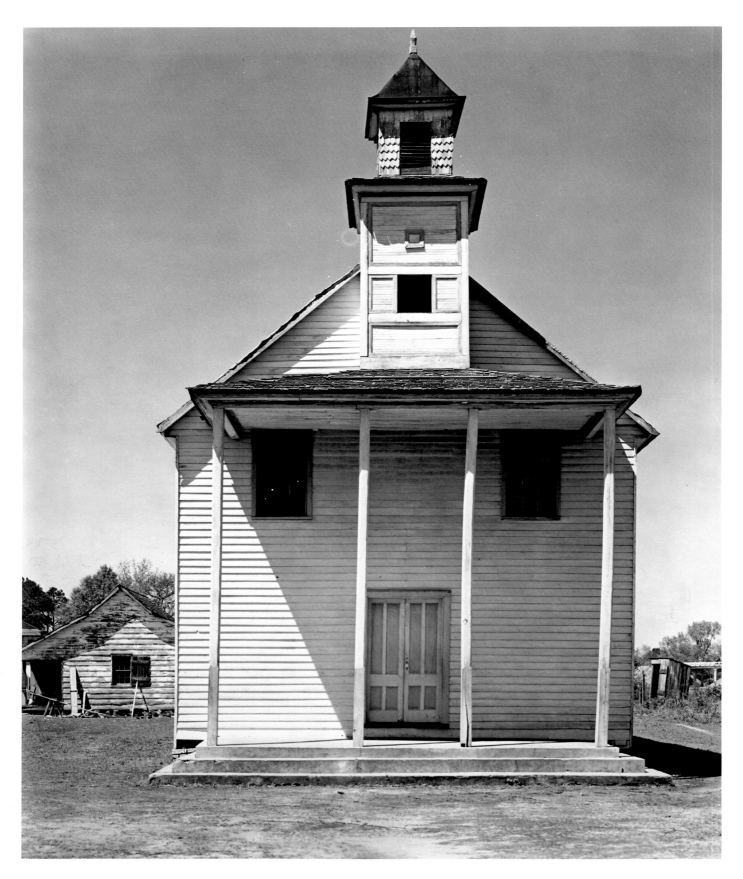

Walker Evans, *Negroes' Church, South Carolina,* 1936

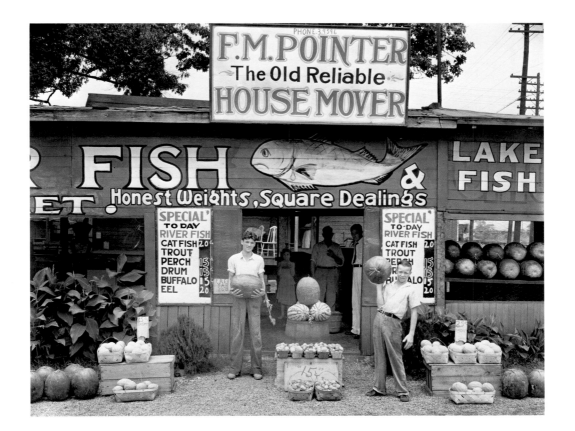

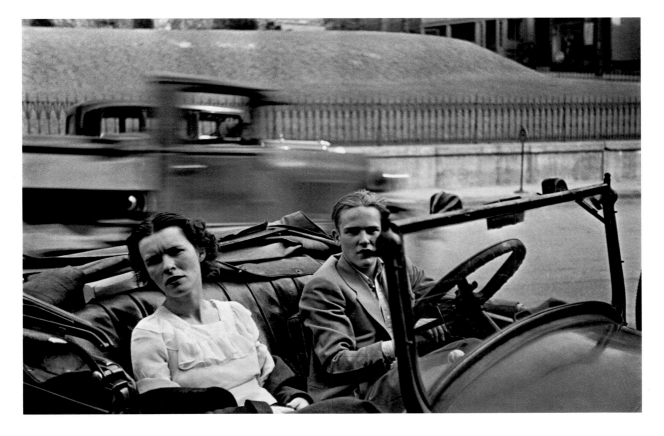

top: Walker Evans, *Roadside Stand, Vicinity Birmingham, Alabama,* 1936
bottom: Walker Evans, *Main Street, Ossining, New York,* 1932

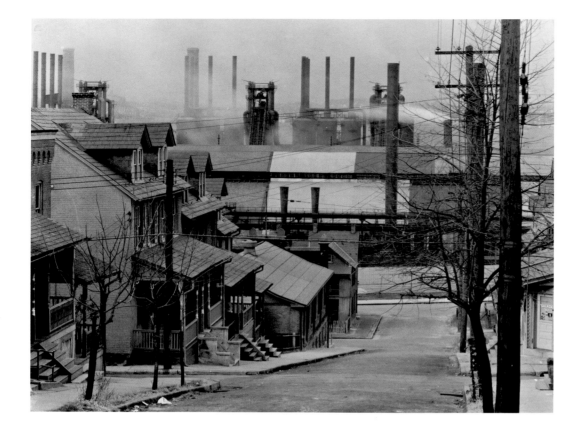

top: Walker Evans, *Houses and Steel Mill, Bethlehem, Pennsylvania,* 1935

bottom: Walker Evans, *Filling Station and Company Houses for Miners, Vicinity Morgantown, West Virginia,* 1935

Walker Evans, *Highway Corner, Reedsville, West Virginia*, 1935

above: Walker Evans, *Breakfast Room at Belle Grove Plantation,
White Chapel, Louisiana,* 1935
opposite: Clarence K. Bros, *Arlington National Cemetery,* c.1940

Modern photographers who are artists are an unusual breed. They work with the conviction, glee, pain, and daring of all artists in all time. Their belief in the power of images is limitless. The younger ones, at least, dream of making photographs like poems—reaching for tone and the spell of evocation; for resonance and panache, rhythm and glissando, no less. They intend to print serenity or shock, intensity, or the very shape of love.

WALKER EVANS, 1969

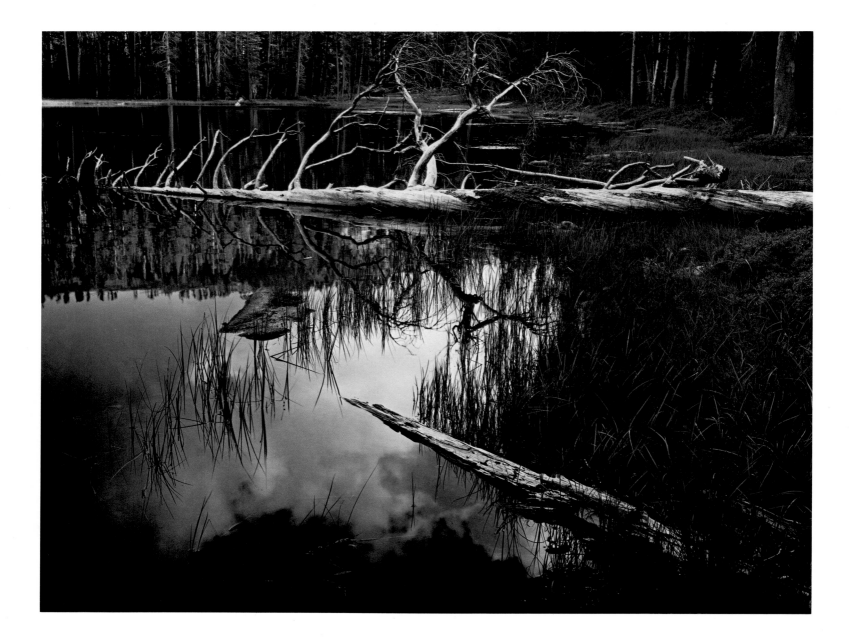

Ansel Adams, *Siesta Lake, Yosemite National Park, California,* c. 1958

Carl Chiarenza, *Somerville 9A,* 1975

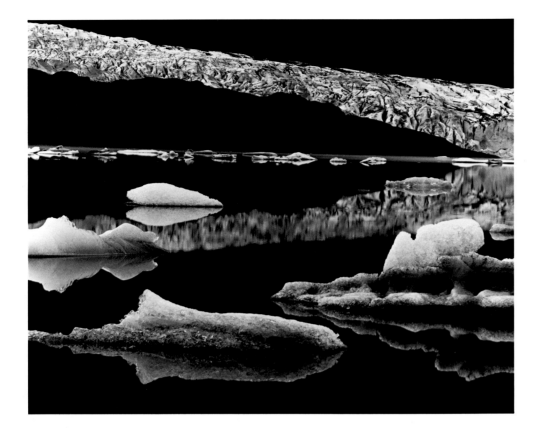

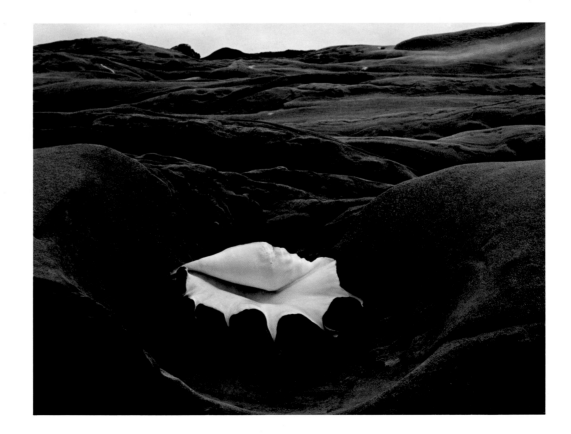

opposite, top: Brett Weston, *Mendenhall Glacier, Alaska,* 1973
bottom: Edward Weston, *Shell,* 1931
above: Wynn Bullock, *Night Scene,* 1959

Aaron Siskind, *Mexico,* 1955

When I make a photograph I want it to be an altogether new object, complete and self-contained, whose basic condition is order—(unlike the world of events and actions whose permanent condition is change and disorder).

AARON SISKIND, 1950

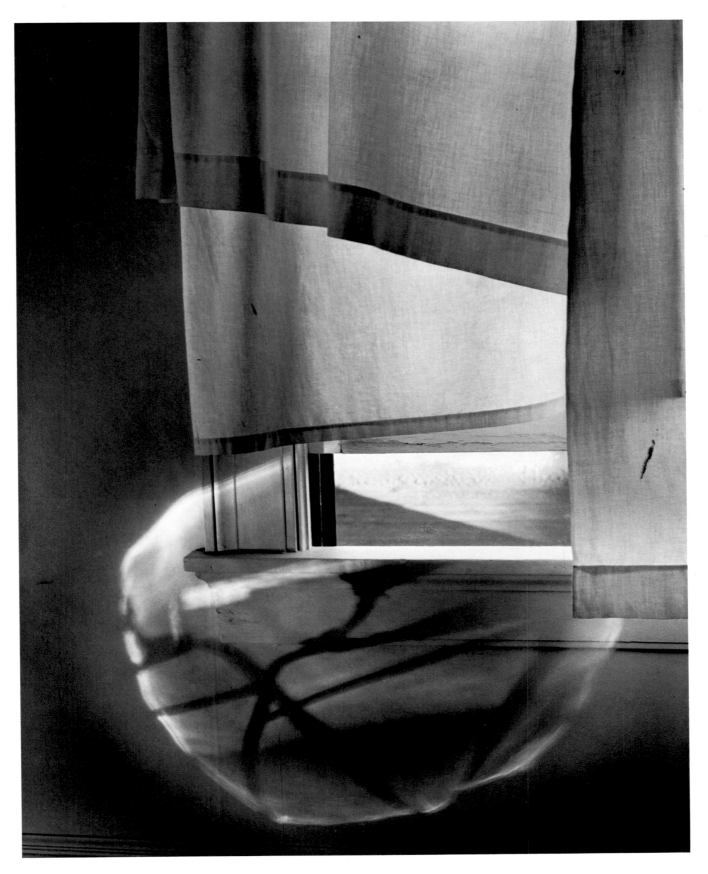

Minor White, *Windowsill Daydreaming, Rochester, New York,* 1958

One must feel definitely, fully, before the exposure. My finished print is there on the ground glass [of the camera], with all its values, in exact proportions. The final result in my work is fixed forever with the shutter's release. Finishing, developing, and printing is no more than a careful carrying on of the image seen on the ground glass.

EDWARD WESTON, 1930

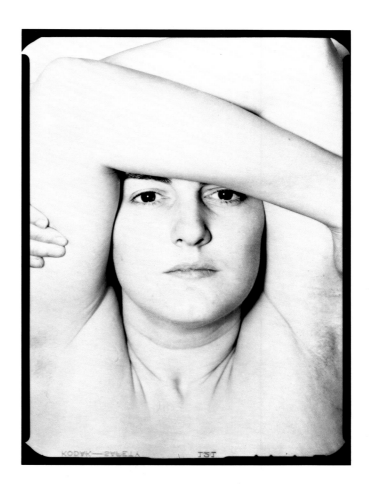

opposite: Harry Callahan, *Cape Cod,* 1972
above: Harry Callahan, *Eleanor,* c. 1947

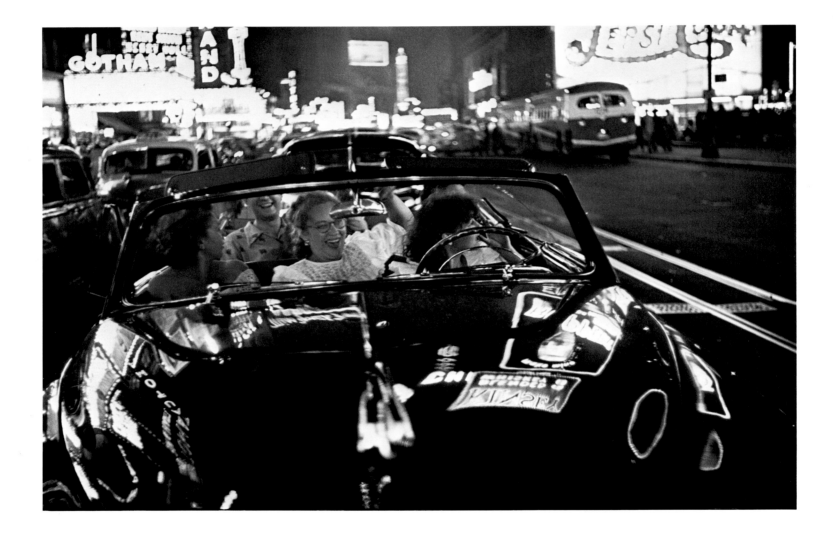

Louis Faurer, *New York City,* 1950

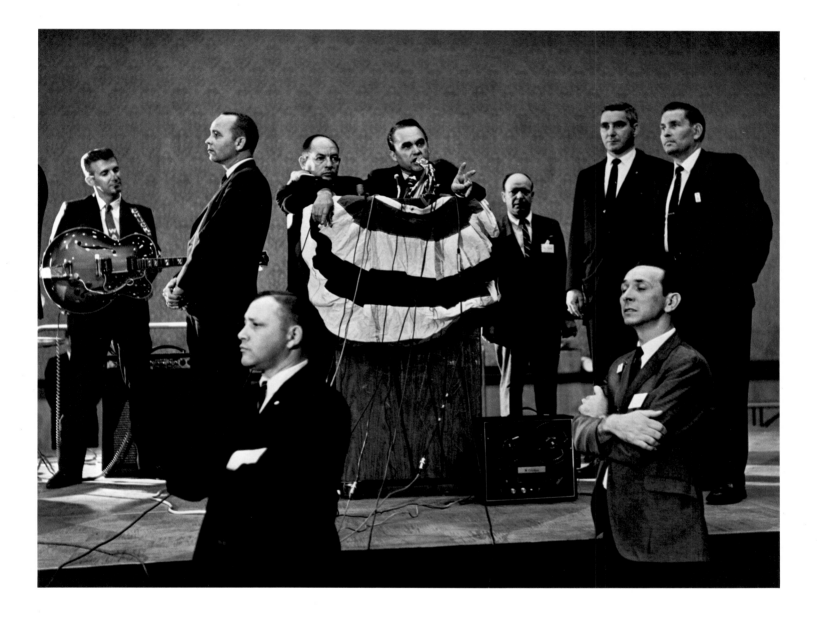

Jerome Liebling, *Governor Wallace, Minnesota,* 1968

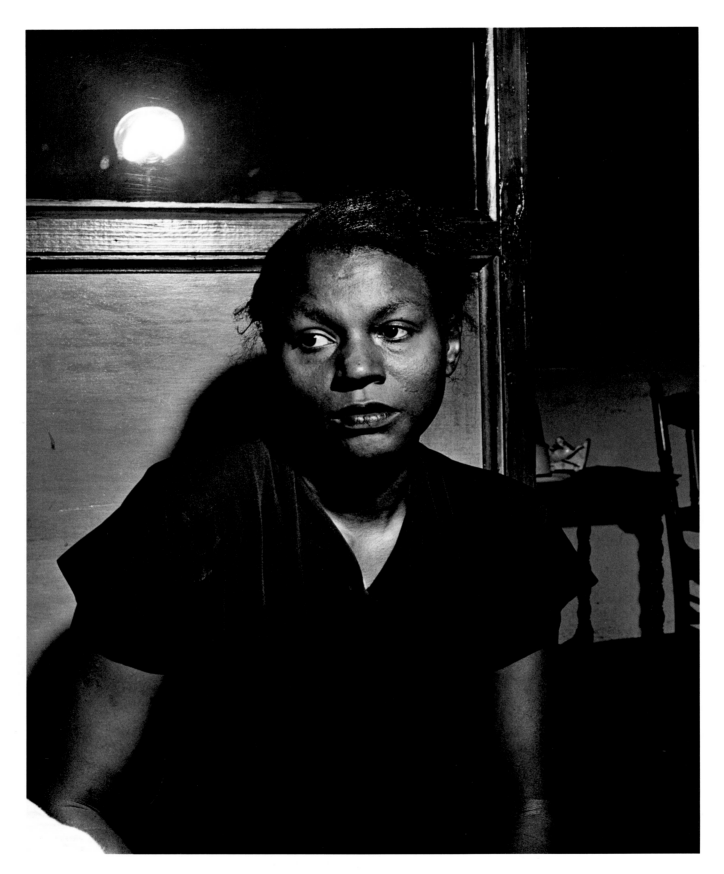

Marion Palfi, *Wife of the Lynch Victim,* 1949

Robert Frank, *Motorama, Los Angeles,* 1956

It is always the instantaneous reaction to oneself that produces a photograph.

ROBERT FRANK, 1958

Jack Welpott, *The Farmer Twins, Stinesville, Indiana,* 1958

Ralph Eugene Meatyard, *Cranston Richie,* 1964

above: Robert Gene Wilcox, *Near Moosonee, Ontario, Canada,* 1963
opposite: Jerry N. Uelsmann, untitled, 1969

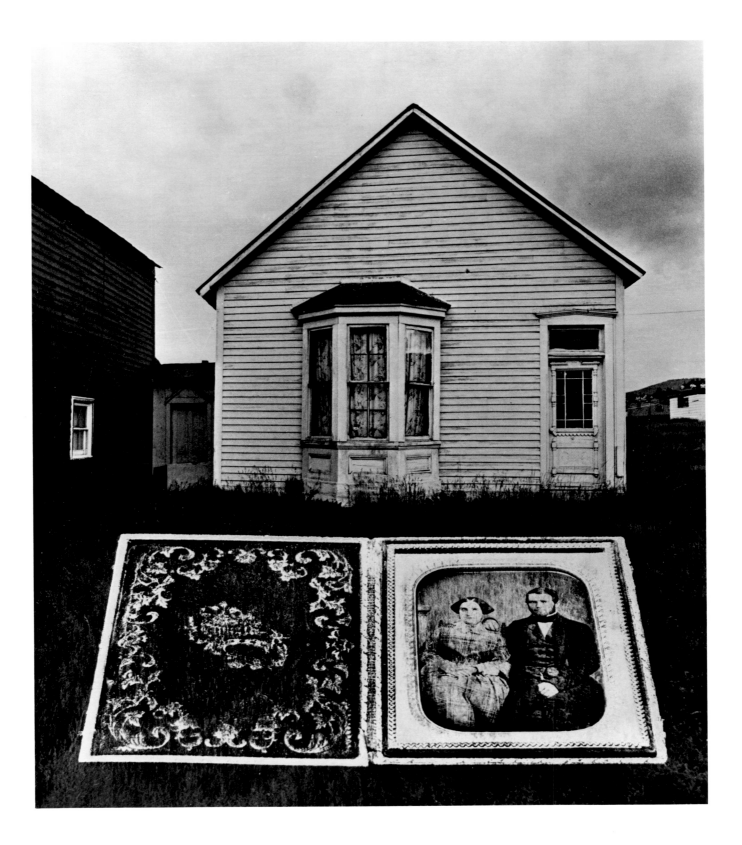

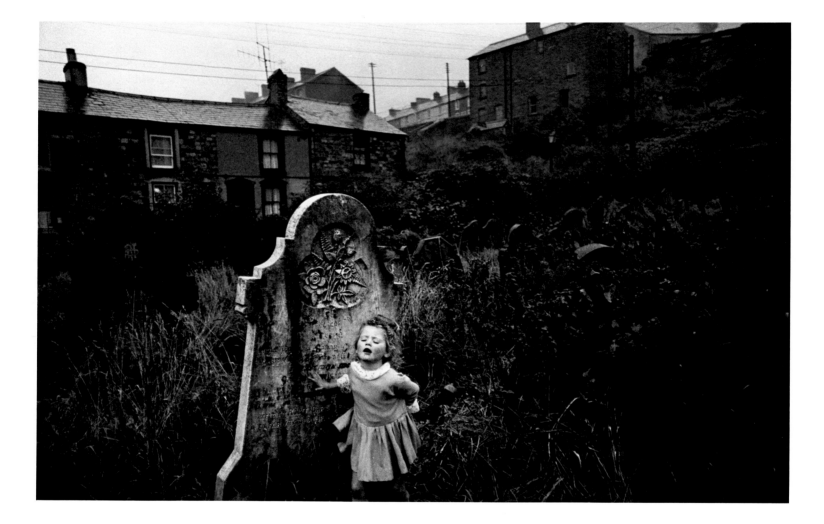

Bruce Davidson, untitled, 1965

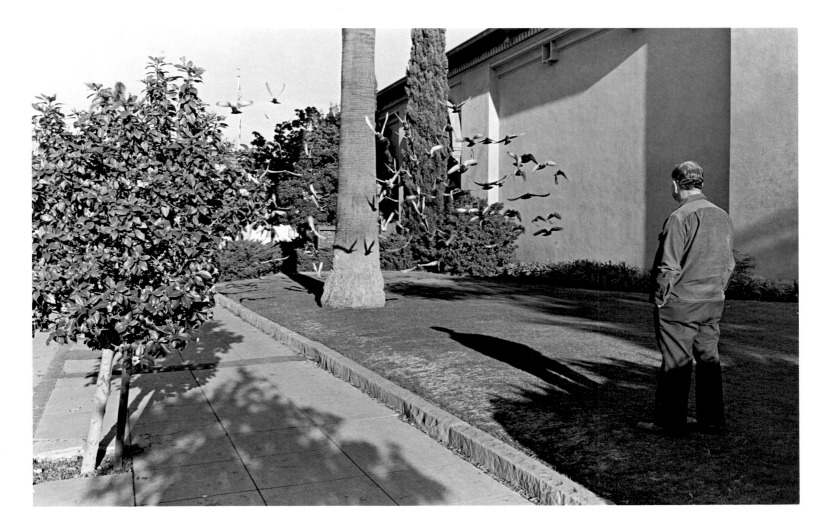

Henry Wessel, Jr., untitled, 1977

There is nothing as mysterious as a fact clearly described. . . . A still photograph is the illusion of a literal description of how a camera saw a piece of time and space. Understanding this, one can postulate the following theorem: Anything and all things are photographable . . . a photograph can look any way. Or, there's no way a photograph has to look (beyond being an illusion of a literal description). Or, there are no external or abstract or preconceived rules of design that can apply to still photographs.

GARRY WINOGRAND, 1974

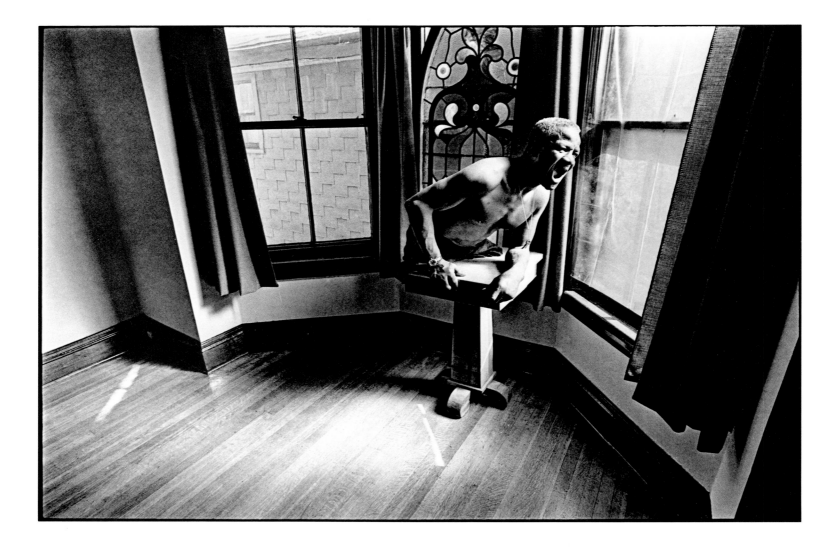

Leslie Krims, *A Human Being as a Piece of Sculpture,* 1969

Mark Cohen, *Wilkes Barre, Pennsylvania,* 1975

opposite: Roger Mertin, untitled, 1971

top: Charles Swedlund, *Three Graces,* 1969

bottom: Emmet Gowin, *Edith and Nancy, Danville, Virginia,* 1970

Arnold Newman, *Georges Rouault,* 1957

Arnold H. Crane, *Brassaï,* New York, 1968

opposite: Weegee, *Eva Gabor and Mama Gabor,* n.d.
above: William Klein, *Inside Goum Department Store, Moscow,* 1959

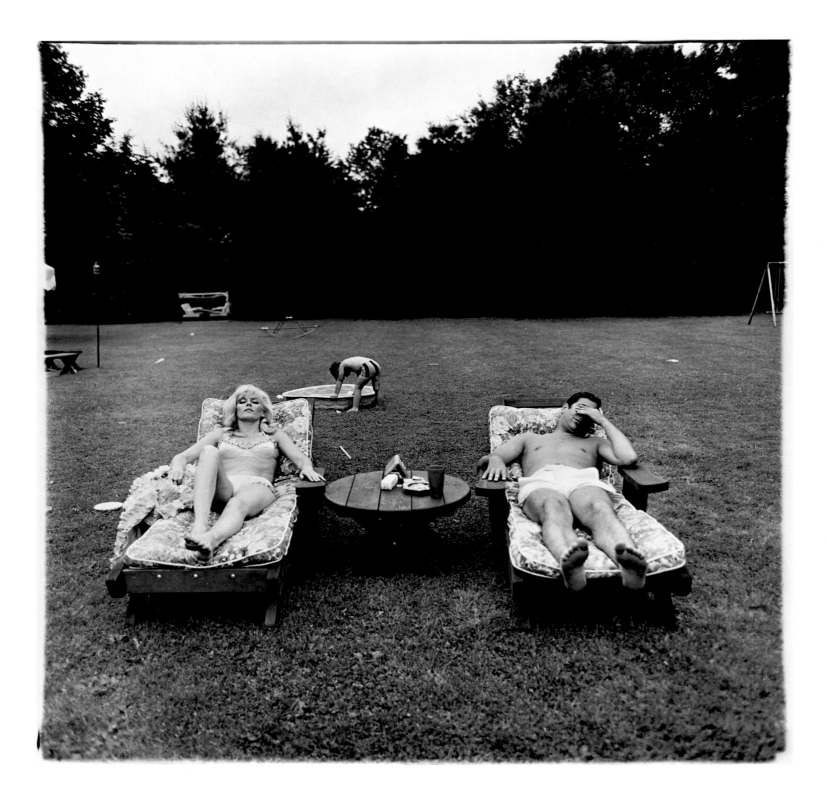

Diane Arbus, *Family on Lawn One Sunday, Westchester*, 1968

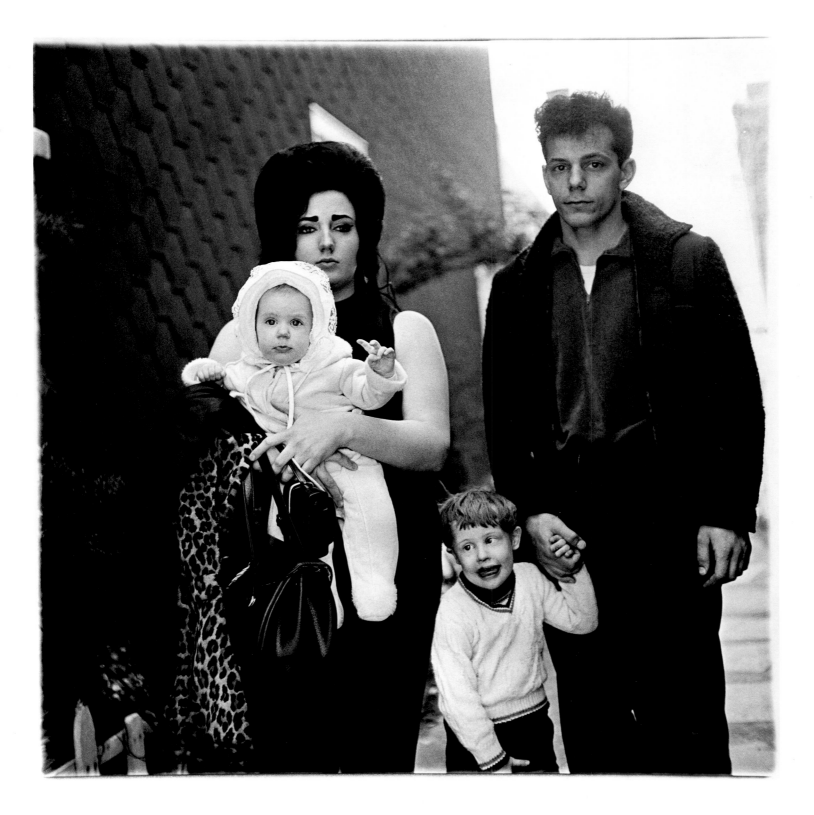

Diane Arbus, *Brooklyn Family on Sunday Outing,* 1966

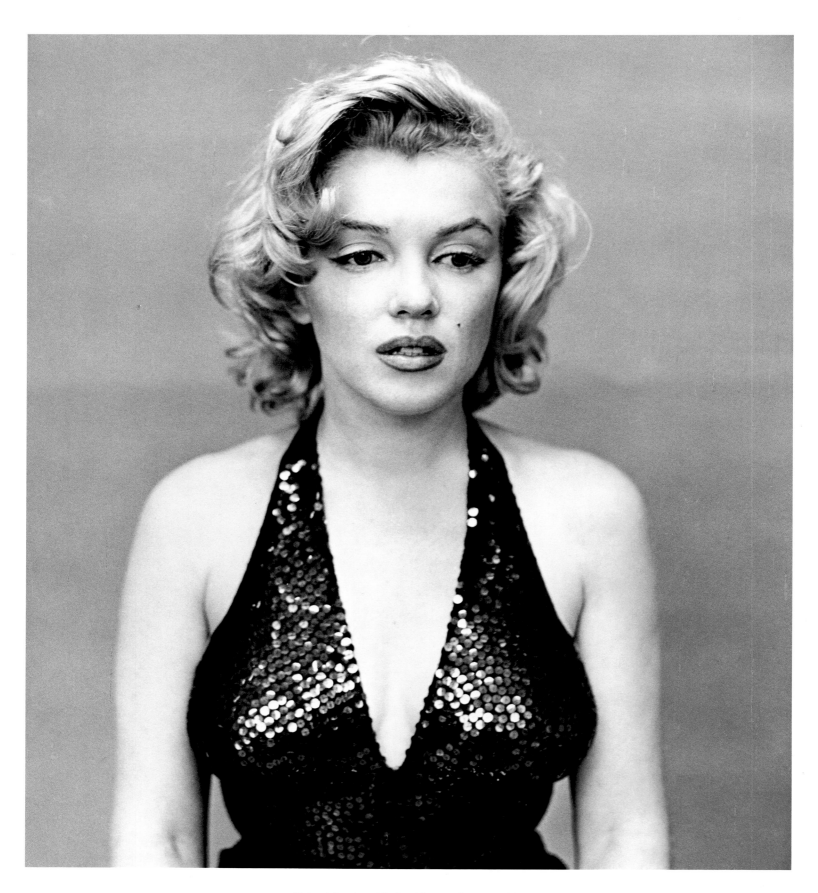

Richard Avedon, *Marilyn Monroe, Actress,* 1962

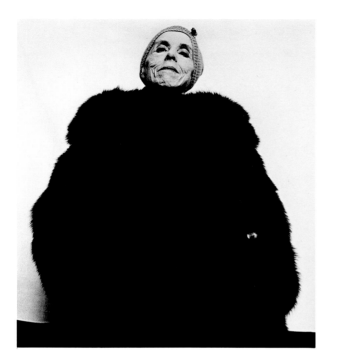

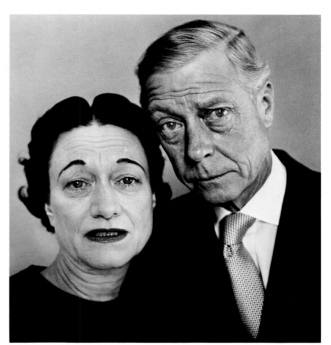

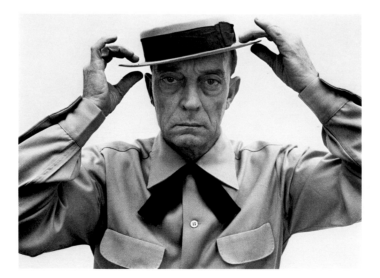

top left: Richard Avedon, *Isak Dinesen, Writer,* 1958
top right: Richard Avedon, *The Duke and Duchess of Windsor,* 1957
bottom: Richard Avedon, *Buster Keaton, Comedian,* 1952

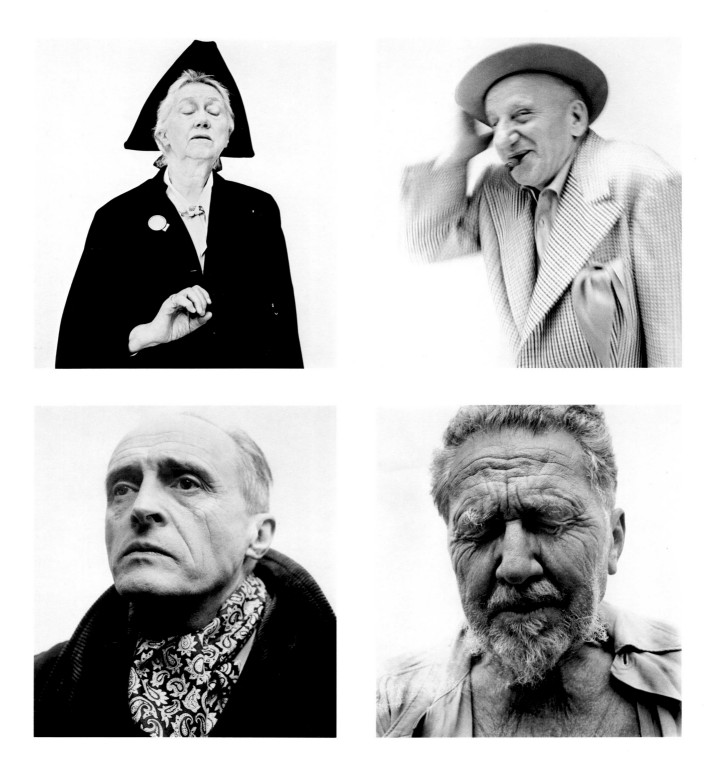

top: Richard Avedon, *Marianne Moore, Poetess,* 1958
bottom: Richard Avedon, *René Clair, Director,* 1958

top: Richard Avedon, *Jimmy Durante, Comedian,* 1953
bottom: Richard Avedon, *Ezra Pound, Poet,* 1958

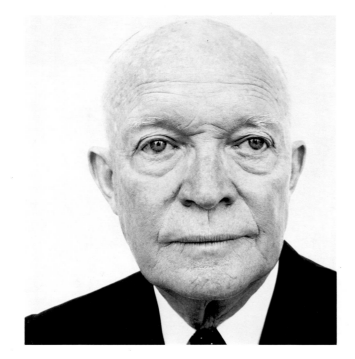

I work out of myselves. There's no other way to do it. All these photographs are linked through me and each is like a sentence in one long inner argument. . . . The photographs have a life of their own now. Whatever it was I brought to them is in *them* and it isn't in me . . . anymore. The photograph of Bogart hangs on the wall. The information in it is self-contained. He's dead. The time is past. Everything has changed. Everything . . . except the photograph.

My photographs don't go below the surface. They don't go below anything. They're readings of what's on the surface. I have great faith in surfaces. A good one is full of clues.

RICHARD AVEDON, 1970

top left: Richard Avedon, *Dwight David Eisenhower,
President of the United States,* 1964
top right: Richard Avedon, *Humphrey Bogart, Actor,* 1953
bottom: Richard Avedon, *Charles Chaplin, Actor,* 1952

Jonas Dovydenas, *Amvets Parade Bugler, Chicago,* 1975

Neil Selkirk, *Zbigniew Brzezinski, Washington, D.C.,* 1978

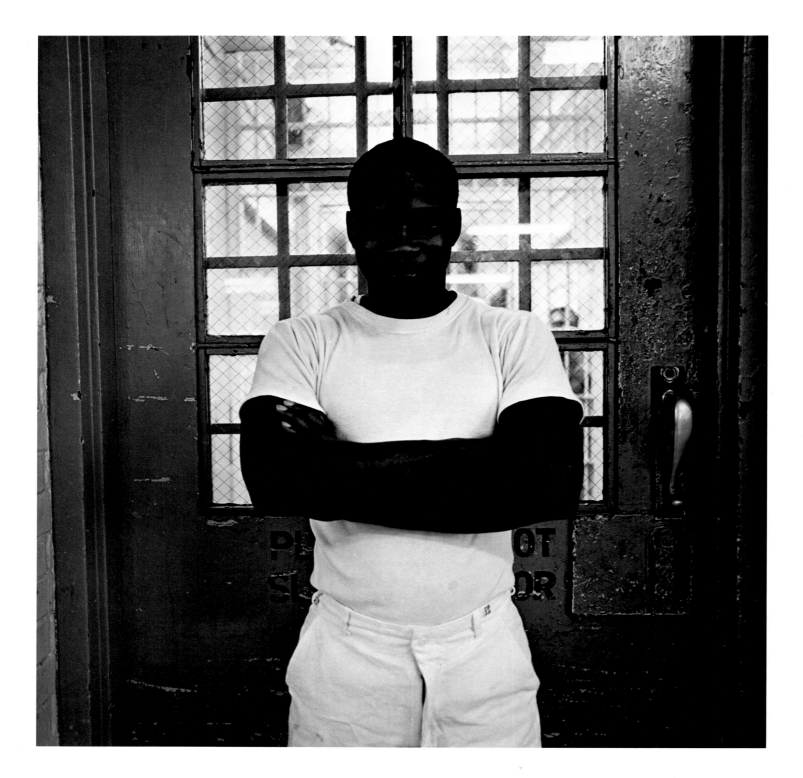

Joel Snyder, *Rebo, Chester, Illinois,* 1975

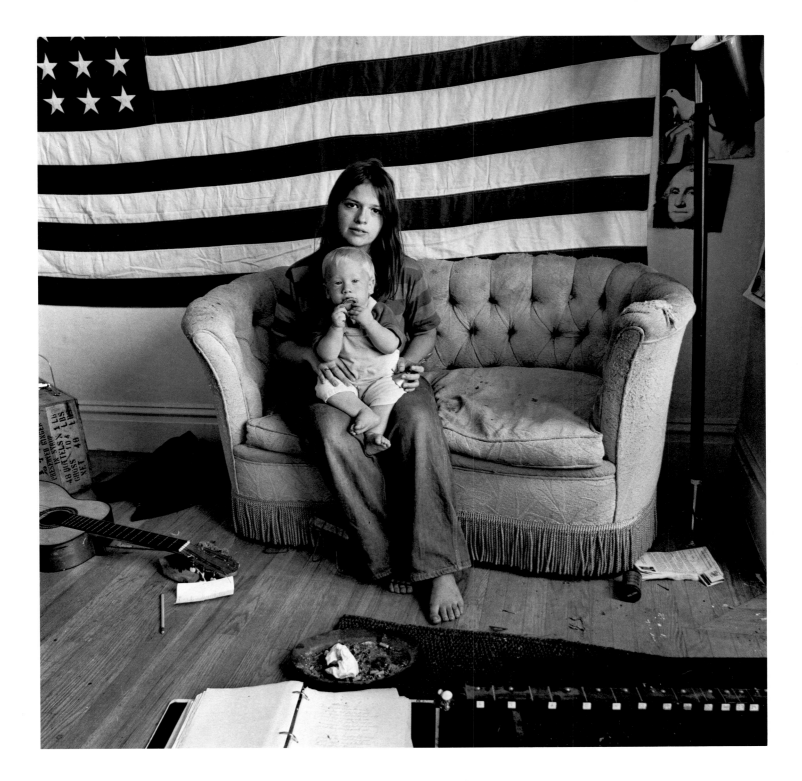

Elaine Mayes, *Kathleen and Max Demian Goldman, Ages Twenty-two and One Year, Cole Street, San Francisco*, 1968

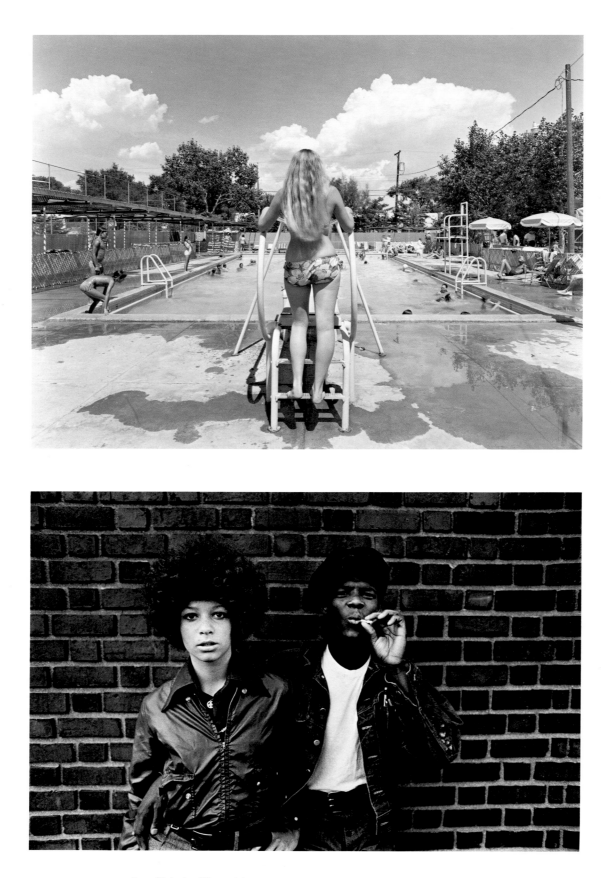

top: Nicholas Nixon, *Mary Hughes, Tennis Club of Albuquerque,* 1973
bottom: Richard Olsenius, from *High School* series, c. 1970

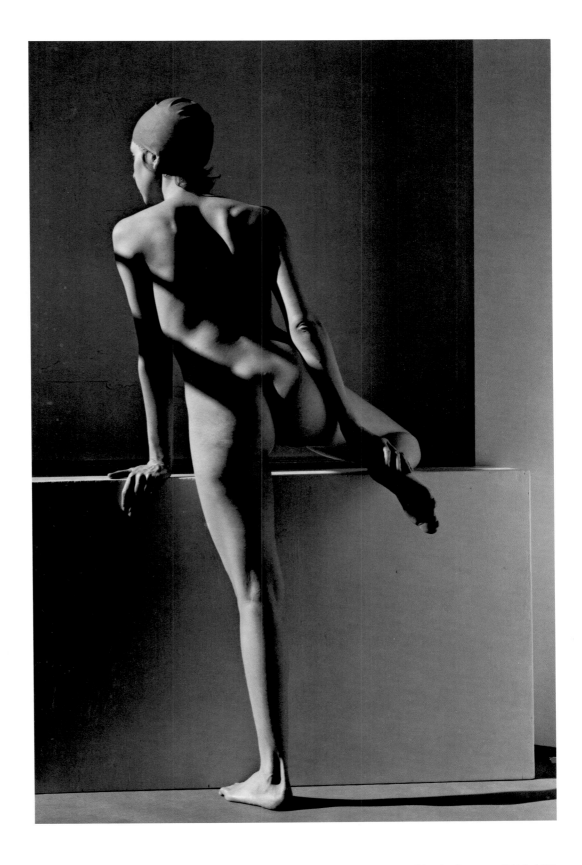

Marsha Burns, *#45006,* 1978

Peter Goin, *Jim,* 1977

Joan Moss, from *Two Women* series, 1977

Ramon J. Muxter, *Baltimore Street,* 1976

Michael Dickey, *Detroit,* 1972

left: Elaine Mayes, *Ruth Murphey, Age Eighteen, Mission District, San Francisco,* 1968

bottom: Larry Fink, *First Communion, Bronx, New York,* 1961

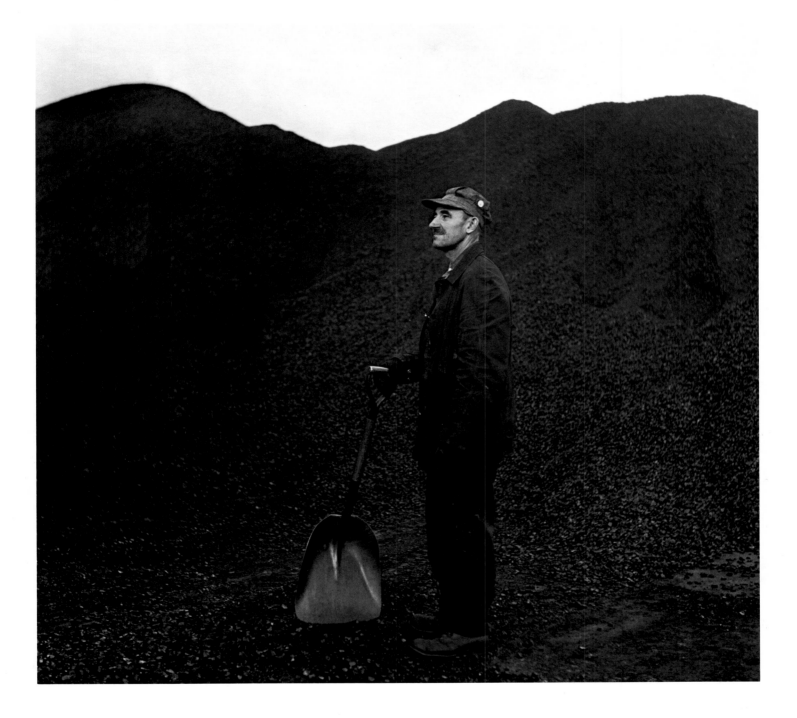

Jerome Liebling, *Coal Worker, Minnesota,* 1952

John Coplans, *Judith and Inigo,* 1980

Robert Holmgren, untitled, 1979

The aesthetic qualities of photography are to be sought in its power to lay bare the realities. . . . Only the impassive lens, stripping its object of all those ways of seeing it, those piled-up preconceptions, that spiritual dust and grime with which my eyes have covered it, is able to present it in all its virginal purity to my attention and consequently to my love. By the power of photography, the natural image of a world that we neither know nor can know, nature at last does more than imitate art; she imitates the artist.

ANDRÉ BAZIN, 1967

above: Thomas F. Arndt, *Street Scene, Chicago,* 1980
opposite: Louis Lanzano, untitled, 1973

above: Peter DeLory, *Andy Ostheimer Reading, Ibiza, Spain,* 1976
opposite, top: Eve Sonneman, *Light on Lead Street, New Mexico,* 1968
bottom: Gerald Lang, *Zion,* 1975

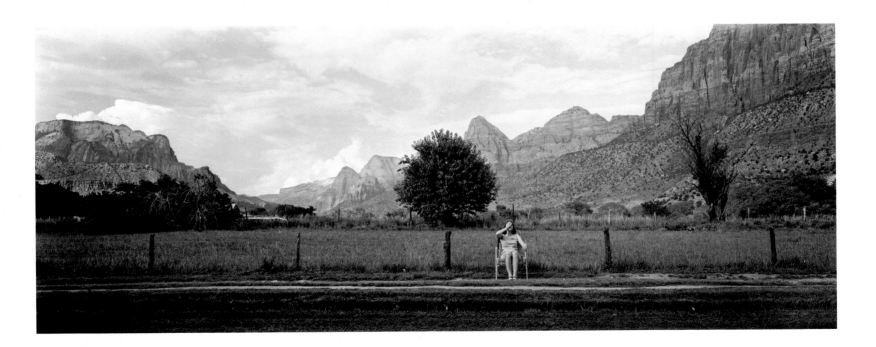

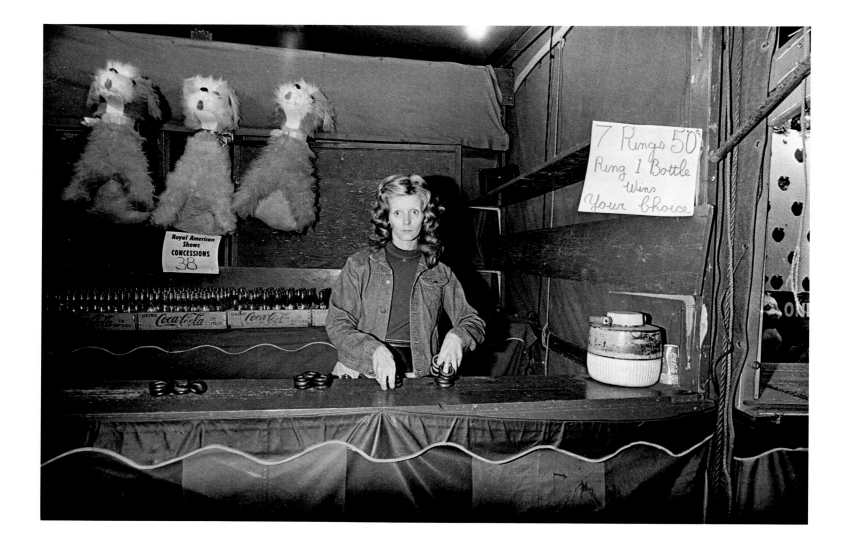

above: Thomas F. Arndt, *Midway Worker, Minnesota State Fair,* 1974
opposite: Mark E. Jensen, *Linus Mullarkey, Barber, Milwaukee, Wisconsin,* 1974

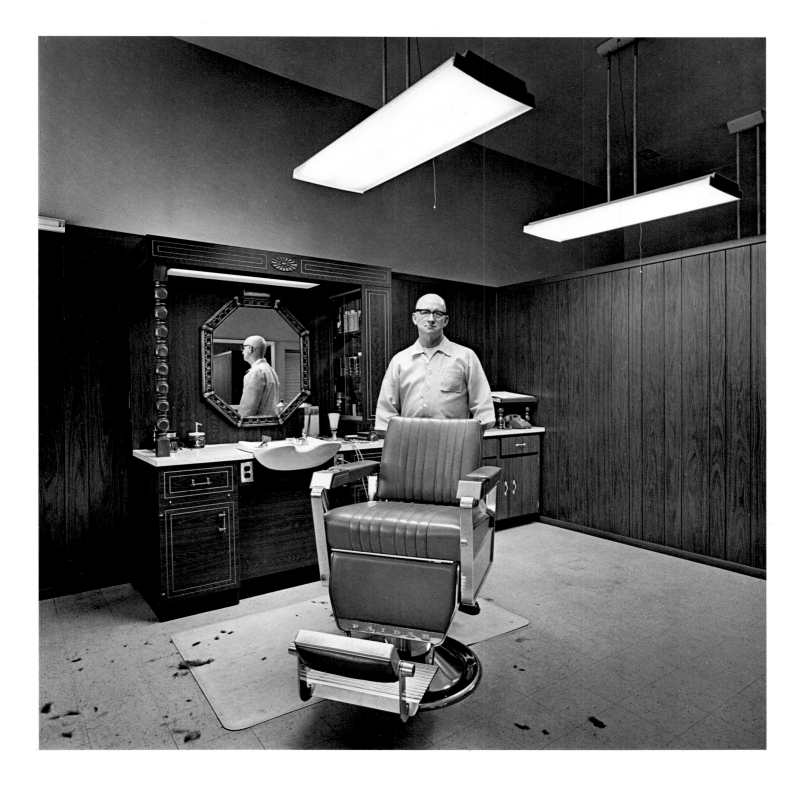

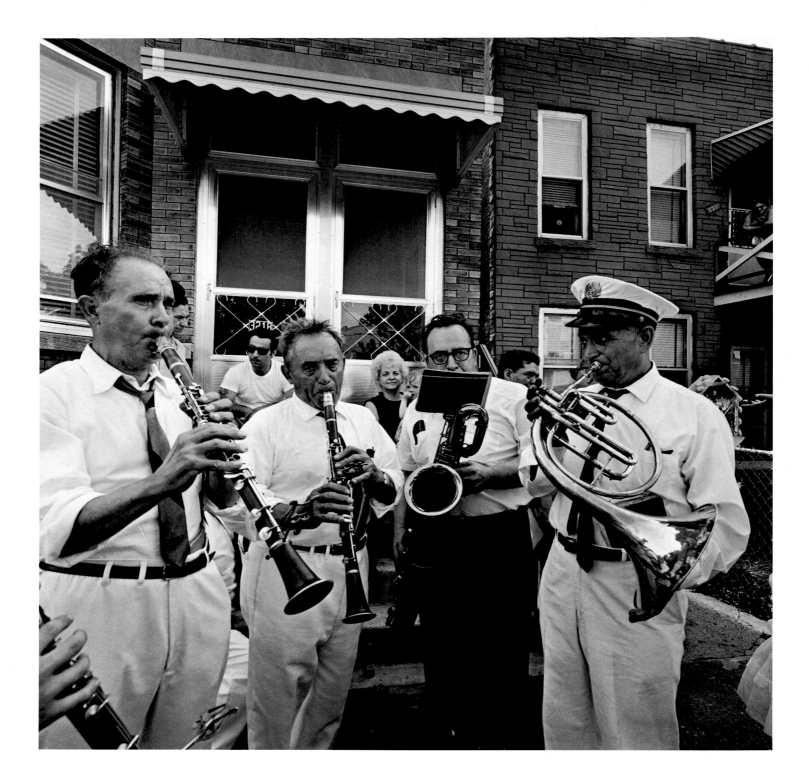

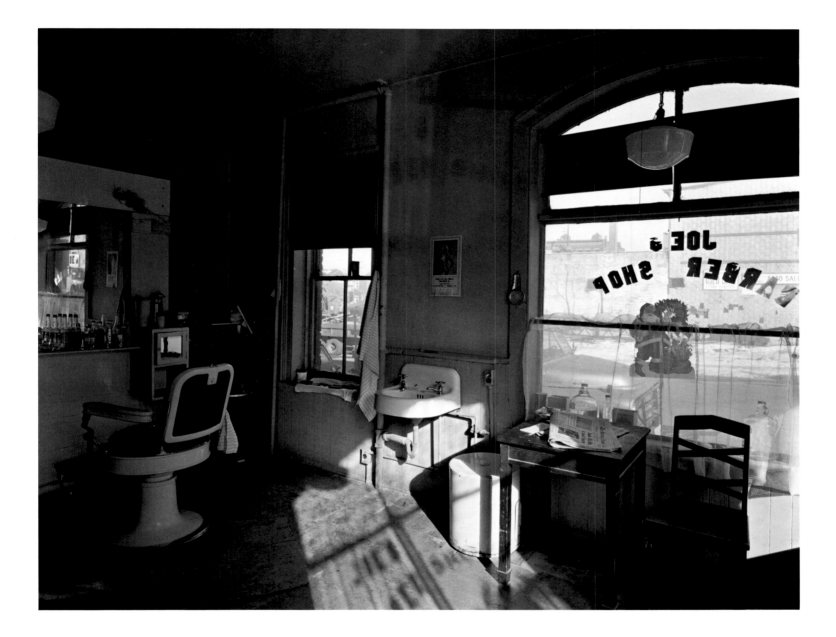

opposite: Jonas Dovydenas, *Church Holiday Musicians, Chicago,* 1968
above: George A. Tice, *Joe's Barber Shop, Paterson, New Jersey,* 1970

Joseph D. Jachna, *Door County, Wisconsin,* 1970

The artist is simply the more or less appropriate *instrument*
through which a culture . . . expresses itself aesthetically.

PIET MONDRIAN, 1918

Joel D. Levinson, *Fractions,* from *Self-Indulgence* series, 1979

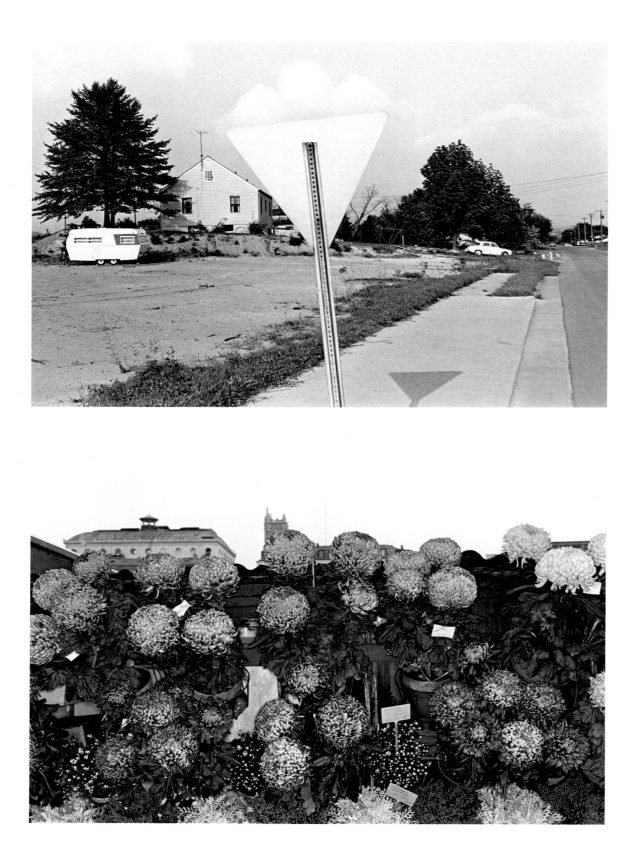

top: Lee Friedlander, *House, Trailer, Sign, and Cloud, Knoxville, Tennessee,* 1971
bottom: Lee Friedlander, *Chrysanthemums at Flower Market, Paris,* 1972

top: Lee Friedlander, *Major General Henry W. Slocum, Napoleon Gun, and Stevens'*
Fifth Maine Battery Marker, Gettysburg National Military Park, 1974
bottom: Lee Friedlander, *Grand Army of the Republic Memorial, Haverstraw, New York*, 1976

Michael Simon, untitled, 1973

Joan Myers, *Monument Valley*, 1979

above: Lawrence McFarland, *Wheatfield, Near Kansas/Nebraska Border,* 1976
opposite: Joe Deal, *View, Magic Mountain, Valencia, California,* 1977

above: Will Agar, *Freeway, Southwest U.S.A.,* 1975
opposite, top: Thomas F. Barrow, from *Cancellations* series, 1975
bottom: Allen Swerdlowe, untitled, 1978

above: Frank W. Gohlke, *Facade and Telephone Pole, St. Louis, Missouri,* 1972
opposite: Michael A. Smith, *Yellowstone National Park, Wyoming,* 1975

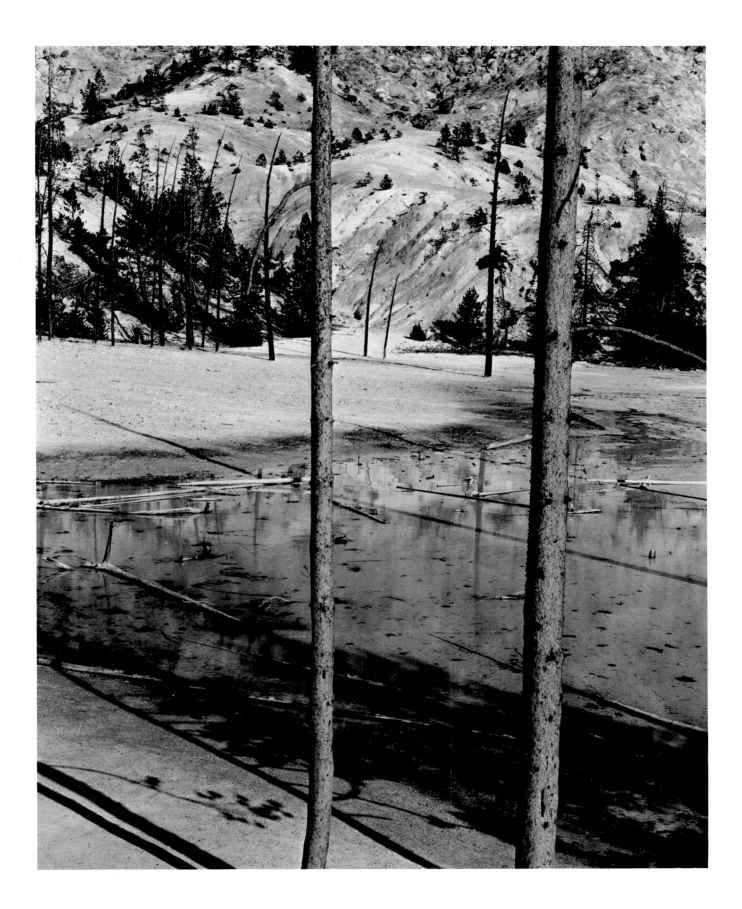

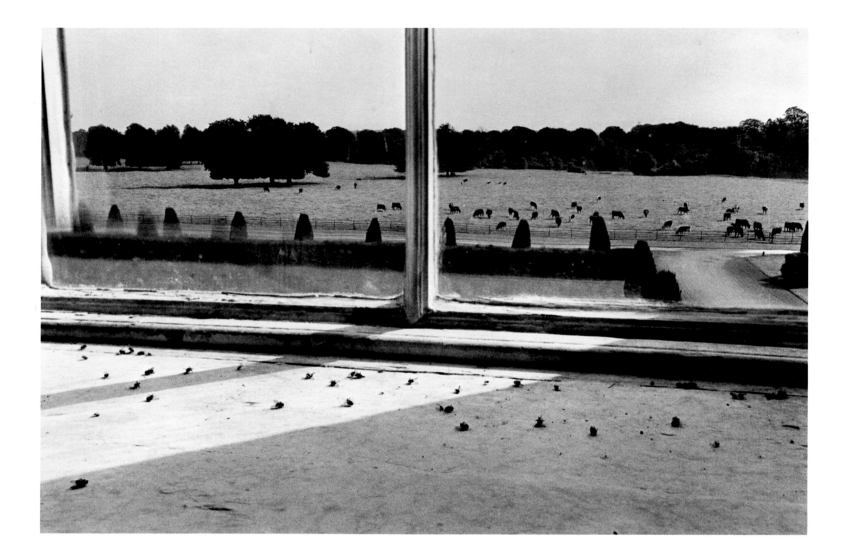

above: Alen MacWeeney, *Flies in the Window,*
Castletown House, Ireland, 1972
opposite: Jane Tuckerman, untitled, 1980

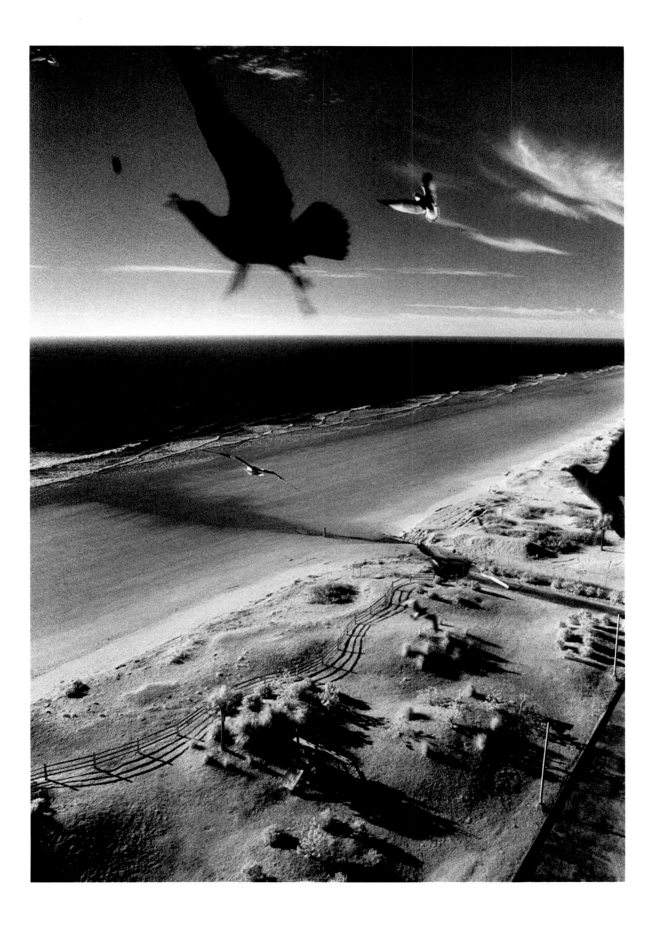

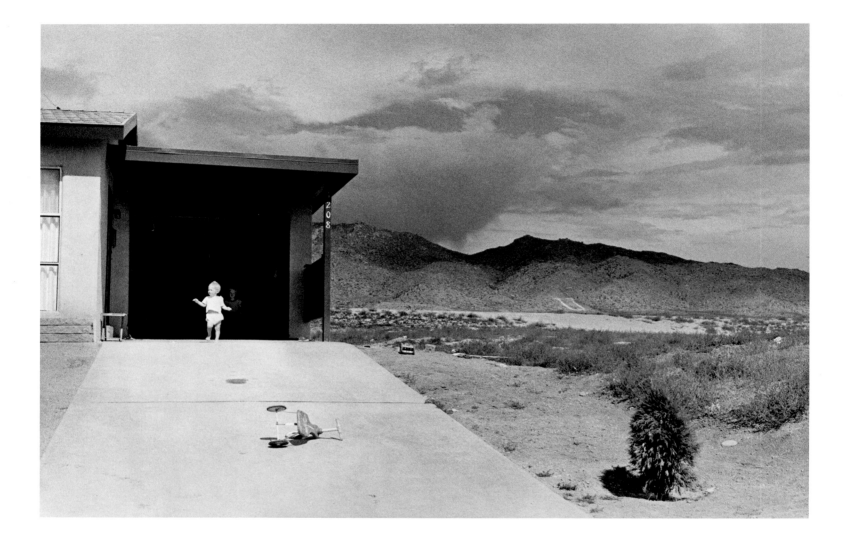

Garry Winogrand, *Albuquerque, New Mexico,* 1958

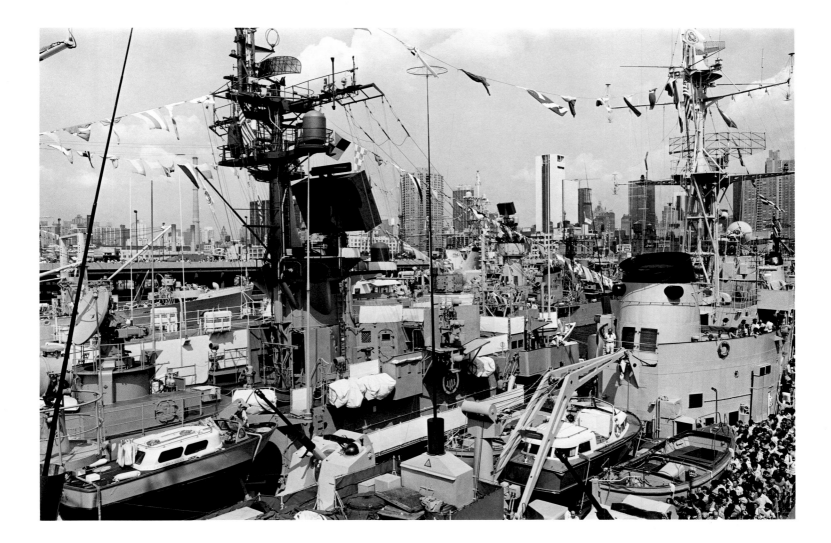

Tod Papageorge, *New York Pier, July 5, 1976*

Thus photography, from being merely another way of procuring or making images of things already seen by our eyes, has become a means to ocular awareness of things that our eyes can never see directly. It has become the necessary tool for all visual comparison of things that are not side by side, and for all visual knowledge of the literally unseeable—unseeable whether because too small, too fast, or hidden under surfaces, and because of the absence of light. Not only has it vastly extended the gamut of our visual knowledge, but through its reproduction in the printing press, it has effected a very complete revolution in the ways we use our eyes and, especially, in the kinds of things our minds permit our eyes to tell us.

WILLIAM M. IVINS, JR., 1953

Joel Meyerowitz, *Truro, Cape Cod,* 1976

Joan Lyons, untitled, 1980

William Eggleston, *Shelly Schuyler, Sumner, Mississippi,* c. 1973

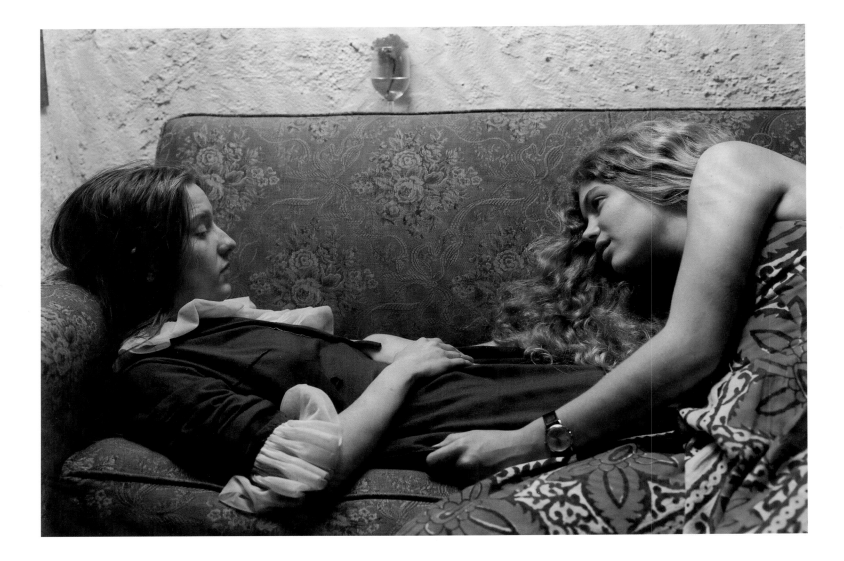

above: William Eggleston, *Two Girls,
Memphis, Tennessee,* 1973
opposite: Jo Ann Callis, *Man in Tie,* 1976

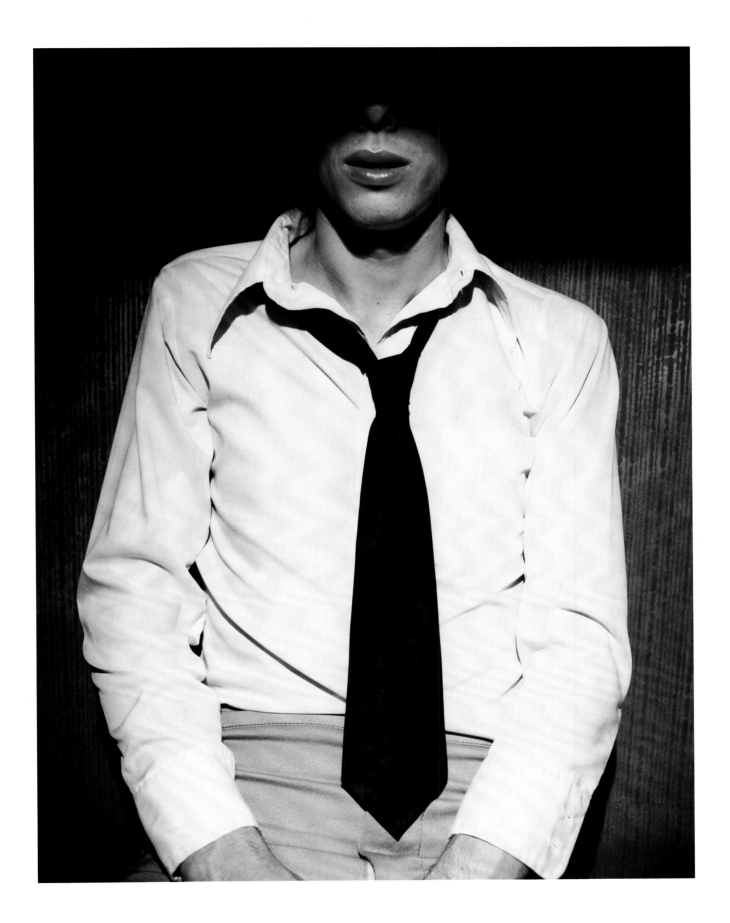

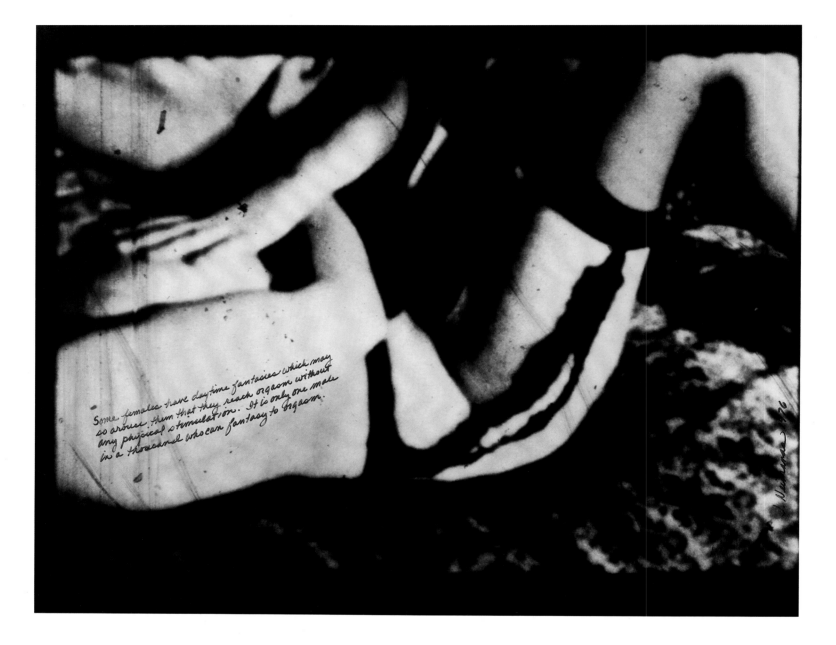

above: Joyce Neimanas, *Some Females Have Daytime Fantasies . . .* , 1976
opposite: Judith Golden, untitled, 1977

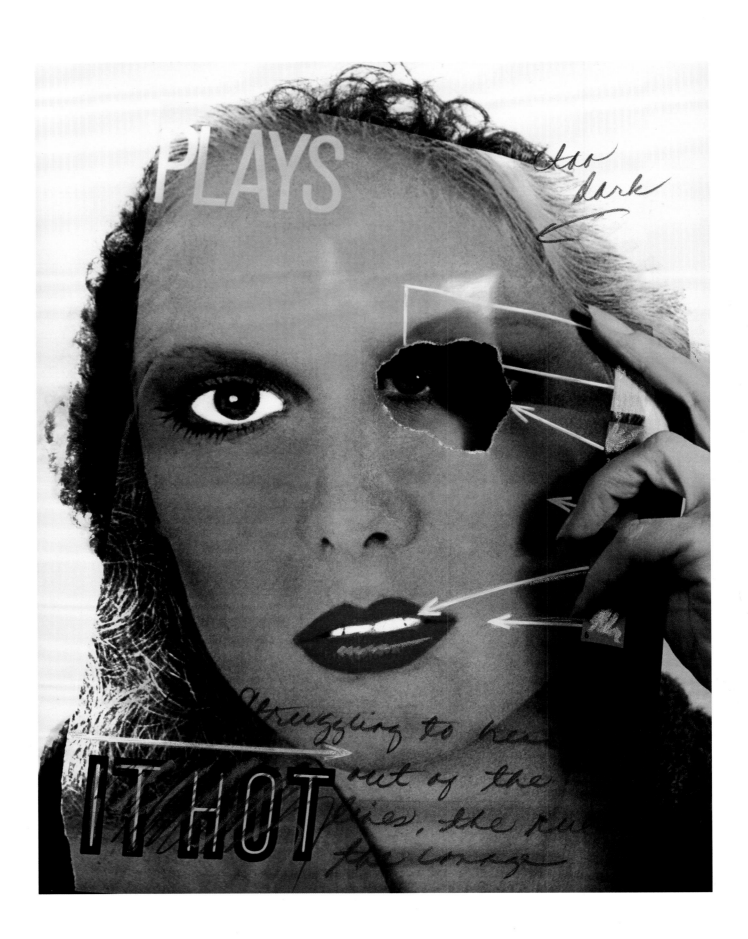

above: Christopher P. James, *Tent/Sky ''B'' No. 4,* 1977
opposite: Reed Estabrook, *Exercise in Solid Geometry No. 31,* 1981

above: James Henkel, *Guatemala/Minnesota,* 1979
opposite, top: Lawrence J. Merrill, untitled, 1982
bottom: Brian Albert, *Foghat/Wet Willie Concert, St. Paul,* 1978

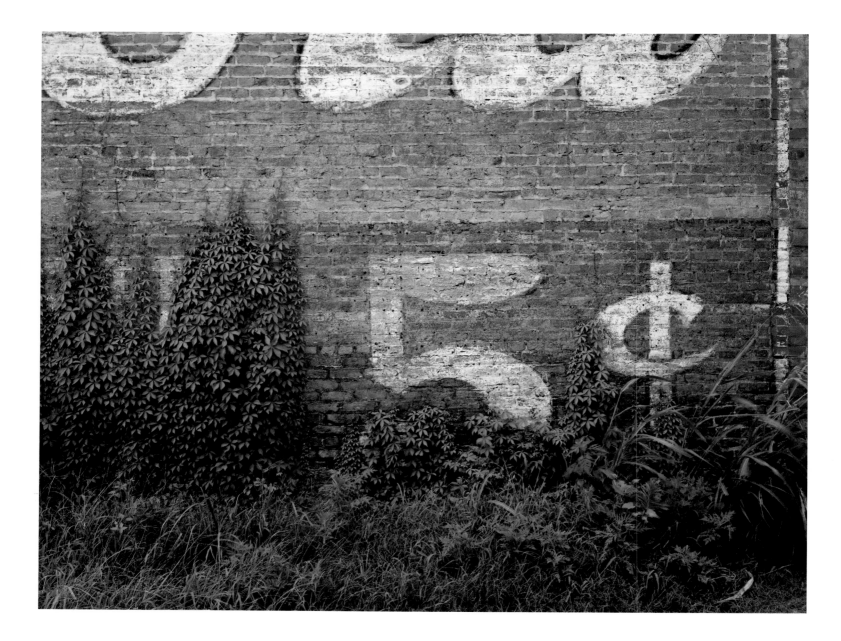

William Christenberry, *5¢ Sign, Demopolis, Alabama,* 1978

Len Jenshel, *World Trade Center, New York, New York,* 1979

Stuart D. Klipper, *Beach, Los Angeles,* 1976

ACKNOWLEDGMENTS The purpose, substance, and life of a museum are its collections. Since the turn of the century, the directors, curators, and staff of The Minneapolis Institute of Arts have worked in concert with many donors to fashion a truly encyclopedic art collection for the residents of Minnesota. So, too, the photography collection at the museum has grown through generous donations of monies and works of art. Most importantly, the continuing assistance of Kate and Hall J. Peterson, whose original gift of discretionary purchase funds in 1971 gave momentum to an assertive program of acquisition, remains at the center of the department's purchase capability. The following contributors are to be thanked as well: D. Thomas Bergen, Christopher Cardozo, Arnold H. Crane, Mrs. Julius E. Davis, Harry McC. Drake, Arnold Gilbert, Lee Kitzenberg, Julia Marshall, Herbert R. Molner, Joanna Steichen, Virginia Zabriskie, and others too numerous to list here. The majority of contemporary photographers represented in the collection have also given photographs and, through their active participation and help, have greatly added to our holdings of their works. The Photography Council, the support and advocacy organization for the Photography Department, has provided funds for the purchase of an outstanding group of images by contemporary photographers. Corporate donations, notably by AT&T, have been of major consequence as well.

Just as significant for the growth of the collection has been the encouragement provided by the three museum directors under whose tenure it was formed: Carl J. Weinhardt, Anthony Morris Clark, and Samuel Sachs II. The collection's most dramatic growth in size, scope, and quality has occurred during the past ten years under the leadership of Sam Sachs, who continues to give so freely of his time and advice.

The National Endowment for the Arts has been a primary source of funding for the purchase of work by American photographers as well as for this publication to document the Institute's photography collection. The NEA grant for this catalogue was awarded on a matching basis and supported by contributions from the Cowles Foundation, Ned Dayton, Jonas and Betsy Dovydenas, Harry McC. Drake, Michael G. and Ann Ginsburg Hofkin, John and Marsha Levine, Julia Marshall, Walter R. McCarthy, Don McNeil, the Andrew W. Mellon Foundation, Virginia P. Moe, Mr. and Mrs. Fred Rosenblatt, Frederick Scheel, Janet and Otto Seidenberg, Carl Sheppard, Mr. and Mrs. C. Steven Wilson, and anonymous donors.

As far as the actual preparation of the catalogue itself, I am indebted to the staff of Aperture and specifically to Carole Kismaric, editor; Mary Wachs, copy editor; Wendy Byrne, designer; and Michael Hoffman, publisher, who together have been my bulwark and sustenance throughout this project. My special thanks go to my past and present curatorial assistants Mary Virginia Swanson and Christian A. Peterson who researched the museum's photography holdings and to Christian, in particular, whose painstaking cataloguing of the collection resulted in the detailed listing included in the catalogue edition. I am also grateful to Sandra L. Lipshultz, writer/editor on The Minneapolis Institute of Arts' staff, who has edited the manuscript with patience and thoroughness, and to Louise Lincoln, editor, who has coordinated the production of the book. The staff at Meriden Gravure, too, has been an inspiration. Their devotion to their art and craft and the guidance they have provided in helping to realize this publication have been unique in my experience. Bob Hennessy, who made the half-tone negatives, is certainly one of the photographic artists that this catalogue means to celebrate.

But of all these people, one in particular deserves special tribute: Anthony Morris Clark. The director of The Minneapolis Institute of Arts from 1965 to 1974 and a scholar of high professional distinction, Tony was rigorously art historical and an unlikely candidate to promote and facilitate the beginnings of a collection of photographs at this museum. It could have been expected that a specialist in 18th-century Italian painting would find little of interest in photography as an art. "Not much substance there," he might have thought and "almost no history comparatively speaking." But Tony was not such an unbending expert closed to other viewpoints and concerns. Instead, like the best administrators, he appropriated the necessary purchase funds to acquire the photographs that I found and successfully defended and then secured the approval (if not the altogether enthusiastic acceptance) of the trustees' accessions committee. He was particularly successful in gaining the support of Hall J. Peterson and his wife Kate Butler whose purchase fund has, as already mentioned, been crucial to the formation of the collection. So it is with the deepest respect and appreciation that I dedicate this book to the memory of Tony Clark—curator, director, advocate, and friend.

TEXT CREDITS Quote page 97 by Richard Avedon from *Avedon* [exhibition catalogue], The Minneapolis Institute of Arts, 1970. Quote page 111 by André Bazin from *What Is Cinema?*, vol. 1, The University of California Press, Berkeley, 1967, pp. 9–16. Quotes pages 58 and 65 by Walker Evans from *Quality: Its Image in the Arts,* Louis Kronenberger, editor, Atheneum, New York, 1969, pp. 169–71. Quote page 77 by Robert Frank from "Statement," 1958. Quoted in *Photography in Print: Writings from 1816 to the Present,* Vicki Goldberg, editor, Simon and Schuster, New York, 1981, p. 401. Quote page 136 by William M. Ivins, Jr., from *Prints and Visual Communication,* by William M. Ivins, Jr., Harvard University Press, Cambridge, 1953, p. 134. Quotes pages 23 and 29 by A. Hyatt Mayor from "The Photographic Eye," *The Metropolitan Museum of Art Bulletin,* Summer 1946. Reprinted in *A. Hyatt Mayor: Selected Writings and a Bibliography,* The Metropolitan Museum of Art, New York, 1983, pp. 77, 79. Quote page 120 by Piet Mondrian from *De Stijl,* vol. 1, 1918. Quoted in *Art and Act,* Peter Gay, Harper and Row, New York, 1976, p. 196. Quote page 70 by Aaron Siskind from "Credo." Prepared for the exhibition "51 American Photographers," seen at The Museum of Modern Art, 1950. Quoted in *Aaron Siskind: Pleasures and Terrors,* by Carl Chiarenza, New York Graphic Society, Boston, 1982, p. 88. Quote page 12 by John Szarkowski from *The Photographer's Eye,* The Museum of Modern Art, New York, 1966, p. 11. Quote page 40 by Forbes Watson from a review of Paul Strand's photographs in 1925 exhibition, "The World." Quoted in *Paul Strand: Sixty Years of Photographs,* Aperture, Millerton, New York, 1976, p. 151. Quote page 73 by Edward Weston from "Photography—Not Pictorial," *Camera Craft,* vol. 37, no. 7, 1930. Reprinted in *Photographers on Photography,* Nathan Lyons, editor, Prentice-Hall, Inc., Englewood Cliffs, New Jersey, 1966, p. 156. Quote page 83 by Garry Winogrand from *Garry Winogrand: A Portfolio of Fifteen Photographs,* The Double Elephant Press, New York, © 1974 Estate of Garry Winogrand.

PHOTO CREDITS Page 66 by Ansel Adams courtesy of the Ansel Adams Publishing Rights Trust. All Rights Reserved. Pages 92-3 by Diane Arbus © the Estate of Diane Arbus. Page 69 by Wynn Bullock courtesy Wynn and Edna Bullock Trust. Page 89 by Arnold H. Crane © Arnold H. Crane. Page 41 by Imogen Cunningham © The Imogen Cunningham Trust. Pages 139-40 by William Eggleston © William Eggleston. Pages 59-64 by Walker Evans courtesy of the Walker Evans Estate. Page 77 by Robert Frank from *The Americans* by Robert Frank, Aperture, Millerton, New York, © 1969 Robert Frank. Page 148 by Len Jenshel courtesy H.F. Manès Gallery, New York. Page 51 by Jacques Henri Lartigue © 1984 S.P.A.D.E.M., Paris/V.A.G.A., New York. Page 40, 88 by Arnold Newman © Arnold Newman. Page 135 by Tod Papageorge © 1976 Tod Papageorge. Page 115 by Eve Sonneman courtesy Eve Sonneman and Leo Castelli Gallery, New York. Pages 52-3 by Edward Steichen © Joanna T. Steichen. Pages 42-3 by Paul Strand © 1982 The Paul Strand Foundation, Millerton, New York. Pages 38-9 by James Van DerZee © Donna Van DerZee. Page 68 by Edward Weston © 1981 Arizona Board of Regents, Center for Creative Photography. Page 71 photograph by Minor White. Reproduction courtesy The Minor White Archive, Princeton University, © 1982 Trustees of Princeton University.

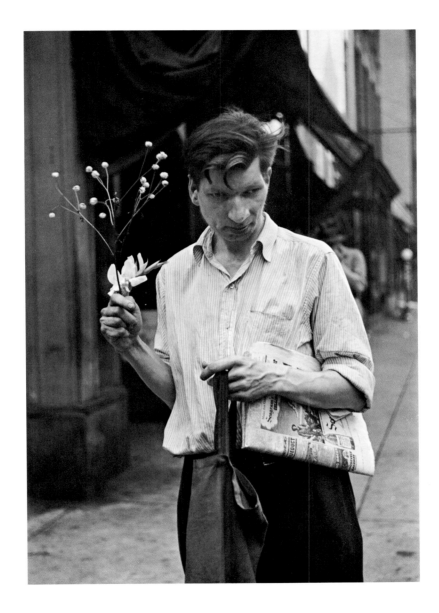

Louis Faurer, *Eddie, 3rd Avenue, New York City, 1947*

CATALOGUE OF THE COLLECTION

The following listing includes all of the photographs that have entered the permanent collection of The Minneapolis Institute of Arts from its first acquisition in 1963 through December 1982. Entries have been arranged alphabetically by the artist's last name. Work by unknown photographers and group portfolios have been listed last. Apparent discrepancies exist between some of the metric measurements and their English system equivalents due to the photographs having been measured by hand. The catalogue was prepared by Christian A. Peterson.

ABBOTT, BERENICE
American, 1898-

Ferry, West 23rd Street. 1935. Gelatin silver print. 7⁹⁄₁₆ × 9⁹⁄₁₆ in. (19.3 × 24.4 cm.). Kate and Hall J. Peterson Fund. 71.21.1.

Forty Eighth Street, Looking Northwest from a Point between 2nd and 3rd Avenues, Manhattan. 1938. Gelatin silver print. 9½ × 7⅝ in. (24.2 × 19.5 cm.). Kate and Hall J. Peterson Fund. 71.21.2.

Irving Place Theatre. 1938. Gelatin silver print. 7⅝ × 9⅝ in. (19.4 × 24.5 cm.). Anonymous gift of funds. 78.92.3.

ABBOTT, C. YARNALL
See *Camera Work*

ADAMS, ANSEL
American, 1902-1984

Portfolio Three: Yosemite Valley. Published by the Sierra Club, San Francisco. 1960. Portfolio of 16 gelatin silver prints. John R. Van Derlip Fund. 69.91.1-16.
Monolith, The Face of Half Dome. c. 1926. 11 × 8⅛ in. (28.0 × 20.6 cm.).
Merced River, Cliffs of Cathedral Rocks, Autumn. 1939. 7⁵⁄₁₆ × 9¹⁄₁₆ in. (18.6 × 23.1 cm.).
Lower Yosemite Fall. c. 1946. 9½ × 7⁹⁄₁₆ in. (24.2 × 19.2 cm.).
Trees and Snow. 1933. 11³⁄₁₆ × 8¾ in. (28.4 × 22.2 cm.).
Branches in Snow. c. 1932. 6¹⁵⁄₁₆ × 5¼ in. (17.6 × 13.4 cm.).
El Capitan, Sunrise. 1956. 9½ × 7⅜ in. (24.2 × 18.7 cm.).
Tenaya Creek, Spring Rain. c. 1948. 7½ × 9½ in. (19.0 × 24.1 cm.).
Water and Foam. c. 1955. 7⅛ × 6⅝ in. (18.1 × 16.8 cm.).
Winter Storm. 1944. 7⅜ × 9 in. (18.7 × 22.9 cm.).
Dogwood Blossoms. 1938. 9¼ × 6⅜ in. (23.5 × 16.2 cm.).
Grass and Pool. c. 1935. 7⅛ × 9 in. (18.2 × 22.9 cm.).
Nevada Fall, Rainbow. c. 1947. 9½ × 7⁵⁄₁₆ in. (24.1 × 18.6 cm.).
Rushing Water, Merced River. c. 1955. 8⅛ × 9¾ in. (20.7 × 24.8 cm.).
Bridalveil Fall. c. 1952. 11¼ × 7¾ in. (28.6 × 19.6 cm.).
Trees and Cliffs. 1954. 11¹⁄₁₆ × 8¼ in. (28.2 × 20.6 cm.).

Half Dome, Thunder Cloud. c. 1956. 9½ × 6½ in. (24.2 × 16.5 cm.).

Siesta Lake, Yosemite National Park, California. c. 1958. Gelatin silver print. 7½ × 9⅜ in. (19.1 × 23.9 cm.). Ethel Morrison Van Derlip Fund. 70.76.1.

ADAMS, ROBERT
American, 1937-

Clear Creek Canyon, Jefferson County, Colorado. 1977. Gelatin silver print. 8¹³⁄₁₆ × 11 in. (22.4 × 28.0 cm.). Gift of the American Telephone and Telegraph Co. 81.120.1.

Near Lyons, Colorado. 1977. Gelatin silver print. 8¹¹⁄₁₆ × 11³⁄₁₆ in. (22.1 × 28.5 cm.). Gift of the American Telephone and Telegraph Co. 81.120.2.

Arkansas River Canyon, Fremont County, Colorado. 1977. Gelatin silver print. 8¹⁵⁄₁₆ × 11³⁄₁₆ in. (22.8 × 28.5 cm.). Gift of the American Telephone and Telegraph Co. 81.120.3.

ADAMSON, PRESCOTT
See *Camera Work*

ADAMSON, ROBERT
See Hill, David Octavius, and Robert Adamson

AGAR, FRANK, Jr.
American, 1917-

Rooms to Let. c. 1960. Series of 60 panels with gelatin silver prints and handwritten text. Each approx. 30 × 20, 40 × 30 in. or reverse. Gift of the artist. 63.31.1-60.

AGAR, WILL
American, 1950-

Oceano, California. 1975. Gelatin silver print. 14⅛ × 17¹⁵⁄₁₆ in. (35.9 × 45.6 cm.). National Endowment for the Arts purchase grant and miscellaneous matching funds. 76.63.1.

Freeway, Southwest U.S.A. 1975. Gelatin silver print. 14¹⁵⁄₁₆ × 18¹³⁄₁₆ in. (38.0 × 47.8 cm.). National Endowment for the Arts purchase grant and miscellaneous matching funds. 76.63.2.

Oceano, California. 1975. Gelatin silver print. 14¹⁵⁄₁₆ × 18¾ in. (37.9 × 47.7 cm.). National Endowment for the Arts purchase grant and miscellaneous matching funds. 76.63.3.

Mary in Tent, Oregon. From *Minnesota Photographers* portfolio. 1976. Gelatin silver print. 13 × 10 in. (33.0 × 25.5 cm.). John R. Van Derlip Fund. 79.48.1.

ALBERT, BRIAN
American, 1956-

Foghat/Wet Willie Concert, St. Paul. From *Adolescent Girls at Rock Concerts* series. 1978. Color coupler print. 8⅞ × 13⅛ in. (22.6 × 33.4 cm.). Mr. and Mrs. Harrison R. Johnston, Jr. Fund. 78.56.

ALBIN-GUILLOT, LAURE
French, 20th century

[portrait]. n.d. Fresson print. 11¹¹⁄₁₆ × 10³⁄₁₆ in. (29.7 × 25.9 cm.). John R. Van Derlip Fund. 81.80.

ALINARI FRATELLI (attribution)
Italian, 19th century

[monument, Florence]. n.d. Albumen print. 13⁵⁄₁₆ × 10¹⁄₁₆ in. (33.9 × 25.6 cm.). John R. Van Derlip Fund. 81.78.

ALLEN, HAROLD
American, 1912-

Charcuterie du Tertre, Montmartre. From *Underware* portfolio. 1945. Gelatin silver print. 17⅛ × 13³⁄₁₆ in. (43.5 × 33.5 cm.). National Endowment for the Arts purchase grant and miscellaneous matching funds. 76.64.1.

ALVAREZ BRAVO, MANUEL
Mexican, 1902-

Manuel Alvarez Bravo. Published by Acorn Editions, Ltd., Geneva, Switzerland. n.d. Portfolio of 15 gelatin silver prints. Gift of Martin Sklar. 81.122.1.1-15.
Carrizo Y Tele. n.d. 6¹³⁄₁₆ × 8¹⁵⁄₁₆ in. (17.3 × 22.8 cm.).
Violin Huichol. 1965. 7 × 9⅜ in. (17.7 × 23.9 cm.).
Ventana a los Magueyes. 1976. 7¹⁄₁₆ × 9¼ in. (18.0 × 23.6 cm.).
Ventana al Coro. c. 1935. 9¼ × 6½ in. (23.6 × 16.6 cm.).
La Vista. n.d. 6½ × 9⁵⁄₁₆ in. (16.6 × 23.6 cm.).
El Perro Veinte. 1958. 7⁹⁄₁₆ × 8¹³⁄₁₆ in. (19.2 × 22.4 cm.).
Margarita de Bonampak. n.d. 9½ × 7½ in. (24.1 × 19.2 cm.).
Dia de Todos Muertos. 1933. 9½ × 7 in. (24.1 × 17.7 cm.).
Angel del Temblor. 1957. 9⁷⁄₁₆ × 6⁹⁄₁₆ in. (24.0 × 16.6 cm.).
Tentaciones en Casa de Antonio. n.d. 9½ × 7¹¹⁄₁₆ in. (24.2 × 19.5 cm.).
Cruce de Chalma. 1942. 9⁷⁄₁₆ × 6¹³⁄₁₆ in. (24.0 × 17.3 cm.).
Manos en el 210 de Fernandez Leal. n.d. 7¹⁄₁₆ × 9⅜ in. (17.9 × 23.9 cm.).
Paisaje Chamula. 1972. 7¹⁄₁₆ × 9⅜ in. (18.0 × 23.9 cm.).
Bicicletas en Domingo. 1968. 7 × 9⅜ in. (17.9 × 23.9 cm.).
Que Chiquito es el Mundo. 1942. 7⁵⁄₁₆ × 9⁹⁄₁₆ in. (18.5 × 24.3 cm.).

Photographs by Manuel Alvarez Bravo. Published by Acorn Editions, Ltd. 1977. Portfolio of 15 gelatin silver prints. Gift of Louis H. Stumberg, 82.125.1-15.
Arena y Pinitos (Sand and 'Small Pines). 1920s. 6⁹⁄₁₆ × 9⁷⁄₁₆ in. (16.7 × 24.0 cm.).
Paisaje de Siembras (Growing Landscape). 1972-1974. 7⅛ × 9½ in. (18.1 × 24.1 cm.).
Votos (Votive Offering). 1969. 7⁵⁄₁₆ × 9⁹⁄₁₆ in. (18.6 × 24.3 cm.).
Luz Restirada (Lengthened Light). 1944. 9½ × 6¹⁵⁄₁₆ in. (24.1 × 17.6 cm.).
Dos Mujeres y la Gran Cortina con Sombras (Two Women, a Large Blind, and Shadows). 1977. 7¼ × 9½ in. (18.4 × 24.2 cm.).
Acto Primero (First Act). 1975. 7¹⁄₁₆ × 9⁷⁄₁₆ in. (17.9 × 24.0 cm.).
Caja de Visiones (Box of Visions). 1930s. 7½ × 9³⁄₁₆ in. (19,0 × 23.4 cm.).
Señor de Papantla (The Man from Papantla). 1934-1935. 9¼ × 7¹⁄₁₆ in. (23.6 × 18.1 cm.).
Los Perros durmiendo ladran (Sleeping Dogs Bark). 1966. 9 × 7⁹⁄₁₆ in. (23.0 × 19.2 cm.).
Dos Pares de Piernas (Two Pairs of Legs). 1928-1929. 9³⁄₁₆ × 7³⁄₁₆ in. (23.3 × 18.3 cm.).

Un Pez que llaman Sierra (A Fish Called Saw). 1942. 9⁷⁄₁₆ × 6⁷⁄₈ in. (24.0 × 17.4 cm.).
Ya Mero (Almost). 1968. 7³⁄₈ × 9⁷⁄₁₆ in. (18.8 × 24.0 cm.).
Gorrión, Claro (Skylight). 1938-1940. 7³⁄₁₆ × 9½ in. (18.3 × 24.1 cm.).
Umbral (Threshold). 1947. 9½ × 7⁵⁄₈ in. (24.2 × 19.3 cm.).
Retrato de lo Eterno (Woman Combing Her Hair). 1932-1933. 9³⁄₈ × 7⁷⁄₁₆ in. (23.8 × 18.9 cm.).

ANDREWS, ALICE
See Wells, Alice

ANNAN, J. CRAIG
See *Camera Work*

ARBUS, DIANE
American, 1923-1971

A Box of Ten Photographs. Published by the photographer and her estate, New York. 1971. Portfolio of 10 gelatin silver prints by Neil Selkirk. Kate and Hall J. Peterson Fund. 72.109.1-10.
Xmas Tree in a Living Room, Levittown, New York. 1962. 14⅛ × 14³⁄₈ in. (36.0 × 36.6 cm.).
Retired Man and His Wife at Home in a Nudist Camp One Morning in New Jersey. On the Television Set are Framed Photographs of Each Other. 1963. 14⁵⁄₁₆ × 14⁵⁄₈ in. (36.4 × 37.2 cm.).
A Young Man in Curlers Dressing for an Annual Drag Ball, N.Y.C. 1966. 15¹⁄₁₆ × 14¾ in. (38.3 × 37.5 cm.).
Brooklyn Family on Sunday Outing. 1966. 14⅞ × 14³⁄₈ in. (37.8 × 36.6 cm.).
Identical Twins, Cathleen (left) and Colleen, Members of a Twin Club in New Jersey. 1966. 14⁵⁄₈ × 14¹¹⁄₁₆ in. (37.2 × 37.3 cm.).
Patriotic Boy with Straw Hat, Buttons and Flag, Waiting to March in a Pro-War Parade, N.Y.C. 1967. 14¹¹⁄₁₆ × 14¹¹⁄₁₆ in. (37.4 × 37.3 cm.).
Family on Lawn One Sunday, Westchester. 1968. 14¾ × 14¾ in. (37.5 × 37.5 cm.).
Their Numbers Were Picked Out of a Hat. They Were Just Chosen King and Queen of a Senior Citizens Dance in N.Y.C. Yetta Grant is 72 and Charles Fahrer is 79. They Have Never Met Before. 1970. 14¹¹⁄₁₆ × 14¹¹⁄₁₆ in. (37.4 × 37.4 cm.).
Lauro Morales, a Mexican Dwarf, in His Hotel Room, in N.Y.C. 1970. 14¾ × 14¼ in. (37.5 × 36.3 cm.).
This Is Eddie Carmel, a Jewish Giant, with His Parents in the Living Room of Their Home in the Bronx, New York. 1970. 14³⁄₈ × 14¹¹⁄₁₆ in. (36.5 × 37.4 cm.).

ARNDT, THOMAS FREDERICK
American, 1944-

[storefront with newspaper]. 1970. Gelatin silver print. 5¹³⁄₁₆ × 8¹¹⁄₁₆ in. (14.8 × 22.1 cm.). Kate and Hall J. Peterson Fund. 73.32.1.
[vacant interior with reflections and shadows]. 1971. Gelatin silver print. 5⁹⁄₁₆ × 8⁷⁄₁₆ in. (14.8 × 22.1 cm.). Kate and Hall J. Peterson Fund. 73.32.2.

[auto]. n.d. Gelatin silver print. 10⁹⁄₁₆ × 10⁹⁄₁₆ in. (26.8 × 26.9 cm.). Kate and Hall J. Peterson Fund. 73.32.3.
[chair]. 1970. Gelatin silver print. 10¹¹⁄₁₆ × 10⁹⁄₁₆ in. (27.2 × 26.9 cm.). Kate and Hall J. Peterson Fund. 73.32.4.
[naked man in locker room]. n.d. Gelatin silver print. 13½ × 18⅜ in. (34.3 × 46.7 cm.). National Endowment for the Arts purchase grant and miscellaneous matching funds. 76.52.1.
[clown on front yard walk]. n.d. Gelatin silver print. 13½ × 18⅜ in. (34.2 × 46.7 cm.). National Endowment for the Arts purchase grant and miscellaneous matching funds. 76.52.2.
[woman sitting on park bench]. 1974-1975. Gelatin silver print. 13¾ × 18½ in. (35.0 × 47.0 cm.). Gift of the artist. 76.53.1.
[two women in white sweaters dancing]. 1974-1975. Gelatin silver print. 13⅝ × 18⅜ in. (34.3 × 46.7 cm.). Gift of the artist. 76.53.2.
[heavy woman with glasses walking]. n.d. Gelatin silver print. 13⅝ × 18⅝ in. (34.5 × 47.3 cm.). Gift of the artist. 80.10.1.
[woman with sunglasses next to doorway]. n.d. Gelatin silver print. 13½ × 18⅜ in. (34.2 × 46.7 cm.). Gift of the artist. 80.10.2.
[man's bare chest]. n.d. Gelatin silver print. 13⅝ × 18⅝ in. (34.6 × 47.3 cm.). Gift of the artist. 80.10.3.
[male figure with Coke glass]. n.d. Gelatin silver print. 13⅞ × 18⅝ in. (35.3 × 47.2 cm.). Gift of the artist. 80.10.4.
[man with sunglasses and uplifted arms in park]. n.d. Gelatin silver print. 13½ × 18⅜ in. (34.3 × 46.8 cm.). Gift of the artist. 80.10.5.
[chauffeur closing automobile door]. n.d. Gelatin silver print. 13⅞ × 18⅜ in. (35.0 × 46.7 cm.). Gift of the artist. 80.10.6.
Midway Worker, Minnesota State Fair. 1974. Gelatin silver print. 13½ × 18⅜ in. (34.5 × 46.8 cm.). Gift of the artist. 80.10.7.
[priest in open casket in church]. n.d. Gelatin silver print. 13⅝ × 18⅝ in. (34.6 × 47.3 cm.). Gift of the artist. 80.10.8.
[man in white shirt jumping up]. n.d. Gelatin silver print. 13⅝ × 18⅝ in. (34.7 × 47.3 cm.). Gift of the artist. 80.10.9.
[two men in blue jeans at outdoor event]. n.d. Gelatin silver print. 13⅝ × 18½ in. (34.5 × 47.2 cm.). Gift of the artist. 80.10.10.
[man leaning against building]. n.d. Gelatin silver print. 13½ × 18⅜ in. (34.3 × 46.7 cm.). Gift of the artist. 80.10.11.
[male midget kissing female athlete]. n.d. Gelatin silver print. 13⅝ × 18⅝ in. (34.5 × 47.3 cm.). Gift of the artist. 80.10.12.
[man in suitcoat holding beer can]. n.d. Gelatin silver print. 13½ × 18⅜ in. (34.3 × 46.7 cm.). Gift of the artist. 80.10.13.

Subway, Brooklyn. 1980. Gelatin silver print. 13¹⁵⁄₁₆ × 20¹⁵⁄₁₆ in. (35.4 × 53.1 cm.). Mr. and Mrs. Julius E. Davis Fund. 81.19.1.
Street Scene, Chicago. 1980. Gelatin silver print. 13⅞ × 20¹³⁄₁₆ in. (35.3 × 53.0 cm.). Mr. and Mrs. Julius E. Davis Fund. 81.19.2.
Hammel and Korn Bar, New York City. 1980. Gelatin silver print. 13⅞ × 20⅞ in. (35.3 × 53.1 cm.). Mr. and Mrs. Julius E. Davis Fund. 81.19.3.
Dog Show, St. Paul. 1976. Gelatin silver print. 9⁷⁄₁₆ × 9½ in. (24.0 × 24.1 cm.). Gift of the artist. 81.69.1.
Bicentennial Fete, Browerville, Minnesota. 1976. Gelatin silver print. 9⁷⁄₁₆ × 9½ in. (24.0 × 24.1 cm.). Gift of the artist. 81.69.2.
Fourth of July, Powderhorn Park, Minneapolis. 1976. Gelatin silver print. 9⁷⁄₁₆ × 9½ in. (24.0 × 24.1 cm.). Gift of the artist. 81.69.3.
Mr. Minnesota Contest, St. Paul, Minnesota. 1976. Gelatin silver print. 9⁷⁄₁₆ × 9½ in. (24.0 × 24.1 cm.). Gift of the artist. 81.69.4.

ATGET, JEAN-EUGÈNE-AUGUSTE
French, 1857-1927

Rue du Chevalier de la Barre. n.d. Albumen print. 8⅜ × 7¹⁄₁₆ in. (21.4 × 18.0 cm.). William Hood Dunwoody Fund. 81.95.1.
[bridge over the Seine River]. n.d. Aristotype. 7 × 9 in. (17.8 × 22.9 cm.). William Hood Dunwoody Fund. 81.95.2.

AVEDON, RICHARD
American, 1923-

Portrait of Georges Braque and Wife. 1959. Gelatin silver print. 16¹⁵⁄₁₆ × 15¹¹⁄₁₆ in. (43.1 × 39.8 cm.). Gift of Bruce B. Dayton. 69.2.3.
The Minneapolis Portfolio. Published by the photographer, New York. 1970. Portfolio of 11 gelatin silver prints. Christina N. and Swan J. Turnblad Memorial Fund. 81.94.1-11.
Charles Chaplin, Actor. 1952. 17⁹⁄₁₆ × 23¹⁵⁄₁₆ in. (44.7 × 60.9 cm.).
Buster Keaton, Comedian. 1952. 18⅝ × 24 in. (47.5 × 61.0 cm.).
Jimmy Durante, Comedian. 1953. 22⁹⁄₁₆ × 19¹⁵⁄₁₆ in. (57.3 × 50.7 cm.).
Humphrey Bogart, Actor. 1953. 22¼ × 19¹⁵⁄₁₆ in. (56.6 × 50.7 cm.).
The Duke and Duchess of Windsor. 1957. 21¾ × 19¹⁵⁄₁₆ in. (55.3 × 50.6 cm.).
Isak Dinesen, Writer. 1958. 22⅞ × 19¹⁵⁄₁₆ in. (58.1 × 50.7 cm.).
Marianne Moore, Poetess. 1958. 22½ × 19¹⁵⁄₁₆ in. (57.2 × 50.7 cm.).
Ezra Pound, Poet. 1958. 22¼ × 19¹⁵⁄₁₆ in. (56.5 × 50.2 cm.).
René Clair, Director. 1958. 22⅜ × 19¹⁵⁄₁₆ in. (56.8 × 50.7 cm.).
Marilyn Monroe, Actress. 1962. 22½ × 19¹⁵⁄₁₆ in. (57.2 × 50.7 cm.).
Dwight David Eisenhower, President of the United States. 1964. 21⅞ × 19¹⁵⁄₁₆ in. (55.6 × 50.7 cm.).

BALDESSARI, JOHN
American, 1931-

Raw Prints. Published by Cirrus Editions, Los Angeles. 1976. Portfolio of 6 lithographs with color coupler photographs. Gift of Benton Case, Jr. 81.99.1-6.
(Yellow). 1976. 14¹¹⁄₁₆ × 20⁷⁄₁₆ in. (37.3 × 52.0 cm.).
(Purple). 1976. 14¹¹⁄₁₆ × 20⁷⁄₁₆ in. (37.3 × 52.0 cm.).
(Orange). 1976. 14⅝ × 20⁷⁄₁₆ in. (37.3 × 52.0 cm.).
(Red). 1976. 14¹¹⁄₁₆ × 20½ in. (37.3 × 52.0 cm.).
(Blue). 1976. 14¹¹⁄₁₆ × 20⁷⁄₁₆ in. (37.3 × 52.0 cm.).
(Green). 1976. 14¹¹⁄₁₆ × 20⁷⁄₁₆ in. (37.3 × 52.0 cm.).

BALTZ, LEWIS
American, 1945-

South Wall, Brinderson Mechanical Corporation, 100 East Baker, Costa Mesa. 1974. Gelatin silver print. 6¹⁄₁₆ × 9¹⁄₁₆ in. (15.3 × 23.1 cm.). Gift of Dr. and Mrs. Eugene Spiritus. 78.104.1.

Northwest Wall, Unoccupied Industrial Spaces, 17875 C and D, Skypark Circle, Irvine. 1974. Gelatin silver print. 6¹⁄₁₆ × 9 in. (15.4 × 22.9 cm.). Gift of Dr. and Mrs. Eugene Spiritus. 78.104.2.

Snowflower Condominiums during Construction, Looking West. 1978. Gelatin silver print. 6⅜ × 9½ in. (16.2 × 24.1 cm.). Gift of the American Telephone and Telegraph Co. 81.120.4.

Snowflower Condominiums during Construction, Looking East. 1978. Gelatin silver print. 6⁵⁄₁₆ × 9½ in. (16.1 × 24.1 cm.). Gift of the American Telephone and Telegraph Co. 81.120.5.

Lot No. 7, Prospector Park, Subdivision Phase 1, Looking Northwest. 1978. Gelatin silver print. 6⅜ × 9½ in. (16.2 × 24.2 cm.). Gift of the American Telephone and Telegraph Co. 81.120.6.

BARROW, THOMAS F.
American, 1938-

Untitled, from *Cancellations* series. From *The New Mexico Portfolio.* 1975. Gelatin silver print. 9³⁄₁₆ × 13⁷⁄₁₆ in. (23.3 × 34.1 cm.). National Endowment for the Arts purchase grant and miscellaneous matching funds. 76.61.1.

BARSOTTI, FRANK
American, 1937-

[arm with scar]. From *Underware* portfolio. 1976. Color coupler print. 15⅞ × 19¹³⁄₁₆ in. (40.3 × 50.4 cm.). National Endowment for the Arts purchase grant and miscellaneous matching funds. 76.64.2.

BAUGHN, LESLIE
American (?), 20th century

[hair]. From *What Ever Happened to Sexuality* portfolio. c. 1977. Gelatin silver print. 8¼ × 5⁹⁄₁₆ in. (21.0 × 14.1 cm.). Gift of the artist. 82.70.1.

BECHER, ARTHUR E.
See *Camera Work*

BELLOCQ, E.J.
American, 1873-1949

[nude woman in window frame]. Modern gelatin silver print on printing-out paper by Lee Friedlander from original plate. c. 1911-1913. 7¹⁵⁄₁₆ × 9¹⁵⁄₁₆ in. (20.2 × 25.3 cm.). Kate and Hall J. Peterson Fund. 72.25.

E.J. Bellocq. Published by Haywire Press, New City, New York. c. 1978. Two volumes of 50 modern gelatin silver prints on printing-out paper by Lee Friedlander from original plates. c. 1911-1913. Each approx. 10 × 8 in. (25.0 × 20.5 cm.) or reverse. Ethel Morrison Van Derlip Fund, Julia B. Bigelow Fund by John Bigelow, and miscellaneous purchase funds. 80.11.1-50.

BERNAT, COREY
American (?), 20th century

Kaleidoscope. From *What Ever Happened to Sexuality* portfolio. c. 1977. Gelatin silver print. 4¾ × 4¼ in. (12.0 × 10.8 cm.). Gift of the artist. 82.70.2.

BLUMENFELD, ERWIN
American (b. Germany), 1897-1969

Henri Matisse, Paris. 1938. Gelatin silver print. 19 × 14½ in. (48.4 × 36.9 cm.). Gift of Bruce B. Dayton. 69.2.1.

Portrait of the Painter Georges Rouault, Paris. 1936. Gelatin silver print. 19⅛ × 14⅞ in. (48.6 × 37.8 cm.). Gift of Bruce B. Dayton. 69.2.2.

BONFILS, FÉLIX
French, 1831-1885

Portes du Saint-Sépulcre. n.d. Albumen print. 10¹³⁄₁₆ × 8¹³⁄₁₆ in. (27.6 × 22.4 cm.). Transfer from reference collections. 81.77.1.

Intérieur de l'Ecce Homo, Jerusalem. n.d. Albumen print. 11⅛ × 8¾ in. (28.2 × 22.2 cm.). Transfer from reference collections. 81.77.2.

Mont des Oliviers, Jerusalem. n.d. Albumen print. 8⅞ × 11 in. (22.5 × 27.9 cm.). Transfer from reference collections. 81.77.3.

Tombeau des Rois, cour intérieure, Jerusalem. n.d. Albumen print. 8¹³⁄₁₆ × 11¹⁄₁₆ in. (22.4 × 28.2 cm.). Transfer from reference collections. 81.77.4.

Tombeau de Rachel, prés de Bethlehem, Palestine. n.d. Albumen print. 8⅝ × 11 in. (21.9 × 27.9 cm.). Transfer from reference collections. 81.77.5.

Vue générale de Jericho prise de la plaine. n.d. Albumen print. 8⅞ × 11¹⁄₁₆ in. (22.6 × 28.1 cm.). Transfer from reference collections. 81.77.6.

Cours du Jourdain. n.d. Albumen print. 8¹³⁄₁₆ × 11⅛ in. (22.4 × 28.3 cm.). Transfer from reference collections. 81.77.7.

Vue de la mer, Jaffa. n.d. Albumen print. 8⁹⁄₁₆ × 11¹⁄₁₆ in. (21.8 × 28.1 cm.). Transfer from reference collections. 81.77.8.

Tour 40 martyrs, Ramelb. n.d. Albumen print. 11⅛ × 8¹³⁄₁₆ in. (28.4 × 22.4 cm.). Transfer from reference collections. 81.77.9.

Porte de Jaffa, Jerusalem. n.d. Albumen print. 8¾ × 11⅛ in. (22.3 × 28.2 cm.). Transfer from reference collections. 81.77.10.

Arc de l'Ecce Homo, Jerusalem, Palestine. n.d. Albumen print. 10¹⁵⁄₁₆ × 8¹³⁄₁₆ in. (27.8 × 22.5 cm.). Transfer from reference collections. 81.77.11.

Le Calvaire, autel grec, Jerusalem. n.d. Albumen print. 8⅝ × 11⅛ in. (21.9 × 28.4 cm.). Transfer from reference collections. 81.77.12.

XIV Station, intérieur du St. Sépulcre. n.d. Albumen print. 11³⁄₁₆ × 8¹⁵⁄₁₆ in. (28.4 × 22.8 cm.). Transfer from reference collections. 81.77.13.

Porte Saint-Etienne, Jerusalem. n.d. Albumen print. 8¹³⁄₁₆ × 11⅛ in. (22.4 × 28.2 cm.). Transfer from reference collections. 81.77.14.

Coupoles du Saint-Sépulcre, Jerusalem. n.d. Albumen print. 8¹³⁄₁₆ × 11³⁄₁₆ in. (22.4 × 28.4 cm.). Transfer from reference collections. 81.77.15.

Porte dorée, Jerusalem. n.d. Albumen print. 11⅛ × 8¾ in. (28.3 × 22.2 cm.). Transfer from reference collections. 81.77.16.

Mosque d'Omar, intérieur, Jerusalem. n.d. Albumen print. 8⅞ × 11¾ in. (22.7 × 28.5 cm.). Transfer from reference collections. 81.77.17.

Vue générale de l'emplacement du Temple de Salomon à Jerusalem, Palestine. n.d. Albumen print. 8¾ × 11¹⁄₁₆ in. (22.2 × 28.2 cm.). Transfer from reference collections. 81.77.18.

Tombeau d'Elie à Jerusalem. n.d. Albumen print. 8¾ × 11³⁄₁₆ in. (22.2 × 28.5 cm.). Transfer from reference collections. 81.77.19.

Porte de Damas à Jerusalem. n.d. Albumen print. 8¹³⁄₁₆ × 11¹⁄₁₆ in. (22.5 × 28.1 cm.). Transfer from reference collections. 81.77.20.

Jerusalem du Mont des Oliviers. n.d. Albumen print. 8⁹⁄₁₆ × 11³⁄₁₆ in. (21.8 × 28.4 cm.). Transfer from reference collections. 81.77.21.

Jardin de Gethsemani. n.d. Albumen print. 8⅞ × 11¼ in. (22.6 × 28.6 cm.). Transfer from reference collections. 81.77.22.

Vallée de Josaphat. n.d. Albumen print. 8½ × 10¹⁵⁄₁₆ in. (21.6 × 27.8 cm.). Transfer from reference collections. 81.77.23.

Vallée de Gihon et l'étang inférieur, Palestine. n.d. Albumen print. 8⅞ × 11 in. (22.5 × 28.1 cm.). Transfer from reference collections. 81.77.24.

Village de Liloe, Palestine. n.d. Albumen print. 8¹³⁄₁₆ × 11⅛ in. (22.4 × 28.2 cm.). Transfer from reference collections. 81.77.25.

Grotte de Jeremie, Jerusalem. n.d. Albumen print. 8¾ × 11⅛ in. (22.2 × 28.4 cm.). Transfer from reference collections. 81.77.26.

Etang de Liloe, Palestine. n.d. Albumen print. 8⁷⁄₁₆ × 11¹⁄₁₆ in. (21.5 × 28.1 cm.). Transfer from reference collections. 81.77.27.

Tombeau d' Absalon, Palestine. n.d. Albumen print. 11⅛ × 8⅝ in. (28.3 × 22.0 cm.). Transfer from reference collections. 81.77.28.

Jardin du roi, Rois XX-4, Vallée de Gehenne, Jerusalem, Palestine. n.d. Albumen print. 8¾ × 11³⁄₁₆ in. (22.2 × 28.4 cm.). Transfer from reference collections. 81.77.29.

Vue générale de Bethlehem. n.d. Albumen print. 8¹³⁄₁₆ × 11³⁄₁₆ in. (22.4 × 28.5 cm.). Transfer from reference collections. 81.77.30.

Intérieur de l'Eglise de la Nativité, Bethlehem. n.d. Albumen print. 8¹¹⁄₁₆ × 11¹⁄₁₆ in. (22.2 × 28.2 cm.). Transfer from reference collections. 81.77.31.

Vasques de Salomon, près Bethlehem, Palestine. n.d. Albumen print. 8¾ × 11³⁄₁₆ in. (22.2 × 28.4 cm.). Transfer from reference collections. 81.77.32.

Montagne de la quarantaine, Palestine. n.d. Albumen print. 8¾ × 11 in. (22.3 × 28.0 cm.). Transfer from reference collections. 81.77.33.

La fontaine d'Elisée, Palestine. n.d. Albumen print. 8¾ × 10¹⁵⁄₁₆ in. (22.3 × 27.8 cm.). Transfer from reference collections. 81.77.34.

Bethanie, Vue générale. n.d. Albumen print. 8¾ × 11¼ in. (22.3 × 28.6 cm.). Transfer from reference collections. 81.77.35.

Tyr., Vue générale, Palestine. n.d. Albumen print. 8⅞ × 11 in. (22.5 × 28.0 cm.). Transfer from reference collections. 81.77.36.

Lidon pris de la forteresse, Palestine. n.d. Albumen print. 8¾ × 11¹⁄₁₆ in. (22.2 × 28.1 cm.). Transfer from reference collections. 81.77.37.

Vue générale de Damas prise de Lalhieh. n.d. Albumen print. 8⅞ × 11¹⁄₁₆ in. (22.6 × 28.2 cm.). Transfer from reference collections. 81.77.38.

Mur par où Saint-Paul s'est enfui, Damas. n.d. Albumen print. 8¹³⁄₁₆ × 11³⁄₁₆ in. (22.4 × 28.4 cm.). Transfer from reference collections. 81.77.39.

Porte du temple de Jupiter, Balbek. n.d. Albumen print. 11¹⁄₁₆ × 8¹¹⁄₁₆ in. (28.1 × 22.1 cm.). Transfer from reference collections. 81.77.40.

Détail des chapiteause du Proanos, Balbek. n.d. Albumen print. 11 × 8⅞ in. (27.9 × 22.6 cm.). Transfer from reference collections. 81.77.41.

Intérieur du temple de Jupiter, Balbek. n.d. Albumen print. 8¹⁵⁄₁₆ × 11³⁄₁₆ in. (22.7 × 28.4 cm.). Transfer from reference collections, 81.77.42.

Vue de l'Acropole, Balbek. n.d. Albumen print. 8¾ × 11³⁄₁₆ in. (22.3 × 28.4 cm.). Transfer from reference collections. 81.77.43.

Mur cyclopéen à Balbek, Syrie. n.d. Albumen print. 8¹³⁄₁₆ × 11³⁄₁₆ in. (22.4 × 28.4 cm.). Transfer from reference collections. 81.77.44.

Le pont au fleur du chien, Syrie. n.d. Albumen print. 8¾ × 11 in. (22.2 × 28.0 cm.). Transfer from reference collections. 81.77.45.

Drogman guide de voyageurs. n.d. Albumen print. 11 × 8¾ in. (28.0 × 22.3 cm.). Transfer from reference collections. 81.77.46.

Sans titre, femme voilée. n.d. Albumen print. 8¹³⁄₁₆ × 6⅝ in. (22.9 × 16.8 cm.). Transfer from reference collections. 81.77.47.

[Wailing Wall of the Jews, Jerusalem]. n.d. Albumen print. 8⁵⁄₁₆ × 11¹⁄₁₆ in. (21.1 × 28.2 cm.). Transfer from reference collections. 81.77.48.

[valley, Palestine]. n.d. Albumen print. 8⅝ × 10¹⁵⁄₁₆ in. (21.9 × 27.8 cm.). Transfer from reference collections. 81.77.49.

BOUGHTON, ALICE
See *Camera Work*

BOYLE, MARK
English, 1934-

Untitled. From *Mark Boyle's Journey to the Surface of the Earth,* book by J. L. Locher, 1978. n.d. Gelatin silver print. 7⅝ × 8 in. (19.4 × 20.3 cm.). Gift of William H. Hahn. 79.49.2.

Untitled. From *Mark Boyle's Journey to the Surface of the Earth,* book by J. L. Locher, 1978. n.d. Gelatin silver print. 7⅝ × 8 in. (19.4 × 20.3 cm.). Gift of Jay Fleming. 79.50.2.

BRANDT, BILL
English, 1905-1983

[back of nude woman on pebbles]. 1953. Gelatin silver print. 13³⁄₁₆ × 11³⁄₁₆ in. (33.5 × 28.5 cm.). Kate and Hall J. Peterson Fund. 72.125.

[hands]. 1959. Gelatin silver print. 13⁵⁄₁₆ × 11⁵⁄₁₆ in. (33.9 × 28.8 cm.). Kate and Hall J. Peterson Fund. 72.126.

[face, arm, and breast of nude woman]. 1952. Gelatin silver print. 13⅛ × 11⁵⁄₁₆ in. (33.4 × 28.8 cm.). Kate and Hall J. Peterson Fund. 72.127.

[nude in room with bed and lamp]. 1949. Gelatin silver print. 13¼ × 11⅜ in. (33.6 x 28.9 cm.). Christina N. and Swan J. Turnblad Fund. 74.37.1.

[woman holding mirror]. 1953. Gelatin silver print. 13¼ × 11⁵⁄₁₆ in. (33.7 × 28.8 cm.). Christina N. and Swan J. Turnblad Fund. 74.37.2.

[nude woman in chair with hand on leg]. 1953. Gelatin silver print. 13³⁄₁₆ × 11¼ in. (33.5 × 28.7 cm.). Christina N. and Swan J. Turnblad Fund. 74.37.3.

[back of nude woman next to table]. n.d. Gelatin silver print. 13³⁄₁₆ × 11⅜ in. (33.5 × 28.8 cm.). Christina N. and Swan J. Turnblad Fund. 74.37.4.

[woman's head and interior]. 1955. Gelatin silver print. 13¼ × 11⁹⁄₁₆ in. (33.7 × 29.4 cm.). Christina N. and Swan J. Turnblad Fund. 74.37.5.

BRASSAÏ
French (b. Hungary), 1899-1984

La Fille au Billard Russe, Paris. 1933. Modern gelatin silver print. 12⁹⁄₁₆ × 9⁷⁄₁₆ in. (32.0 × 24.0 cm.). Anonymous gift of funds. 78.92.2.

BRATNOBER, JOHN
American, 1951-

Pine Hill Farm. Published by the photographer. 1974. Portfolio of five gelatin silver prints. Kate and Hall J. Peterson Fund. 74.88.1-5.
[nature study]. 7⁹⁄₁₆ × 9½ in. (19.3 × 24.2 cm.).
[nature study]. 7⁹⁄₁₆ × 9⁹⁄₁₆ in. (19.2 × 24.3 cm.).
[nature study]. 7⁹⁄₁₆ × 9⁹⁄₁₆ in. (19.2 × 24.3 cm.).
[nature study]. 7⁹⁄₁₆ × 9⁹⁄₁₆ in. (19.2 × 24.3 cm.).
[nature study]. 7⁹⁄₁₆ × 9⁹⁄₁₆ in. (19.2 × 24.2 cm.).

BRAVO, MANUEL ALVAREZ
See Alvarez Bravo, Manuel

BREMER, KARL
American (?), 20th century

[dogs running]. From *What Ever Happened to Sexuality* portfolio. c. 1977. Gelatin silver print. 4 × 8⁹⁄₁₆ in. (10.2 × 21.8 cm.). Gift of the artist. 82.70.3.

BREMER, THOMAS
American, 1951-

[white cross]. 1975. Color coupler print. 13⁹⁄₁₆ × 14¹⁄₁₆ in. (34.5 × 35.8 cm.). Gift of the artist. 82.33.1.

[globe]. 1981. Color coupler print. 13⁹⁄₁₆ × 14¹⁄₁₆ in. (34.5 × 35.8 cm.). Gift of the artist. 82.33.2.

[figures and Biagio's Deli]. 1981. Color coupler print. 13⁹⁄₁₆ × 14¹⁄₁₆ in. (34.5 × 35.8 cm.). Gift of the artist. 82.33.3.

[pink flamingos and bird bath]. 1981. Color coupler print. 13⁹⁄₁₆ × 14¹⁄₁₆ in. (34.5 × 35.8 cm.). Gift of the artist. 82.33.4.

BRIGMAN, ANNE W.
See *Camera Work*

BROOKS, LINDA
American, 1951-

Fantasy Volumes and Interior Spaces, after *Form XVII.* From *Minnesota Photographers* portfolio. 1978. Gelatin silver print. 5¾ × 5¹¹⁄₁₆ in. (14.6 × 14.5 cm.). John R. Van Derlip Fund. 79.48.2.

BROS, CLARENCE K.
American, 1901-

Architectural Phantasy. c. 1935. Gelatin silver print. 9½ × 6⁹⁄₁₆ in. (21.1 × 16.5 cm.). Gift of the artist. 81.12.1.

Vertical Repetition. c. 1936. Gelatin silver print. 10⁵⁄₁₆ × 6³⁄₁₆ in. (26.3 × 15.7 cm.). Gift of the artist. 81.12.2.

Light Pattern. c. 1935. Gelatin silver print. 9½ × 6½ in. (24.2 × 16.6 cm.). Gift of the artist. 81.12.3.

Arlington National Cemetery. n.d. Gelatin silver print. 12¹³⁄₁₆ × 10¼ in. (32.5 × 26.2 cm.). Gift of the artist. 81.12.4.

Two Gals. n.d. Gelatin silver print. 10¼ × 11⁹⁄₁₆ in. (26.1 × 29.5 cm.). Gift of the artist. 81.12.5.

BROWN, LAURIE
American, 1937-

[plowed earth]. From *L. A. Issue* portfolio. n.d. 2 gelatin silver prints. Each 5⅝ × 7¹¹⁄₁₆ in. (13.4 × 19.5 cm.). Gift of funds from the Photography Council of The Minneapolis Institute of Arts. 80.25.1.

BRUGIÈRE, FRANCIS
See *Camera Work*

BRUMFIELD, JOHN
American, 1934-

["Richard Holding a Serious Pose"]. From *L. A. Issue* portfolio. n.d. Gelatin silver print. 17¹¹⁄₁₆ × 11¹⁵⁄₁₆ in. (45.0 × 30.4 cm.). Gift of funds from the Photography Council of The Minneapolis Institute of Arts. 80.25.2.

BULLOCK, WYNN
American, 1902-1975

Night Scene. 1959. Gelatin silver print. 7⁹⁄₁₆ × 9½ in. (19.2 × 24.2 cm.). Ethel Morrison Van Derlip Fund. 76.50.1.

Florence, Trees and Sand Dunes. 1957. Gelatin silver print. 7⁹⁄₁₆ × 9⁷⁄₁₆ in. (19.3 × 24.0 cm.). Ethel Morrison Van Derlip Fund. 76.50.2.

Point Lobos Wave. 1958. Gelatin silver print. 8⁹⁄₁₆ × 7³⁄₁₆ in. (21.7 × 18.3 cm.). Ethel Morrison Van Derlip Fund. 76.50.3.

Twin Oaks. 1956. Gelatin silver print. 7½ × 9½ in. (19.1 × 24.1 cm.). Ethel Morrison Van Derlip Fund. 76.50.4.

Woman and Dog in Forest. 1953. Gelatin silver print. 7⁹⁄₁₆ × 9⁹⁄₁₆ in. (19.2 × 24.3 cm.). Ethel Morrison Van Derlip Fund. 76.50.5.

In the Surf. 1968. Gelatin silver print. 7⅜ × 9⅜ in. (18.8 × 23.8 cm.). Ethel Morrison Van Derlip Fund. 76.50.6.

Redwood Driftwood. 1951. Gelatin silver print. 7½ × 9⅜ in. (19.1 × 23.9 cm.). Ethel Morrison Van Derlip Fund. 76.50.7.

Doorway. c. 1955. Gelatin silver print. 9⁷⁄₁₆ × 7⁹⁄₁₆ in. (24.0 × 19.2 cm.). Anonymous gift of funds. 78.92.4.

BURCHARD, JERRY
American, 1931-

Ping Yuen. From *New California Views* portfolio. 1979. Gelatin silver print. 10⅞ × 16 in. (27.7 × 40.7 cm.). Gift of funds from the Photography Council of The Minneapolis Institute of Arts. 80.24.1.

BURCHFIELD, JERRY
American, 1947-

Considering Painting. From *L. A. Issue* portfolio. 1978. Dye bleach color print (Cibachrome). 8¹⁄₁₆ × 11¹¹⁄₁₆ in. (20.5 × 29.7 cm.). Gift of funds from the Photography Council of The Minneapolis Institute of Arts. 80.25.3.

BURNS, MARSHA
American, 1945-

#45006. 1978. Gelatin silver print. 8⅝ × 5⁹⁄₁₆ in. (21.9 × 14.1 cm.). Anonymous gift of funds. 78.100.

BURNS, MICHAEL JOHN
American, 1942-

Lighthouse Wall, Whidbey Island, Washington. 1976. Gelatin silver print. 7⁹⁄₁₆ × 9⅝ in. (19.3 × 24.4 cm.). Anonymous gift of funds. 78.99.

BUSSE, SUSAN
American (?), 20th century

[hands]. From *What Ever Happened to Sexuality* portfolio. c. 1977. Gelatin silver print. 5⅞ × 9⅜ in. (14.9 × 23.8 cm.). Gift of the artist. 82.70.4.

Cadby, WILLIAM A.
See *Camera Work*

CALLAHAN, HARRY
American, 1912-

Aix-en-Provence. 1958. Gelatin silver print. 9⅛ × 7⅛ in. (23.2 × 18.1 cm.). Kate and Hall J. Peterson Fund. 72.26.

Michigan. 1948. Gelatin silver print. 6⅝ × 6½ in. (16.8 × 16.5 cm.). Kate and Hall J. Peterson Fund. 72.27.

Horseneck Beach. 1975. Gelatin silver print. 10³⁄₁₆ × 10³⁄₁₆ in. (25.9 × 25.9 cm.). National Endowment for the Arts purchase grant and miscellaneous matching funds. 76.17.1.

Cape Cod. 1972. Gelatin silver print. 9½ × 9¹¹⁄₁₆ in. (24.2 × 24.7 cm.). National Endowment for the Arts purchase grant and miscellaneous matching funds. 76.17.2.

Cape Cod. 1972. Gelatin silver print. 10½ × 10⁹⁄₁₆ in. (26.7 × 26.9 cm.). National Endowment for the Arts purchase grant and miscellaneous matching funds. 76.17.3.

Chicago. 1951. Dye transfer print. 8¹³⁄₁₆ × 13⅜ in. (22.4 × 33.9 cm.). Gift of Emanuel M. Brotman. 80.69.1.

Chicago. 1946. Dye transfer print. 8¾ × 13⅜ in. (22.2 × 34.0 cm.). Gift of Emanuel M. Brotman. 80.69.2.

Chicago. 1950. Dye transfer print. 8⅞ × 13½ in. (22.5 × 34.3 cm.). Gift of Emanuel M. Brotman. 80.69.3.

Detroit. 1951. Dye transfer print. 8¹³⁄₁₆ × 13⁷⁄₁₆ in. (22.4 × 34.2 cm.). Gift of Emanuel M. Brotman. 80.69.4.

Chicago. c. 1952. Dye transfer print. 8¹³⁄₁₆ × 13⁷⁄₁₆ in. (22.4 × 34.2 cm.). Gift of Emanuel M. Brotman. 80.69.5.

Chicago. c. 1949. Dye transfer print. 8¹³⁄₁₆ × 13⁷⁄₁₆ in. (22.3 × 34.2 cm.). Gift of Emanuel M. Brotman. 80.69.6.

Collages. c. 1956. Dye transfer print. 8¹³⁄₁₆ × 13⁷⁄₁₆ in. (22.4 × 34.1 cm.). Gift of Emanuel M. Brotman. 80.69.7.

Providence. 1962. Dye transfer print. 8¹³⁄₁₆ × 13⁷⁄₁₆ in. (22.5 × 34.1 cm.). Gift of Emanuel M. Brotman. 80.69.8.

Chicago. 1953. Dye transfer print. 8¾ × 13⁷⁄₁₆ in. (22.3 × 34.1 cm.). Gift of Emanuel M. Brotman. 80.69.9.

Providence. c. 1962. Dye transfer print. 8¹³⁄₁₆ × 13⁷⁄₁₆ in. (22.4 × 34.2 cm.). Gift of Emanuel M. Brotman. 80.69.10.

Florence. 1957. Dye transfer print. 8¹³⁄₁₆ × 13⁷⁄₁₆ in. (22.4 × 34.1 cm.). Gift of Emanuel M. Brotman. 80.69.11.

Venice. 1957. Dye transfer print. 8¹³⁄₁₆ × 13⁷⁄₁₆ in. (22.4 × 34.1 cm.). Gift of Emanuel M. Brotman. 80.69.12.

Providence. 1962. Dye transfer print. 6 × 9 in. (15.2 × 22.8 cm.). Gift of Emanuel M. Brotman. 80.69.13.

Venice. 1978. Dye transfer print. 8¾ × 13⁷⁄₁₆ in. (22.2 × 34.1 cm.). Gift of Emanuel M. Brotman. 80.69.14.

Atlanta. 1977. Dye transfer print. 8⁹⁄₁₆ × 13⁷⁄₁₆ in. (22.4 × 34.2 cm.). Gift of Emanuel M. Brotman. 80.69.15.

Providence. 1977. Dye transfer print. 8¹¹⁄₁₆ × 13⁷⁄₁₆ in. (22.5 × 34.2 cm.). Gift of Emanuel M. Brotman. 80.69.16.

New York. 1977. Dye transfer print. 8⁹⁄₁₆ × 13⁷⁄₁₆ in. (22.3 × 34.2 cm.). Gift of Emanuel M. Brotman. 80.69.17.

Providence. 1977. Dye transfer print. 8⅞ × 13⁷⁄₁₆ in. (22.5 × 34.2 cm.). Gift of Emanuel M. Brotman. 80.69.18.

Providence. 1977. Dye transfer print. 8¹³⁄₁₆ × 13⁷⁄₁₆ in. (22.3 × 34.1 cm.). Gift of Emanuel M. Brotman. 80.69.19.

Providence. 1977. Dye transfer print. 8⅞ × 13⁷⁄₁₆ in. (22.6 × 34.1 cm.). Gift of Emanuel M. Brotman. 80.69.20.

New York. 1978. Dye transfer print. 8⅞ × 13⁷⁄₁₆ in. (22.5 × 34.1 cm.). Gift of Emanuel M. Brotman. 80.69.21.

Cape Cod. 1978. Dye transfer print. 7¼ × 7⅛ in. (18.5 × 18.1 cm.). Gift of Emanuel M. Brotman. 80.69.22.

Horseneck Beach. 1977. Dye transfer print. 7¼ × 7⅛ in. (18.4 × 18.1 cm.). Gift of Emanuel M. Brotman. 80.69.23.

Horseneck Beach. c. 1971. Dye transfer print. 7⁵⁄₁₆ × 7⅛ in. (18.5 × 18.2 cm.). Gift of Emanuel M. Brotman. 80.69.24.

Providence. 1971. Dye transfer print. 7⅜ × 7¼ in. (18.7 × 18.5 cm.). Gift of Emanuel M. Brotman. 80.69.25.

Cape Cod. 1978. Dye transfer print. 7 × 9¼ in. (17.9 × 23.5 cm.). Gift of Emanuel M. Brotman. 80.69.26.

Egypt. 1978. Dye transfer print. 7 × 9⅜ in. (17.8 × 23.4 cm.). Gift of Emanuel M. Brotman. 80.69.27.

Bass Rocks. 1978. Dye transfer print. 7¼ × 7⅛ in. (18.4 × 18.2 cm.). Gift of Emanuel M. Brotman. 80.69.28.

Horseneck Beach. 1978. Dye transfer print. 7¹⁄₁₆ × 7⅛ in. (17.9 × 18.1 cm.). Gift of Emanuel M. Brotman. 80.69.29.

Providence. 1971. Dye transfer print. 7⁵⁄₁₆ × 7⅛ in. (18.6 × 18.2 cm.). Gift of Emanuel M. Brotman. 80.69.30.

Eleanor. c. 1947. Gelatin silver print. 4⁹⁄₁₆ × 3⁵⁄₁₆ in. (11.7 × 8.3 cm.). David Draper Dayton Fund. 81.21.2.

[street scene]. 1978. Color coupler print. 9⅛ × 13⁹⁄₁₆ in. (23.2 × 34.5 cm.). Gift of the American Telephone and Telegraph Co. 81.120.7.

[houses]. 1978. Color coupler print. 9³⁄₁₆ × 13⁹⁄₁₆ in. (23.4 × 34.5 cm.). Gift of the American Telephone and Telegraph Co. 81.120.8.

[vegetation]. 1978. Color coupler print. 10½ × 10⁷⁄₁₆ in. (26.7 × 26.6 cm.). Gift of the American Telephone and Telegraph Co. 81.120.9.

CALLIS, JO ANN
American, 1940-

Man in Tie. From *Silver See* portfolio. 1976. Color coupler print. 9⅛ × 7 in. (23.1 × 17.8 cm.). National Endowment for the Arts purchase grant and miscellaneous matching funds. 77.39.1.

Woman with Blue Bow. 1977. Color coupler print. 14⅚₆ × 17⁹⁄₁₆ in. (36.4 × 44.6 cm.). Anonymous gift of funds. 78.98.1.

Man at Table. 1977. Color coupler print. 9⅜ × 11⁷⁄₁₆ in. (23.8 × 29.1 cm.). Anonymous gift of funds. 78.98.2.

Tigger and Apple Pie. 1980. Color coupler print. 9⅝ × 12³⁄₁₆ in. (24.4 × 30.9 cm.). Gift of funds from the Photography Council of The Minneapolis Institute of Arts. 81.46.

CAMERA WORK
Quarterly magazine edited and published by Alfred Stieglitz, New York. 1903-1917.

Complete set of 50 numbers in 47 issues plus 3 special issues. 559 plates and illustrations in photogravure, halftone, color halftone, collotype, and letterpress. (Only photographic images listed here. For a complete index, see *Camera Work: A Pictorial Guide,* edited by Marianne Fulton Margolis, Dover Publications, 1978.) William Hood Dunwoody Fund. 64.34.1-50.
Abbott, C. Yarnall (3). Adamson, Prescott (1). Annan, J. Craig (25). Becher, Arthur E. (1). Boughton, Alice (6). Brigman, Anne W. (11). Bruguière, Francis (1). Cadby, William A. (2). Cameron, Julia Margaret (5). Coburn, Alvin Langdon (26). Davison, George (8). Demachy, Robert (16). De Meyer, Baron Adolf (21). Devens, Mary (1). Dugmore, A. Radclyffe (2). Dyer, William B. (2). Eugene, Frank (28). Evans, Frederick H. (7). French, Herbert G. (5). Haviland, Paul B. (9). Henneberg, Hugo (3). Herzog, F. Benedict (5). Hill, David Octavius, and Robert Adamson (21). Hinton, A. Horsley (2). Hofmeister, Theodor and Oscar (6). Käsebier, Gertrude (12). Keiley, Joseph T. (7). Kernochan, Marshall R. (1). Kuehn, Heinrich (19). Lamb, H. Mortimer (1). Le Bégue, Renée (2). Lewis, Arthur Allen (1). Muir, Ward (2). Post, William B. (1). Pratt, Frederick H. (1). Puyo, E. J. Constant (3). Renwick, William W. (1). Rey, Guido (2). Rubincam, Harry C. (1). Sears, Sarah C. (2). Seeley, George H. (18). Shaw, George Bernard (1). Spencer, Ema (1). Steichen, Eduard J. (68). Stieglitz, Alfred (47). Stieglitz, Alfred, and Clarence H. White (4). Strand, Paul (17). Strauss, John Francis (1). Struss, Karl F. (8). Watson-Schütze, Eva (4). Watzek, Hans (5). White, Clarence H. (27). Wilmerding, William E. (1).

Another Set. Nearly complete; missing only issues no. 11 (July 1905) and no. 49/50 (June 1917). Gift of Julia Marshall. 69.133.1-48.

CAMERON, JULIA MARGARET
English (b. India), 1815-1879

George Frederic Watts. 1864. Albumen print. 8⅝ in. (21.9 cm.) diameter. Paul J. Schmitt Fund. 78.5.1.

The Spirit of the Spring. n.d. Albumen print. 13⅝ × 10 in. (34.6 × 25.3 cm.). Paul J. Schmitt Fund. 78.5.2.

Sir Gallahad and the Pale Nun. n.d. Albumen print. 13⅝ × 10⅞ in. (34.6 × 27.7 cm.). Paul J. Schmitt Fund. 78.5.3.

[Kate Keown]. 1866. Albumen print. 2⁵⁄₁₆ × 2¹⁵⁄₁₆ in. (6.0 × 7.4 cm.). Paul J. Schmitt Fund. 78.5.4.

See also *Camera Work*

CARDOZO, CHRISTOPHER
American, 1948-

San Andres Chicahauxtla, Oaxaca. 1973. Gelatin silver print, Kodalith paper. 12¼ × 8⅜ in. (31.2 × 20.9 cm.). Gift of the artist. 75.15.11.

[woman with two children]. From *Los Triques* series, Oaxaca, Mexico. 1973. Gelatin silver print, Kodalith paper. 8⅚₆ × 12½ in. (21.2 × 31.8 cm.). National Endowment for the Arts purchase grant and miscellaneous matching funds. 76.69.1.

[band of men]. From *Los Triques* series, Oaxaca, Mexico. 1973. Gelatin silver print, Kodalith paper. 8⅚₆ × 12½ in. (21.2 × 31.8 cm.). National Endowment for the Arts purchase grant and miscellaneous matching funds. 76.69.2.

[shrine among foliage]. From *Los Triques* series, Oaxaca, Mexico. 1973. Gelatin silver print, Kodalith paper. 8⅜ × 12½ in. (21.3 × 31.7 cm.). National Endowment for the Arts purchase grant and miscellaneous matching funds. 76.69.3.

[men carrying Christ figure]. From *Los Triques* series, Oaxaca, Mexico. 1973. Gelatin silver print, Kodalith paper. 8⅚₆ × 12½ in. (21.2 × 31.8 cm.). National Endowment for the Arts purchase grant and miscellaneous matching funds. 76.69.4.

[two groups carrying religious figures]. From *Los Triques* series, Oaxaca, Mexico. 1973. Gelatin silver print, Kodalith paper. 8⅚₆ × 12½ in. (21.2 × 31.8 cm.). National Endowment for the Arts purchase grant and miscellaneous matching funds. 76.69.5.

[man standing in front of dwelling]. From *Los Triques* series, Oaxaca, Mexico. 1973. Gelatin silver print, Kodalith paper. 8⅜ × 12½ in. (21.3 × 31.8 cm.). National Endowment for the Arts purchase grant and miscellaneous matching funds. 76.69.6.

[highway and overhanging sign]. From *Kodalith* series. c. 1971. Gelatin silver print, Kodalith paper. 4⅝ × 6¹³⁄₁₆ in. (11.7 × 17.3 cm.). Kate and Hall J. Peterson Fund. 82.94.1.

[Jeep on mountain road]. From *Aspen Kodalith Series.* c. 1971. Gelatin silver print, Kodalith paper. 6¼ × 9¼ in. (15.9 × 23.5 cm.). Kate and Hall J. Peterson Fund. 82.94.2.

Rocks, Aspen, Colorado. From *Aspen Landscape Series No. 2.* 1971. Gelatin silver print. 5⅞ × 7¾ in. (14.9 × 19.7 cm.). Kate and Hall J. Peterson Fund. 82.94.3.

Rocks, Aspen, Colorado. From *Aspen Landscape Series No. 2.* 1971. Gelatin silver print. 6³⁄₁₆ × 7¹³⁄₁₆ in. (15.7 × 19.8 cm.). Kate and Hall J. Peterson Fund. 82.94.4.

[white fence and foliage]. From *Dellwood* series. c. 1971. Gelatin silver print. 4⁹⁄₁₆ × 6¾ in. (11.6 × 17.2 cm.). Kate and Hall J. Peterson Fund. 82.94.5.

[shadow in yard]. From *Dellwood* series. c. 1971. Gelatin silver print. 4⁷⁄₁₆ × 6¹¹⁄₁₆ in. (11.3 × 17.1 cm.). Kate and Hall J. Peterson Fund. 82.94.6.

[light on wall]. From *Dellwood* series. c. 1971. Gelatin silver print. 3¾ × 5⅝ in. (9.5 × 14.3 cm.). Kate and Hall J. Peterson Fund. 82.94.7.

[doorway]. From *Dellwood* series. c. 1971. Gelatin silver print. 3¾ × 5⁹⁄₁₆ in. (9.6 × 14.1 cm.). Kate and Hall J. Peterson Fund. 82.94.8.

[chair reflection in window]. From *Dellwood* series. c. 1971. Gelatin silver print. 4³⁄₁₆ × 6³⁄₁₆ in. (10.6 × 15.7 cm.). Kate and Hall J. Peterson Fund. 82.94.9.

[ice on dock]. From *Dellwood* series. c. 1971. Gelatin silver print. 4⁹⁄₁₆ × 6¹³⁄₁₆ in. (11.6 × 17.3 cm.). Kate and Hall J. Peterson Fund. 82.94.10.

CARJAT, ETIENNE
French, 1828-1906

Georges Clémenceau. From *Galerie Contemporaine.* 1879. Woodburytype. 8¾ × 7⅛ in. (22.3 × 18.1 cm.). David Dayton Draper Fund. 75.59.3.

CARRILLO, MANUEL
Mexican, 1915-

[man with fishing nets]. n.d. Gelatin silver print. 9½ × 7⁹⁄₁₆ in. (24.1 × 19.2 cm.). Gift of Arnold M. Gilbert. 76.48.1.

[group of children]. n.d. Gelatin silver print. 9½ × 7⁹⁄₁₆ in. (24.1 × 19.3 cm.). Gift of Arnold M. Gilbert. 76.48.2.

[girl crouching against wall]. n.d. Gelatin silver print. 7⁹⁄₁₆ × 9½ in. (19.3 × 24.1 cm.). Gift of Arnold M. Gilbert. 76.48.3.

[boy and two horses]. n.d. Gelatin silver print. 7⁹⁄₁₆ × 9½ in. (19.2 × 24.1 cm.). Gift of Arnold M. Gilbert. 76.48.4.

[dog on grave]. n.d. Gelatin silver print. 7⁹⁄₁₆ × 9½ in. (19.2 × 24.1 cm.). Gift of Arnold M. Gilbert. 76.48.5.

[woman among pots with hand over face]. n.d. Gelatin silver print. 7⁹⁄₁₆ × 9½ in. (19.2 × 24.2 cm.). Gift of Arnold M. Gilbert. 76.48.6.

[man with two horses at stream]. n.d. Gelatin silver print. 7¹¹⁄₁₆ × 9½ in. (19.5 × 24.2 cm.). Gift of Arnold M. Gilbert. 76.48.7.

[two figures carrying pots]. n.d. Gelatin silver print. 7⁹⁄₁₆ × 9½ in. (19.2 × 24.1 cm.). Gift of Arnold M. Gilbert. 76.48.8.

[woman with hand over mouth]. n.d. Gelatin silver print. 9⁷⁄₁₆ × 7⁹⁄₁₆ in. (24.0 × 19.2 cm.). Gift of Arnold M. Gilbert. 76.48.9.

[girl with flowers]. n.d. Gelatin silver print. 9½ × 7⁹⁄₁₆ in. (24.1 × 19.3 cm.). Gift of Arnold M. Gilbert. 76.48.10.

[boy with two dogs]. n.d. Gelatin silver print. 7⁹⁄₁₆ × 9½ in. (19.2 × 24.1 cm.). Gift of Arnold M. Gilbert. 76.48.11.

[dog at man's feet]. n.d. Gelatin silver print. 9½ × 7⁹⁄₁₆ in. (24.2 × 19.2 cm.). Gift of Arnold M. Gilbert. 76.48.12.

[woman ascending step]. n.d. Gelatin silver print. 9½ × 7⁷⁄₁₆ in. (24.2 × 19.3 cm.). Gift of Arnold M. Gilbert. 76.48.13.

[girl with raised arms]. n.d. Gelatin silver print. 9⅝ × 7⅝ in. (24.5 × 19.3 cm.). Gift of Arnold M. Gilbert. 76.48.14.

[black cat]. n.d. Gelatin silver print. 9½ × 7⁹⁄₁₆ in. (24.2 × 19.3 cm.). Gift of Arnold M. Gilbert. 76.48.15.

CHARLESWORTH, BRUCE
American, 1950-

Debut. 1978. Polaroid SX-70, with acrylic and collage. 3⅛ × 3¹⁄₁₆ in. (8.0 × 7.9 cm.). Mr. and Mrs. Harrison R. Johnston, Jr. Fund. 78.42.1.

Patrol. 1978. Polaroid SX-70, with acrylic and collage. 3⅛ × 3¹⁄₁₆ in. (8.0 × 7.8 cm.). Mr. and Mrs. Harrison R. Johnston, Jr. Fund. 78.42.2.

Mimosa. 1978. Polaroid SX-70, with acrylic and collage. 3⅛ × 3¹⁄₁₆ in. (8.0 × 7.8 cm.). Mr. and Mrs. Harrison R. Johnston, Jr. Fund. 78.42.3.

Elevator. 1978. Polaroid SX-70, with acrylic and collage. 3⅛ × 3¹⁄₁₆ in. (8.0 × 7.8 cm.). Gift of the artist. 78.43.

CHESLEY, PAUL
American, 1946-

Flow, Yellowstone. 1977. Color coupler print. 19⅝ × 15⁹⁄₁₆ in. (49.8 × 39.6 cm.). Christina N. and Swan J. Turnblad Memorial Fund. 78.46.1.

Double Flow, Yellowstone. 1977. Color coupler print. 14¾ × 20 in. (37.5 × 50.9 cm.). Christina N. and Swan J. Turnblad Memorial Fund. 78.46.2.

Line Formations, Yellowstone. 1977. Color coupler print. 15⅛ × 20 in. (38.4 × 50.8 cm.). Christina N. and Swan J. Turnblad Memorial Fund. 78.46.3.

Cloud over Mountain, Colorado. 1975. Color coupler print. 15¼ × 20 in. (38.7 × 50.8 cm.). Gift of the artist. 78.47.1.

Clouds with Rainbow, Colorado. 1975. Color coupler print. 16 × 20 in. (40.7 × 50.8 cm.). Gift of the artist. 78.47.2.

CHIARENZA, CARL
American, 1935-

Fitchburg 22. 1976. Gelatin silver print. 9⁹⁄₁₆ × 12¼ in. (24.3 × 31.2 cm.). Kate and Hall J. Peterson Fund. 78.93.1.

Quincy 4. 1977. Gelatin silver print. 10¹⁄₁₆ × 13³⁄₁₆ in. (25.6 × 33.5 cm.). Kate and Hall J. Peterson Fund. 78.93.2.

Somerville 10. 1976. Gelatin silver print. 9⁷⁄₁₆ × 11¾ in. (24.1 × 29.9 cm.). Kate and Hall J. Peterson Fund. 78.93.3.

Rochester. 1954. Gelatin silver print. 4⅛ × 6⅞ in. (10.4 × 17.6 cm.). Kate and Hall J. Peterson Fund. 80.12.1.

Rochester. 1956. Gelatin silver print. 4¾ × 3⅞ in. (12.0 × 9.9 cm.). Kate and Hall J. Peterson Fund. 80.12.2.

Rochester. 1957. Gelatin silver print. 4½ × 3⁹⁄₁₆ in. (11.5 × 9.0 cm.). Kate and Hall J. Peterson Fund. 80.12.3.

Marblehead. 1957. Gelatin silver print. 9½ × 12⅞ in. (24.2 × 32.8 cm.). Kate and Hall J. Peterson Fund. 80.12.4.

Michigan. 1958. Gelatin silver print. 9⁷⁄₁₆ × 7½ in. (24.0 × 19.1 cm.). Kate and Hall J. Peterson Fund. 80.12.5.

Michigan. 1958. Gelatin silver print. 9¼ × 6¹¹⁄₁₆ in. (23.5 × 17.0 cm.). Kate and Hall J. Peterson Fund. 80.12.6.

Honeye Falls. 1960. Gelatin silver print. 7⁵⁄₁₆ × 5½ in. (18.5 × 13.9 cm.). Kate and Hall J. Peterson Fund. 80.12.7.

Boston. 1964. Gelatin silver print. 6¹⁵⁄₁₆ × 8¹³⁄₁₆ in. (17.6 × 22.4 cm.). Kate and Hall J. Peterson Fund. 80.12.8.

Bucks County. 1969-70. Gelatin silver print. 13¼ × 10⁷⁄₁₆ in. (33.7 × 26.6 cm.). Kate and Hall J. Peterson Fund. 80.12.9.

Cambridge 31. 1974. Gelatin silver print. 8³⁄₁₆ × 10¹³⁄₁₆ in. (20.9 × 27.5 cm.). Kate and Hall J. Peterson Fund. 80.12.10.

Cambridge 19. 1974. Gelatin silver print. 7¹³⁄₁₆ × 10¾ in. (19.9 × 27.4 cm.). Kate and Hall J. Peterson Fund. 80.12.11.

Cambridge 14. 1974. Gelatin silver print. 8 × 10¹³⁄₁₆ in. (20.3 × 27.6 cm.). Kate and Hall J. Peterson Fund. 80.12.12.

Richmond 26. 1975. Gelatin silver print. 9³⁄₁₆ × 12³⁄₁₆ in. (23.4 × 31.0 cm.). Kate and Hall J. Peterson Fund. 80.12.13.

Somerville 9A. 1975. Gelatin silver print. 8¹¹⁄₁₆ × 11 in. (22.0 × 28.0 cm.). Kate and Hall J. Peterson Fund. 80.12.14.

Somerville 12. 1975. Gelatin silver print. 9³⁄₁₆ × 12⁵⁄₁₆ in. (23.3 × 31.3 cm.). Kate and Hall J. Peterson Fund. 80.12.15.

Hudson 3. 1975. Gelatin silver print. 9⅜ × 9 in. (23.9 × 22.8 cm.). Kate and Hall J. Peterson Fund. 80.12.16.

Richmond 19. 1975. Gelatin silver print. 11 × 8¹¹⁄₁₆ in. (28.0 × 22.0 cm.). Kate and Hall J. Peterson Fund. 80.12.17.

Fall River 8. 1975. Gelatin silver print. 13¼ × 9⁷⁄₁₆ in. (33.8 × 24.0 cm.). Kate and Hall J. Peterson Fund. 80.12.18.

Somerville 17. 1975. Gelatin silver print. 9⅛ × 12⅜ in. (23.2 × 31.5 cm.). Kate and Hall J. Peterson Fund. 80.12.19.

Somerville 1. 1975. Gelatin silver print. 9⅜ × 10⅞ in. (23.8 × 27.7 cm.). Kate and Hall J. Peterson Fund. 80.12.20.

Somerville 8. 1975. Gelatin silver print. 9 × 12⁵⁄₁₆ in. (22.9 × 31.3 cm.). Kate and Hall J. Peterson Fund. 80.12.21.

Somerville 25. 1976. Gelatin silver print. 9⅛ × 12⁵⁄₁₆ in. (23.3 × 31.4 cm.). Kate and Hall J. Peterson Fund. 80.12.22.

Somerville 10. 1976. Gelatin silver print. 9⁷⁄₁₆ × 11¹⁵⁄₁₆ in. (24.0 × 30.3 cm.). Kate and Hall J. Peterson Fund. 80.12.23.

Somerville 1. 1976. Gelatin silver print. 9½ × 12⁵⁄₁₆ in. (24.2 × 31.4 cm.). Kate and Hall J. Peterson Fund. 80.12.24.

Fall River 6. 1976. Gelatin silver print. 9½ × 12⁵⁄₁₆ in. (24.1 × 31.2 cm.). Kate and Hall J. Peterson Fund. 80.12.25.

Charlestown 43. 1976. Gelatin silver print. 9⁷⁄₁₆ × 12⁵⁄₁₆ in. (24.0 × 31.3 cm.). Kate and Hall J. Peterson Fund. 80.12.26.

Charlestown 23. 1976. Gelatin silver print. 12¼ × 9⅛ in. (31.2 × 23.2 cm.). Kate and Hall J. Peterson Fund. 80.12.27.

Somerville 5. 1976. Gelatin silver print. 12⁵⁄₁₆ × 9⁷⁄₁₆ in. (31.3 × 24.1 cm.). Kate and Hall J. Peterson Fund. 80.12.28.

Charlestown 15. 1976. Gelatin silver print. 9⅛ × 12³⁄₁₆ in. (23.1 × 31.0 cm.). Kate and Hall J. Peterson Fund. 80.12.29.

Fall River 19. 1976. Gelatin silver print. 9¼ × 11⅞ in. (23.6 × 30.2 cm.). Kate and Hall J. Peterson Fund. 80.12.30.

Charlestown 37. 1976. Gelatin silver print. 8¹⁵⁄₁₆ × 12³⁄₁₆ in. (22.7 × 31.0 cm.). Kate and Hall J. Peterson Fund. 80.12.31.

Fitchburg 12. 1976. Gelatin silver print. 9½ × 12³⁄₁₆ in. (24.2 × 31.0 cm.). Kate and Hall J. Peterson Fund. 80.12.32.

Charlestown 38. 1976. Gelatin silver print. 9⁷⁄₁₆ × 12⁵⁄₁₆ in. (24.0 × 31.3 cm.). Kate and Hall J. Peterson Fund. 80.12.33.

White Sands 4. 1976. Gelatin silver print. 8¾ × 11¼ in. (22.2 × 28.6 cm.). Kate and Hall J. Peterson Fund. 80.12.34.

White Sands 1. 1976. Gelatin silver print. 9 × 11¹¹⁄₁₆ in. (22.8 × 29.8 cm.). Kate and Hall J. Peterson Fund. 80.12.35.

Tucson 1. 1976. Gelatin silver print. 9 × 12¹⁄₁₆ in. (23.0 × 30.6 cm.). Kate and Hall J. Peterson Fund. 80.12.36.

Somerville 16. 1976. Gelatin silver print. 9⁵⁄₁₆ × 11⅞ in. (23.7 × 30.2 cm.). Kate and Hall J. Peterson Fund. 80.12.37.

Charlestown 42. 1976. Gelatin silver print. 9⅜ × 12⁵⁄₁₆ in. (23.9 × 31.2 cm.). Kate and Hall J. Peterson Fund. 80.12.38.

Somerville 32. 1976. Gelatin silver print. 9³⁄₁₆ × 11¹⁵⁄₁₆ in. (23.4 × 30.3 cm.). Kate and Hall J. Peterson Fund. 80.12.39.

Somerville 21. 1976. Gelatin silver print. 9³⁄₁₆ × 11¹⁵⁄₁₆ in. (23.3 × 30.4 cm.). Kate and Hall J. Peterson Fund. 80.12.40.

Fitchburg 20. 1976. Gelatin silver print. 9⅜ × 12¼ in. (23.8 × 31.2 cm.). Kate and Hall J. Peterson Fund. 80.12.41.

Quarry 3. 1976. Gelatin silver print. 9⅛ × 11¹¹⁄₁₆ in (23.2 × 29.8 cm.). Kate and Hall J. Peterson Fund. 80.12.42.

Charlestown 10. 1976. Gelatin silver print. 9⁵⁄₁₆ × 12¼ in. (23.7 × 31.2 cm.). Kate and Hall J. Peterson Fund. 80.12.43.

White Sands 5. 1976. Gelatin silver print. 8⅝ × 11⅝ in. (21.9 × 29.6 cm.). Kate and Hall J. Peterson Fund. 80.12.44.

Revere 3. 1977. Gelatin silver print. 10 × 13⁵⁄₁₆ in. (25.4 × 33.9 cm.) Kate and Hall J. Peterson Fund. 80.12.45.

Quincy 4. 1977. Gelatin silver print. 10⅛ × 13³⁄₁₆ in. (25.7 × 33.5 cm.). Kate and Hall J. Peterson Fund. 80.12.46.

Providence 25. 1977. Gelatin silver print. 9⁹⁄₁₆ × 12⁹⁄₁₆ in. (24.3 × 31.9 cm.). Kate and Hall J. Peterson Fund. 80.12.47.

Accabonac 4. 1979. Gelatin silver print. 12¹⁵⁄₁₆ × 9¾ in. (32.8 × 24.8 cm.). Kate and Hall J. Peterson Fund. 80.12.48.

Arlington 2. 1979. Gelatin silver print. 13⅛ × 18⅝ in. (33.3 × 47.4 cm.). Kate and Hall J. Peterson Fund. 80.12.49.

Rockland 2. 1979. Gelatin silver print. 15⅞ × 13½ in. (40.3 × 34.3 cm.). Kate and Hall J. Peterson Fund. 80.12.50.

Rockland 9. 1979. Gelatin silver print. 17³⁄₁₆ × 13 in. (43.7 × 33.0 cm.). Kate and Hall J. Peterson Fund. 80.12.51.

Accabonac 1. 1979. Gelatin silver print. 13⅛ × 17⁹⁄₁₆ in. (33.4 × 44.7 cm.). Kate and Hall J. Peterson Fund. 80.12.52.

CHRISTENBERRY, WILLIAM
American, 1936-

5¢ Sign, Demopolis, Alabama. 1978. Color coupler print (Ektacolor). 17½ × 22 in. (44.5 × 56.0 cm.). Kate and Hall J. Peterson Fund. 79.33.

Beale Street. Published by Caldecot Chubb, New York. 1979. Book of 10 color coupler prints (Ektacolor). Kate and Hall J. Peterson Fund. 80.13.1-10.
[Club Handy, 195 Beale Street]. 4⅞ × 3⅛ in. (12.3 × 8.0 cm.).
[193 Beale Street]. 3⅛ × 4⅞ in. (7.9 × 12.3 cm.).
[Bubber's, 197 Beale Street]. 4⅞ × 3⅛ in. (12.3 × 7.9 cm.).
[172 Beale Street]. 3¼ × 4⅞ in. (8.2 × 12.4 cm.).
[77 Beale Street]. 4⅞ × 3³⁄₁₆ in. (12.4 × 8.1 cm.).
[602 Third Street]. 3⅛ × 4⅞ in. (8.0 × 12.3 cm.).
[screen door with sign]. 4⅞ × 3⅛ in. (12.3 × 7.9 cm.).
[150 Beale Street]. 3³⁄₁₆ × 4⅞ in. (8.2 × 12.3 cm.).
[boarded-up facade with overhanging lamp]. 4⅞ × 3¼ in. (12.4 × 8.2 cm.).
[boarded-up building with red arches]. 3³⁄₁₆ × 4⅞ in. (8.1 × 12.3 cm.).

CLIFT, WILLIAM
American, 1944-

Santa Fe River Gorge from Cerro Seguro. 1978. Gelatin silver print. 11¹⁵⁄₁₆ × 16¹³⁄₁₆ in. (30.4 × 42.7 cm.). Gift of the American Telephone and Telegraph Co. 81.120.10.

Fence, Tetilla Peak. 1978. Gelatin silver print. 12³⁄₁₆ × 16⅞ in. (31.0 × 42.9 cm.). Gift of the American Telephone and Telegraph Co. 81.120.11.

Santa Fe River Gorge and Tetilla Peak. 1978. Gelatin silver print. 11⅝ × 16¹³⁄₁₆ in. (29.6 × 42.7 cm.). Gift of the American Telephone and Telegraph Co. 81.120.12.

COBURN, ALVIN LANGDON
English (b. United States), 1882-1966

Kensington Gardens. n.d. Photogravure. 7⅞ × 6⁷⁄₁₆ in. (20.1 × 16.4 cm.). Kate and Hall J. Peterson Fund. 72.37.

New York, The Tunnel-Builders. 1908. Photogravure. 7⁹⁄₁₆ × 6¼ in. (19.2 × 16.0 cm.). Kate and Hall J. Peterson Fund. 72.38.

Night Theatre. n.d. Photogravure. 7¹⁵⁄₁₆ × 6⅛ in. (20.2 × 15.7 cm.). Gift of Mr. and Mrs. Russell Cowles II. 79.12.20.

See also *Camera Work*

COHEN, MARK
American, 1943-

Public Square. 1974. Gelatin silver print. 11¾ × 17⅝ in. (30.0 × 44.9 cm.). National Endowment for the Arts purchase grant and miscellaneous matching funds. 76.24.1.

Wilkes Barre, Pennsylvania. 1974. Gelatin silver print. 11¹³⁄₁₆ × 17¹¹⁄₁₆ in. (30.0 × 44.9 cm.). National Endowment for the Arts purchase grant and miscellaneous matching funds. 76.24.2.

Wilkes Barre, Pennsylvania. 1975. Gelatin silver print. 11⅞ × 17¾ in. (30.2 × 45.1 cm.). National Endowment for the Arts purchase grant and miscellaneous matching funds. 76.24.3.

Plymouth, Pennsylvania. 1974. Gelatin silver print. 11¾ × 17⅝ in. (30.0 × 44.9 cm.). National Endowment for the Arts purchase grant and miscellaneous matching funds. 76.24.4.

Wilkes Barre, Pennsylvania. 1975. Gelatin silver print. 11¹³⁄₁₆ × 17¼ in. (30.0 × 43.9 cm.). National Endowment for the Arts purchase grant and miscellaneous matching funds. 76.24.5.

Wilkes Barre, Pennsylvania. 1974. Gelatin silver print. 12⅛ × 18³⁄₁₆ in. (30.8 × 46.2 cm.). National Endowment for the Arts purchase grant and miscellaneous matching funds. 76.24.6.

COKE, VAN DEREN
American, 1921-

Homage to the Dada Constructivists. From *The New Mexico Portfolio*. 1974. Gelatin silver print. 8⅛ × 9⅞ in. (20.6 × 25.0 cm.). National Endowment for the Arts purchase grant and miscellaneous matching funds. 76.61.2.

CONNOR, LINDA S.
American, 1944-

[chairs]. From *Underware* portfolio. 1975. Gelatin silver print. 7⁷⁄₁₆ × 9¹¹⁄₁₆ in. (19.0 × 24.6 cm.). National Endowment for the Arts purchase grant and miscellaneous matching funds. 76.64.3.

[formed tree branches]. From *New California Views* portfolio. 1978. Gelatin silver print. 7¹¹⁄₁₆ × 9⁹⁄₁₆ in. (19.5 × 24.4 cm.). Gift of funds from the Photography Council of The Minneapolis Institute of Arts. 80.24.2.

Petroglyphs, Bishop, California. 1978. Gelatin silver print. 7⅝ × 9⅜ in. (19.4 × 23.8 cm.). Gift of the American Telephone and Telegraph Co. 81.120.13.

Spiral Petroglyph, Canyon de Chelly, Arizona. 1978. Gelatin silver print. 7⅝ × 9⅛ in. (19.4 × 23.3 cm.). Gift of the American Telephone and Telegraph Co. 81.120.14.

Offering, Oahu, Hawaii. 1978. Gelatin silver print. 7³⁄₁₆ × 9⁷⁄₁₆ in. (18.3 × 24.0 cm.). Gift of the American Telephone and Telegraph Co. 81.120.15.

COPLANS, JOHN
British, 1920-

Judith and Inigo. 1980. Gelatin silver print. 17½ × 21⅞ in. (44.5 × 55.6 cm.). Ethel Morrison Van Derlip Fund. 82.89.2.

COWIN, EILEEN
American, 1947-

Self-Portrait in Mirror. 1970. Sheet film and electrostatic print, hand colored. 7½ × 7¹³⁄₁₆ in. (19.1 × 19.9 cm.). Kate and Hall J. Peterson Fund. 71.21.3.

[symbol and cymbal]. From *Silver See* portfolio. 1976. Color electrostatic print with lithography. 15¹⁄₁₆ × 20¹⁄₁₆ in. (38.3 × 51.0 cm.). National Endowment for the Arts purchase grant and miscellaneous matching funds. 77.39.2.

CRANE, ARNOLD H.
American, 1932-

Bill Brandt, London. 1969. Gelatin silver print. 13¹¹⁄₁₆ × 9⅜ in. (34.9 × 23.8 cm.). Christina N. and Swan J. Turnblad Memorial Fund. 74.38.

Aaron Siskind, Chicago. From *Living Photographers* series. 1970. Gelatin silver print. 8⅜ × 13¹¹⁄₁₆ in. (21.2 × 34.9 cm.). Gift of Herbert R. Molner. 76.81.1.

Bill Brandt, London. From *Living Photographers* series. 1969. Gelatin silver print. 13¹¹⁄₁₆ × 9⅛ in. (34.8 × 23.3 cm.). Gift of Herbert R. Molner. 76.81.2.

Imogen Cunningham, San Francisco. From *Living Photographers* series. 1969. Gelatin silver print. 9⅛ × 13¹¹⁄₁₆ in. (23.1 × 34.9 cm.). Gift of Herbert R. Molner. 76.81.3.

Edward Steichen, Connecticut. From *Living Photographers* series. 1969. Gelatin silver print. 9¹⁄₁₆ × 13¾ in. (23.0 × 35.0 cm.). Gift of Herbert R. Molner. 76.81.4.

Walker Evans, Old Lyme. From *Living Photographers* series. 1968. Gelatin silver print. 8⅞ × 13¾ in. (22.5 × 34.9 cm.). Gift of Herbert R. Molner. 76.81.5.

Ansel Adams, Point Lobos. From *Living Photographers* series. 1969. Gelatin silver print. 13½ × 9 in. (34.3 × 22.9 cm.). Gift of Herbert R. Molner. 76.81.6.

Edward Steichen, Connecticut. From *Living Photographers* series. 1969. Gelatin silver print. 13¹¹⁄₁₆ × 9¹⁄₁₆ in. (34.9 × 23.0 cm.). Gift of Herbert R. Molner. 76.81.7.

Man Ray, Paris. From *Living Photographers* series. 1973. Gelatin silver print. 19⁹⁄₁₆ × 15⅝ in. (49.7 × 39.7 cm.). Gift of Herbert R. Molner. 76.81.8.

Manuel Alvarez Bravo, Mexico. From *Living Photographers* series. n.d. Gelatin silver print. 13¹³⁄₁₆ × 9¹⁄₁₆ in. (35.0 × 23.0 cm.). Gift of Herbert R. Molner. 76.81.9.

Man Ray, Paris. From *Living Photographers* series. n.d. Gelatin silver print. 13⅜ × 8¹³⁄₁₆ in. (34.1 × 22.4 cm.). Gift of Herbert R. Molner. 76.81.10.

Man Ray, Paris. From *Living Photographers* series. n.d. Gelatin silver print. 13¾ × 9¹⁄₁₆ in. (35.0 × 23.1 cm.). Gift of Herbert R. Molner. 76.81.11.

Paul Strand, France. From *Living Photographers* series. 1968. Gelatin silver print. 9¼ × 13¾ in. (23.5 × 34.9 cm.). Gift of Herbert R. Molner. 76.81.12.

Paul Strand, Yvelines. From *Living Photographers* series. 1969. Gelatin silver print. 19⅝ × 13³⁄₁₆ in. (50.0 × 33.5 cm.). Gift of Herbert R. Molner. 76.81.13.

Bill Brandt, London. From *Living Photographers* series. 1969. Gelatin silver print. 8⅞ × 13¾ in. (22.6 × 34.9 cm.). Gift of Herbert R. Molner. 76.81.14.

Minor White, Boston. From *Living Photographers* series. 1970. Gelatin silver print. 13⅞ × 8⅞ in. (35.3 × 22.6 cm.). Gift of Herbert R. Molner. 76.81.15.

Paul Strand, France. From *Living Photographers* series. 1968. Gelatin silver print. 9³⁄₁₆ × 13¾ in. (23.4 × 34.9 cm.). Gift of Herbert R. Molner. 76.81.16.

Minor White, Boston. From *Living Photographers* series. 1970. Gelatin silver print. 13⁷⁄₁₆ × 9 in. (34.2 × 22.8 cm.). Gift of Herbert R. Molner. 76.81.17.

Brassäi, Paris. From *Living Photographers* series. 1968. Gelatin silver print. 13⁷⁄₁₆ × 19⅝ in. (34.2 × 49.9 cm.). Gift of Herbert R. Molner. 76.81.18.

Harry Callahan, Providence. From *Living Photographers* series. 1969. Gelatin silver print. 8¹³⁄₁₆ × 13⁷⁄₁₆ in. (22.4 × 34.2 cm.). Gift of Herbert R. Molner. 76.81.19.

Imogen Cunningham, San Francisco. From *Living Photographers* series. 1969. Gelatin silver print. 13¾ × 9³⁄₁₆ in. (34.9 × 23.4 cm.). Gift of Herbert R. Molner. 76.81.20.

Bill Brandt, London. From *Living Photographers* series. 1969. Gelatin silver print. 19⅝ × 13⅜ in. (49.9 × 34.0 cm.). Gift of Herbert R. Molner. 76.81.21.

Paul and Hazel Strand, Yvelines. From *Living Photographers* series. 1968. Gelatin silver print. 8¹³⁄₁₆ × 13¾ in. (22.3 × 34.9 cm.). Gift of Herbert R. Molner. 76.81.22.

Edward Steichen, Connecticut. From *Living Photographers* series. 1969. Gelatin silver print. 19⁹⁄₁₆ × 13⅜ in. (49.8 × 34.0 cm.). Gift of Herbert R. Molner. 76.81.23.

Walker Evans, Old Lyme. From *Living Photographers* series. 1969. Gelatin silver print. 13¾ × 9⅛ in. (34.9 × 23.2 cm.). Gift of Herbert R. Molner. 76.81.24.

Edward Steichen, Connecticut. From *Living Photographers* series. 1969. Gelatin silver print. 10¹⁄₁₆ × 13¹³⁄₁₆ in. (25.6 × 35.1 cm.). Gift of Herbert R. Molner. 76.81.25.

Berenice Abbott, Maine. From *Living Photographers* series. 1968. Gelatin silver print. 9 × 13¹¹⁄₁₆ in. (22.9 × 34.9 cm.). Gift of Herbert R. Molner. 76.81.26.

Brassäi, Paris. From *Living Photographers* series. 1969. Gelatin silver print. 19⅝ × 13¼ in. (49.9 × 33.6 cm.). Gift of Herbert R. Molner. 76.81.27.

Walker Evans, Old Lyme. From *Living Photographers* series. 1969. Gelatin silver print. 6¹⁄₁₆ × 19½ in. (15.4 × 49.6 cm.). Gift of Herbert R. Molner. 76.81.28.

W. Eugene Smith, New York. From *Living Photographers* series. n.d. Gelatin silver print. 9³⁄₁₆ × 13¹¹⁄₁₆ in. (23.3 × 34.9 cm.). Gift of Herbert R. Molner. 76.81.29.

Brassäi, New York. From *Living Photographers* series. 1968. Gelatin silver print. 13¹³⁄₁₆ × 10¾ in. (35.2 × 27.3 cm.). Gift of Herbert R. Molner. 76.81.30.

Bill Brandt, London. From *Living Photographers* series. 1969. Gelatin silver print. 19¹¹⁄₁₆ × 13⅝ in. (50.0 × 33.8 cm.). Gift of Herbert R. Molner. 76.81.31.

André Kertész, New York. From *Living Photographers* series. 1968. Gelatin silver print. 13¹¹⁄₁₆ × 9¹⁄₁₆ in. (34.9 × 23.0 cm.). Gift of Herbert R. Molner. 76.81.32.

W. Eugene Smith, New York. From *Living Photographers* series. 1971. Gelatin silver print. 9¹⁄₁₆ × 13¹³⁄₁₆ in. (23.1 × 35.1 cm.). Gift of Herbert R. Molner. 76.81.33.

Edward Steichen, Connecticut, Overlooking Shad-Blow Tree. From *Living Photographers* series. 1969. Gelatin silver print. 9 × 13¾ in. (22.9 × 35.0 cm.). Gift of Herbert R. Molner. 76.81.34.

Walker Evans, Old Lyme. From *Living Photographers* series. 1968. Gelatin silver print. 13¾ × 9¼ in. (34.9 × 23.6 cm.). Gift of Herbert R. Molner. 76.81.35.

Paul Strand, France. From *Living Photographers* series. 1968. Gelatin silver print. 13¾ × 9⅜ in. (34.9 × 23.9 cm.). Gift of Herbert R. Molner. 76.81.36.

Walker Evans, Between Chicago and New York. From *Living Photographers* series. 1970. Gelatin silver print. 9 × 13¾ in. (22.9 × 34.9 cm.). Gift of Herbert R. Molner. 76.81.37.

Harry Callahan, Providence. From *Living Photographers* series. 1969. Gelatin silver print. 8¾ × 13½ in. (22.3 × 34.3 cm.). Gift of Herbert R. Molner. 76.81.38.

Robert Doisneau, Paris. From *Living Photographers* series. 1969. Gelatin silver print. 11¾ × 10⅝ in. (30.0 × 27.0 cm.). Gift of Herbert R. Molner. 76.81.39.

Robert Doisneau, Paris. From *Living Photographers* series. 1969. Gelatin silver print. 13¾ × 9¹⁄₁₆ in. (34.9 × 23.0 cm.). Gift of Herbert R. Molner. 76.81.40.

Man Ray, Paris. From *Living Photographers* series. n.d. Gelatin silver print. 13¹¹⁄₁₆ × 9¹⁄₁₆ in. (34.9 × 23.0 cm.). Gift of Herbert R. Molner. 76.81.41.

Bill Brandt, London. From *Living Photographers* series. 1969. Gelatin silver print. 8⅞ × 13¹¹⁄₁₆ in. (22.5 × 34.9 cm.). Gift of Herbert R. Molner. 76.81.42.

Harry Callahan, Providence. From *Living Photographers* series. Gelatin silver print. 9 × 13¾ in. (22.9 × 35.0 cm.). Gift of Herbert R. Molner. 76.81.43.

Walker Evans, Old Lyme. From *Living Photographers* series. 1969. Gelatin silver print. 13¹¹⁄₁₆ × 9³⁄₁₆ in. (34.9 × 23.4 cm.). Gift of Herbert R. Molner. 76.81.44.

W. Eugene Smith, New York. From *Living Photographers* series. n.d. Gelatin silver print. 13¾ × 9⅜ in. (34.9 × 23.4 cm.). Gift of Herbert R. Molner. 76.81.45.

Arthur Rothstein, New York. From *Living Photographers* series. n.d. Gelatin silver print. 13¾ × 9 in. (35.0 × 22.9 cm.). Gift of Herbert R. Molner. 76.81.46.

Man Ray, Paris. From *Living Photographers* series. n.d. Gelatin silver print. 13¾ × 10¹¹⁄₁₆ in. (35.0 × 27.2 cm.). Gift of Herbert R. Molner. 76.81.47.

Berenice Abbott, Maine. From *Living Photographers* series. 1970. Gelatin silver print. 13¾ × 8¹¹⁄₁₆ in. (35.0 × 22.2 cm.). Gift of Herbert R. Molner. 76.81.48.

Ansel Adams, Big Sur. From *Living Photographers* series. 1969. Gelatin silver print. 19⅝ × 13³⁄₁₆ in. (50.0 × 33.4 cm.). Gift of Herbert R. Molner. 76.81.49.

Robert Doisneau, Paris. From *Living Photographers* series. 1969. Gelatin silver print. 19⅝ × 13⁷⁄₁₆ in. (49.9 × 34.2 cm.). Gift of Herbert R. Molner. 76.81.50.

CRANE, BARBARA
American, 1928-

[gridwork of blobs]. From *Underware* portfolio. 1976. Gelatin silver print. 10¼ × 9¼ in. (26.1 × 23.6 cm.). National Endowment for the Arts purchase grant and miscellaneous matching funds. 76.64.4.

CRAWFORD, GREY
American, 1951-

[latticework with parking sign]. From *L. A. Issue* portfolio. Gelatin silver print. 12⅜ × 18¼ in. (31.4 × 46.4 cm.). Gift of funds from the Photography Council of The Minneapolis Institute of Arts. 80.25.4.

CROUCH, STEVE
American, 1915-1983

Hills on Lonoak Road, Southern Monterey County. n.d. Gelatin silver print. 7¹³⁄₁₆ × 9¹³⁄₁₆ in. (19.8 × 25.0 cm.). Gift of Arnold M. Gilbert. 74.61.6.

Fall, Shuteye Creek, Sierra National Forest, California. n.d. Gelatin silver print. 9⁷⁄₁₆ × 7⁹⁄₁₆ in. (24.1 × 19.3 cm.). Gift of Arnold M. Gilbert. 74.61.7.

Earth Forms, Death Valley. n.d. Gelatin silver print. 6¹³⁄₁₆ × 8⁹⁄₁₆ in. (17.3 × 21.8 cm.). Gift of Arnold M. Gilbert. 74.61.8.

CUMMING, ROBERT
American, 1943-

The Burtons, Academy Awards. From *New California Views* portfolio. 1978. Dye bleach color print (Cibachrome). 6⅜ × 9⁷⁄₁₆ in. (16.2 × 24.1 cm.). Gift of funds from the Photography Council of The Minneapolis Institute of Arts. 80.24.3.

CUNNINGHAM, IMOGEN
American, 1883-1976

Ruth Asawa and Her Family. 1957. Gelatin silver print. 10⅜ × 10¼ in. (26.3 × 26.1 cm.). Gift of Abby Grey. 75.16.

Alfred Stieglitz at An American Place. 1934. Gelatin silver print. 9⁹⁄₁₆ × 7½ in. (24.3 × 19.0 cm.). Ethel Morrison Van Derlip Fund. 76.51.

CURRAN, DARRYL
American, 1935-

[snapshots with contact strip]. From *Silver See* portfolio. 1977. Cyanotype. 14¹⁵⁄₁₆ × 19¹⁵⁄₁₆ in. (37.9 × 50.7 cm.). National Endowment for the Arts purchase grant and miscellaneous matching funds. 77.39.3.

CURTIS, EDWARD S.
American, 1868-1952

Havasupai Cliff Dwelling. 1903. Photogravure. 7¼ × 5⁵⁄₁₆ in. (18.4 × 13.6 cm.). Ethel Morrison Van Derlip Fund. 74.41.1.

Nayenenzgani—Navaho. 1904. Photogravure. 7⁵⁄₁₆ × 5⅜ in. (18.6 × 13.6 cm.). Ethel Morrison Van Derlip Fund. 74.41.2.

Tobazischini—Navaho. 1904. Photogravure. 7⁵⁄₁₆ × 5⅜ in. (18.6 × 13.7 cm.). Ethel Morrison Van Derlip Fund. 74.41.3.

Ga(n)askidi—Navaho. 1904. Photogravure. 7⁵⁄₁₆ × 5⅜ in. (18.5 × 13.7 cm.). Ethel Morrison Van Derlip Fund. 74.41.4.

Tonenili, Tobadzischini, Nayenezgani—Navaho. 1904. Photogravure. 5⁵⁄₁₆ × 6¹⁵⁄₁₆ in. (13.0 × 17.6 cm.). Ethel Morrison Van Derlip Fund. 74.41.5.

Pima Burial Grounds. 1906. Photogravure. 5⁷⁄₁₆ × 7¼ in. (13.8 × 18.4 cm.). Ethel Morrison Van Derlip Fund. 74.41.6.

Hasen Harvest—Qahatika. 1907. Photogravure. 5⁵⁄₁₆ × 7¼ in. (13.5 × 18.3 cm.). Ethel Morrison Van Derlip Fund. 74.41.7.

Ceremonial Ki—Pima. 1907. Photogravure. 5⅜ × 7¼ in. (13.7 × 18.4 cm.). Ethel Morrison Van Derlip Fund. 74.41.8.

Mohave Still Life. 1907. Photogravure. 5⁵⁄₁₆ × 7¼ in. (13.6 x 18.5 cm.). Ethel Morrison Van Derlip Fund. 74.41.10.

A Pima Home. 1907. Photogravure. 5⁵⁄₁₆ × 7¼ in. (13.9 × 18.5 cm.). Ethel Morrison Van Derlip Fund. 74.41.11.

A Yuma. 1907. Photogravure. 7¼ × 5⅜ in. (18.5 × 13.6 cm.). Ethel Morrison Van Derlip Fund. 74.41.12.

White Man Runs Him. 1908. Photogravure. 7¼ × 4¹¹⁄₁₆ in. (18.5 × 11.9 cm.). Ethel Morrison Van Derlip Fund. 74.41.14.

Fog in the Morning—Apsaroke. 1908. Photogravure. 7¼ × 5⁵⁄₁₆ in. (18.4 × 13.4 cm.). Ethel Morrison Van Derlip Fund. 74.41.15.

Klickitat Basketry. 1909. Photogravure. 5⁵⁄₁₆ × 7⁵⁄₁₆ in. (13.5 × 18.5 cm.). Ethel Morrison Van Derlip Fund. 74.41.16.

Many Bears—Flathead. 1910. Photogravure. 7³⁄₁₆ × 5 in. (18.4 × 12.7 cm.). Ethel Morrison Van Derlip Fund. 74.41.17.

Flathead Female Type. 1910. Photogravure. 7³⁄₁₆ × 5 in. (18.3 × 12.7 cm.). Ethel Morrison Van Derlip Fund. 74.41.18.

A Quinault Type. 1910. Photogravure. 7⅜ × 3¹³⁄₁₆ in. (18.7 × 9.7 cm.). Ethel Morrison Van Derlip Fund. 74.41.20.

Quinault Handiwork. 1912. Photogravure. 5 × 7³⁄₁₆ in. (12.7 × 18.2 cm.). Ethel Morrison Van Derlip Fund. 74.41.21.

Masked Dancer—Cowichan. 1912. Photogravure. 7⁵⁄₁₆ × 3⅞ in. (18.6 × 9.9 cm.). Ethel Morrison Van Derlip Fund. 74.41.22.

Lifting the Net—Quinault. 1912. Photogravure. 5¹⁄₁₆ × 7⅛ in. (24.1 × 18.1 cm.). Ethel Morrison Van Derlip Fund. 74.41.23.

Goathair Blanket—Cowichan. 1912. Photogravure. 7³⁄₁₆ × 4¹⁵⁄₁₆ in. (18.2 × 12.6 cm.). Ethel Morrison Van Derlip Fund. 74.41.24.

Yalqablu—Skokomish. 1912. Photogravure. 7¾ × 5⁹⁄₁₆ in. (19.7 × 14.2 cm.). Ethel Morrison Van Derlip Fund. 74.41.25.

Chimakum Woman. 1912. Photogravure. 7¹³⁄₁₆ × 5¹¹⁄₁₆ in. (19.9 × 14.5 cm.). Ethel Morrison Van Derlip Fund. 74.41.26.

Grizzly-Bear Dancer—Qagyuhl. 1914. Photogravure. 7½ × 5⁷⁄₁₆ in. (19.1 × 13.8 cm.). Gift of Christopher Cardozo. 75.15.1.

Atlumhl—Koskimo. 1914. Photogravure. 7½ × 5⁷⁄₁₆ in. (19.0 × 13.8 cm.). Gift of Christopher Cardozo. 75.15.2.

Crests of a Nimkish Family. 1914. Photogravure. 7⁷⁄₁₆ × 5¹¹⁄₁₆ in. (19.0 × 14.4 cm.). Gift of Christopher Cardozo. 75.15.3.

Tawihyilahl—Qagyuhl. 1914. Photogravure. 7½ × 5½ in. (19.1 × 14.0 cm.). Gift of Christopher Cardozo. 75.15.4.

A Mamelekala Chief's Mortuary House. 1914. Photogravure. 5½ × 7½ in. (13.9 × 19.1 cm.). Gift of Christopher Cardozo. 75.15.5.

A Housefront—Awaitlala. 1914. Photogravure. 5¾ × 7½ in. (14.5 × 19.1 cm.). Gift of Christopher Cardozo. 75.15.6.

Preparing Salmon—Wishham. 1909. Photogravure. 5⁵⁄₁₆ × 7⁵⁄₁₆ in. (13.5 × 18.6 cm.). Gift of Christopher Cardozo. 75.15.7.

Jerking Meat—Flathead. 1910. Photogravure. 4¹⁵⁄₁₆ × 7³⁄₁₆ in. (12.6 × 18.2 cm.). Gift of Christopher Cardozo. 75.15.8.

Dressing Skins—Kutenai. 1910. Photogravure. 5⁵⁄₁₆ × 7⁵⁄₁₆ in. (13.6 × 18.6 cm.). Gift of Christopher Cardozo. 75.15.9.

Drying Meat—Flathead. 1910. Photogravure. 5⁵⁄₁₆ × 7⁵⁄₁₆ in. (13.6 × 18.5 cm.). Gift of Christopher Cardozo. 75.15.10.

Papago Primitive Home. 1907. Photogravure. 5⅜ × 7³⁄₁₆ in. (13.7 × 18.2 cm.). Gift of Stanley B. and Lucile A. Slocum. 78.89.1.

Kwahwumhl—Koskimo. 1914. Photogravure. 7½ × 5⁹⁄₁₆ in. (19.1 × 14.2 cm.). Gift of Stanley B. and Lucile A. Slocum. 78.89.2.

Hamatsa Emerging from the Woods—Koskimo. 1914. Photogravure. 8 × 5¹⁵⁄₁₆ in. (20.4 × 15.2 cm.). Gift of Stanley B. and Lucile A. Slocum. 78.89.3.

Das Lan—Apache. 1907. Photogravure. 7⁵⁄₁₆ × 5⁵⁄₁₆ in. (18.6 × 13.6 cm.). Gift of Stanley B. and Lucile A. Slocum. 78.89.4.

Sand Mosaic—Apache. 1907. Photogravure. 4¹⁵⁄₁₆ × 6¼ in. (12.5 × 15.9 cm.). Gift of Stanley B. and Lucile A. Slocum. 78.89.5.

Bone Carving—Cascade. 1910. Photogravure. 7¼ × 5⅜ in. (18.4 × 13.6 cm.). Gift of Stanley B. and Lucile A. Slocum. 78.89.6.

A Yuma House. 1907. Photogravure. 5⁷⁄₁₆ × 7¼ in. (13.8 × 18.5 cm.). Gift of Stanley B. and Lucile A. Slocum. 78.89.7.

Nalin Lage—Apache. 1906. Photogravure. 7¼ × 5⅜ in. (18.5 × 13.7 cm.). Gift of Stanley B. and Lucile A. Slocum. 78.89.8.

Blue Horse—Ogalala. 1907. Photogravure. 7¼ × 5¹⁴⁄₁₆ in. (18.4 × 13.4 cm.). Kate and Hall J. Peterson Fund. 82.98.

D'ALESSANDRO, ROBERT
American, 1942-

New Mexico. From *The New Mexico Portfolio.* 1975. Gelatin silver print. 8¾ × 11⅛ in. (22.3 × 28.4 cm.). National Endowment for the Arts purchase grant and miscellaneous matching funds. 76.61.3.

DAVIDSON, BRUCE
American, 1933-

Welsh Miners. Published by Douglas Kenyon. 1982. Portfolio of 10 gelatin silver prints. Gift of Mr. and Mrs. Paul N. Rifkin. 82.124.13-22.
[man and child]. 1965. 9¹⁵⁄₁₆ × 7¹⁵⁄₁₆ in. (25.3 × 20.2 cm.).

[miners]. 1965. 12 × 14⅝ in. (30.6 × 37.2 cm.).
[child with stroller]. 1965. 7⅞ × 11¹³⁄₁₆ in. (20.0 × 30.0 cm.).
[bride and groom]. 1965. 7¹⁵⁄₁₆ × 11¹³⁄₁₆ in. (20.1 × 30.1 cm.).
[street sweeper]. 1965. 8 × 11¹³⁄₁₆ in. (20.3 × 30.0 cm.).
[children and tree]. 1965. 9¹¹⁄₁₆ × 14⅝ in. (24.6 × 37.1 cm.).
[miners and donkey]. 1965. 11⅞ × 7¹⁵⁄₁₆ in. (30.2 × 20.2 cm.).
[miners]. 1965. 7⅞ × 11¹³⁄₁₆ in. (20.0 × 30.1 cm.).
[child in graveyard]. 1965. 7⅞ × 11¹³⁄₁₆ in. (20.1 × 30.0 cm.).
[horse]. 1965. 9¹³⁄₁₆ × 14⁹⁄₁₆ in. (24.9 × 37.0 cm.).

DAVIES, BEVAN
American, 1941-

Baltimore, Maryland. 1978. Gelatin silver print. 15¹⁄₁₆ × 18⅜ in. (38.3 × 46.7 cm.). Gift of the American Telephone and Telegraph Co. 81.120.16.

Baltimore, Maryland. 1978. Gelatin silver print. 15 × 18⁷⁄₁₆ in. (38.1 × 46.9 cm.). Gift of the American Telephone and Telegraph Co. 81.120.17.

Baltimore, Maryland. 1978. Gelatin silver print. 15 × 18⁷⁄₁₆ in. (38.2 × 46.8 cm.). Gift of the American Telephone and Telegraph Co. 81.120.18.

DAVIS, LYNN
American, 1944-

The Metropolitan Museum. 1976. Gelatin silver print. 15⅛ × 15¼ in. (38.4 × 38.7 cm.). Anonymous gift of funds. 78.57.

DAVISON, GEORGE
See *Camera Work*

DEAL, JOE
American, 1947-

View, Magic Mountain, Valencia, California. From *New California Views* portfolio. 1977. Gelatin silver print. 11⅛ × 11⁵⁄₁₆ in. (28.3 × 28.8 cm.). Gift of funds from the Photography Council of The Minneapolis Institute of Arts. 80.24.4.

The Fault Zone. Published by the photographer. 1981. Portfolio of 19 gelatin silver prints. Gift of funds from the Photography Council of The Minneapolis Institute of Arts. 81.72.1-19.
Indio, California. 1978. 11³⁄₁₆ × 11¼ in. (28.5 × 28.3 cm.).
San Bernardino, California (I). 1978. 11³⁄₁₆ × 11⅛ in. (28.5 × 28.3 cm.).
Fontana, California. 1978. 11¼ × 11⅛ in. (28.5 × 28.3 cm.).
Newport Beach, California. 1979. 11³⁄₁₆ × 11⅛ in. (28.5 × 28.3 cm.).
Near Beaumont, California. 1979. 11³⁄₁₆ × 11³⁄₁₆ in. (28.5 × 28.4 cm.).
Brea, California. 1979. 11³⁄₁₆ × 11⅛ in. (28.5 × 28.4 cm.).
Baldwin Hills, California. 1979. 11³⁄₁₆ × 11⅛ in. (28.5 × 28.4 cm.).
Glendale, California. 1979. 11³⁄₁₆ × 11⅛ in. (28.5 × 28.3 cm.).
Hemet, California. 1979. 11³⁄₁₆ × 11⅛ in. (28.5 × 28.4 cm.).

Soboba Hot Springs, California (I). 1979. 11¼ × 11⅛ in. (28.5 × 28.4 cm.).
Santa Barbara, California. 1978. 11³⁄₁₆ × 11⅛ in. (28.5 × 28.4 cm.).
Inglewood, California. 1979. 11¼ × 11³⁄₁₆ in. (28.6 × 28.4 cm.).
San Bernardino, California (I). 1978. 11³⁄₁₆ × 11⅛ in. (28.4 × 28.3 cm.).
San Fernando, California. 1978. 11³⁄₁₆ × 11⅛ in. (28.5 × 28.3 cm.).
Monrovia, California. 1979. 11³⁄₁₆ × 11³⁄₁₆ in. (28.5 × 28.4 cm.).
Soboba Hot Springs, California (II). 1979. 11³⁄₁₆ × 11³⁄₁₆ in. (28.5 × 28.4 cm.).
Palm Springs, California. 1979. 11³⁄₁₆ × 11⅛ in. (28.4 × 28.3 cm.).
Colton, California. 1978. 11³⁄₁₆ × 11⅛ in. (28.5 × 28.4 cm.).
Chatsworth, California. 1980. 11³⁄₁₆ × 11³⁄₁₆ in. (28.5 × 28.4 cm.).

DeBIASO, THOMAS
American, 1947-

Untitled. From *Light Series.* 1977. Gelatin silver print. 13⅛ × 19⅜ in. (33.4 × 49.2 cm.). Gift of Carl D. and Patricia H. Sheppard. 82.58.1.

Untitled. From *Light Series.* 1977. Gelatin silver print. 13⅛ × 19⅜ in. (33.4 × 49.2 cm.). Gift of Carl D. and Patricia H. Sheppard. 82.58.2.

DeCARAVA, ROY
American, 1919-

Public School Entrance. 1978. Gelatin silver print. 10 × 13 in. (25.4 × 33.1 cm.). Gift of the American Telephone and Telegraph Co. 81.120.19.

Man in a Window. 1978. Gelatin silver print. 13 × 8¾ in. (33.1 × 22.3 cm.). Gift of the American Telephone and Telegraph Co. 81.120.20.

Man Smoking Cigar on Ashcan. 1978. Gelatin silver print. 9¹⁵⁄₁₆ × 13¹⁄₁₆ in. (25.2 × 33.2 cm.). Gift of the American Telephone and Telegraph Co. 81.120.21.

DeLORY, PETER
American, 1948-

Hot Springs Bathers, Hailey, Idaho. 1975. Gelatin silver print, hand colored. 18 × 12 in. (45.7 × 30.5 cm.). National Endowment for the Arts purchase grant and miscellaneous matching funds. 76.22.1.

Garden of the Gods, Colorado. 1973. Gelatin silver print, hand colored. 18 × 12 in. (45.7 × 30.5 cm.). National Endowment for the Arts purchase grant and miscellaneous matching funds. 76.22.2.

Window, Stanley, Idaho. 1975. Gelatin silver print, hand colored. 12 × 17¹⁵⁄₁₆ in. (30.5 × 45.7 cm.). National Endowment for the Arts purchase grant and miscellaneous matching funds. 76.22.3.

The Thinker, San Francisco, California. 1974. Gelatin silver print, hand colored. 10³⁄₁₆ × 16 in. (25.9 × 40.7 cm.). National Endowment for the Arts purchase grant and miscellaneous matching funds. 76.22.4.

Valley View, Ketchum, Idaho. 1974. Gelatin silver print, hand colored. 12¹⁄₁₆ × 17⅞ in. (30.7 × 45.5 cm.). National Endowment for the Arts purchase grant and miscellaneous matching funds. 76.22.5.

Night Trees, Sun Valley, Idaho. 1975. Gelatin silver print, hand colored. 10½ × 16 in. (26.7 × 40.6 cm.). National Endowment for the Arts purchase grant and miscellaneous matching funds. 76.22.6.

Model A, Tuscorara, Nevada. 1976. Gelatin silver print. 12 × 17¹⁵⁄₁₆ in. (30.4 × 45.6 cm.). Gift of Stanley B. and Lucile A. Slocum. 78.88.1.

Old Car Meeting, Boulder, Colorado. 1973. Gelatin silver print. 12 × 17¹⁵⁄₁₆ in. (30.4 × 45.6 cm.). Gift of Stanley B. and Lucile A. Slocum. 78.88.2.

Wheel and Fender (1947 Chrysler), Aspen, Colorado. 1971. Gelatin silver print. 12 × 17¹⁵⁄₁₆ in. (30.4 × 45.6 cm.). Gift of Stanley B. and Lucile A. Slocum. 78.88.3.

Museum Piece, San Francisco, California. 1972. Gelatin silver print. 10¹⁵⁄₁₆ × 15¹⁵⁄₁₆ in. (27.9 × 40.6 cm.). Gift of Stanley B. and Lucile A. Slocum. 78.88.4.

Store Window, California. 1972. Gelatin silver print. 10⅞ × 16 in. (27.6 × 40.7 cm.). Gift of Stanley B. and Lucile A. Slocum. 78.88.5.

Stucco Wall, Foremetera, Baltic Island. 1976. Gelatin silver print. 18 × 12 in. (45.7 × 30.5 cm.). Gift of Stanley B. and Lucile A. Slocum. 78.88.6.

Paris Reflection, Store Front, France. 1976. Gelatin silver print. 17⅞ × 12 in. (45.6 × 30.5 cm.). Gift of Stanley B. and Lucile A. Slocum. 78.88.7.

View from a Window, Latin Quarter, Paris, France. 1976. Gelatin silver print. 18 × 12 in. (45.7 × 30.5 cm.). Gift of Stanley B. and Lucile A. Slocum. 78.88.8.

Surf Drive, Orleans, Massachusetts. 1970. Gelatin silver print. 12 × 18 in. (30.5 × 45.7 cm.). Gift of Lee Kitzenberg. 81.22.

Andy Floating. 1976. Gelatin silver print. 17¹⁵⁄₁₆ × 12 in. (45.5 × 30.5 cm.). Gift of Frank Kolodny. 82.126.1.

Andy Ostheimer Reading, Ibiza, Spain. 1976. Gelatin silver print. 12⅛ × 17⅞ in. (30.8 × 45.5 cm.). Gift of Frank Kolodny. 82.126.2.

Formantera Bicycle Ride, Spain. 1976. Gelatin silver print. 11¹⁵⁄₁₆ × 17⅞ in. (30.4 × 45.5 cm.). Gift of Frank Kolodny. 82.126.3.

Bog Light. 1976. Gelatin silver print. 11¹⁵⁄₁₆ × 17⅞ in. (30.3 × 45.5 cm.). Gift of Frank Kolodny. 82.126.4.

Hand in Water, Idaho. 1975. Gelatin silver print, hand colored. 11¹⁵⁄₁₆ × 17⅞ in. (30.3 × 45.4 cm.). Gift of Frank Kolodny. 82.126.5.

The Pinch, English Channel. 1976. Gelatin silver print, hand colored. 11¹⁵⁄₁₆ × 17⅞ in. (30.3 × 45.5 cm.). Gift of Frank Kolodny. 82.126.6.

Mud Volcano, Yellowstone. 1977. Gelatin silver print, hand colored. 11¹⁵⁄₁₆ × 17¹⁵⁄₁₆ in. (30.3 × 45.5 cm.). Gift of Frank Kolodny. 82.126.7.

Hands and Legs with Fly. 1977. Gelatin silver print, hand colored. 11¹⁵⁄₁₆ × 17⅞ in. (30.3 × 45.4 cm.). Gift of Frank Kolodny. 82.126.8.

Kelp in Dunes, Fort Bragg, California. 1972. Gelatin silver print. 8¹⁵⁄₁₆ × 8¹⁵⁄₁₆ in. (22.7 × 22.7 cm.), diamond shaped. Gift of Frank Kolodny. 82.126.9.

Burrow in the Dunes, Fort Bragg, California. 1972. Gelatin silver print. 8¹⁵/₁₆ × 8¹⁵/₁₆ in. (22.7 × 22.7 cm.), diamond shaped. Gift of Frank Kolodny. 82.126.10.

DEMACHY, ROBERT
See *Camera Work*

DE MEYER, BARON ADOLF
See *Camera Work*

DEVENS, MARY
See *Camera Work*

DICKEY, MICHAEL
American, 1944-

Near Mountain Grove. 1977. Gelatin silver print. 4¹³/₁₆ × 7⅛ in. (12.2 × 18.2 cm.). Kate and Hall J. Peterson Fund. 79.9.1.

Kingston, Ontario. 1974. Gelatin silver print. 4¹³/₁₆ × 7³/₁₆ in. (12.3 × 18.3 cm.). Kate and Hall J. Peterson Fund. 79.9.2.

Detroit. 1972. Gelatin silver print. 4¹¹/₁₆ × 7 in. (11.9 × 17.8 cm.). Kate and Hall J. Peterson Fund. 80.14.1.

Palm Tree, Interior. 1978. Gelatin silver print. 4⅝ × 7 in. (11.8 × 17.8 cm.). Kate and Hall J. Peterson Fund. 80.14.2.

DINE, JIM
See Lee Friedlander

DIVOLA, JOHN
American, 1949-

[ocean view through burned-out room]. From *New California Views* portfolio. 1978. Color coupler print (Ektacolor). 9¹³/₁₆ × 12 in. (24.9 × 30.5 cm.). Gift of funds from the Photography Council of The Minneapolis Institute of Arts. 80.24.5.

DONOHUE, BONNIE
American, 1946-

Teri's Tatoo. From *Underware* portfolio. 1976. Gelatin silver print. 15⅜ × 15⅜ in. (39.1 × 39.0 cm.). National Endowment for the Arts purchase grant and miscellaneous matching funds. 76.64.5.

DOROSHOW, HELEN
American, 1928-

Friends, Light, and Plant. From *The New Mexico Portfolio.* 1974. Gelatin silver print. 10 × 10 in. (25.4 × 25.4 cm.). National Endowment for the Arts purchase grant and miscellaneous matching funds. 76.61.4.

DOVYDENAS, JONAS
American (b. Lithuania), 1939-

Faces. Published by the photographer, Chicago. 1975. Portfolio of 15 gelatin silver prints. National Endowment for the Arts purchase grant and miscellaneous matching funds. 76.27.1-15.

Softball Winners, Chicago. 1969. 6⁹/₁₆ × 6½ in. (16.6 × 16.4 cm.).

Luann Jackson, Goose Creek, Kentucky. 1971. 6⁷/₁₆ × 6½ in. (16.4 × 16.5 cm.).

Ranchers, Smokey Valley, Nevada. 1974. 6⁷/₁₆ × 6⅜ in. (16.3 × 16.2 cm.).

St. Pietro Lutheran Church Elders, Grygla, Minnesota. 1973. 6⅜ × 6⁵/₁₆ in. (16.3 × 16.1 cm.).

Old Timers, Elko, Nevada. 1974. 6½ × 6½ in. (16.4 × 16.5 cm.).

A Young Family, Grass Valley, Nevada. 1973. 6½ × 6½ in. (16.6 × 16.4 cm.).

Church Holiday Musicians, Chicago. 1968. 6½ × 6⁷/₁₆ in. (16.5 × 16.4 cm.).

Sisters, Miami Beach. 1972. 5¼ × 7¾ in. (13.3 × 19.7 cm.).

Amvets Parade Bugler, Chicago. 1975. 6⅜ × 6⅜ in. (16.2 × 16.3 cm.).

Politicians, Chicago. 1972. 5⁵/₁₆ × 7¹³/₁₆ in. (13.5 × 19.8 cm.).

Bystanders, Chicago. 1970. 5³/₁₆ × 7¾ in. (13.2 × 19.6 cm.).

Adolescent Boy, Manchester, Kentucky. 1971. 5³/₁₆ × 7¹¹/₁₆ in. (13.2 × 19.6 cm.).

Deer Hunters, Red Lake, Minnesota. 1973. 5¼ × 7¹¹/₁₆ in. (13.3 × 19.6 cm.).

Overnight Campers, Santa Cruz, California. 1973. 6⅜ × 6⅜ in. (16.2 × 16.2 cm.).

Transients, Elko, Nevada. 1974. 6⅜ × 6⅜ in. (16.3 × 16.2 cm.).

DOWNS, ALLEN
American, 1915-1983

Duluth. 1952. Gelatin silver print. 5⁵/₁₆ × 7⅞ in. (13.5 × 20.0 cm.). Kate and Hall J. Peterson Fund. 82.91.1.

Buffalo Harbor. 1946. Gelatin silver print. 6⅞ × 9⁹/₁₆ in. (17.4 × 24.4 cm.). Kate and Hall J. Peterson Fund. 82.91.2.

Buffalo Harbor. 1948. Gelatin silver print. 5 × 9⅛ in. (12.8 × 23.3 cm.). Kate and Hall J. Peterson Fund. 82.91.3.

State Fair. 1949. Gelatin silver print. 8¼ × 12¹³/₁₆ in. (21.0 × 32.6 cm.). Kate and Hall J. Peterson Fund. 82.91.4.

DUGMORE, A. RADCLYFFE
See *Camera Work*

DYER, WILLIAM B.
See *Camera Work*

EAKINS, THOMAS
American, 1844-1916

[three female nudes, Pennsylvania Academy of Arts]. c. 1880. Albumen print. 4³/₁₆ × 3¼ in. (10.6 × 8.3 cm.). Mr. and Mrs. Harrison R. Johnston, Jr. Fund. 77.67.

EELS, LARRY
American (?), 20th century

[face]. From *What Ever Happened to Sexuality* portfolio. c. 1977. Gelatin silver print. 6⁵/₁₆ × 9¼ in. (16.1 × 23.5 cm.). Gift of the artist. 82.70.5.

EGGLESTON, WILLIAM
American, 1939-

Memphis. c. 1970. Dye transfer print. 12¹/₁₆ × 17³/₁₆ in. (30.6 × 43.7 cm.). Kate and Hall J. Peterson Fund. 79.34.1.

Two Girls, Memphis, Tennessee. 1973. Color coupler print (Ektacolor). 13⅛ × 19¹/₁₆ in. (33.3 × 48.5 cm.). Kate and Hall J. Peterson Fund. 79.34.2.

Shelly Schuyler, Sumner, Mississippi. c. 1973. Color coupler print (Ektacolor). 16¹/₁₆ × 11¼ in. (40.8 × 28.6 cm.). Kate and Hall J. Peterson Fund. 79.34.3.

[lily pads]. 1978. Color coupler print. 10³/₁₆ × 15 in. (25.9 × 38.1 cm.). Gift of the American Telephone and Telegraph Co. 81.120.22.

[fern]. 1978. Color coupler print. 10¹/₁₆ × 15¹/₁₆ in. (25.6 × 38.2 cm.). Gift of the American Telephone and Telegraph Co. 81.120.23.

[tree tops]. 1978. Color coupler print. 10³/₁₆ × 15 in. (25.9 × 38.1 cm.). Gift of the American Telephone and Telegraph Co. 81.120.24.

ENDSLEY, FRED
American, 1949-

Martinique. From *Underware* portfolio. 1971-76. Gelatin silver print with collaged paper. 15¹⁵/₁₆ × 19¾ in. (40.5 × 50.2 cm.). National Endowment for the Arts purchase grant and miscellaneous matching funds. 76.64.6.

ERWITT, ELLIOTT
American (b. France), 1928-

Elliott Erwitt. Published by Acorn Editions, Ltd., Geneva, Switzerland. 1977. Portfolio of 15 gelatin silver prints. Gift of Richard L. Zorn. 78.87.1-10 and 81.45.1-5.

Yale, New Yaven. 1955. 6⁵/₁₆ × 9⁷/₁₆ in. (16.0 × 24.0 cm.).

Inspecting Guards, Teheran. 1967. 9½ × 6⅜ in. (24.2 × 16.2 cm.).

Monkey Paw, St. Tropez. 1968. 6⁵/₁₆ × 9⁷/₁₆ in. (16.1 × 24.0 cm.).

Confessional, Czestochowa, Poland. 1964. 6⅜ × 9⁷/₁₆ in. (16.1 × 24.1 cm.).

Piano Lesson, Odessa. 1957. 6⅜ × 9½ in. (16.2 × 24.1 cm.).

Southern Charm, Alabama. 1955. 6¼ × 9⁷/₁₆ in. (15.8 × 24.0 cm.).

Diana, New York. 1949. 9½ × 6⅜ in. (24.2 × 16.2 cm.).

Lost Persons, Pasadena. 1963. 6⅜ × 9⁷/₁₆ in. (16.2 × 24.1 cm.).

Soldier, New Jersey. 1951. 6⅜ × 9⁹/₁₆ in. (16.2 × 24.3 cm.).

Car and Poles, Rome. 1965. 9½ × 6⅜ in. (24.1 × 16.2 cm.).

Parade Group, Paris. 1951. 9½ × 6⅜ in. (24.2 × 16.2 cm.).

Geese, Hungary. 1964. 6⁵/₁₆ × 9⁷/₁₆ in. (16.1 × 24.0 cm.).

Waves, Brighton. 1956. 6⁵/₁₆ × 9⁷/₁₆ in. (16.1 × 24.0 cm.).

Beach Group, Sylt, West Germany. 1968. 6⅜ × 9⁷/₁₆ in. (16.1 × 24.0 cm.).

Man and Dog, South Carolina. 1962. 9⅜ × 6⅜ in. (23.8 × 16.2 cm.).

[boardwalk]. 1978. Gelatin silver print. 7¹³/₁₆ × 11¹¹/₁₆ in. (19.9 × 29.7 cm.). Gift of the American Telephone and Telegraph Co. 81.120.25.

[man and beach umbrella]. 1978. Gelatin silver print. 12⅛ × 8⅛ in. (30.9 × 20.7 cm.). Gift of the American Telephone and Telegraph Co. 81.120.26.

[figures on beach with kite]. 1978. Gelatin silver print. 7⅞ × 11¹¹⁄₁₆ in. (20.0 × 29.7 cm.). Gift of the American Telephone and Telegraph Co. 81.120.27.

Mt. Fuji and Sign, Mt. Fuji, Japan. n.d. Gelatin silver print. 11⅞ × 8 in. (30.2 × 20.3 cm.). Gift of Martin Sklar. 81.122.2.1.

Coke Machine and Missiles, Alabama. n.d. Gelatin silver print. 12⅛ × 8¼ in. (30.8 × 21.0 cm.). Gift of Martin Sklar. 81.122.2.2.

People and Statues on Beach, San Juan, Puerto Rico. n.d. Gelatin silver print. 11¾ × 7⅞ in. (29.9 × 20.1 cm.). Gift of Martin Sklar. 81.122.2.3.

Cats and Dogs, Alabama. n.d. Gelatin silver print. 12¹⁄₁₆ × 8⅛ in. (30.7 × 20.7 cm.). Gift of Martin Sklar. 81.122.2.4.

Pennsylvania Dutch and Adidas, Santa Cruz. n.d. Gelatin silver print. 8 × 11⅞ in. (20.3 × 30.2 cm.). Gift of Martin Sklar. 81.122.2.5.

Scratchers, Kyoto, Japan. n.d. Gelatin silver print. 11¾ × 7¹³⁄₁₆ in. (29.8 × 19.9 cm.). Gift of Martin Sklar. 81.122.2.6.

Photographer, Herat, Afghanistan. n.d. Gelatin silver print. 7¹⁵⁄₁₆ × 11¹³⁄₁₆ in. (20.1 × 30.0 cm.). Gift of Martin Sklar. 81.122.2.7.

Legs on a Wall, New York. n.d. Gelatin silver print. 11¾ × 7⅞ in. (30.0 × 20.0 cm.). Gift of Martin Sklar. 81.122.2.8.

Tree and Sign, Panama City. n.d. Gelatin silver print. 12⅛ × 8¹⁄₁₆ in. (30.8 × 20.5 cm.). Gift of Martin Sklar. 81.122.2.9.

Bearded Man with Tree. n.d. Gelatin silver print. 11¾ × 7¹³⁄₁₆ in. (29.8 × 19.9 cm.). Gift of Martin Sklar. 81.122.2.10.

ESTABROOK, REED
American, 1944-

Exercise in Solid Geometry No. 13. 1981. Color coupler print (Type C). 18 × 22¹⁄₁₆ in. (45.7 × 56.0 cm.). Gift of funds from the Photography Council of The Minneapolis Institute of Arts. 81.44.1.

Exercise in Solid Geometry No. 18. 1981. Color coupler print (Type C). 18 × 22¹⁄₁₆ in. (45.8 × 56.0 cm.). Gift of funds from the Photography Council of The Minneapolis Institute of Arts. 81.44.2.

Exercise in Solid Geometry No. 29. 1981. Color coupler print (Type C). 18 × 22 in. (45.8 × 56.0 cm.). Gift of funds from the Photography Council of The Minneapolis Institute of Arts. 81.44.3.

Exercise in Solid Geometry No. 31. 1981. Color coupler print (Type C). 22 × 18¹⁄₁₆ in. (56.0 × 45.8 cm.). Gift of funds from the Photography Council of The Minneapolis Institute of Arts. 81.44.4.

EUGENE, FRANK
See *Camera Work*

EVANS, FREDERICK H.
English, 1853-1943

Mr. and Mrs. S. Maudson Grant, Lincoln. n.d. Platinum print. 5⁷⁄₁₆ × 7⁷⁄₁₆ in. (13.8 × 18.9 cm.). Kate and Hall J. Peterson Fund. 75.43.1.

Durham Cathedral, Font from Isle. n.d. Platinum print. 9¹¹⁄₁₆ × 5¹¹⁄₁₆ in. (24.7 × 14.5 cm.). Kate and Hall J. Peterson Fund. 75.43.2.

Ely Cathedral, Octagon. n.d. Platinum print. 8⅜ × 10⅛ in. (21.3 × 25.7 cm.). Kate and Hall J. Peterson Fund. 75.43.3.

See also *Camera Work*

EVANS, WALKER
American, 1903-1975

Couple at Coney Island, New York. 1928. Gelatin silver print. 9¼ × 5¹⁵⁄₁₆ in. (23.5 × 15.0 cm.). William Hood Dunwoody Fund. 75.25.1.

New York. 1929. Gelatin silver print. 2⁷⁄₁₆ × 1⁹⁄₁₆ in. (6.1 × 4.0 cm.). William Hood Dunwoody Fund. 75.25.2.

Brooklyn Bridge. 1929. Gelatin silver print. 4⅛ × 2½ in. (10.5 × 6.4 cm.). William Hood Dunwoody Fund. 75.25.3.

New York. 1929. Gelatin silver print. 3⅝ × 2¼ in. (9.3 × 5.8 cm.). William Hood Dunwoody Fund. 75.25.4.

New York. 1929. Gelatin silver print. 2⅝ × 1¹¹⁄₁₆ in. (6.6 × 4.3 cm.). William Hood Dunwoody Fund. 75.25.5.

Coal Dock Worker. 1932. Gelatin silver print. 4¹¹⁄₁₆ × 4¹⁄₁₆ in. (11.9 × 10.3 cm.). William Hood Dunwoody Fund. 75.25.6.

[houses and street, Cuba]. 1932. Gelatin silver print. 5¹⁵⁄₁₆ × 7¹¹⁄₁₆ in. (15.1 × 19.5 cm.). William Hood Dunwoody Fund. 75.25.7.

[movie theatre, Cuba]. 1932. Gelatin silver print. 6¹⁄₁₆ × 7¼ in. (15.4 × 18.4 cm.). William Hood Dunwoody Fund. 75.25.8.

[subway portrait, boy with cap]. 1941. Gelatin silver print. 5⅛ × 6¾ in. (13.0 × 17.3 cm.). William Hood Dunwoody Fund. 75.25.9.

[subway portrait, side view of man reading newspaper]. 1941 Gelatin silver print. 4⅞ × 7¾ in. (12.4 × 19.8 cm.). William Hood Dunwoody Fund. 75.25.10.

[subway portrait, man reading newspaper]. 1941. Gelatin silver print. 4¹³⁄₁₆ × 5¹⁵⁄₁₆ in. (12.2 × 15.0 cm.). William Hood Dunwoody Fund. 75.25.11.

[subway portrait, two women]. 1941. Gelatin silver print. 5¹⁄₁₆ × 5¹³⁄₁₆ in. (12.9 × 14.8 cm.). William Hood Dunwoody Fund. 75.25.12.

[subway portrait, woman holding child]. 1941. Gelatin silver print. 5 × 7⁹⁄₁₆ in. (12.8 × 19.3 cm.). William Hood Dunwoody Fund. 75.25.13.

[subway portrait, man and woman on 7th Ave. Local]. 1941. Gelatin silver print. 5⅜ × 8⅛ in. (13.8 × 20.8 cm.). William Hood Dunwoody Fund. 75.25.14.

Political Poster, Massachusetts Village. 1929. Gelatin silver print. 6⅝ × 4⅝ in. (16.8 × 11.8 cm.). William Hood Dunwoody Fund. 75.26.1.

Sidewalk and Shopfront, New Orleans. 1935. Gelatin silver print. 9¹¹⁄₁₆ × 7¾ in. (24.6 × 19.7 cm.). William Hood Dunwoody Fund. 75.26.2.

Main Street, Ossining, New York. 1932. Gelatin silver print. 6⁵⁄₁₆ × 9⁷⁄₁₆ in. (16.0 × 24.1 cm.). William Hood Dunwoody Fund. 75.26.3.

Girl in Fulton Street, New York. 1929. Gelatin silver print. 9½ × 6⁵⁄₁₆ in. (24.2 × 16.0 cm.). William Hood Dunwoody Fund. 75.26.4.

Negroes' Houses, Mississippi. 1936. Gelatin silver print. 7⁹⁄₁₆ × 9⅝ in. (19.3 × 24.4 cm.). William Hood Dunwoody Fund. 75.26.5.

A Miner's Home, West Virginia. 1935. Gelatin silver print. 9½ × 7½ in. (24.2 × 19.1 cm.). William Hood Dunwoody Fund. 75.26.6.

Roadside Stand, Vicinity Birmingham, Alabama. 1936. Gelatin silver print. 7⅝ × 9⁹⁄₁₆ in. (19.4 × 24.3 cm.). William Hood Dunwoody Fund. 75.26.7.

Steel Mills and Workers' Houses, Birmingham, Alabama. 1936. Gelatin silver print. 7½ × 9½ in. (19.2 × 24.2 cm.). William Hood Dunwoody Fund. 75.26.8.

Company Houses, West Virginia. 1935. Gelatin silver print. 6¹⁄₁₆ × 6¾ in. (15.4 × 17.2 cm.). William Hood Dunwoody Fund. 75.26.9.

Frame Houses in Virginia. 1936. Gelatin silver print. 6¼ × 7¾ in. (15.9 × 19.7 cm.). William Hood Dunwoody Fund. 75.26.10.

Cottage at Ossining Camp Woods, New York. 1930. Gelatin silver print. 6 × 7⅜ in. (15.3 × 18.7 cm.). William Hood Dunwoody Fund. 75.26.11.

Waterfront Poolroom, New York. 1933. Gelatin silver print. 7⁹⁄₁₆ × 9½ in. (19.3 × 24.2 cm.). William Hood Dunwoody Fund. 75.26.12.

Uncle Sam Plantation, Convent, Louisiana. 1935. Gelatin silver print. 7⅝ × 9⅝ in. (19.4 × 24.5 cm.). William Hood Dunwoody Fund. 75.26.13.

Allie Mae Burroughs, Wife of a Cotton Share-cropper, Hale County, Alabama. 1936. Gelatin silver print. 9½ × 7⁹⁄₁₆ in. (24.2 × 19.2 cm.). William Hood Dunwoody Fund. 75.26.14.

Tin Building, Moundville, Alabama. 1936. Gelatin silver print. 7⅝ × 9⁷⁄₁₆ in. (19.3 × 24.3 cm.). William Hood Dunwoody Fund. 75.26.15.

Mining Company Store, Westmoreland County, Pennsylvania. 1935. Gelatin silver print. 7⁹⁄₁₆ × 9⁹⁄₁₆ in. (19.2 × 24.2 cm.). William Hood Dunwoody Fund. 75.26.16.

Highway Corner, Reedsville, West Virginia. 1935. Gelatin silver print. 9 × 7⁷⁄₁₆ in. (22.8 × 19.0 cm.). William Hood Dunwoody Fund. 75.26.17.

Filling Station and Company Houses for Miners, Vicinity Morgantown, West Virginia. 1935. Gelatin silver print. 7½ × 9⁹⁄₁₆ in. (19.1 × 24.3 cm.). William Hood Dunwoody Fund. 75.26.18.

Street Scene, Vicksburg, Mississippi. 1936. Gelatin silver print. 7⁹⁄₁₆ × 9⁹⁄₁₆ in. (19.2 × 24.2 cm.). William Hood Dunwoody Fund. 75.26.19.

Railroad Yard and Houses, Bethlehem, Pennsylvania. 1935. Gelatin silver print. 7⁹⁄₁₆ × 9½ in. (19.2 × 24.1 cm.). William Hood Dunwoody Fund. 75.26.20.

Houses and Steel Mill, Bethlehem, Pennsylvania. 1935. Gelatin silver print. 7⁹⁄₁₆ × 9⁹⁄₁₆ in. (19.2 × 24.3 cm.). William Hood Dunwoody Fund. 75.26.21.

Street Scene, New Orleans, Louisiana. 1935. Gelatin silver print. 7⅝ × 9⅝ in. (19.3 × 24.4 cm.). William Hood Dunwoody Fund. 75.26.22.

Negroes' Church, South Carolina. 1936. Gelatin silver print. 9¹¹⁄₁₆ × 7⅝ in. (24.5 × 19.4 cm.). William Hood Dunwoody Fund. 75.26.23.

Mayor's Office, Moundville, Alabama. 1936. Gelatin silver print. 7⁹⁄₁₆ × 9⁹⁄₁₆ in. (19.3 × 24.3 cm.). William Hood Dunwoody Fund. 75.26.24.

William Edward (Bud) Fields, Hale County, Alabama. 1936. Gelatin silver print. 9⁹⁄₁₆ × 7⁹⁄₁₆ in. (24.3 × 19.2 cm.). William Hood Dunwoody Fund. 75.26.25.

Roadside Restaurant, Alabama. 1936. Gelatin silver print. 7⁵⁄₁₆ × 9⅝ in. (18.6 × 24.4 cm.). William Hood Dunwoody Fund. 75.26.26.

[White House Garage, New York]. n.d. Gelatin silver print. 6⅜ × 8⁵⁄₁₆ in. (16.2 × 21.2 cm.). William Hood Dunwoody Fund. 75.26.27.

[men and Palumbo truck]. n.d. Gelatin silver print. 7⁹⁄₁₆ × 9⁹⁄₁₆ in. (19.3 × 24.3 cm.). William Hood Dunwoody Fund. 75.26.28.

Sidewalk Scene in the French Market, New Orleans, Louisiana. 1935. Gelatin silver print. 7⁹⁄₁₆ × 9⅝ in. (19.2 × 24.4 cm.). William Hood Dunwoody Fund. 75.26.29.

Photographer's Window Display, Birmingham, Alabama. 1936. Gelatin silver print. 9⁹⁄₁₆ × 7⅝ in. (24.4 × 19.4 cm.). Gift of D. Thomas Bergen. 75.41.1.

Torn Movie Poster, Truro, Massachusetts. 1930. Gelatin silver print. 6⅝ × 4⅝ in. (16.8 × 11.8 cm.). Gift of D. Thomas Bergen. 75.41.2.

Sharecropper's Wife (Mrs. Frank Tengle), Hale County, Alabama. 1936. Gelatin silver print. 7¾ × 2¹¹⁄₁₆ in. (19.7 × 6.8 cm.). Gift of D. Thomas Bergen. 75.41.3.

Citizen in Downtown Havana. 1932. Gelatin silver print. 9⅜ × 5¹⁄₁₆ in. (23.9 × 13.0 cm.). Gift of D. Thomas Bergen. 75.41.4.

Street Scene, Vicksburg, Mississippi. 1936. Gelatin silver print. 7⁹⁄₁₆ × 9½ in. (19.2 × 24.1 cm.). Gift of D. Thomas Bergen. 75.41.5.

View of Easton, Pennsylvania. 1935. Gelatin silver print. 7½ × 9½ in. (19.1 × 24.1 cm.). Gift of D. Thomas Bergen. 75.41.6.

Westchester, New York, Farmhouse. 1931. Gelatin silver print. 4¹⁵⁄₁₆ × 6⅞ in. (12.5 × 17.5 cm.). Gift of D. Thomas Bergen. 75.41.7.

Gothic Gate Cottage Near Poughkeepsie, New York. 1931. Gelatin silver print. 6⁷⁄₁₆ × 8⁷⁄₁₆ in. (16.4 × 21.4 cm.). Gift of D. Thomas Bergen. 75.41.8.

Ossining, New York. 1931. Gelatin silver print. 8¹⁄₁₆ × 6³⁄₁₆ in. (20.5 × 15.7 cm.). Gift of D. Thomas Bergen. 75.41.9.

Breakfast Room at Belle Grove Plantation, White Chapel, Louisiana. 1935. Gelatin silver print. 7⁹⁄₁₆ × 9⁹⁄₁₆ in. (19.2 × 24.4 cm.). Gift of D. Thomas Bergen. 75.41.10.

Washroom in the Dog Run of Floyd Burrough's Home, Hale County, Alabama. 1936. Gelatin silver print. 9½ × 7¹⁵⁄₁₆ in. (24.1 × 18.6 cm.). Gift of D. Thomas Bergen. 75.41.11.

Tuscaloosa Wrecking Company, Alabama. 1936. Gelatin silver print. 7⅝ × 9⁹⁄₁₆ in. (19.4 × 24.4 cm.). Gift of D. Thomas Bergen. 75.41.12.

Storefront and Signs, Beaufort, South Carolina. 1936. Gelatin silver print. 8 × 9¹⁵⁄₁₆ in. (20.3 × 25.3 cm.). Gift of D. Thomas Bergen. 75.41.13.

View of Easton, Pennsylvania. 1935. Gelatin silver print. 7½ × 9½ in. (19.1 × 24.1 cm.). Gift of D. Thomas Bergen. 75.41.14.

Graveyard, Houses, and Steel Mill, Bethlehem, Pennsylvania. 1935. Gelatin silver print. 7½ × 9½ in. (19.1 × 24.1 cm.). Gift of D. Thomas Bergen. 75.41.15.

Scene in the Negro Quarter, Tupelo, Mississippi. 1936. Gelatin silver print. 7⁹⁄₁₆ × 9⁹⁄₁₆ in. (19.3 × 24.5 cm.). Gift of D. Thomas Bergen. 75.41.16.

Roadside Store, Vicinity Selma, Alabama. 1935. Gelatin silver print. 7⅝ × 9¹³⁄₁₆ in. (19.3 × 25.0 cm.). Gift of D. Thomas Bergen. 75.41.17.

License Photo Studio, New York. 1934. Gelatin silver print. 7¹¹⁄₁₆ × 6³⁄₁₆ in. (19.6 × 15.7 cm.). Gift of Arnold H. Crane. 75.42.1.

Negroes' Barber Shop, Atlanta, Georgia. 1936. Gelatin silver print. 7⅝ × 9⅝ in. (19.4 × 24.4 cm.). Gift of Arnold H. Crane. 75.42.2.

Man on Porch, Florida. c. 1934. Gelatin silver print. 6⅝ × 8⅜ in. (16.8 × 21.3 cm.). Gift of Arnold H. Crane. 75.42.3.

Church Interior, Alabama. 1936. Gelatin silver print. 7⅝ × 9⁹⁄₁₆ in. (19.4 × 24.4 cm.). Gift of Arnold H. Crane. 75.42.4.

Wooden Houses, Boston. 1930. Gelatin silver print. 4⅜ × 5¾ in. (11.1 × 14.7 cm.). Gift of Arnold H. Crane. 75.42.5.

Auto Graveyard. c. 1942. Gelatin silver print. 5⅞ × 9⅜ in. (15.0 × 23.8 cm.). Gift of Arnold H. Crane. 75.42.6.

Floyd Burrough's Bedroom, Hale County, Alabama. 1936. Gelatin silver print. 7⅝ × 9⁹⁄₁₆ in. (19.3 × 24.2 cm.). Gift of Arnold H. Crane. 75.42.7.

Company Houses for Tannery Workers, Gormania, West Virginia. 1935. Gelatin silver print. 7⅝ × 9⅝ in. (19.3 × 24.4 cm.). Gift of D. Thomas Bergen. 76.82.1.

Millworkers' Houses in Willimantic, Connecticut. 1931. Gelatin silver print. 9¹⁄₁₆ × 12⅞ in. (23.1 × 32.8 cm.). Gift of D. Thomas Bergen. 76.82.2.

[grain elevators]. c. 1961. Gelatin silver print. 10⁹⁄₁₆ × 13½ in. (26.9 × 34.2 cm.). Gift of D. Thomas Bergen. 76.82.3.

[slum housing in snow]. c. 1961. Gelatin silver print. 9¹⁄₁₆ × 13⁹⁄₁₆ in. (23.1 × 34.5 cm.). Gift of D. Thomas Bergen. 76.82.4.

Fred Olson. n.d. Gelatin silver print. 10⅝ × 11³⁄₁₆ in. (27.0 × 28.5 cm.). Gift of D. Thomas Bergen. 76.82.5.

[Nation-Wide grocery store]. n.d. Gelatin silver print. 8 × 6³⁄₁₆ in. (20.4 × 15.7 cm.). Gift of D. Thomas Bergen. 76.82.6.

[Pearly King of Edmonton]. n.d. Gelatin silver print. 13½ × 9⁹⁄₁₆ in. (34.3 × 23.7 cm.). Gift of D. Thomas Bergen. 76.82.7.

[Yale University student's room]. n.d. Gelatin silver print. 9⅞ × 9¹¹⁄₁₆ in. (25.1 × 24.6 cm.). Gift of D. Thomas Bergen. 76.82.8.

View of Bethlehem, Pennsylvania. 1935. Gelatin silver print. 7⁹⁄₁₆ × 9½ in. (19.3 × 24.2 cm.). Gift of D. Thomas Bergen. 76.82.9.

[houses in winter]. n.d. Gelatin silver print. 9¹⁄₁₆ × 13⁹⁄₁₆ in. (23.0 × 34.0 cm.). Gift of D. Thomas Bergen. 76.82.10.

FAURER, LOUIS
American, 1916-

Untitled, New York City. 1950. Gelatin silver print. 8⁷⁄₁₆ × 12½ in. (21.4 × 31.8 cm.). Ethel Morrison Van Derlip Fund. 81.98.1.

Family, Times Square, New York City. 1948. Gelatin silver print. 8⅞ × 13⁹⁄₁₆ in. (22.5 × 34.5 cm.). Ethel Morrison Van Derlip Fund. 81.98.2.

[man with crutch]. 1937. Gelatin silver print. 9⁷⁄₁₆ × 6⅝ in. (24.1 × 16.8 cm.). Ethel Morrison Van Derlip Fund. 81.98.3.

Flea Circus, 42nd Street, New York City. c. 1947. Gelatin silver print. 12⁷⁄₁₆ × 8³⁄₁₆ in. (31.7 × 20.9 cm.). Gift of Mr. and Mrs. Paul N. Rifkin. 82.124.1.

Hells Kitchen, New York City. c. 1947. Gelatin silver print. 11⁷⁄₁₆ × 7⅝ in. (29.1 × 19.4 cm.). Gift of Mr. and Mrs. Paul N. Rifkin. 82.124.2.

Eddie, 3rd Avenue, New York City. 1947. Gelatin silver print. 13⁹⁄₁₆ × 9⅜ in. (34.4 × 23.8 cm.). Gift of Mr. and Mrs. Paul N. Rifkin. 82.124.3.

Freudian Hand Clasp, New York City. c. 1946. Gelatin silver print. 11¹¹⁄₁₆ × 8⅛ in. (28.2 × 20.6 cm.). Gift of Mr. and Mrs. Paul N. Rifkin. 82.124.4.

Woman with Umbrella, Times Square, New York City. c. 1948 Gelatin silver print. 7⅜ × 8⁷⁄₁₆ in. (18.7 × 21.5 cm.). Gift of Mr. and Mrs. Paul N. Rifkin. 82.124.5.

San Genaro Festival, New York City. 1950. Gelatin silver print. 8¼ × 12⅜ in. (20.9 × 31.5 cm.). Gift of Mr. and Mrs. Paul N. Rifkin. 82.124.6.

Repaving of Broadway, "Edge of Doom." 1950. Gelatin silver print. 8⁵⁄₁₆ × 12⁹⁄₁₆ in. (21.1 × 31.9 cm.). Gift of Mr. and Mrs. Paul N. Rifkin. 82.124.7.

Indian Summer, 42nd Street, New York City. c. 1949. Gelatin silver print. 7¾ × 11⁹⁄₁₆ in. (19.7 × 29.3 cm.). Gift of Mr. and Mrs. Paul N. Rifkin. 82.124.8.

Boardwalk, Atlantic City, New Jersey. c. 1938. Gelatin silver print. 5⁷⁄₁₆ × 8⅛ in. (13.8 × 20.6 cm.). Gift of Mr. and Mrs. Paul N. Rifkin. 82.124.9.

New York City. c. 1947. Gelatin silver print.7¹/₁₆ × 10⁹/₁₆ in. (18.0 × 26.9 cm.). Gift of Mr. and Mrs. Paul N. Rifkin. 82.124.10.

Tulips on Broadway. c. 1948. Gelatin silver print. 6⁵/₈ × 9¹⁵/₁₆ in. (16.7 x 25.2 cm.). Gift of Mr. and Mrs. Paul N. Rifkin. 82.124.11.

14th Street Horn and Hardart, New York City. c. 1947. Gelatin silver print. 8⁵/₁₆ × 11⁷/₈ in. (21.1 × 30.3 cm.). Gift of Mr. and Mrs. Paul N. Rifkin. 82.124.12.

FELICE, NICHOLAS D.
American, 1951-

'48 Pontiac. 1974. Color coupler print. 6⁷/₁₆ × 9⁹/₁₆ in. (16.4 x 24.4 cm.). Kate and Hall J. Peterson Fund. 74.86.1.

Minneapolis Bus. 1974. Color coupler print. 6¼ × 9½ in. (15.9 x 24.3 cm.). Kate and Hall J. Peterson Fund. 74.86.2.

Blue Rectangles. 1974. Color coupler print. 6³/₈ × 9⁹/₁₆ in. (16.3 x 24.4 cm.). Kate and Hall J. Peterson Fund. 74.86.3.

FELLMAN, SANDI
American, 1952-

Scarlett and Other Women. Published by The Exposure Press, Madison, Wisconsin. 1975. Book of 15 gelatin silver prints. National Endowment for the Arts purchase grant and miscellaneous matching funds. 76.18.1-15.
[woman and sign]. 7 × 6¹⁵/₁₆ in. (17.8 x 17.6 cm.).
[woman in white dress]. 7 × 6¹⁵/₁₆ in. (17.7 × 17.7 cm.).
[woman with hair spread out]. 6¹⁵/₁₆ × 7 in. (17.7 × 17.8 cm.).
[woman with *National Examiner*]. 7 × 6¹⁵/₁₆ in. (17.8 × 17.6 cm.).
[woman with male pinups]. 7 × 7 in. (17.8 × 17.8 cm.).
[woman with hands clasped on knee]. 6¹⁵/₁₆ × 7 in. (17.7 × 17.8 cm.).
[two women reclining]. 7 × 7 in. (17.8 × 17.8 cm.).
[woman reclining] 7 × 6¹⁵/₁₆ in (17.8 × 17.7 cm.).
[woman reclining]. 6¹⁵/₁₆ × 6¹⁵/₁₆ in. (17.7 × 17.7 cm.).
[three women on couch]. 7 × 7 in. (17.8 × 17.8 cm.).
[woman with tatooed buttock]. 6¹⁵/₁₆ × 6¹⁵/₁₆ in. (17.7 × 17.7 cm.).
[three women on couch]. 6¹⁵/₁₆ × 7 in. (17.7 × 17.8 cm.).
[three women on bed]. 7 × 7 in. (17.7 × 17.8 cm.).
[four women]. 7 × 7 in. (17.7 × 17.8 cm.).
[nude woman with "happy face"]. 6¹⁵/₁₆ × 7 in. (17.7 × 17.8 cm.).

Mustang Ranch. Published by The Exposure Press, Madison, Wisconsin. 1976-77. Portfolio of 15 gelatin silver prints. Kate and Hall J. Peterson Fund. 80.15.1-15.
[woman on bed with reflections]. 10 × 10 in. (25.4 × 25.4 cm.).
[two women on bed]. 10 × 9¹⁵/₁₆ in. (25.4 × 25.4 cm.).

[makeup table with reflection]. 10 × 10 in. (25.4 × 25.4 cm.).
[woman on bed]. 10 × 10 in. (25.4 × 25.4 cm.).
[two women on bed]. 9¹⁵/₁₆ × 9¹⁵/₁₆ in. (25.3 × 25.4 cm.).
[woman reclining]. 9¹⁵/₁₆ × 9¹⁵/₁₆ in. (25.4 × 25.3 cm.).
[woman on bed]. 10 × 10 in. (25.4 × 25.4 cm.).
[woman in corner]. 10 × 10 in. (25.4 × 25.4 cm.).
[woman with wash basin]. 10 × 10 in. (25.4 × 25.4 cm.).
[nude black woman]. 10 × 10 in. (25.4 × 25.4 cm.).
[woman in white]. 9¹⁵/₁₆ × 9¹⁵/₁₆ in. (25.3 × 25.3 cm.).
[woman with toy animals]. 10 × 10 in. (25.4 × 25.4 cm.).
[woman reclining]. 9¹⁵/₁₆ × 9¹³/₁₆ in. (25.2 × 25.0 cm.).
[two women on bed]. 10 × 10 in. (25.4 × 25.5 cm.).
[woman standing]. 10 × 10 in. (25.4 × 25.4 cm.).

FICHTER, ROBERT W.
American, 1939-

The Machine in the Garden. From *Underware* portfolio. 1976. Gelatin silver print. 16¹/₈ × 19¹⁵/₁₆ in. (41.0 × 50.7 cm.). National Endowment for the Arts purchase grant and miscellaneous matching funds. 76.64.7.

David at Sea. From *Silver See* portfolio. 1977. Lithograph with cyanotype. 14¹⁵/₁₆ × 19¾ in. (37.9 × 50.1 cm.). National Endowment for the Arts purchase grant and miscellaneous matching funds. 77.39.4.

FINK, LARRY
American, 1941-

[three females at table]. 1978. Gelatin silver print. 14⁹/₁₆ × 14¹⁵/₁₆ in. (37.1 × 38.0 cm.). Gift of the American Telephone and Telegraph Co. 81.120.28.

[woman on chair]. 1978. Gelatin silver print. 14¹¹/₁₆ × 14⁷/₈ in. (37.3 × 37.9 cm.). Gift of the American Telephone and Telegraph Co. 81.120.29.

[couple under sign]. 1978. Gelatin silver print. 14⁵/₈ × 14¹³/₁₆ in. (37.1 × 37.7 cm.). Gift of the American Telephone and Telegraph Co. 81.120.30.

Making Out, 1957-1980. Published by Karad, Inc. 1980. Portfolio of 15 gelatin silver prints. Gift of Mr. and Mrs. Paul N. Rifkin. 82.124.23-37.
Model, Moses Soyer Studio. 1957. 14¾ × 14⁷/₈ in. (37.5 × 37.8 cm.).
Girls on Porch, Martins Creek, Pennsylvania. 1977. 14¹⁵/₁₆ × 14⁷/₈ in. (38.0 × 37.7 cm.).
Teen Couple, Allentown Fair. 1978. 14⁵/₈ × 14¹³/₁₆ in. (37.2 × 37.6 cm.).
Debutante Ball, Hotel Pierre, New York City. 1978. 14⁵/₈ × 14¹⁵/₁₆ in. (37.2 × 38.0 cm.).
Ninth Birthday Party, Sabatine's, Martins Creek, Pennsylvania. 1978. 14¾ × 15¹/₁₆ in. (37.5 × 38.2 cm.).
Eleventh Birthday Party at the Sabatine's, Martins Creek, Pennsylvania. 1980. 14¹¹/₁₆ × 14¹⁵/₁₆ in. (37.4 × 38.1 cm.).

Couple at Sabatines's, Martins Creek, Pennsylvania. 1980. 14⁵/₈ × 14¹⁵/₁₆ in. (37.1 × 38.0 cm.).
Declaration of Independence, Martins Creek, Pennsylvania. 1978. 14⁹/₁₆ × 14¾ in. (37.0 × 37.5 cm.).
Family Group, Boat Train, London—Paris. 1968. 19¹/₈ × 12⁷/₈ in. (48.7 × 32.7 cm.).
Count and Kelly, Martins Creek, Pennsylvania. 1977. 14¹³/₁₆ × 14⁷/₈ in. (37.7 × 37.9 cm.).
Gary and Nancy, New Jersey. 1973. 14⁵/₈ × 14¹³/₁₆ in. (37.2 × 37.7 cm.).
Two Women, Debutante Ball, Hotel Pierre, New York City. 1978. 14¹¹/₁₆ × 14¹³/₁₆ in. (37.4 × 37.6 cm.).
Parsons School of Design, Costume Party. 1972. 12¹⁵/₁₆ × 19³/₈ in. (33.0 × 49.3 cm.).
First Communion, Bronx, New York. 1961. 15¹/₈ × 19¼ in. (38.4 × 48.9 cm.).
Lovers in a Doorway, Houston, Texas. 1959. 14¹³/₁₆ × 14¹³/₁₆ in. (37.6 × 37.6 cm.).

FIRTH, ROBERT, Jr.
American, 1949-

Main Fork, Salmon River, Idaho, Dawn. 1976. Dye bleach color print (Cibachrome). 8 × 7⁷/₈ in. (20.4 × 20.1 cm.) Kate and Hall J. Peterson Fund. 77.12.

FITCH, STEVE
American, 1949-

[railroad crossing signal]. From *New California Views* portfolio. 1978. Dye transfer print. 11¹¹/₁₆ × 11¹³/₁₆ in. (29.6 × 30.1 cm.). Gift of funds from the Photography Council of The Minneapolis Institute of Arts. 80.24.6.

FLICK, ROBBERT
American (b. Holland), 1939-

[geometric design]. From *Silver See* portfolio. 1977. Gelatin silver print, cut. 5¹/₁₆ × 7⁹/₁₆ in. (12.9 × 19.3 cm.). National Endowment for the Arts purchase grant and miscellaneous matching funds. 77.39.5.

FOLEY, JANE TUCKERMAN
See Tuckerman, Jane

FOSTER, EDWARD A.
American, 1940-

Oklahoma Storm. 1979. Gelatin silver print. 8⁹/₁₆ × 57⁷/₈ in. (21.7 × 146.0 cm.). Ethel Morrison Van Derlip Fund. 80.48.

FRANK, ROBERT
American (b. Switzerland), 1924-

Motorama, Los Angeles. 1956. Gelatin silver print. 8¹/₈ × 12¹/₈ in. (20.7 × 30.9 cm.). William Hood Dunwoody Fund. 81.96.

FREEMAN, VIDA
American, 1937-

Tule Springs. From *L. A. Issue* portfolio. 1979. Palladium print with text. 6¹⁵/₁₆ × 7½ in. (17.7 × 19.1 cm.). Gift of funds from the Photography Council of The Minneapolis Institute of Arts. 80.25.5.

FRENCH, HERBERT G.
See *Camera Work*

FRIEDKIN, ANTHONY ENTON
American, 1949-

Jaws, Universal Studios. From *L. A. Issue* portfolio. 1978. Gelatin silver print. 8¹³/₁₆ × 13¼ in. (22.4 × 33.7 cm.). Gift of funds from the Photography Council of The Minneapolis Institute of Arts. 80.25.6.

FRIEDLANDER, LEE
American, 1934-

15 Photographs. Published by The Double Elephant Press, New York. 1973. Portfolio of 15 gelatin silver prints. Anonymous gift. 73.47.1-15.

TV in Hotel Room, Galax, Virginia. 1962. 5¹³/₁₆ × 8⅞ in. (14.8 × 22.5 cm.).

Bed in Window, Cincinnati, Ohio. 1963. 9⅝ × 6⅜ in. (24.5 × 16.2 cm.).

Women in Window, New York City. 1963. 6⅝ × 10 in. (16.8 × 25.5 cm.).

Man in Window, New York City. 1964. 6¾ × 10¼ in. (17.1 × 26.1 cm.).

Plane over Bull, Kansas City, Missouri. 1965. 6½ × 9¹³/₁₆ in. (16.5 × 25.0 cm.).

Flag, New York City. 1965. 6⅜ × 9¹¹/₁₆ in. (16.2 × 24.6 cm.).

Shadow, New York City. 1966. 6¼ × 9½ in. (16.0 × 24.1 cm.).

Party, New York City. 1968. 8⁷/₁₆ × 12¹¹/₁₆ in. (21.4 × 32.2 cm.).

Filling Station, Rearview Mirror, Hillcrest, New York. 1970. 6⁹/₁₆ × 9¹⁵/₁₆ in. (16.6 × 25.3 cm.).

Lee Avenue, Butte, Montana. 1970. 6¼ × 9⁷/₁₆ in. (15.9 × 24.0 cm.).

Car and Fence and Bush, San Diego, California. 1970. 7⅜ × 11¹/₁₆ in. (18.7 × 28.2 cm.).

Street Scene, Trees and Houses, Hollywood, California. 1970. 6⁹/₁₆ × 10 in. (16.6 × 25.5 cm.).

Statue, New Jersey. 1971. 6⅝ × 10 in. (16.9 × 25.5 cm.).

House, Trailer, Sign, and Cloud, Knoxville, Tennessee. 1971. 6½ × 9⅞ in. (16.4 × 25.1 cm.).

Street Scene, Man, Pole, Etc., Chicago. 1972. 6⁹/₁₆ × 10 in. (16.2 × 25.4 cm.).

Photographs of Flowers. Published by Graphicstudio, Tampa, Florida, and Haywire Press, New City, New York. 1975. Portfolio of 15 gelatin silver prints. National Endowment for the Arts purchase grant and miscellaneous matching funds. 76.15.1-15.

Wall of Potted Plants and Trees, Putney, Vermont. 1972. 6⅞ × 10¼ in. (17.5 × 26.1 cm.).

Roses in Vase, New York City. 1974. 12⅞ × 8⁷/₁₆ in. (32.8 × 21.0 cm.).

Rosebush with Leafy Background, Fort Lee, New Jersey. 1972. 9⁹/₁₆ × 6⅜ in. (24.4 × 16.3 cm.).

Chrysanthemums at Flower Market, Paris. 1972. 6¾ × 10³/₁₆ in. (17.2 × 25.9 cm.).

Hollyhocks, Taos, New Mexico. 1972. 6¹⁵/₁₆ × 10⁷/₁₆ in. (17.6 × 26.5 cm.).

Roses with Eaten Leaves, Parc St. Cloud, France. 1973. 6⅝ × 9¹⁵/₁₆ in. (16.8 × 25.3 cm.).

Cactus, Brooklyn Botanical Gardens. 1973. 7¹⁵/₁₆ × 11¹⁵/₁₆ in. (20.2 × 30.4 cm.).

Chrysanthemums in Garden Pot, Luxembourg Gardens, Paris. 1972. 4¹³/₁₆ × 7½ in. (12.2 × 19.0 cm.).

Kerria Japonica Shrub, New City, New York. 1974. 7¹⁵/₁₆ × 11 in. (18.6 × 28.0 cm.).

Evergreen Tree, Northern France. 1972. 6½ × 9⅞ in. (16.5 × 25.2 cm.).

Single Rose Bloom in Formal Garden, Bagatelle Gardens, Paris. 1973. 9¹⁵/₁₆ × 6⁹/₁₆ in. (25.3 × 16.7 cm.)

Potted Fern, Marikosa, California. 1972. 7¹/₁₆ × 10⅝ in. (17.8 × 27.0 cm.).

Petunias, Salinas, California. 1972. 9¾ × 6½ in. (24.8 × 16.6 cm.).

Climbing Rose Vines, Saratoga Springs, New York. 1973. 7¹/₁₆ × 10¾ in. (17.9 × 27.3 cm.).

Potted Rose, Putney, Vermont. 1972. 8⅝ × 5¹¹/₁₆ in. (21.9 × 14.5 cm.).

The American Monument. Published by Eakins Press Foundation, New York. 1976. Deluxe edition portfolio of 10 gelatin silver prints and book. National Endowment for the Arts purchase grant and miscellaneous matching funds. 76.58.1-11.

Alabama State Memorial, Vicksburg National Military Park. 1974. 9¹⁵/₁₆ × 6⅝ in. (25.3 × 16.8 cm.).

Major General Henry W. Slocum, Napoleon Gun, and Stevens' Fifth Maine Battery Marker, Gettysburg National Military Park. 1974. 6⅝ × 9¹⁵/₁₆ in. (16.9 × 25.3 cm.).

Father Duffy, Times Square, New York, New York. 1974. 6⅝ × 9¹⁵/₁₆ in. (16.9 × 25.3 cm.).

Civil War Seacoast Mortar, St. Augustine, Florida. 1973. 6⅝ × 9¹⁵/₁₆ in. (16.9 × 25.3 cm.).

Grand Army of the Republic Memorial, Haverstraw, New York. 1976. 6⅝ × 9¹⁵/₁₆ in. (16.9 × 25.3 cm.).

Kiener Memorial Fountain and Runner Statue, Gateway Mall, St. Louis, Missouri. 1972. 6⅝ × 9¹⁵/₁₆ in. (16.9 × 25.3 cm.).

To Michigan Soldiers and Sailors, Campus Martius, Detroit, Michigan. 1972. 6⅝ × 9¹⁵/₁₆ in. (16.9 × 25.3 cm.).

To the Men and Women Who Settled in Newbury, Newbury, Massachusetts. 1974. 6⅝ × 9¹⁵/₁₆ in. (16.8 × 25.3 cm.).

Mount Rushmore, South Dakota. 1969. 6¹¹/₁₆ × 9¹⁵/₁₆ in. (16.9 × 25.3 cm.).

A Boy Scout Statue of Liberty, Wichita, Kansas. 1975. 9¹⁵/₁₆ × 6⅝ in. (25.2 × 16.9 cm.).

The American Monument. Published by Eakins Press Foundation, New York. 1976. Special edition of 1 gelatin silver print and book. Gift of the artist. 76.59.1-2.

[David Thompson and Finnan MacDonald Memorial]. n.d. Gelatin silver print. 6⅝ × 10 in. (16.8 × 25.3 cm.).

Lee Friedlander: Photographs. Published by Haywire Press, New City, New York. 1978. Special edition of 2 gelatin silver prints and book. Christina N. and Swan J. Turnblad Memorial Fund. 78.37.1-3.

Albuquerque, New Mexico. 1972. 7⅜ × 11⅛ in. (18.8 × 28.3 cm.).

Newark, New Jersey. 1962. 7⅜ × 11⅛ in. (18.8 × 28.3 cm.).

See also Friedlander, Lee, and Jim Dine

FRIEDLANDER, LEE and JIM DINE
American, 1934- American, 1935-

Photographs and Etchings. Published by Petersburg Press, London. 1969. Portfolio of 16 sheets, each with one or more gelatin silver prints and etching. Image size varies, sheet size approx. 18 × 30 in. National Endowment for the Arts purchase grant and gift of funds from Russell Cowles II. 76.16.1-16.

FRITH, FRANCIS
English, 1822-1898

Travelers Boat at Ibrim. Title page from *Lower Egypt and Thebes* album. c. 1860. Albumen print. 5⅜ × 6¹¹/₁₆ in. (13.6 × 17.0 cm.). David Draper Dayton Fund. 74.11.1.

Tombs in the Southern Cemetery, First View. From *Lower Egypt and Thebes* album. c. 1860. Albumen print. 6⁵/₁₆ × 8¹⁵/₁₆ in. (16.0 × 22.7 cm.). David Draper Dayton Fund. 74.11.2.

The Citadel of Cairo from Below Gebel El-Mukattam. From *Lower Egypt and Thebes* album. 1857. Albumen print. 6⅜ × 9⅛ in. (16.1 × 23.2 cm.). David Draper Dayton fund. 74.11.3.

The Sphynx and Great Pyramid, Geezeh. From *Lower Egypt and Thebes* album. c. 1860 Albumen print. 6⁵/₁₆ × 8¹⁵/₁₆ in. (16.0 × 22.7 cm.). David Draper Dayton Fund. 74.11.4.

The Pyramids of Dahshoor, From the East. From *Lower Egypt and Thebes* album. c. 1860 Albumen print. 6⅛ × 18¹⁵/₁₆ in. (15.6 × 22.6 cm.). David Draper Dayton Fund. 74.11.5.

Cleopatra's Temple at Erment, Near Thebes. From *Lower Egypt and Thebes* album. 1857. Albumen print. 6⁷/₁₆ × 8⅞ in. (16.4 × 22.6 cm.). David Draper Dayton Fund. 74.11.6

GAMMELL, LINDA
American, 1948-

St. Paul Attic. 1974. Gelatin silver print. 4⅛ × 6 in. (10.5 × 15.3 cm.). Kate and Hall J. Peterson Fund. 74.87.1.

St. Paul Attic. 1974. Gelatin silver print. 4¹/₁₆ × 6¹/₁₆ in. (10.4 × 15.4 cm.). Kate and Hall J. Peterson Fund. 74.87.2.

St. Paul Attic. 1974. Gelatin silver print. 4⅛ × 6¹/₁₆ in. (10.5 × 15.4 cm.). Kate and Hall J. Peterson Fund. 74.87.3.

St. Paul Attic. 1974. Gelatin silver print. 4⅛ × 6¹/₁₆ in. (10.4 × 15.4 cm.). Kate and Hall J. Peterson Fund. 74.87.4.

Pueblo. From *Minnesota Photographers* portfolio. 1978. Color coupler print (Type C). 9½ × 9½ in. (24.1 × 24.2 cm.). John R. Van Derlip Fund. 79.48.3.

GATES, JEFF
American, 1949-

Chimera No. 11. From *L. A. Issue* portfolio. 1978. Gelatin silver print. 9½ × 13½ in. (24.1 × 34.3 cm.). Gift of funds from the Photography Council of The Minneapolis Institute of Arts. 80.25.7.

GOHLKE, FRANK W.
American, 1942-

Shrouded Trailer, St. Paul. 1972. Gelatin silver print. 7⅞ × 7¹³⁄₁₆ in. (20.0 × 19.8 cm.). Kate and Hall J. Peterson Fund. 73.28.1.

Painted Wall, St. Paul. 1972. Gelatin silver print. 7¼ × 7³⁄₁₆ in. (18.5 × 18.3 cm.). Kate and Hall J. Peterson Fund. 73.28.2.

Semitrailer, Minneapolis. 1972. Gelatin silver print. 7¼ × 7¼ in. (18.4 × 18.4 cm.). Kate and Hall J. Peterson Fund. 73.28.3.

Garages, St. Paul. 1972. Gelatin silver print. 7¼ × 7¼ in. (18.5 × 18.5 cm.). Kate and Hall J. Peterson Fund. 73.28.4.

Grain Elevators, Minneapolis. 1972. Gelatin silver print. 7¹⁵⁄₁₆ × 7⅞ in. (20.2 × 20.0 cm.). Kate and Hall J. Peterson Fund. 73.28.5.

Grain Elevators, Minneapolis. 1972. Gelatin silver print. 7¹¹⁄₁₆ × 7⅝ in. (19.6 × 19.4 cm.). Kate and Hall J. Peterson Fund. 73.28.6.

Grain Elevators, Minneapolis. 1972. Gelatin silver print. 7¾ × 7¾ in. (19.7 × 19.7 cm.). Kate and Hall J. Peterson Fund. 73.28.7.

Crumpled Box Car, Minneapolis. 1973. Gelatin silver print. 7¹³⁄₁₆ × 7¾ in. (19.9 × 19.8 cm.). Kate and Hall J. Peterson Fund. 73.28.8.

Grain Elevators, Minneapolis. 1973. Gelatin silver print. 7¹¹⁄₁₆ × 7⅝ in. (19.5 × 19.3 cm.). Kate and Hall J. Peterson Fund. 73.28.9.

I-94, Minneapolis. 1974. Gelatin silver print. 8¹⁵⁄₁₆ × 8¹⁵⁄₁₆ in. (22.7 × 22.7 cm.). Kate and Hall J. Peterson Fund. 75.47.1.

Landscape, Albuquerque, New Mexico. 1974. Gelatin silver print. 13 × 13 in. (33.0 × 33.0 cm.). Kate and Hall J. Peterson Fund. 75.47.2.

Grain Elevator, Loading Shed, Minneapolis. 1974. Gelatin silver print. 9³⁄₁₆ × 9³⁄₁₆ in. (23.4 × 23.4 cm.). National Endowment for the Arts purchase grant and miscellaneous matching funds. 76.86.1.

Grain Elevator, Minneapolis. 1974. Gelatin silver print. 9⁵⁄₁₆ × 9⁵⁄₁₆ in. (23.6 × 23.6 cm.). National Endowment for the Arts purchase grant and miscellaneous matching funds. 76.86.2.

Yard at Harman-Toles Elevator Company, Happy, Texas. 1975. Gelatin silver print. 13⅞ × 13¹⁵⁄₁₆ in. (35.3 × 35.4 cm.). National Endowment for the Arts purchase grant and miscellaneous matching funds. 76.86.3.

Soybeans Spilled on Highway 13, Burnsville, Minnesota. 1976. Gelatin silver print. 13¾ × 13¹³⁄₁₆ in. (35.0 × 35.1 cm.). National Endowment for the Arts purchase grant and miscellaneous matching funds. 76.86.4.

Putt Putt Miniature Golf Course, Minneapolis. 1975. Gelatin silver print. 13¹³⁄₁₆ × 13¹³⁄₁₆ in. (35.1 × 35.1 cm.). National Endowment for the Arts purchase grant and miscellaneous matching funds. 76.86.5.

Landscape, Cornfield and Thunderstorm, Near Plainview, Texas. 1975. Gelatin silver print. 13¾ × 13¾ in. (35.0 × 35.0 cm.). National Endowment for the Arts purchase grant and miscellaneous matching funds. 76.86.6.

Frame Building, Hanlontown, Iowa. 1973. Gelatin silver print. 8¼ × 8¼ in. (21.0 × 20.9 cm.). Gift of the artist. 76.87.1.

Benson's Seed and Grain Elevator, Enid, Oklahoma. 1973. Gelatin silver print. 8¹³⁄₁₆ × 8¹³⁄₁₆ in. (22. 4 × 22.4 cm.). Gift of the artist. 76.87.2.

Grain Elevator, U.S. 56, Central Kansas. 1973. Gelatin silver print. 8¹⁵⁄₁₆ × 8⅞ in. (22.6 × 22.6 cm.). Gift of the artist. 76.87.3.

Grain Elevators, Kinsley, Kansas. 1973. Gelatin silver print. 8⅞ × 8⅞ in. (22.6 × 22.6 cm.). Gift of the artist. 76.87.4.

Facade and Telephone Pole, St. Louis, Missouri. 1972. Gelatin silver print. 7⁷⁄₁₆ × 7⅜ in. (18.9 × 18.7 cm.). Gift of the artist. 76.87.5.

Grain Elevators, Minneapolis. 1974. Gelatin silver print. 9³⁄₁₆ × 9³⁄₁₆ in. (23.4 × 23.4 cm.). Gift of the artist. 76.87.6.

House, Port Arthur, Texas. 1978. Gelatin silver print. 14¹⁄₁₆ × 17½ in. (35.8 × 44.5 cm.). Gift of the American Telephone and Telegraph Co. 81.120.31.

House and Cypress Trees, Hillsboro, Texas. 1978. Gelatin silver print. 14⅛ × 17³⁄₁₆ in. (35.9 × 43.8 cm.). Gift of the American Telephone and Telegraph Co. 81.120.32.

Dallas, Texas. 1978. Gelatin silver print. 14⅛ × 17½ in. (35.9 × 44.5 cm.). Gift of the American Telephone and Telegraph Co. 81.120. 33.

Sky-Light Galleries, Albuquerque. 1974. Gelatin silver print. 9⁷⁄₁₆ × 9½ in. (24.0 × 24.1 cm.). Gift of the artist. 82.29.1.

Poodle, Albuquerque. 1974. Gelatin silver print. 8⅞ × 8⅞ in. (22.6 × 22.6 cm.). Gift of the artist. 82.29.2.

Landscape, Downtown Los Angeles. 1974. Gelatin silver print. 9⁷⁄₁₆ × 9⅝ in. (24.1 × 24.4 cm.). Gift of the artist. 82.29.3.

Landscape, Minneapolis. 1974. Gelatin silver print. 12⅞ × 12⅞ in. (32.7 × 32.7 cm.). Gift of the artist. 82.29.4.

Landscape, Minneapolis. 1973. Gelatin silver print. 9¹⁄₁₆ × 9⅛ in. (23.1 × 23.2 cm.). Gift of the artist. 82.29.5.

White Building, Los Angeles. 1974. Gelatin silver print. 8⅞ × 8¹⁵⁄₁₆ in. (22.5 × 22.8 cm.). Gift of the artist. 82.29.6.

Melody Bar, Los Angeles. 1974. Gelatin silver print. 8⅞ × 8⅞ in. (22.5 × 22.5 cm.). Gift of the artist. 82.29.7.

Landscape, Los Angeles. 1974. Gelatin silver print. 12⅞ × 12¹⁵⁄₁₆ in. (32.8 × 32.9 cm.). Gift of the artist. 82.29.8.

Landscape, Roseville, Minnesota. 1974. Gelatin silver print. 9⁷⁄₁₆ × 9⁷⁄₁₆ in. (24.1 × 24.1 cm.). Gift of the artist. 82.29.9.

Landscape, Albuquerque. 1974. Gelatin silver print. 9⁷⁄₁₆ × 9½ in. (24.0 × 24.1 cm.). Gift of the artist. 82.29.10.

GOIN, PETER
American, 1951-

Jim. 1977. Gelatin silver print, toned. 11³⁄₁₆ × 14¼ in. (28.4 × 36.2 cm.). Kate and Hall J. Peterson Fund. 78.48.1.

Blank Sheet. 1977. Gelatin silver print, toned. 11½ × 13¹⁵⁄₁₆ in. (29.2 × 35.5 cm.). Kate and Hall J. Peterson Fund. 78.48.2.

"El Conde" Temple near North Group, Palenque, Mexico. 1978. Gelatin silver print, toned. 9 × 11¹⁄₁₆ in. (22.9 × 28.2 cm.). Anonymous gift of funds. 78.49.1.

Three Buildings. 1978. 3 gelatin silver prints, toned. Each approx. 4⅛ × 11⅜ in. (10.5 × 29.0 cm.). Anonymous gift of funds. 78.49.2.

Facade at Tulum. 1978. Gelatin silver print. 9⅜ × 9⁷⁄₁₆ in. (23.8 × 24.0 cm.). Anonymous gift of funds. 78.49.3.

GOLDEN, JUDITH
American, 1934-

[female face]. From *Silver See* portfolio. 1977. Gelatin silver print, hand colored. 13⅞ × 10⅞ in. (35.3 × 27.7 cm.). National Endowment for the Arts purchase grant and miscellaneous matching funds. 77.39.6.

GORDON, SUSAN J.
American, 1952-

[female waist]. 1977. Gelatin silver print. 8 × 12¹⁄₁₆ in. (20.3 × 30.6 cm.). Christina N. and Swan J. Turnblad Memorial Fund. 78.54.1.

[man's chest with goose bumps]. n.d. Gelatin silver print. 8 × 12 in. (20.4 × 30.5 cm.). Christina N. and Swan J. Turnblad Memorial Fund. 78.54.2.

[female pelvis]. 1977. Gelatin silver print. 8 × 12¹⁄₁₆ in. (20.3 × 30.7 cm.). Christina N. and Swan J. Turnblad Memorial Fund. 78.54.3.

GOSSAGE, JOHN
American, 1946-

Chevy Chase, Maryland. 1978. Gelatin silver print. 12¹¹⁄₁₆ × 10¼ in. (32.3 × 26.1 cm.). Gift of the American Telephone and Telegraph Co. 81.120.34.

Ornamentals II. 1978. Gelatin silver print. 11³⁄₁₆ × 9 in. (28.4 × 22.9 cm.). Gift of the American Telephone and Telegraph Co. 81.120.35.

Ornamentals, N. W. Washington, D. C. 1978. Gelatin silver print. 12¹¹⁄₁₆ × 10¼ in. (32.3 × 26.0 cm.). Gift of the American Telephone and Telegraph Co. 81.120.36.

GOWIN, EMMET
American, 1941-

Edith and Elijah. 1969. Gelatin silver print. 5³⁄₁₆ × 6⁹⁄₁₆ in. (13.2 × 16.7 cm.). Kate and Hall J. Peterson Fund. 71.21.4.

Children, Danville, Virginia. 1969. Gelatin silver print. 5¼ × 6¹¹⁄₁₆ in. (13.4 × 17.0 cm.). Kate and Hall J. Peterson Fund. 72.33.

Edith, Danville, Virginia. 1971. Gelatin silver print. 8 × 9⅞ in. (20.3 × 25.2 cm.). Kate and Hall J. Peterson Fund. 72.34.

Edith and Rennie Booher, Danville, Virginia. 1971. Gelatin silver print. 6⅛ × 6⅛ in. (15.6 × 15.6 cm.). Kate and Hall J. Peterson Fund. 72.35.

Edith and Nancy, Danville, Virginia. 1970. Gelatin silver print. 6⅟16 × 6 in. (15.4 × 15.2 cm.). Kate and Hall J. Peterson Fund. 72.36.

Nancy, Danville, Virginia. 1969. Gelatin silver print. 5⅜ × 6⅞ in. (13.6 × 17.4 cm.). David Draper Dayton Fund. 81.21.1.

GRANT, SUSAN K.
American, 1954-

Retailing, Wrinkles and Wisdom. Published by The Black Rose Press, Madison, Wisconsin. 1976. Book of 13 gelatin silver prints. David Draper Dayton Fund. 77.70.1-13.

Mr. and Mrs. L. S. Coryell, "Campus Jeweler." 4⅟16 × 6⅜ in. (11.3 × 16.3 cm.).

Mrs. Antonia Jafferis, "London Hat Cleaning Shop." 4⅜ × 6⅜ in. (11.1 × 16.2 cm.).

Mr. Louis Wagner, "Washington Hotel Proprietor." 4⅜ × 6⅜ in. (11.1 × 16.2 cm.).

Mr. Jay Beardsley, "The Clock Repair Service." 4⅟16 × 6⅜ in. (11.3 × 16.2 cm.).

Mr. Paul C. Bennett, "Petrie's Racket Stringer." 4⅟16 × 6⅜ in. (11.0 × 16.2 cm.).

Mr. and Mrs. Wood, "Ethel Wood's Intimate Apparel." 4⅜ × 6⅜ in. (11.2 × 16.2 cm.).

Mrs. Cecil David, "Badger Tailor, Secretary-Receptionist." 4⅟16 × 6⅜ in. (11.2 × 16.2 cm.).

Mr. David Ballarine, "Roadside Market." 4⅜ × 6⅜ in. (11. × 16.2 cm.).

Mr. Harold Mathison, "Matt's Upholstery." 4⅜ × 6⅜ in. (11.1 × 16.2 cm.).

Mr. Nick David, "Badger Master Tailor." 4⅟16 × 6⅜ in. (11.3 × 16.2 cm.).

Mrs. Mildred E. Brown, "M. Cabrini Shop." 4⅜ × 6⅜ in. (11.0 × 16.2 cm.).

Mr. N. W. Madding, "The Vacuum Repair Shop." 4⅜ × 6⅜ in. (11.1 × 16.2 cm.).

Mrs. Eva Marie Sullivan, "The Doll Hospital." 4⅝ × 6⅜ in. (11.0 × 16.2 cm.).

GREEN, JONATHAN
American, 1939-

[tree shadow on orange wall]. 1976. Color coupler print. 7½ × 11⅟16 in. (19.1 × 28.2 cm.). Gift of Donn Gabor. 80.49.

Key West. 1978. Dye transfer print. 8⅟16 × 13⅟16 in. (22.8 × 34.1 cm.). Gift of the American Telephone and Telegraph Co. 81.120.37.

Miami Beach. 1978. Dye transfer print. 9 × 13⅜ in. (22.9 × 34.0 cm.). Gift of the American Telephone and Telegraph Co. 81.120.38.

Miami Beach. 1978. Dye transfer print. 9 × 13⅟16 in. (22.8 × 34.1 cm.). Gift of the American Telephone and Telegraph Co. 81.120.39.

GROOVER, JAN
American, 1943-

Tybee Forks and Starts (I). 1978. Color coupler print. 3¾ × 4¾ in. (9.5 × 12.0 cm.). Gift of the American Telephone and Telegraph Co. 81.120.40.

Tybee Forks and Starts (L). 1978. Color coupler print. 3¾ × 4¾ in. (9.5 × 12.0 cm.). Gift of the American Telephone and Telegraph Co. 81.120.41.

Tybee Forks and Starts (B). 1978. Color coupler print. 3⅟16 × 4¾ in. (9.5 × 12.0 cm.). Gift of the American Telephone and Telegraph Co. 81.120.42.

GROSZ, GEORGE
American (b. Germany), 1893–1959

Erste Landung. Published by Kimmel/Cohn Photography Arts, New York. 1977. Portfolio of 10 modern gelatin silver prints. Ethel Morrison Van Derlip Fund. 81.41.1-10.

Erste Landung. 1932. 5⅝16 × 7⅟16 in. (13.5 × 19.8 cm.).

Over the Rail. 1932. 5⅛ × 7⅟16 in. (13.1 × 19.6 cm.).

Matrosen. 1932. 5⅜ × 8⅛ in. (13.7 × 20.7 cm.).

Fellow Traveller. 1932. 5⅟16 × 7⅟16 in. (13.2 × 19.9 cm.).

Remembering. 1932. 5¼ × 7⅟16 in. (13.3 × 19.9 cm.).

New York. 1932. 5 × 6½ in. (12.7 × 16.5 cm.).

Shoeshine. 1932. 5⅛ × 7⅝ in. (13.0 × 19.3 cm.).

A Face in the Crowd. 1932. 5¼ × 7¾ in. (13.4 × 19.7 cm.).

Double-Decker. 1932. 5⅛ × 7⅝ in. (13.0 × 19.3 cm.).

Young American. 1932. 5⅛ × 7⅝16 in. (13.0 × 19.2 cm.).

GURNEY, JEREMIAH
American, 19th century

[portrait of a gentleman]. c. 1852. Daguerreotype, (halfplate). 4⅝16 × 3½ in. (oval). Gift of Virginia P. Moe. 81.121.

HAHN, BETTY
American, 1940-

[Lone Ranger]. From *The New Mexico Portfolio.* 1976. Lithograph. 13 × 10¼ in. (33.1 × 26.1 cm.). National Endowment for the Arts purchase grant and miscellaneous matching funds. 76.61.5.

HAJEK-HALKE, HEINZ
German, 1898-

Akt Komposition. c. 1930. Gelatin silver print. 15⅜ × 11⅟16 in. (39.2 × 29.7 cm.). John R. Van Derlip Fund. 81.81.

HALLMAN, GARY L.
American, 1940-

Retaining Wall. 1971. Gelatin silver print, toned. 22⅛ × 33⅟16 in. (56.3 × 84.0 cm.). Kate and Hall J. Peterson Fund. 72.111.

Winter Fountain Cover. n.d. Gelatin silver print, toned. 22 × 32⅟16 in. (55.9 × 80.9 cm.). Kate and Hall J. Peterson Fund. 72.112.

Only Select Beans. 1975. Gelatin silver print. 19⅟16 × 29⅟16 in. (50.4 × 74.8 cm.). Kate and Hall J. Peterson Fund. 72.113.

Salad under Glass (Thin Potatoes Fall Somewhat Farther than Thicker Onions). 1975. Gelatin silver print. 19⅟16 × 29¼ in. (50.0 × 74.3 cm.). Kate and Hall J. Peterson Fund. 72.114.

Midwestern Monoliths. Published by Christopher Cardozo, Inc. 1982. Portfolio of 10 gelatin silver prints. Gift of Frank Kolodny. 82.126.11-20.

St. Anthony Elevator No. 3, Minneapolis. 1976. 12⅟16 × 15⅝16 in. (31.6 × 38.9 cm.).

Gold Medal Elevator, Minneapolis. 1976. 12⅟16 × 15⅝16 in. (31.6 × 38.9 cm.).

P.V. Electric Steel Elevator, Minneapolis. 1976. 12⅟16 × 15⅝16 in. (31.6 × 38.9 cm.).

Kurth Malting, Minneapolis. 1976. 12⅜ × 15⅝16 in. (31.5. × 38.8 cm.).

ConAgra, Minneapolis. 1976. 12⅟16 × 15⅝16 in. (31.6 × 38.9 cm.).

General Mills Elevator (Broadway-Central), Minneapolis. 1976. 12⅟16 × 15⅝16 in. (31.6 × 38.9 cm.).

Calumet Elevator, Minneapolis. 1976. 12⅟16 × 15⅝16 in. (31.6 × 38.9 cm.).

Hiawatha Elevator, Minneapolis. 1976. 12⅜ × 15¼ in. (31.5. × 38.8 cm.).

Peavey Elevator (Great Northern Line), Minneapolis. 1976. 12⅟16 × 15⅝16 in. (31.6 × 38.9 cm.).

Peavey Elevator (Northern Pacific Line), Minneapolis. 1976. 12⅟16 × 15⅝16 in. (31.6 × 38.9 cm.).

HALVORSON, GLENN
American, 1946-

[clown and people at lake]. 1975. Gelatin silver print. 12⅟16 × 18⅟16 in. (32.2 × 47.8 cm.). Kate and Hall J. Peterson Fund. 75.45.1.

[waitress and kitchen window]. n.d. Gelatin silver print. 12⅟16 × 18½ in. (31.7 × 47.0 cm.). Kate and Hall J. Peterson Fund. 75.45.3.

[man and woman in store aisle]. 1975. Gelatin silver print. 12¾ × 18⅟16 in. (32.4 × 48.1 cm.). Kate and Hall J. Peterson Fund. 75.45.4.

[shoppers at meat counter]. 1975. Gelatin silver print. 12⅟16 × 18⅞ in. (32.3 × 48.0 cm.). Kate and Hall J. Peterson Fund. 75.45.5.

[girl sitting at table]. 1975. Gelatin silver print. 12¾ × 19 in. (32.3 × 48.2 cm.). Kate and Hall J. Peterson Fund. 75.45.6.

[two men and a woman]. 1976. Gelatin silver print. 14 × 13⅟16 in. (35.6 × 35.5 cm.). Gift of the artist. 82.59.1.

[women against building]. 1976. Gelatin silver print. 14 × 13⅟16 in. (35.6 × 35.5 cm.). Gift of the artist. 82.59.2.

HAMMERBECK, WANDA LEE
American, 1945-

[trees and pipe]. From *New California Views* portfolio. 1979. Color coupler print (Ektacolor). 9¼ × 13⅟16 in. (23.6 × 34.5 cm.). Gift of funds from the Photography Council of The Minneapolis Institute of Arts. 80.24.7.

HARTER, DONALD SCOTT
American, 1950-

Land Extractions. Published by LTD Press, Madison, Wisconsin. 1975. Portfolio of 10 gelatin silver prints. Each 6¼ × 6¼ in. (15.9 × 15.9 cm.). National Endowment for the Arts purchase grant and miscellaneous matching funds. 76.65.1-10.
[smokestack].
[two tanks].
[silos].
[building].
[building].
[corrugated building].
[Soo Line rail car].
[tanks].
[building].
[Cenex tank].

Shadow of My Likeness. Published by LTD Press, Madison, Wisconsin. 1976. Booklet of 7 gelatin silver prints, toned, and bound accordian style. Each 4¼ × 4¼ in. (11.0 × 11.0 cm.). National Endowment for the Arts purchase grant and miscellaneous matching funds. 76.66.

A Matchless Flipperbook. 1976. 12 gelatin silver prints in matchbook cover. 2⅝ × 2⅛ in. (5.8 × 5.4 cm.). Gift of the artist. 82.60.

HAVILAND, PAUL B.
See *Camera Work*

HEATH, DAVID
Canadian (b. United States), 1931-

Work in Progress. Published by Westbank Gallery, Minneapolis. 1965. Portfolio of 5 gelatin silver prints. Ethel Morrison Van Derlip Fund. 70.76.12-16.
[crushed mask]. 1964. 5⅛ × 7½ in. (12.8 × 19.1 cm.).
[children]. 1964. 5 × 7½ in. (12.7 × 19.0 cm.).
[woman at mirror]. 1964. 7½ × 5¹/₁₆ in. (19.0 × 12.9 cm.).
[old black hands]. 1964. 5 × 7⅞ in. (12.8 × 19.0 cm.).
[woman]. 1964. 7⁷/₁₆ × 5¹/₁₆ in. (19.0 × 12.9 cm.).

Work in Progress. Another copy. Gift of Christopher Cardozo. 79.36.1-5.

HEINECKEN, ROBERT
American, 1931-

3 Repro-lingual Items for Bart. From *Underware* portfolio. 1976. Polaroid SX-70, electrostatic print, and stamp. 16 × 20 in. (40.7 × 50.8 cm.). National Endowment for the Arts purchase grant and miscellaneous matching funds. 76.64.8.

State of the Art/Computer Image Enhancement and Analysis. From *Silver See* portfolio. 1976. Lithograph with color coupler print. 19⅞ × 14⅞ in. (50.5 × 37.8 cm.). National Endowment for the Arts purchase grant and miscellaneous matching funds. 77.39.7.

HELLMUTH, SUZANNE and JOCK REYNOLDS
American, 1947- American, 1947-

Exchange. 1982. 3 gelatin silver prints. 20 × 72 in. approx. total. Gift of Martin Weinstein. 82.133.1-3.

HENKEL, JAMES
American, 1947-

Miami/Minneapolis. 1977. Color coupler print. 8⁷/₁₆ × 12¹⁵/₁₆ in. (21.5 × 32.8 cm.). Paul J. Schmitt Fund. 78.40.1.

Miami/Minneapolis. 1977. Color coupler print. 8⁷/₁₆ × 13 in. (21.5 × 33.0 cm.). Paul J. Schmitt Fund. 78.40.2.

Minneapolis. 1977. Color coupler print. 8⅜ × 12⅞ in. (21.3 × 32.8 cm.). Paul J. Schmitt Fund. 78.40.3.

Miami/Minneapolis. 1978. Color coupler print. 8¼ × 12⅞ in. (21.4 × 32.9 cm.). Paul J. Schmitt Fund. 78.40.4.

Miami/Minneapolis. 1977. Color coupler print. 8⅜ × 12¹⁵/₁₆ in. (21.4 × 32.8 cm.). Gift of the artist. 78.41.

Wawa/Mpls. From *Minnesota Photographers* portfolio. 1978. Color coupler print. 8½ × 12¹⁵/₁₆ in. (21.7 × 33.0 cm.). John R. Van Derlip Fund. 79.48.4.

Mexico/Minnesota. 1979. Color coupler print. 21¹⁵/₁₆ × 33 in. (55.8 × 83.8 cm.). Gift of Ron and Lucy Moody. 80.21.2.

Guatemala/Minnesota. 1979. Color coupler print. 11⅞ × 17⅞ in. (30.1 × 45.4 cm.). Gift of the artist. 80.50.

HENNEBERG, HUGO
See *Camera Work*

HENZE, CLAIRE
American, 1945-

Waikiki. From *Silver See* portfolio. 1974. Gelatin silver print. 5¹³/₁₆ × 8¹¹/₁₆ in. (14.8 × 22.1 cm.). National Endowment for the Arts purchase grant and miscellaneous matching funds. 77.39.8.

HERZOG, F. BENEDICT
See *Camera Work*

HILL, DAVID OCTAVIUS and ROBERT ADAMSON
Scottish, 1802-1870 Scottish, 1821-1848

The Reverend Robert Young. c. 1845. Calotype. 8 × 6 in. (20.3 × 15.2 cm.). Anonymous gift of funds. 78.4.

See also *Camera Work*

HINE, LEWIS W.
American, 1874-1940

[newsboy, Indianapolis, Indiana]. 1908. Gelatin silver print. 6⅝ × 4¹¹/₁₆ in. (16.9 × 11.9 cm.). Kate and Hall J. Peterson Fund. 71.21.5.

[girl at cotton machine, North Carolina]. 1908. Gelatin silver print. 5 × 6⁹/₁₆ in. (12.7 × 16.7 cm.). Kate and Hall J. Peterson Fund. 71.21.6.

[newsboys, Waco, Texas]. 1913. Gelatin silver print. 4⁷/₁₆ × 6⁷/₁₆ in. (11.3 × 16.3 cm.). Kate and Hall J. Peterson Fund. 71.21.7.

[girl entering factory door, New York City]. 1912. Gelatin silver print. 4¹³/₁₆ × 6¾ in. (12.1 × 17.1 cm.). Kate and Hall J. Peterson Fund. 71.21.8.

[child mill workers, South Carolina]. 1908. Gelatin silver print. 4¾ × 6¹¹/₁₆ in. (12.1 × 17.0 cm.). Kate and Hall J. Peterson Fund. 71.21.9.

[newsboys in cafe, Cincinnati, Ohio]. 1908. Gelatin silver print. 6¹¹/₁₆ × 4¾ in. (16.9 × 12.2 cm.). Kate and Hall J. Peterson Fund. 71.21.10.

[housing condition, New Jersey]. 1910. Gelatin silver print. 3⁷/₁₆ × 4½ in. (8.8 × 11.4 cm.). Kate and Hall J. Peterson Fund. 71.21.11.

[workers leaving Hamilton-Brown Shoe Company]. 1910. Gelatin silver print. 4¹¹/₁₆ × 6⅝ in. (11.9 × 16.9 cm.). Kate and Hall J. Peterson Fund. 72.121.

Boy at Planing Machine, Peru, Indiana. 1908. Gelatin silver print. 4¾ × 6¹¹/₁₆ in. (12.0 × 17.0 cm.). Kate and Hall J. Peterson Fund. 72.122.

[physical examination]. 1913. Gelatin silver print. 6¹³/₁₆ × 4⅞ in. (17.4 × 12.4 cm.). David Draper Dayton Fund. 74.13.1.

[young worker, St. Louis, Missouri]. 1910. Gelatin silver print. 4¹¹/₁₆ × 3⅜ in. (12.0 × 8.6 cm.). David Draper Dayton Fund. 74.13.2.

Girls Going Home from Indianapolis Tile Works. 1908. Gelatin silver print. 4⅝ × 6⅝ in. (11.7 × 16.9 cm.). David Draper Dayton Fund. 74.13.3.

[newsboy, Waco, Texas]. 1913. Gelatin silver print. 4⅜ × 6⅜ in. (11.2 × 16.3 cm.). David Draper Dayton Fund. 74.13.4.

[girl with baskets]. 1908. Gelatin silver print. 6⅝ × 4⅝ in. (16.9 × 11.8 cm.). Ethel Morrison Van Derlip Fund. 74.39.1.

[boy with one arm, West Virginia]. 1907. Gelatin silver print. 6⅝ × 4⅝ in. (16.8 × 11.8 cm.). Ethel Morrison Van Derlip Fund. 74.39.2.

[child, North Carolina]. 1908. Gelatin silver print. 4⅝ × 6⅝ in. (11.8 × 16.9 cm.). Ethel Morrison Van Derlip Fund. 74.39.3.

[children standing by porch, South Carolina]. 1908. Gelatin silver print. 4⅝ × 6⁹/₁₆ in. (11.7 × 16.7 cm.). Ethel Morrison Van Derlip Fund. 74.39.4.

[woman with children outside house, South Carolina]. 1908. Gelatin silver print. 4¹¹/₁₆ × 6⁹/₁₆ in. (11.9 × 16.7 cm.). Ethel Morrison Van Derlip Fund. 74.39.5.

Macon, Georgia. 1909. Gelatin silver print. 4¹¹/₁₆ × 6⅝ in. (11.9 × 16.9 cm.). Ethel Morrison Van Derlip Fund. 74.39.6.

[newsgirls, Connecticut]. 1909. Gelatin silver print. 4¾ × 6¹¹/₁₆ in. (12.0 × 17.1 cm.). Ethel Morrison Van Derlip Fund. 74.39.7.

[young females at mill entrance, New Hampshire]. 1909. Gelatin silver print. 4⅝ × 6⁹/₁₆ in. (11.7 × 16.7 cm.). Ethel Morrison Van Derlip Fund. 74.39.8.

[interior with mattress]. 1910. Gelatin silver print. 2¹³/₁₆ × 4⅜ in. (7.1 × 11.2 cm.). Ethel Morrison Van Derlip Fund. 74.39.9.

[child and man mill workers, Mississippi]. 1911. Gelatin silver print. 4⅝ × 6⅝ in. (11.7 × 16.9 cm.). Ethel Morrison Van Derlip Fund. 74.39.10.

[homeworkers in tenements, New York City]. 1911. Gelatin silver print. 4¹¹/₁₆ × 6½ in. (12.0 × 16.5 cm.). Ethel Morrison Van Derlip Fund. 74.39.11.

[homeworkers, Massachusetts]. 1912. Gelatin silver print. 4⅝ × 6⁹/₁₆ in. (11.8 × 16.7 cm.). Ethel Morrison Van Derlip Fund. 74.39.12.

[Western Union messenger boy on bike, Waco, Texas]. 1913. Gelatin silver print. 4⁷⁄₁₆ × 6³⁄₈ in. (11.3 × 16.1 cm.). Ethel Morrison Van Derlip Fund. 74.39.13.

[mill workers resting, Indianapolis, Indiana]. 1908. Gelatin silver print. 4³⁄₈ × 6⁹⁄₁₆ in. (11.1 × 16.6 cm.). Ethel Morrison Van Derlip Fund. 74.39.14.

[man and his three sons, West Virginia]. 1908. Gelatin silver print. 4¹¹⁄₁₆ × 6⅝ in. (12.0 × 16.9 cm.). Ethel Morrison Van Derlip Fund. 74.39.15.

[factory children, North Carolina]. 1908. Gelatin silver print. 4⅝ × 6¹¹⁄₁₆ in. (11.8 × 16.9 cm.). Ethel Morrison Van Derlip Fund. 74.39.16.

[row of mill workers' homes, South Carolina]. 1908. Gelatin silver print. 5 × 6¹³⁄₁₆ in. (12.7 × 17.3 cm.). Ethel Morrison Van Derlip Fund. 74.39.17.

[children entering mill, South Carolina]. 1908. Gelatin silver print. 4⅝ × 6⅝ in. (11.8 × 16.9 cm.). Ethel Morrison Van Derlip Fund. 74.39.18.

[female workers, Macon, Georgia]. 1909. Gelatin silver print. 4¾ × 6¹¹⁄₁₆ in. (12.0 × 17.1 cm.). Ethel Morrison Van Derlip Fund. 74.39.19.

[newsboys, Connecticut]. 1909. Gelatin silver print. 4⅝ × 6½ in. (11.8 × 16.4 cm.). Ethel Morrison Van Derlip Fund. 74.39.20.

[berry picker, Baltimore]. 1909. Gelatin silver print. 4½ × 6⁹⁄₁₆ in. (11.5 × 16.7 cm.). Ethel Morrison Van Derlip Fund. 74.39.21.

[messenger boy, Delaware]. 1910. Gelatin silver print. 4¹¹⁄₁₆ × 3¹¹⁄₁₆ in. (11.9 × 9.4 cm.). Ethel Morrison Van Derlip Fund. 74.39.22.

[mill workers, Virginia]. 1911. Gelatin silver print. 4½ × 5¼ in. (11.5 × 13.3 cm.). Ethel Morrison Van Derlip Fund. 74.39.23.

[homeworker Annie De Martius and children]. 1911. Gelatin silver print. 4¹¹⁄₁₆ × 6¹¹⁄₁₆ in. (12.0 × 17.0 cm.). Ethel Morrison Van Derlip Fund. 74.39.24.

[newspaper stand]. 1913. Gelatin silver print. 4⁷⁄₁₆ × 6³⁄₈ in. (11.2 × 16.3 cm.). Ethel Morrison Van Derlip Fund. 74.39.25.

[child mill worker, Texas]. 1913. Gelatin silver print. 4½ × 6⁹⁄₁₆ in. (11.5 × 16.7 cm.). Ethel Morrison Van Derlip Fund. 74.39.26.

[boy with one arm]. 1907. Gelatin silver print. 5³⁄₈ × 2⁷⁄₁₆ in. (13.7 × 6.3 cm.). Ethel Morrison Van Derlip Fund. 74.39.27.

[man leaving mill, Indiana]. 1908. Gelatin silver print. 4⅝ × 5¹³⁄₁₆ in. (11.8 × 14.8 cm.). Ethel Morrison Van Derlip Fund. 74.39.28.

[child in front of carriage, North Carolina]. 1908. Gelatin silver print. 4⅝ × 6⅝ in. (11.8 × 16.9 cm.). Ethel Morrison Van Derlip Fund. 74.39.29.

[figures with porch, South Carolina]. 1908. Gelatin silver print. 4¹¹⁄₁₆ × 6⅝ in. (11.8 × 16.9 cm.). Ethel Morrison Van Derlip Fund. 74.39.30.

[mill workers, North Carolina]. c. 1908. Gelatin silver print. 4¹¹⁄₁₆ × 6⅝ in. (11.9 × 16.8 cm.). Ethel Morrison Van Derlip Fund. 74.39.31.

[boy on porch, Macon, Georgia]. 1909. Gelatin silver print. 4⅝ × 6⅝ in. (11.7 × 16.9 cm.). Ethel Morrison Van Derlip Fund. 74.39.32.

[seven women]. 1909. Gelatin silver print. 3¼ × 5½ in. (8.3 × 14.0 cm.). Ethel Morrison Van Derlip Fund. 74.39.33.

[children, New Jersey]. 1909. Gelatin silver print. 4⅝ × 5⅝ in. (11.8 × 14.3 cm.). Ethel Morrison Van Derlip Fund. 74.39.34.

[cotton mill workers, Tennessee]. 1910. Gelatin silver print. 4⅝ × 6½ in. (11.7 × 16.5 cm.). Ethel Morrison Van Derlip Fund. 74.39.35.

[child, Maine]. 1911. Gelatin silver print. 2¹⁄₁₆ × 4¼ in. (5.3 × 10.8 cm.). Ethel Morrison Van Derlip Fund. 74.39.36.

[mill exterior]. c. 1912. Gelatin silver print. 4¾ × 6¹¹⁄₁₆ in. (12.1 × 17.0 cm.). Ethel Morrison Van Derlip Fund. 74.39.37.

[young cotton pickers in field, Denison, Texas]. 1913. Gelatin silver print. 4¹³⁄₁₆ × 6¾ in. (12.3 × 17.2 cm.). Ethel Morrison Van Derlip Fund. 74.39.38.

[child worker, Indianapolis, Indiana]. 1908. Gelatin silver print. 6⅝ × 4⅝ in. (16.8 × 11.8 cm.). Ethel Morrison Van Derlip Fund. 74.39.39.

[boy, Indiana]. 1908. Gelatin silver print. 4¹¹⁄₁₆ × 6⅝ in. (11.8 × 16.8 cm.). Ethel Morrison Van Derlip Fund. 74.39.40.

[boys and porch, North Carolina]. 1908. Gelatin silver print. 4⅝ × 6⅝ in. (11.8 × 16.9 cm.). Ethel Morrison Van Derlip Fund. 74.39.41.

[girls in front of porch, South Carolina]. 1908. Gelatin silver print. 4¹⁵⁄₁₆ × 6¹¹⁄₁₆ in. (12.5 × 17.0 cm.). Ethel Morrison Van Derlip Fund. 74.39.42.

[child workers, Macon, Georgia]. 1909. Gelatin silver print. 4⅝ × 6⁹⁄₁₆ in. (11.7 × 16.6 cm.). Ethel Morrison Van Derlip Fund. 74.39.43.

[cigar factory interior, Tampa, Florida]. 1909. Gelatin silver print. 4⅝ × 6⁹⁄₁₆ in. (11.8 × 16.6 cm.). Ethel Morrison Van Derlip Fund. 74.39.44.

[four women]. 1909. Gelatin silver print. 3⁷⁄₁₆ × 5½ in. (8.3 × 14.0 cm.). Ethel Morrison Van Derlip Fund. 74.39.45.

[cranberry pickers, New Jersey]. 1910. Gelatin silver print. 3¹¹⁄₁₆ × 4¾ in. (9.5 × 12.0 cm.). Ethel Morrison Van Derlip Fund. 74.39.46.

[child by dwelling, Mississippi]. 1911. Gelatin silver print. 4⁷⁄₁₆ × 6⁷⁄₁₆ in. (11.4 × 16.4 cm.). Ethel Morrison Van Derlip Fund. 74.39.47.

[berry pickers in field, Massachusetts]. 1911. Gelatin silver print. 4⁹⁄₁₆ × 6⁹⁄₁₆ in. (11.6 × 16.7 cm.). Ethel Morrison Van Derlip Fund. 74.39.48.

[woman carrying box on head, New York City]. 1912. Gelatin silver print. 4¹¹⁄₁₆ × 6¹¹⁄₁₆ in. (12.0 × 16.9 cm.). Ethel Morrison Van Derlip Fund. 74.39.49.

Messenger Boy, Waco, Texas. 1913. Gelatin silver print. 4⅝ × 6⅝ in. (11.8 × 16.9 cm.). Ethel Morrison Van Derlip Fund. 74.39.50.

Man and Mechrometer. 1930. Gelatin silver print. 7⁵⁄₁₆ × 9⅜ in. (18.6 × 23.8 cm.). Anonymous gift of funds. 78.92.1.

HINTON, A. HORSLEY
See Camera Work

HISER, CHERI
American, 1935-

Self Portrait with Sandy. From The New Mexico Portfolio. 1974. Gelatin silver print. 6⅝ × 10 in. (16.8 × 25.5 cm.). National Endowment for the Arts purchase grant and miscellaneous matching funds. 76.61.6.

HODSON, RANDY
American (?), 20th century

[shadow]. From What Ever Happened to Sexuality portfolio. c. 1977. Gelatin silver print. 5⁹⁄₁₆ × 7⅞ in. (14.1 × 19.9 cm.). Gift of the artist. 82.70.6.

HOEHN, GEORGE
American, 1935-

Mantilla. From Maya—Portraits in Illusion. 1977. Gelatin silver print. 7 × 4⅜ in. (17.7 × 11.2 cm.). Mr. and Mrs. Harrison R. Johnston, Jr. Fund. 78.17.1.

Cloche. From Maya—Portraits in Illusion. 1977. Gelatin silver print. 6 × 4⅞ in. (15.2 × 12.4 cm.). Mr. and Mrs. Harrison R. Johnston, Jr. Fund. 78.17.2.

Reflection. From Maya—Portraits in Illusion. 1977. Gelatin silver print. 7⁹⁄₁₆ × 4⁹⁄₁₆ in. (19.2 × 11.6 cm.). Mr. and Mrs. Harrison R. Johnston, Jr. Fund. 78.17.3.

Beads. From Maya—Portraits in Illusion. 1977. Gelatin silver print. 5¹⁵⁄₁₆ × 4⅞ in. (15.1 × 12.4 cm.). Mr. and Mrs. Harrison R. Johnston, Jr. Fund. 78.17.4.

Black. From Maya—Portraits in Illusion. 1977. Gelatin silver print. 6⅞ × 4½ in. (17.5 × 11.5 cm.). Mr. and Mrs. Harrison R. Johnston, Jr. Fund. 78.17.5.

HOFFMAN, ALAN
American, 1953-

Little Girl between Cars. From The New Mexico Portfolio. 1974. Gelatin silver print. 7⁷⁄₁₆ × 11⅝ in. (18.9 × 29.6 cm.). National Endowment for the Arts purchase grant and miscellaneous matching funds. 76.61.7.

HOFMEISTER, THEODOR and OSCAR
See Camera Work

HOLMGREN, ROBERT
American, 1946-

[hand with specks of white paint]. 1978. Gelatin silver print. 12³⁄₁₆ × 17⅞ in. (31.0 × 45.5 cm.). Gift of funds from the Photography Council of The Minneapolis Institute of Arts. 81.67.1.

[hand holding fish out of water]. 1979. Gelatin silver print. 12¼ × 17¹⁵⁄₁₆ in. (31.2 × 45.5 cm.). Gift of funds from the Photography Council of The Minneapolis Institute of Arts. 81.67.2.

Jake. 1979. Gelatin silver print. 12¼ × 17¹⁵⁄₁₆ in. (31.2 × 45.6 cm.). Gift of funds from the Photography Council of The Minneapolis Institute of Arts. 81.67.3.

[baby bottle in chain-link fence]. 1981. Gelatin silver print. 12⅛ × 17⅞ in. (30.9 × 45.5 cm.). Gift of the artist. 81.68.

HOPE, JAMES D.
American, 1846-1929

Reflection in Cathedral, Watkins Glen, New York. n.d. Albumen print. 9½ × 7⁹⁄₁₆ in. (24.1 × 19.3 cm.). Kate and Hall J. Peterson Fund. 80.16.1.

HORNER, PATRICIA
American, 1945-

[swimsuit]. c. 1977. 2 color coupler prints. Each 4⅛ × 6¼ in. (10.5 × 16.0 cm.). Kate and Hall J. Peterson Fund and anonymous gift of funds. 78.44.1.

[figure in white door]. c. 1977. 2 color coupler prints. Each 4⅛ × 6¼ in. (10.5 × 16.0 cm.). Kate and Hall J. Peterson Fund and anonymous gift of funds. 78.44.2.

[sweatered figure and chair]. c. 1977. 2 color coupler prints. Each 5⅝ × 8½ in. (14.0 × 21.5 cm.). Kate and Hall J. Peterson Fund and anonymous gift of funds. 78.44.3.

[pencil against green wall]. c. 1977. 2 color coupler prints. Each 4½ × 6¾ in. (11.5 × 17.5 cm.). Kate and Hall J. Peterson Fund and anonymous gift of funds. 78.44.4.

[daughter of the artist]. c. 1977. 2 color coupler prints. Each 4½ × 6⅞ in. (11.5 × 17.5 cm.). Kate and Hall J. Peterson Fund and anonymous gift of funds. 78.44.5.

[hands and strip of portraits against sky]. c. 1977. 2 color coupler prints. Each 4¼ × 6⅜ in. (10.5 × 16.0 cm.). Gift of the artist. 78.45.1.

[figure with sunset]. c. 1977. 2 color coupler prints. Each 5⅛ × 7¾ in. (13.0 × 19.5 cm.). Gift of the artist. 78.45.2.

[woman in bathing suit]. From *Minnesota Photographers* portfolio. 1978. Color coupler print. 6½ × 9⅞ in. (16.6 × 25.2 cm.). John R. Van Derlip Fund. 79.48.5.

HOUSE, SUDA
American, 1951-

What's a Woman to Do. From *L. A. Issue* portfolio. Electrostatic images on fabric, stitched. 13⅝ × 8⅝ in. (34.6 × 21.9 cm.). Gift of funds from the Photography Council of The Minneapolis Institute of Arts. 80.25.8.

HOWE, GRAHAM
American (b. Australia), 1950-

Stakes in Ground. From *New California Views* portfolio. 1978. Gelatin silver print. 13 × 16⁵⁄₁₆ in. (33.1 × 41.6 cm.). Gift of funds from the Photography Council of The Minneapolis Institute of Arts. 80.24.8.

HUSEBYE, TERRY L.
American, 1945-

Flood Victims of Harrisburg. Published by Push-press, Madison, Wisconsin. 1973. Book of 19 gelatin silver prints. Kate and Hall J. Peterson Fund. 74.15.1-19.
[Stella Jones]. 4 × 2¾ in. (10.2 × 7.0 cm.).
[man in front of house]. 4³⁄₁₆ × 6³⁄₁₆ in. (10.7 × 15.7 cm.).

[woman among ruins]. 6³⁄₁₆ × 4¼ in. (15.8 × 10.8 cm.).
[three children]. 6³⁄₁₆ × 4¼ in. (15.8 × 10.7 cm.).
[man and boys cleaning debris]. 4³⁄₁₆ × 6¼ in. (10.7 × 15.8 cm.).
[man and woman inside dwelling]. 4¼ × 6¼ in. (10.7 × 15.9 cm.).
[woman against staircase and wall]. 4³⁄₁₆ × 6³⁄₁₆ in. (10.7 × 15.7 cm.).
[man in window]. 4¼ × 6³⁄₁₆ in. (10.7 × 15.7 cm.).
[two women in kitchen]. 4¼ × 6³⁄₁₆ in. (10.7 × 15.7 cm.).
[young man holding saw]. 4³⁄₁₆ × 6³⁄₁₆ in. (10.7 × 15.7 cm.).
[baby in run-down dwelling]. 6¼ × 4³⁄₁₆ in. (15.8 × 10.7 cm.).
[bulldozer seen through dirty window]. 6³⁄₁₆ × 4¼ in. (15.7 × 10.7 cm.).
[man and woman cleaning window]. 4¼ × 6³⁄₁₆ in. (10.7 × 15.7 cm.).
[black man in striped shirt]. 4³⁄₁₆ × 6¼ in. (10.7 × 15.8 cm.).
[woman and two boys at store door]. 4³⁄₁₆ × 6³⁄₁₆ in. (10.7 × 15.7 cm.).
[two girls against wall of graffiti]. 4¼ × 6³⁄₁₆ in. (10.7 × 15.7 cm.).
[black couple]. 6¼ × 4³⁄₁₆ in. (15.9 × 10.7 cm.).
[woman carrying boxes upstairs]. 4¼ × 6³⁄₁₆ in. (10.7 × 15.8 cm.).
[young girl and row of mobile homes]. 4¼ × 6¼ in. (10.7 × 15.8 cm.).

Untitled. From *Ocotillo Flat* series. 1981. Color coupler print. 17 × 16¹⁵⁄₁₆ in. (43.2 × 43.1 cm.). Ethel Morrison Van Derlip Fund. 82.35.1.

Untitled. From *Ocotillo Flat* series. 1981. Color coupler print. 17 × 16¹⁵⁄₁₆ in. (43.2 × 43.1 cm.). Ethel Morrison Van Derlip Fund. 82.35.2.

Untitled. From *Ocotillo Flat* series. 1981. Color coupler print. 17 × 16¹⁵⁄₁₆ in. (43.2 × 43.1 cm.). Ethel Morrison Van Derlip Fund. 82.35.3.

Untitled. From *Ocotillo Flat* series. 1979. Color coupler print. 17 × 16¹⁵⁄₁₆ in. (43.2 × 43.1 cm.). Gift of the artist. 82.36.1.

Untitled. From *Ocotillo Flat* series. 1980. Color coupler print. 17 × 17 in. (43.2 × 43.1 cm.). Gift of the artist. 82.36.2.

HUSOM, DAVID
American, 1948-

Tree Study I. 1973. Gelatin silver print (Kodalith paper). 5¹⁵⁄₁₆ × 8⅝ in. (15.1 × 22.0 cm.). Kate and Hall J. Peterson Fund. 73.30.1.

Tree Study I. 1973. Gelatin silver print (Kodalith paper). 6 × 8¹¹⁄₁₆ in. (15.2 × 22.0 cm.). Kate and Hall J. Peterson Fund. 73.30.2.

Flat Iron for Alfred Stieglitz. 1973. Gelatin silver print (Kodalith paper). 5¹⁵⁄₁₆ × 8⅜ in. (15.2 × 21.2 cm.). Kate and Hall J. Peterson Fund. 73.30.3.

Flat Iron for Alfred Stieglitz. 1973. Gelatin silver print (Kodalith paper). 6 × 8¼ in. (15.3 × 21.0 cm.). Kate and Hall J. Peterson Fund. 73.30.4.

Barrier Series No. 7. 1976. Color coupler print. 11¾ × 17⅛ in. (29.9 × 43.6 cm.). Kate and Hall J. Peterson Fund. 77.13.1.

Barrier Series No. 5. 1976. Color coupler print. 11⅝ × 17⅛ in. (29.6 × 43.6 cm.). Kate and Hall J. Peterson Fund. 77.13.2.

Barrier Series No. 1. 1976. Color coupler print. 11¾ × 17⅛ in. (30.0 × 43.6 cm.). Kate and Hall J. Peterson Fund. 77.13.3.

Barrier Series No. 9. 1976. Color coupler print. 11⅝ × 17⅛ in. (29.6 × 43.6 cm.). Gift of the artist. 77.14.1.

Barrier Series No. 4. 1976. Color coupler print. 11¾ × 17⅛ in. (29.9 × 43.6 cm.). Gift of the artist. 77.14.2.

Sancious. From *Minnesota Photographers* portfolio. 1978. Color coupler print. 7¾ × 11¾ in. (19.7 × 29.9 cm.). John R. Van Derlip Fund. 79.48.6.

JACHNA, JOSEPH D.
American, 1935-

Door County, Wisconsin. 1970. Gelatin silver print. 6³⁄₁₆ × 9¼ in. (15.7 × 23.5 cm.). Gift of Arnold M. Gilbert. 74.61.1.

Door County, Wisconsin. 1970. Gelatin silver print. 8¹⁄₁₆ × 12 in. (20.5 × 30.6 cm.). Gift of Arnold M. Gilbert. 74.61.2.

Under the Influence of Wynn Bullock. 1967. Gelatin silver print. 8¹⁵⁄₁₆ × 8¹⁵⁄₁₆ in. (22.7 × 22.7 cm.). Gift of Arnold M. Gilbert. 74.61.3.

South Fork, Flambeau River. 1967. Gelatin silver print. 9⅞ × 10 in. (25.2 × 25.4 cm.). Gift of Arnold M. Gilbert. 74.61.4.

Slaugh Gundy. 1967. Gelatin silver print. 9¹³⁄₁₆ × 10 in. (25.0 × 25.4 cm.). Gift of Arnold M. Gilbert. 75.61.5.

Colorado. From *Underware* portfolio. 1975. Gelatin silver print. 9 × 13⁷⁄₁₆ in. (22.8 × 34.1 cm.). National Endowment for the Arts puchase grant and miscellaneous matching funds. 76.64.9.

JACKSON, WILLIAM HENRY
American, 1843-1942

Mt. Hayden of the Great Teton. From *Photographs of the Yellowstone National Park* album. 1873. Albumen print. 12¹³⁄₁₆ × 9¹⁵⁄₁₆ in. (32.5 × 25.3 cm.). Mr. and Mrs. Julius E. Davis Fund. 81.7.1.

The Three Tetons. From *Photographs of the Yellowstone National Park* album. 1873. Albumen print. 10 × 12¹³⁄₁₆ in. (25.3 × 32.6 cm.). Mr. and Mrs. Julius E. Davis Fund. 81.7.2.

The Three Tetons, Panoramic View. From *Photographs of the Yellowstone National Park* album. 1873. Albumen print. 10 × 12¹⁵⁄₁₆ in. (25.4 × 32.9 cm.). Mr. and Mrs. Julius E. Davis Fund. 81.7.3.

Hot Spring and Castle Geyser. From *Photographs of the Yellowstone National Park* album. 1873. Albumen print. 8¹¹⁄₁₆ × 12⁷⁄₁₆ in. (22.1 × 31.6 cm.). Mr. and Mrs. Julius E. Davis Fund. 81.7.4.

Upper Falls of the Yellowstone. From *Photographs of the Yellowstone National Park* album. 1873. Albumen print. 10 × 12⅞ in. (25.4 × 32.7 cm.). Mr. and Mrs. Julius E. Davis Fund. 81.7.5.

JAMES, CHRISTOPHER P.
American, 1947-

Self Portrait with Horn No. 4. 1976. Gelatin silver print, hand-dyed and enameled. 5 × 7¼ in. (12.5 × 18.5 cm.). National Endowment for the Arts purchase grant and miscellaneous matching funds. 76.85.

Parking Lot "A" No. 3. 1977. Gelatin silver print, hand dyed and enameled. 5⅛ × 7⅜ in. (13.0 × 19.0 cm.). David Draper Dayton Fund. 77.71.1.

Leaves No. 7. 1977. Gelatin silver print, hand dyed and enameled. 5⅛ × 7⅜ in. (13.0 × 19.0 cm.). David Draper Dayton Fund. 77.71.2.

Tent/Sky "B" No. 4. 1977. Gelatin silver print, hand dyed and enameled. 5¼ × 7⅜ in. (13.0 × 19.0 cm.). David Draper Dayton Fund. 77.71.3.

Priscilla's Gown No. 3. 1978. Gelatin silver print, hand dyed and enameled. 5 × 7¼ in. (12.5 × 18.5 cm.). Kate and Hall J. Peterson Fund. 78.36.

JANASHAK, PAT
American (?), 20th century

[policeman]. From *What Ever Happened to Sexuality* portfolio. c. 1977. Gelatin silver print. 7¹⁵⁄₁₆ × 5³⁄₁₆ in. (20.3 × 13.2 cm.). Gift of the artist. 82.70.7.

JENNINGS, DE ANN
American, 1945-

[white-gloved hand holding tomato]. From *L. A. Issue* portfolio. n.d. Dye bleach color print (Cibachrome). 6⁹⁄₁₆ × 9⅝ in. (16.7 × 24.5 cm.). Gift of funds from the Photography Council of The Minneapolis Institute of Arts. 80.25.9.

JENSEN, CAROLYN
American (?), 20th century

[feet and apple]. From *What Ever Happened to Sexuality* portfolio. c. 1977. Gelatin silver print. 8 × 5 in. (20.3 × 12.7 cm.). Gift of the artist. 82.70.8.

JENSEN, MARK
American, 1945-

Linus Mullarkey, Barber, Milwaukee, Wisconsin. 1974. Gelatin silver print. 8¹³⁄₁₆ × 8¹³⁄₁₆ in. (22.4 × 22.4 cm.). Gift of the artist. 76.14.

Fox Point Dining Room. c. 1975. Gelatin silver print. 8¹³⁄₁₆ × 8¹³⁄₁₆ in. (22.5 × 22.5 cm.). National Endowment for the Arts purchase grant and miscellaneous matching funds. 76.25.1.

Platz Studio, Milwaukee. c. 1975. Gelatin silver print. 8¹³⁄₁₆ × 8¹³⁄₁₆ in. (22.5 × 22.5 cm.). National Endowment for the Arts purchase grant and miscellaneous matching funds. 76.25.2.

[woman and child, Aspen, Colorado]. c. 1968. Gelatin silver print. 7⅝ × 7⅝ in. (19.3 × 19.4 cm.). Kate and Hall J. Peterson Fund. 82.95.1.

[man in chair, Edina, Minnesota]. c. 1970. Gelatin silver print. 7¾ × 7⁹⁄₁₆ in. (19.6 × 19.2 cm.). Kate and Hall J. Peterson Fund. 82.95.2.

[men with child, St. Paul]. c. 1970. Gelatin silver print. 7⅝ × 7⁹⁄₁₆ in. (19.5 × 19.3 cm.). Kate and Hall J. Peterson Fund. 82.95.3.

[boy with gun, Minneapolis]. c. 1970. Gelatin silver print. 7⅝ × 7⅝ in. (19.3 × 19.3 cm.). Kate and Hall J. Peterson Fund. 82.95.4.

[man, Minneapolis]. c. 1970. Gelatin silver print. 7⅝ × 7⅝ in. (19.3 × 19.3 cm.). Kate and Hall J. Peterson Fund. 82.95.5.

JENSHEL, LEN
American, 1949-

World Trade Center, New York, New York. 1979. Color coupler print. 12⅞ × 19¹⁄₁₆ in. (32.8 × 48.4 cm.). Gift of funds from the Photography Council of The Minneapolis Institute of Arts. 82.130.1.

Coe Estate, Oyster Bay, New York. 1982. Color coupler print. 14¹⁵⁄₁₆ × 19 in. (37.9 × 48.3 cm.). Gift of funds from the Photography Council of The Minneapolis Institute of Arts. 82.130.2.

JOHNSON, LEAH
American, 1951-

Field Variation Green. From *Minnesota Photographers* portfolio. 1978. Gum print. 9 × 13⅛ in. (22.9 × 33.4 cm.). John R. Van Derlip Fund. 79.48.7.

JONES, PHILLIP T.
American, 1940-

[woman holding child]. From *L. A. Issue* portfolio. 1977. Gelatin silver print. 8 × 11⅜ in. (20.3 × 28.9 cm.). Gift of funds from the Photography Council of The Minneapolis Institute of Arts. 80.25.10.

JORRIN, MARIO
American, died c. 1975

[enlarged contact sheet: conversation]. 1969. Gelatin silver print. 14¹⁵⁄₁₆ × 16 in. (37.9 × 40.6 cm.). Miscellaneous purchase funds. 82.96.

JOSEPHSON, KENNETH
American, 1932-

[pencil point on woman's hip]. From *Underware* portfolio. 1976. Gelatin silver print. 10⅞ × 11 in. (27.7 × 28.0 cm.). National Endowment for the Arts purchase grant and miscellaneous matching funds. 76.64.10.

KAHN, **STEVE**
American, 1943-

[table and chairs against wall]. From *Silver See* portfolio. 1976. Gelatin silver print. 9 × 11⅞ in. (22.9 × 30.3 cm.). National Endowment for the Arts purchase grant and miscellaneous matching funds. 77.39.9.

KARANT, BARBARA
American, 1952-

[bathroom]. 1980. Color coupler print (Type C). 9¾ × 7¹¹⁄₁₆ in. (24.7 × 19.6 cm.). Gift of funds from the Photography Council of The Minneapolis Institute of Arts. 81.70.1.

[party scene]. 1979. Color coupler print (Type C). 9¹¹⁄₁₆ × 7¹¹⁄₁₆ in. (24.7 × 19.6 cm.). Gift of funds from the Photography Council of The Minneapolis Institute of Arts. 81.70.2.

[movie theatre powder room]. 1980. Color coupler print (Type C). 9¾ × 7¹¹⁄₁₆ in. (24.8 × 19.6 cm.). Gift of funds from the Photography Council of The Minneapolis Institute of Arts. 81.70.3.

[purple tiled bathroom]. 1980. Color coupler print (Type C). 9⅞ × 7¹³⁄₁₆ in. (25.1 × 19.9 cm.). Gift of the artist. 81.71.

KÄSEBIER, GERTRUDE
See *Camera Work*

KASTEN, BARBARA
American, 1936-

[screen abstraction]. From *L. A. Issue* portfolio. 1979. Gelatin silver print. 15⅞ × 19⅞ in. (40.4 × 50.5 cm.). Gift of funds from the Photography Council of The Minneapolis Institute of Arts. 80.25.11.

KEILEY, JOSEPH T.
See *Camera Work*

KEPPLER, VICTOR
American, 1904-

Man and Camera. n.d. Portfolio of 10 gelatin silver prints. Gift of John W. Weikert. 82.30.1-10.
[woman with pen and paper]. 1917. 10 × 7⅝ in. (25.4 × 19.5 cm.).
[bowl, vase, and plate]. 1921. 8¹³⁄₁₆ × 7⅝ in. (22.4 × 19.4 cm.).
[eyeglasses]. 1927. 9¹⁵⁄₁₆ × 7½ in. (25.2 × 19.1 cm.).
[man on construction beam]. 1932. 9¾ × 7¾ in. (24.8 × 19.2 cm.).
Eddie Cantor. 1938. 9¹⁵⁄₁₆ × 7⅝ in. (25.4 × 19.4 cm.).
[thread and spool]. 1939. 6¹⁵⁄₁₆ × 9¹⁵⁄₁₆ in. (17.6 × 25.3 cm.).
Imprisoned by a Lump of Coal. 1940. 7½ × 9⁵⁄₁₆ in. (19.0 × 23.7 cm.).
Uncle Sam Fighting Mad. 1942. 9¹⁵⁄₁₆ × 7⅝ in. (25.3 × 19.5 cm.).
Swans, Trees, and Bed Sheets. 1969. 9¹⁵⁄₁₆ × 6⅞ in. (25.2 × 17.4 cm.).
Dogwood. 1978. 7³⁄₁₆ × 9⅞ in. (18.3 × 25.1 cm.).

KERNOCHAN, MARSHALL R.
See *Camera Work*

KERTÉSZ, ANDRÉ
American (b. Austria-Hungary), 1894-

Chez Mondrian, Paris. 1926. Gelatin silver print. 9¹¹⁄₁₆ × 7³⁄₁₆ in. (24.6 × 18.3 cm.). Mr. and Mrs. Harrison R. Johnston, Jr. Fund. 78.34.

Martinique. 1972. Gelatin silver print. 7½ × 9½ in. (19.0 × 24.7 cm.). Mr. and Mrs. Harrison R. Johnston, Jr. Fund. 78.35.

A Hungarian Memory. Published by Hyperion Press. 1980. Portfolio of 9 gelatin silver prints. Gift of Diane Chen. 82.132.1-9.
Wandering Violinist, Abony. 1921. 9¹¹⁄₁₆ × 7½ in. (24.6 × 19.1 cm.).
The Swing, Esztergom. 1917. 9¹¹⁄₁₆ × 7½ in. (24.6 × 19.1 cm.).
Bocskay Tér, Budapest. 1914. 7⅜ × 9¹¹⁄₁₆ in. (18.8 × 24.1 cm.).

My Brothers, Budapest. 1919. 7¹¹/₁₆ × 9¹¹/₁₆ in. (19.6 × 24.7 cm.).

Trio, Ráczkeve. 1923. 7³/₈ × 9¹¹/₁₆ in. (18.7 × 24.7 cm.).

Transport, Braila, Rumania. 1918. 7³/₁₆ × 9¹¹/₁₆ in. (18.3 × 24.7 cm.).

Tisza-Szalka. 1924. 7¾ × 9¹¹/₁₆ in. (19.7 × 24.7 cm.).

Country Accident, Esztergom. 1916. 7⅝ × 9¹¹/₁₆ in. (19.3 × 24.7 cm.).

Forced March to the Front between Lonié and Mitulen, Poland. 1915. 6¾ × 9¾ in. (17.2 × 24.8 cm.).

KETCHUM, ROBERT GLENN
American, 1947-

Avalanche Lake Basin (Cirque Headwalls in a Blizzard). From *Silver See* portfolio. 1974. Gelatin silver print. 12⅜ × 8½ in. (31.5 × 21.6 cm.). National Endowment for the Arts purchase grant and miscellaneous matching funds. 77.39.10.

KING, B. A.
American, 1934-

[gull]. 1969. Gelatin silver print. 2⁵/₁₆ × 3⁷/₁₆ in. (5.9 × 8.7 cm.). Gift of the artist. 69.77.1.

[barn and snow]. 1969. Gelatin silver print. 4 × 5¹⁵/₁₆ in. (10.2 × 15.1 cm.). Gift of the artist. 69.77.2.

[hat and mirror]. n.d. Composite gelatin silver print. 6¹/₁₆ × 9 in. (15.4 × 22.8 cm.). Kate and Hall J. Peterson Fund. 77.10.

Toronto. 1977. Gelatin silver print. 15¼ × 15⅝ in. (38.9 × 39.8 cm.). Kate and Hall J. Peterson Fund. 78.97.

Abstract Thought. 1978. Gelatin silver print. 6⅛ × 9⅛ in. (15.6 × 23.2 cm.). Paul J. Schmitt Fund. 80.17.

KLEIN, WILLIAM
American, 1928-

Inside Goum Department Store, Moscow. 1959. Gelatin silver print. 13³/₁₆ × 19 in. (33.5 × 48.2 cm.). David Draper Dayton Fund. 82.21.3.

KLIPPER, STUART D.
American, 1941-

First Earth Day, Union Square. 1969. Gelatin silver print. 7¹/₁₆ × 5¹/₁₆ in. (17.9 × 12.9 cm.). Kate and Hall J. Peterson Fund. 73.31.1.

CBS Building, 53rd Street, Manhattan. 1968. Gelatin silver print. 8³/₁₆ × 9⁷/₁₆ in. (20.8 × 24.0 cm.). Kate and Hall J. Peterson Fund. 73.31.2.

Church, Taos, New Mexico. 1968. Gelatin silver print. 9 × 8¹⁵/₁₆ in. (22.9 × 22.7 cm.). Kate and Hall J. Peterson Fund. 73.31.3.

Sam's Point, Ellenville, New York. 1967. Gelatin silver print. 9 × 8¹⁵/₁₆ in. (22.9 × 22.7 cm.). Kate and Hall J. Peterson Fund. 73.31.4.

Nyhamn, Copenhagen. 1964. Gelatin silver print. 9 × 8¹⁵/₁₆ in. (22.9 × 22.7 cm.). Kate and Hall J. Peterson Fund. 73.31.5.

Lower West Side, Manhattan. 1969. Gelatin silver print. 8⁵/₁₆ × 10⁹/₁₆ in. (21.1 × 26.9 cm.). Kate and Hall J. Peterson Fund. 73.31.6.

47th Street, Manhattan. 1968. Gelatin silver print. 8⁵/₁₆ × 10⁹/₁₆ in. (21.1 × 26.9 cm.). Kate and Hall J. Peterson Fund. 73.31.7.

Little Deer Isle, Maine. 1969. Gelatin silver print. 8⁵/₁₆ × 10⁹/₁₆ in. (21.1 × 26.9 cm.). Kate and Hall J. Peterson Fund. 73.31.8.

Hudson Street, Manhattan. 1969. Gelatin silver print. 8⁵/₁₆ × 10⁹/₁₆ in. (21.1 × 26.9 cm.). Kate and Hall J. Peterson Fund. 73.31.9.

Hudson Street, Manhattan. 1969. Gelatin silver print. 8³/₁₆ × 9¹⁵/₁₆ in. (20.8 × 25.3 cm.). Kate and Hall J. Peterson Fund. 73.31.10.

Old Taos Pueblo Road, New Mexico. 1968. Gelatin silver print. 9 × 8¹⁵/₁₆ in. (22.9 × 22.7 cm.). Kate and Hall J. Peterson Fund. 73.31.11.

New York. 1970. Gelatin silver print. 5⁷/₁₆ × 7³/₁₆ in. (13.8 × 18.2 cm.). Kate and Hall J. Peterson Fund. 74.14.

2212 Grand Avenue S., Minneapolis. 1973. Color coupler print. 3⁷/₁₆ × 4⅞ in. (8.8 × 12.4 cm.). Kate and Hall J. Peterson Fund. 74.89.1.

Rochester, New York. 1974. Color coupler print. 3⁷/₁₆ × 4¹⁵/₁₆ in. (8.7 × 12.5 cm.). Kate and Hall J. Peterson Fund. 74.89.2.

Parking Lot, I.D.S. Building Reflection, Minneapolis. 1973. Color coupler print. 3⁷/₁₆ × 4¹⁵/₁₆ in. (8.7 × 12.6 cm.). Kate and Hall J. Peterson Fund. 74.89.3.

Roof of Visual Studies Workshop, Rochester, New York. 1974. Color coupler print. 3⁷/₁₆ × 4⅞ in. (8.8 × 12.5 cm.). Kate and Hall J. Peterson Fund. 74.89.4.

Houston Street, New York City. 1974. Color coupler print. 3⁷/₁₆ × 4¹⁵/₁₆ in. (8.7 × 12.6 cm.). Kate and Hall J. Peterson Fund. 74.89.5.

Sixth Street, Minneapolis. 1973. Color coupler print. 3⁷/₁₆ × 4¹⁵/₁₆ in. (8.8 × 12.6 cm.). Kate and Hall J. Peterson Fund. 74.89.6.

Downtown Minneapolis. 1972. Color coupler print. 4¹⁵/₁₆ × 4⅞ in. (12.1 × 12.4 cm.). Kate and Hall J. Peterson Fund. 74.89.7.

Downtown Minneapolis. 1972. Color coupler print. 4¹⁵/₁₆ × 4¹³/₁₆ in. (12.6 × 12.3 cm.). Kate and Hall J. Peterson Fund. 74.89.8.

Express Bus, Parkchester, Bronx, New York. 1974. Color coupler print. 3⁷/₁₆ × 4¹⁵/₁₆ in. (8.8 × 12.6 cm.). Kate and Hall J. Peterson Fund. 74.89.9.

Fourth Avenue, Minneapolis. 1973. Color coupler print. 3⁷/₁₆ × 4⅞ in. (8.7 × 12.3 cm.). Kate and Hall J. Peterson Fund. 74.89.10.

West Broadway, New York City. 1974. Color coupler print. 3⁷/₁₆ × 4¹⁵/₁₆ in. (8.8 × 12.6 cm.). Kate and Hall J. Peterson Fund. 74.89.11.

Prince Street, New York City. 1974. Color coupler print. 3⁷/₁₆ × 4¹⁵/₁₆ in. (8.8 × 12.5 cm.). Kate and Hall J. Peterson Fund. 74.89.12.

Milwaukee, Wisconsin. 1974. Color coupler print. 3½ × 4¹⁵/₁₆ in. (8.8 × 12.5 cm.). Kate and Hall J. Peterson Fund. 75.23.1.

Rochester, New York. 1974. Color coupler print. 3½ × 4¹⁵/₁₆ in. (8.8 × 12.5 cm.). Kate and Hall J. Peterson Fund. 75.23.2.

2431 Hennepin Avenue S., Minneapolis. 1974. Color coupler print. 3⁷/₁₆ × 4⅞ in. (8.8 × 12.4 cm.). Kate and Hall J. Peterson Fund. 75.23.3.

Lake Street Putt-Putt and Old Elevator, Minneapolis. 1974. Color coupler print. 3⁷/₁₆ × 4⅞ in. (8.7 × 12.4 cm.). Kate and Hall J. Peterson Fund. 75.23.4.

Harriet Avenue S., Minneapolis. 1974. Color coupler print. 3⁷/₁₆ × 4⅞ in. (8.7 × 12.4 cm.). Kate and Hall J. Peterson Fund. 75.23.5.

Marigold Ballroom and Nicollet Avenue, Minneapolis. 1974. Color coupler print. 3½ × 4⅞ in. (8.8 × 12.4 cm.). Kate and Hall J. Peterson Fund. 75.23.6.

My American Flag Picture (Reluctant), Minnesota State Fair, Republican Headquarters. 1974. Color coupler print. 3½ × 4⅞ in. (8.8 × 12.3 cm.). 75.23.7.

University Avenue Near Minneapolis/St. Paul Border. 1974. Color coupler print. 3½ × 4⅞ in. (8.8 × 12.4 cm.). Kate and Hall J. Peterson Fund. 75.23.8.

Masonic Ball, Oakland Avenue S., Minneapolis. 1974. Color coupler print. 3⁷/₁₆ × 4⅞ in. (8.8 × 12.5 cm.). Kate and Hall J. Peterson Fund. 75.23.9.

Dinkytown McDonalds behind Its Hedges, Minneapolis (for R. Israel). 1974. Color coupler print. 3⁵/₁₆ × 4⅞ in. (8.8 × 12.3 cm.). Kate and Hall J. Peterson Fund. 75.23.10.

Truncated Tree and House, Rochester, New York. 1974. Color coupler print. 3⁷/₁₆ × 4¹⁵/₁₆ in. (8.8 × 12.6 cm.). Kate and Hall J. Peterson Fund. 75.23.11.

Minnesota State Fair, St. Paul. 1974. Color coupler print. 3½ × 4¹⁵/₁₆ in. (8.8 × 12.5 cm.). Kate and Hall J. Peterson Fund. 75.23.12.

Intersection Hennepin Avenue, Minneapolis. 1975. Color coupler print. 4⁹/₁₆ × 6⅝ in. (11.5 × 16.9 cm.). National Endowment for the Arts purchase grant and miscellaneous matching funds. 76.56.1.

Marquette Avenue, Downtown Minneapolis. 1975. Color coupler print. 4⁹/₁₆ × 6⅝ in. (11.5 × 16.8 cm.). National Endowment for the Arts purchase grant and miscellaneous matching funds. 76.56.2.

24th Street S., Minneapolis. 1975. Color coupler print. 4½ × 6¹¹/₁₆ in. (11.5 × 16.9 cm.). National Endowment for the Arts purchase grant and miscellaneous matching funds. 76.56.3.

Motorcycle, Westwood, Los Angeles. 1976. Color coupler print. 5 × 6¹³/₁₆ in. (12.6 × 17.4 cm.). National Endowment for the Arts purchase grant and miscellaneous matching funds. 76.56.4.

Beach, Los Angeles. 1976. Color coupler print. 5 × 6¹³/₁₆ in. (12.6 × 17.3 cm.). Gift of the artist. 76.57.1.

[post office, downtown Minneapolis]. n.d. Color coupler print. 4⁹/₁₆ × 6⁹/₁₆ in. (11.6 × 16.6 cm.). Gift of the artist. 76.57.2.

Dawn on Herdubreid over Odadahraun, Iceland. 1976. Gelatin silver print. 9⅜ × 13¹¹/₁₆ in. (23.8 × 34.8 cm.). Gift of Christopher Cardozo. 79.39.

Fjord Ice in Eriksfjord, Greenland. From *Scans of Greenland and Iceland* series. 1976. Gelatin silver print. 9⅜ × 13¾ in. (23.9 × 35.0 cm.). Gift of the artist. 80.18.

Miami Beach, Florida. 1972. Gelatin silver print. 3½ × 4¹³⁄₁₆ in. (8.8 × 12.3 cm.). Gift of the artist. 82.61.1.

Superior from Elevated Aerial Lift Bridge, Duluth. 1977. Color coupler print. 13¼ × 19½ in. (33.6 × 49.6 cm.). Gift of the artist. 82.61.2.

Cars, Trucks, and Letters, First Avenue N., Minneapolis. 1974. Color coupler print. 3½ × 4⅞ in. (8.8 × 12.4 cm.). Kate and Hall J. Peterson Fund. 82.97.

KNEE, ERNIE
American, 1907-

Old Church at Taos. From *The New Mexico Portfolio.* 1941. Gelatin silver print. 11¹⁵⁄₁₆ × 9¹⁵⁄₁₆ in. (30.4 × 22.9 cm.). National Endowment for the Arts purchase grant and miscellaneous matching funds. 76.61.8.

KOPPEL, ROLF
American, 1937-

[reclining woman, "My Mother"]. From *The New Mexico Portfolio.* 1973. Gelatin silver print. 10⅜ × 10³⁄₁₆ in. (26.4 × 26.0 cm.). National Endowment for the Arts purchase grant and miscellaneous matching funds. 76.61.9.

KRIMS, LESLIE
American, 1943-

[two women making muscles over man]. 1969. Gelatin silver print (Kodalith paper). 5¹⁄₁₆ × 7⁹⁄₁₆ in. (12.9 × 19.3 cm.). Kate and Hall J. Peterson Fund. 71.21.12.

A Human Being as a Piece of Sculpture. 1969. Gelatin silver print (Kodalith paper). 4¹⁵⁄₁₆ × 7⅜ in. (12.6 × 18.8 cm.). Kate and Hall J. Peterson Fund. 71.21.13.

[nude in dentist's office]. 1970. Gelatin silver print (Kodalith paper). 4¹³⁄₁₆ × 7⅛ in. (12.3 × 18.1 cm.). Kate and Hall J. Peterson Fund. 71.21.14.

[nudes on bicycles with balloons]. 1970. Gelatin silver print (Kodalith paper). 4¹⁵⁄₁₆ × 7⁵⁄₁₆ in. (12.5 × 18.6 cm.). Kate and Hall J. Peterson Fund. 71.21.15.

[Paul with sutures in chest]. 1971. Gelatin silver print (Kodalith paper). 4¹⁵⁄₁₆ × 7⁵⁄₁₆ in. (12.5 × 18.6 cm.). Kate and Hall J. Peterson Fund. 72.23.

[girl with mushrooms]. 1971. Gelatin silver print (Kodalith paper). 4⅞ × 7¼ in. (12.4 × 18.4 cm.). Kate and Hall J. Peterson Fund. 72.24.

KRUEGER, GARY
American, 1945-

[two men standing]. From *L. A. Issue* portfolio. n.d. Gelatin silver print. 5 × 7⅛ in. (12.8 × 18.2 cm.). Gift of funds from the Photography Council of The Minneapolis Institute of Arts. 80.25.12.

KUEHN, HEINRICH
See *Camera Work*

LAMB, H. MORTIMER
See *Camera Work*

LAMBERT, NANCY
American (?), 20th century

[door]. From *What Ever Happened to Sexuality* portfolio. c. 1977. Gelatin silver print. 6¹⁵⁄₁₆ × 4¹⁵⁄₁₆ in. (17.7 × 12.5 cm.). Gift of the artist. 82.70.9.

LANDWEBER, VICTOR
American, 1943-

My High School Colors. From *Silver See* portfolio. 1976. 9 color coupler prints mounted edge-to-edge. 14⅛ × 9⅝ in. (35.9 × 24.6 cm.). National Endowment for the Arts purchase grant and miscellaneous matching funds. 77.39.11.

Ishi Bar, San Francisco Airport. From *New California Views* portfolio. 1977. Dye bleach color print (Cibachrome). 9 × 13½ in. (22.9 × 34.4 cm.). Gift of funds from the Photography Council of The Minneapolis Institute of Arts. 80.24.9.

LANG, GERALD
American, 1939-

Rock and Figure, Craters of the Moon. 1975. Gelatin silver print. 6¹¹⁄₁₆ × 16½ in. (16.9 × 42.0 cm.). Kate and Hall J. Peterson Fund. 77.11.1.

Craters of the Moon Landscape. 1975. Gelatin silver print. 6⅝ × 16½ in. (16.9 × 42.0 cm.). Kate and Hall J. Peterson Fund. 77.11.2.

Bruneau. 1975. Gelatin silver print. 6⅝ × 15³⁄₁₆ in. (16.9 × 38.7 cm.). Kate and Hall J. Peterson Fund. 77.11.3.

Zion. 1975. Gelatin silver print. 6⅝ × 16⁹⁄₁₆ in. (16.8 × 42.1 cm.). Kate and Hall J. Peterson Fund. 77.11.4.

LANZANO, LOUIS
American, 1947-

[woman against wall]. 1974. Gelatin silver print. 12⅜ × 9¼ in. (31.6 × 23.5 cm.). National Endowment for the Arts purchase grant and miscellaneous matching funds. 76.21.1.

[woman with cigarette in ray of light]. 1975. Gelatin silver print. 13¼ × 10 in. (33.7 × 25.5 cm.). National Endowment for the Arts purchase grant and miscellaneous matching funds. 76.21.2.

[woman, man, and church]. 1973. Gelatin silver print. 12¼ × 9⅛ in. (31.2 × 23.3 cm.). National Endowment for the Arts purchase grant and miscellaneous matching funds. 76.21.3.

[headless figure and mailbox]. 1974. Gelatin silver print. 13¹¹⁄₁₆ × 10¹⁄₁₆ in. (34.9 × 25.6 cm.). National Endowment for the Arts purchase grant and miscellaneous matching funds. 76.21.4.

[woman with cane and building]. 1973. Gelatin silver print. 13⅜ × 9¹⁄₁₆ in. (34.0 × 23.0 cm.). National Endowment for the Arts purchase grant and miscellaneous matching funds. 76.21.5.

[woman's legs]. 1975. Gelatin silver print. 13 × 10 in. (33.1 × 25.3 cm.). National Endowment for the Arts purchase grant and miscellaneous matching funds. 76.21.6.

[woman with white fur]. 1973. Gelatin silver print. 12½ × 9⁷⁄₁₆ in. (31.9 × 24.1 cm.). National Endowment for the Arts purchase grant and miscellaneous matching funds. 76.21.7.

[woman holding eyeglasses]. 1975. Gelatin silver print. 13½ × 10⅛ in. (34.4 × 25.7 cm.). National Endowment for the Arts purchase grant and miscellaneous matching funds. 76.21.8.

[made-up woman in city]. 1973. Gelatin silver print. 12¾ × 9⅝ in. (32.4 × 24.4 cm.). National Endowment for the Arts purchase grant and miscellaneous matching funds. 76.21.9.

[child and woman at curb]. 1973. Gelatin silver print. 9⅛ × 13⁷⁄₁₆ in. (23.2 × 34.2 cm.). National Endowment for the Arts purchase grant and miscellaneous matching funds. 76.21.10.

[descending view of woman]. 1973. Gelatin silver print. 13¼ × 9¾ in. (33.8 × 24.8 cm.). National Endowment for the Arts purchase grant and miscellaneous matching funds. 76.21.11.

[man in checkered jacket and woman's face]. 1974. Gelatin silver print. 12⁹⁄₁₆ × 9½ in. (32.0 × 24.1 cm.). Gift of the artist. 76.49.

[woman with finger in mouth]. 1976. Gelatin silver print. 13½ × 10³⁄₁₆ in. (34.3 × 25.9 cm.). David Draper Dayton Fund. 77.73.1.

New York. 1976. Gelatin silver print. 13½ × 10³⁄₁₆in. (34.3 × 25.9 cm.). David Draper Dayton Fund. 77.73.2.

New York. 1976. Gelatin silver print. 13½ × 10 in. (34.3 × 25.5 cm.). David Draper Dayton Fund. 77.73.3.

New York. 1976. Gelatin silver print. 13⁵⁄₁₆ × 10⁵⁄₁₆ in. (33.9 × 26.2 cm.). Gift of the artist. 77.73.4.

LARSON, WILLIAM G.
American, 1942-

Atlantic City Bicentennial Celebration. From *Underware* portfolio. 1976. Computer printout. 12¼ × 11⁹⁄₁₆ in. (31.2 × 29.4 cm.). National Endowment for the Arts purchase grant and miscellaneous matching funds. 76.64.11.

LARTIGUE, JACQUES HENRI
French, 1894-

A Portfolio of Photographs by Jacques Henri Lartigue. Published by Witkin-Berley, Ltd., New York. 1972. Portfolio of 10 modern gelation silver prints. Kate and Hall J. Peterson Fund. 72.118.1-10.
Cousin "Bichonade" in Flight. 1905. 6¹¹⁄₁₆ × 9¹⁄₁₆ in. (17.0 × 23.1 cm.).
Simone Roussel on the Beach at Villerville. 1906. 9⅛ × 6¹¹⁄₁₆ in. (23.2 × 17.0 cm.).
My Brother, Zissou, Gets His Glider Airborne, Chateau de Rouzat. 1908. 6¹¹⁄₁₆ × 9⅛ in. (17.0 × 23.1 cm.).
The Race Course at Auteuil, Paris. 1910. 6¾ × 9¹⁄₁₆ in. (17.3 × 23.1 cm.).
Woman with Fox Fur, Avenue des Acacias. 1911. 6¹¹⁄₁₆ × 9¹⁄₁₆ in. (17.0 × 23.1 cm.).
Zissou in His Tire Boat, Chateau de Rouzat. 1911. 9¹⁄₁₆ × 6¾ in. (23.1 × 17.2 cm.).
Wheeled Bobsleigh Designed by Jacques Henri Lartigue. 1911. 6¹¹⁄₁₆ × 9¹⁄₁₆ in. (17.0 × 23.1 cm.).

Grand Prix of the Automobile Club of France. 1912. 6¹¹⁄₁₆ × 9¹⁄₁₆ in. (17.1 × 23.1 cm.).
The Famous Rowe Twins of the Casino de Paris. 1929. 9¹⁄₁₆ × 6¾ in. (23.1 × 17.2 cm.).
Picasso. 1955. 9¹⁄₁₆ × 6¹¹⁄₁₆ in. (23.1 × 17.0 cm.).

The Beach at Villerville. 1908. Gelatin silver print. 9¾ × 13¾ in. (24.7 × 35.0 cm.). Kate and Hall J. Peterson Fund. 72.119.

Renée (Pearle). 1930. Gelatin silver print. 13¹³⁄₁₆ × 9⅞ in. (35.2 × 25.2 cm.). Kate and Hall J. Peterson Fund. 72.120.

LAVAUD, H.
French, 19th century

[portrait of Jean-Baptiste Camille Corot]. n.d. Albumen print. 10⁷⁄₁₆ × 8 in. (26.6 × 20.4 cm.). Gift of Frank T. Kacmarcik. 75.86.

LAZAR, ARTHUR
American, 1940-

Lava Formation. From *The New Mexico Portfolio.* 1970. Gelatin silver print. 8¹⁵⁄₁₆ × 12 in. (22.8 × 30.5 cm.). National Endowment for the Arts purchase grant and miscellaneous matching funds. 76.61.10.

LAZORIK, WAYNE R.
American, 1939-

[seated woman]. n.d. Gelatin silver print. 4 × 3⅜ in. (10.2 × 8.6 cm.). Ethel Morrison Van Derlip Fund. 70.76.7.

[men and women in attic]. From *Fantasy Series.* 1971. Gelatin silver print. 8⅜ × 8⅜ in. (21.3 × 21.2 cm.). Kate and Hall J. Peterson Fund. 72.117.1.

[two women in attic]. From *Fantasy Series.* 1971. Gelatin silver print. 8⅜ × 8⁵⁄₁₆ in. (21.4 × 21.2 cm.). Kate and Hall J. Peterson Fund. 72.117.2.

[men and women in attic]. From *Fantasy Series.* 1971. Gelatin silver print. 8⅜ × 8⅜ in. (21.3 × 21.2 cm.). Kate and Hall J. Peterson Fund. 72.117.3.

[women in attic]. From *Fantasy Series.* 1971. Gelatin silver print. 5⅛ in. (13.0 cm.) diameter. Kate and Hall J. Peterson Fund. 72.117.4.

[man and woman in attic]. From *Fantasy Series.* 1971. Gelatin silver print. 8⅜ × 8⅜ in. (21.3 × 21.3 cm.). Kate and Hall J. Peterson Fund. 72.117.5.

[woman in chair]. From *Fantasy Series.* 1971. Gelatin silver print. 8⁵⁄₁₆ × 8⅜ in. (21.2 × 21.3 cm.). Kate and Hall J. Peterson Fund. 72.117.6.

[woman in chair with bedpost]. From *Fantasy Series.* 1971. Gelatin silver print. 4 in. (10.1 cm.) diameter. Kate and Hall J. Peterson Fund. 72.117.7.

[nude woman on bed]. From *Fantasy Series.* 1971. Gelatin silver print. 5¹⁄₁₆ in. (12.9 cm.) diameter. Kate and Hall J. Peterson Fund. 72.117.8.

[woman in corner with mirror]. From *Fantasy Series.* 1972. Gelatin silver print. 7 × 8³⁄₁₆ in. (17.7 × 20.9 cm.). Kate and Hall J. Peterson Fund. 72.117.9.

[woman sitting on edge of bed]. From *Fantasy Series.* 1972. Gelatin silver print. 8³⁄₁₆ × 6½ in. (20.9 × 16.5 cm.). Kate and Hall J. Peterson Fund. 72.117.10.

Ivy. 1973. Gelatin silver print. 29⁵⁄₁₆ × 29⁹⁄₁₆ in. (74.4 × 75.1 cm.). Kate and Hall J. Peterson Fund. 73.29.

Ivy. From *The New Mexico Portfolio.* 1973. Gelatin silver print. 7½ × 7½ in. (19.0 × 19.0 cm.). National Endowment for the Arts purchase grant and miscellaneous matching funds. 76.61.11.

LE BÉGUE, RENÉE
See *Camera Work*

LERNER, NATHAN
American, 1915-

Light Volume. 1937. Gelatin silver print. 6⅞ × 9¾ in. (17.5 × 24.8 cm.). Gift of Arnold M. Gilbert. 74.61.15.

LESESNE, RICHARD H.
American, 1880-1946

[forest road]. n.d. Orotone. 13¹⁵⁄₁₆ × 11 in. (35.5 × 27.9 cm.). Gift of Gene Kunz. 75.40.

LEVINE, MICHAEL G.
American, 1952-

Wild Wall/Rollway. From *L. A. Issue* portfolio. 1979. Gelatin silver print. 13¾ × 17¹⁵⁄₁₆ in. (34.9 × 45.6 cm.). Gift of funds from the Photography Council of The Minneapolis Institute of Arts. 80.25.13.

LEVINSON, JOEL D.
American, 1953-

Fractions. From *Self-Indulgence* series. 1979. Gelatin silver print. 14⁷⁄₁₆ × 17⅛ in. (36.7 × 43.6 cm.). Mr. and Mrs. Julius E. Davis Fund. 81.8.1.

Residuals. From *Self-Indulgence* series. Gelatin silver print. 18⅛ × 13⅛ in. (46.1 × 33.5 cm.). Mr. and Mrs. Julius E. Davis Fund. 81.8.2.

LEVY, ROBERT
American, 20th century

[man in store window]. 1972. Gelatin silver print. 7¹¹⁄₁₆ × 5 in. (19.6 × 12.7 cm.). Kate and Hall J. Peterson Fund. 72.115.

[store window with figures]. 1972. Gelatin silver print. 7⅜ × 4¹⁵⁄₁₆ in. (18.7 × 12.6 cm.). Kate and Hall J. Peterson Fund. 72.116.

LEWIS, ARTHUR ALLEN
See *Camera Work*

LIEBLING, JEROME
American, 1924-

Brooklyn, New York. 1947. Gelatin silver print. 5⁷⁄₁₆ × 5¹⁄₁₆ in. (13.8 × 12.9 cm.). Ethel Morrison Van Derlip Fund. 70.76.17.

[mannequin head]. n.d. Gelatin silver print. 19¼ × 15 in. (49.0 × 38.2 cm.). Ethel Morrison Van Derlip Fund. 70.76.18.

[blind woman, St. Paul]. c. 1963. Gelatin silver print. 19 × 23⅝ in. (48.3 × 59.2 cm.). Ethel Morrison Van Derlip Fund. 70.76.19.

Jerome Liebling Photographs. Published by the photographer. 1976. Portfolio of 10 gelatin silver prints. National Endowment for the Arts purchase grant and miscellaneous matching funds. 76.60.1-10.
Boy and Car, New York City. 1949. 10 × 10 in. (25.4 × 25.5 cm.).

Coal Worker, Minnesota. 1952. 9¾ × 10⅜ in. (24.9 × 26.3 cm.).
Woman's Lips, Neck, Minnesota. 1960. 9⅜ × 12⁹⁄₁₆ in. (23.9 × 32.0 cm.).
Slaughterhouse, South St. Paul, Minnesota. 1962. 10 × 9⅝ in. (25.5 × 24.4 cm.).
Mannequin, Minnesota. 1963. 12¹³⁄₁₆ × 9⅝ in. (32.6 × 24.4 cm.).
Confirmation Dress, Spain. 1966. 9¹³⁄₁₆ × 12¹⁵⁄₁₆ in. (24.9 × 32.9 cm.).
Governor Wallace, Minnesota. 1968. 9¹¹⁄₁₆ × 12¼ in. (24.7 × 31.2 cm.).
Goya, Louvre, Paris. 1974. 11¼ × 9⅝ in. (28.6 × 24.5 cm.).
Cadaver, New York City. 1973. 12¹³⁄₁₆ × 9⁹⁄₁₆ in. (32.6 × 24.4 cm.).
Mother, Baby's Hand, Mexico. 1974. 11¹³⁄₁₆ × 9½ in. (30.0 × 24.1 cm.).

[Metropolitan Building, Minneapolis]. n.d. Gelatin silver print. 19³⁄₁₆ × 14¹¹⁄₁₆ in. (48.8 × 37.4 cm.). Gift of Sheldon and Rhoda Karlins. 81.124.1.

LIFSON, BENJAMIN, M.
American, 1941-

San Fernando Valley. 1973. Gelatin silver print. 5⅜ × 8 in. (13.7 × 20.3 cm.). Gift of the artist. 75.39.1.

Bell Gardens. 1973. Gelatin silver print. 5¹⁵⁄₁₆ × 9 in. (15.0 × 22.9 cm.). Gift of the artist. 75.39.2.

Glendale. 1973. Gelatin silver print. 5¹⁵⁄₁₆ × 8¹⁵⁄₁₆ in. (15.1 × 22.6 cm.). Gift of the artist. 75.39.3.

Hollywood. 1973. Gelatin silver print. 5¹⁵⁄₁₆ × 8¹⁵⁄₁₆ in. (15.1 × 22.6 cm.). Gift of the artist. 75.39.4.

Hollywood. 1973. Gelatin silver print. 5¹⁵⁄₁₆ × 8¹⁵⁄₁₆ in. (15.0 × 22.7 cm.). Kate and Hall J. Peterson Fund. 75.44.1.

Hollywood. 1974. Gelatin silver print. 6 × 9¹⁄₁₆ in. (15.3 × 23.0 cm.). Kate and Hall J. Peterson Fund. 75.44.2.

Hollywood. 1974. Gelatin silver print. 5¹⁵⁄₁₆ × 9 in. (15.1 × 22.9 cm.). Kate and Hall J. Peterson Fund. 75.44.3.

San Fernando Valley. 1974. Gelatin silver print. 7¹⁄₁₆ × 10⁹⁄₁₆ in. (17.9 × 26.9 cm.). Kate and Hall J. Peterson Fund. 75.44.4.

Los Angeles. 1974. Gelatin silver print. 6⅞ × 10⅝ in. (17.5 × 26.2 cm.). Kate and Hall J. Peterson Fund. 75.44.5.

San Fernando Valley. 1974. Gelatin silver print. 5¹⁵⁄₁₆ × 9¹⁄₁₆ in. (15.2 × 23.0 cm.). Kate and Hall J. Peterson Fund. 75.44.6.

San Fernando Valley. n.d. Gelatin silver print. 5¹⁵⁄₁₆ × 8¹⁵⁄₁₆ in. (15.1 × 22.8 cm.). Kate and Hall J. Peterson Fund. 75.44.7.

Hollywood. 1973. Gelatin silver print. 6 × 9 in. (15.2 × 22.9 cm.). Kate and Hall J. Peterson Fund. 75.44.8.

Hollywood. 1973. Gelatin silver print. 5⅞ × 8¹⁵⁄₁₆ in. (15.0 × 22.7 cm.). Kate and Hall J. Peterson Fund. 75.44.9.

Hollywood. 1974. Gelatin silver print. 6 × 9 in. (15.2 × 22.9 cm.). Kate and Hall J. Peterson Fund. 75.44.10.

LINS, PAM
American (?), 20th century

[foot in doorway]. From *What Ever Happened to Sexuality* portfolio. c. 1977. Gelatin silver print. 8¹/₁₆ × 5⅝ in. (20.1 × 14.3 cm.). Gift of the artist. 82.70.10.

LIPSKI, DONALD
American, 1947-

[hand-held mirror with motel]. 1975. Color coupler print. 15¾ × 19¾ in. (40.1 × 50.2 cm.). Frances E. Andrews Fund. 75.22.

LYONS, JOAN
American, 1937-

Presences. Published by the Visual Studies Workshop, Rochester, New York. 1980. Portfolio of 11 offset lithographs. Ethel Morrison Van Derlip Fund. 82.34.1-11.
Untitled. 1980. 22⅜ × 16½ in. (56.8 × 42.0 cm.).
Untitled. 1980. 22⅜ × 16⅝ in. (56.8 × 42.2 cm.).
Untitled. 1980. 22⅜ × 16⁹/₁₆ in. (56.8 × 42.1 cm.).
Untitled. 1980. 22⁷/₁₆ × 16¹¹/₁₆ in. (57.0 × 42.5 cm.).
Untitled. 1980. 21⁷/₁₆ × 16½ in. (54.4 × 41.9 cm.).
Untitled. 1980. 22⅛ × 16⅝ in. (56.3 × 42.2 cm.).
Untitled. 1980. 22 × 16½ in. (55.9 × 42.0 cm.).
Untitled. 1980. 21½ × 16⅞ in. (54.7 × 42.8 cm.).
Untitled. 1980. 21⁹/₁₆ × 16¹³/₁₆ in. (54.8 × 42.7 cm.).
Untitled. 1980. 21⅜ × 16½ in. (54.3 × 41.9 cm.).
Untitled. 1980. 21⅜ × 16¹¹/₁₆ in. (54.3 × 42.5 cm.).

LYONS, NATHAN
American, 1930-

[nature form]. 1959. Gelatin silver print. 9¾ × 7¾ in. (24.8 × 19.7 cm.). Ethel Morrison Van Derlip Fund. 70.76.3.

[wood form]. 1962. Gelatin silver print. 7¾ × 9¾ in. (19.6 × 24.8 cm.). Ethel Morrison Van Derlip Fund. 70.76.4.

[barn]. 1957. Gelatin silver print. 7¹¹/₁₆ × 9¾ in. (19.6 × 24.7 cm.). Ethel Morrison Van Derlip Fund. 70.76.5.

MacWEENEY, ALEN
American (b. Ireland), 1939-

Alen MacWeeney. Published by Hyperion Press. 1979. Portfolio of 12 gelatin silver prints. Gift of Ivor Massey. 82.127.16-27.
White Horse, Donegal, Ireland. 1965-66. 11¹³/₁₆ × 11¾ in. (30.0 × 29.9 cm.).
Wicklow Trees, County Wicklow, Ireland. 1965-66. 11¾ × 11¹³/₁₆ in. (29.9 × 30.0 cm.).
Chimney Sweep and Children, Ireland. 1965-66. 11¹¹/₁₆ × 11¹¹/₁₆ in. (29.7 × 29.7 cm.).
Flies in the Window, Castletown House, Ireland. 1972. 10¹¹/₁₆ × 15⅝ in. (27.2 × 39.7 cm.).
Horsewoman, Ireland. 1965. 11¾ × 11¹¹/₁₆ in. (29.9 × 29.7 cm.).
The Head of Blessed Oliver Plunkett, Ireland. 1965-66. 11¹⁵/₁₆ × 11¼ in. (30.4 × 28.5 cm.).
Nightwalkers, Dublin, Ireland. 1965-66. 10⅝ × 15½ in. (27.0 × 39.4 cm.).

Joe and Olivene, Ireland. 1965-66. 10⅜ × 15⅝ in. (26.4 × 39.7 cm.).
John Grogan, a Patriot and His Dog, Ireland. 1965-66. 12³/₁₆ × 11⅞ in. (31.0 × 30.2 cm.).
Watching—A Street Scene, Dublin, Ireland. 1965-66. 12¹¹/₁₆ × 11⁵/₁₆ in. (32.3 × 28.7 cm.).
Little Tinker Child, Ireland. 1965-66. 11½ × 11½ in. (29.2 × 29.2 cm.).
The Townland, Donegal, Ireland. 1965-66. 11¾ × 11¹¹/₁₆ in. (29.9 × 29.8 cm.).

MANZAVRAKOS, MICHAEL
American, 1951-

Mazatlan, Mexico. 1975. Gelatin silver print. 34 × 34 in. (86.5 × 86.5 cm.). National Endowment for the Arts purchase grant and miscellaneous matching funds. 80.19.1.

Mazatlan, Mexico. 1975. Gelatin silver print. 34 × 33⅞ in. (86.5 × 86.0 cm.). National Endowment for the Arts purchase grant and miscellaneous matching funds. 80.19.2.

Puget Sound. 1975. Gelatin silver print. 34 × 34⅛ in. (86.5 × 87.0 cm.). National Endowment for the Arts purchase grant and miscellaneous matching funds. 80.19.3.

Northern California. 1975. Gelatin silver print. 33⅞ × 34 in. (86.0 × 86.5 cm.). National Endowment for the Arts purchase grant and miscellaneous matching funds. 80.19.4.

MARK, MARY ELLEN
American, 1941-

Relaxing at Home. 1978. Gelatin silver print. 7¹⁵/₁₆ × 12¹/₁₆ in. (20.2 × 30.7 cm.). Gift of the American Telephone and Telegraph Co. 81.120.43.

Jeanette and Chastity Sandy. 1978. Gelatin silver print. 7¹⁵/₁₆ × 12¹/₁₆ in. (20.2 × 30.7 cm.). Gift of the American Telephone and Telegraph Co. 81.120.44.

Jeanette Alejandro Looking out Her Window in Brooklyn. 1978. Gelatin silver print. 7⅞ × 12⅛ in. (20.1 × 30.8 cm.). Gift of the American Telephone and Telegraph Co. 81.120.45.

MARSHALL, JOHN F.
American, 1949-

[overlooking bridge supports]. n.d. Gelatin silver print. 9⅜ × 14¹/₁₆ in. (23.9 × 35.7 cm.). Ethel Morrison Van Derlip Fund. 74.40.1.

[mud]. 1973. Gelatin silver print. 9⁵/₁₆ × 14¹/₁₆ in. (23.7 × 35.7 cm.). Ethel Morrison Van Derlip Fund. 74.40.2.

[view out of excavation]. 1973. Gelatin silver print. 9⅜ × 14¹/₁₆ in. (23.8 × 35.8 cm.). Ethel Morrison Van Derlip Fund. 74.40.3.

[wire and concrete]. 1973. Gelatin silver print. 9⁵/₁₆ × 14¹/₁₆ in. (23.7 × 35.7 cm.). Ethel Morrison Van Derlip Fund. 74.40.4.

[scrap under bridge supports]. 1973. Gelatin silver print. 9⁵/₁₆ × 14 in. (23.7 × 35.6 cm.). Ethel Morrison Van Derlip Fund. 74.40.5.

[bridge supports]. 1973. Gelatin silver print. 9⅜ × 4¹/₁₆ in. (23.8 × 35.7 cm.). Ethel Morrison Van Derlip Fund. 74.40.6.

[bridge ruins]. 1973. Gelatin silver print. 9⁵/₁₆ × 14¹/₁₆ in. (23.8 × 35.7 cm.). Ethel Morrison Van Derlip Fund. 74.40.7.

[earth and bridge in snow]. 1973. Gelatin silver print. 9⅜ × 14⅛ in. (23.8 × 35.8 cm.). Ethel Morrison Van Derlip Fund. 74.40.8.

MARTIN, PETER
American, 1949-

Nicollet Avenue Bus Stop. 1975. Gelatin silver print. 12⅛ × 18¼ in. (30.7 × 46.5 cm.). David Draper Dayton Fund. 77.69.1.

Hamilton Metal Plane. 1975. Gelatin silver print. 13⅞ × 17¾ in. (35.3 × 45.2 cm.). David Draper Dayton Fund. 77.69.2.

MATHIASON, JEROME D.
American, 1947-

End Table. From *Minnesota Photographers* portfolio. 1977. Color coupler print. 10½ × 10 in. (26.7 × 25.5 cm.). John R. Van Derlip Fund. 79.48.8.

MAYES, ELAINE
American, 1938-

Kathleen and Max Demian Goldman, Ages 22 and 1 Year, Cole Street, August 16, 1968. From *We Are the Haight-Ashbury* series. Gelatin silver print. 8¹³/₁₆ × 8⅝ in. (22.4 × 21.9 cm.). John R. Van Derlip Fund. 69.140.1.

Ruth Murphey, Age 18, Mission District. From *We Are the Haight-Ashbury* series. 1968. Gelatin silver print. 8¹³/₁₆ × 8⁹/₁₆ in. (22.3 × 21.7 cm.). John R. Van Derlip Fund. 69.140.2.

Jerry Liebling on TV, Minneapolis. 1969. Gelatin silver print. 7⅜ × 11⅛ in. (18.8 × 28.3 cm.). Ethel Morrison Van Derlip Fund. 82.89.1.

McFARLAND, LAWRENCE
American, 1942-

Black Sign, near Kansas/Missouri Border. 1976. Gelatin silver print. 7⅜ × 11¹⁵/₁₆ in. (18.8 × 30.4 cm.). David Draper Dayton Fund. 77.72.1.

Tractor and Tractor Graveyard, near Kansas/Nebraska Border. 1976. Gelatin silver print. 7½ × 12¹/₁₆ in. (19.0 × 30.7 cm.). David Draper Dayton Fund. 77.72.2.

July 4, 1976, near Geographical Center of Continental United States, Sylvan Grove, Kansas. 1976. Gelatin silver print. 7½ × 12 in. (19.1 × 30.5 cm.). David Draper Dayton Fund. 77.72.3.

Route 22, near Millerton, New York. 1977. Gelatin silver print. 7½ × 11¹⁵/₁₆ in. (19.0 × 30.5 cm.). David Draper Dayton Fund. 77.72.4.

Painted Desert, Arizona. 1975. Gelatin silver print. 7½ × 12 in. (19.0 × 30.6 cm.). David Draper Dayton Fund. 77.72.5.

Farmer Plowing and Star, Kansas. 1976. Gelatin silver print. 7½ × 12 in. (19.1 × 30.4 cm.). David Draper Dayton Fund. 77.72.6.

Wheatfield, near Kansas/Nebraska Border. 1976. Gelatin silver print. 7½ × 12¹/₁₆ in. (19.1 × 30.7 cm.). David Draper Dayton Fund. 77.72.7.

Little Church, near Minnesota/Iowa Border. 1976. Gelatin silver print. 7½ × 12 in. (19.0 × 30.5 cm.). David Draper Dayton Fund. 77.72.8.

Grain Elevator, Waverly, Nebraska. 1976. Gelatin silver print. 7½ × 12 in. (19.0 × 30.6 cm.). David Draper Dayton Fund. 77.72.9.

Black and White Tanks. 1976. Gelatin silver print. 7½ × 12 in. (19.1 × 30.5 cm.). David Draper Dayton Fund. 77.72.10.

Branched Oak Lake, Nebraska. 1976. Gelatin silver print. 7½ × 12 in. (19.0 × 30.6 cm.). Gift of the artist. 77.72.11.

Church on Hill, Marysville, Kansas. 1976. Gelatin silver print. 7½ × 12¹⁄₁₆ in. (19.0 × 30.6 cm.). Gift of the artist. 77.72.12.

Plowed Field and Camper, near Lincoln, Nebraska. 1976. Gelatin silver print. 7½ × 12 in. (19.0 × 30.6 cm.). Gift of the artist. 77.72.13.

Dust and Rain Storm, Denver, Colorado. 1976. Gelatin silver print. 7½ × 12 in. (19.0 × 30.6 cm.). Gift of the artist. 77.72.14.

McGOWAN, KENNETH
American, 1940-

Pink Panthers. From *New California Views* portfolio. 1978. Dye bleach color print (Cibachrome). 10⅛ × 10 in. (25.7 × 25.5 cm.). Gift of funds from the Photography Council of The Minneapolis Institute of Arts. 80.24.10.

McGRATH, TERRY
American (?), 20th century

[figures and flag]. From *What Ever Happened to Sexuality* portfolio. c. 1977. Gelatin silver print. 8⅞ × 6⁹⁄₁₆ in. (22.6 × 16.7 cm.). Gift of the artist. 82.70.11.

McLOUGHLIN, MICHAEL D.
American, 1936-

Washington. From *The New Mexico Portfolio.* 1969. Gelatin silver print. 7¾ × 10⁵⁄₁₆ in. (19.8 × 26.3 cm.). National Endowment for the Arts purchase grant and miscellaneous matching funds. 76.61.12.

McMILLAN, JERRY
American, 1936-

[cut and wrinkled paper]. From *Silver See* portfolio. 1977. Gelatin silver print. 19¹⁵⁄₁₆ × 16¹⁄₁₆ in. (50.6 × 40.9 cm.). National Endowment for the Arts purchase grant and miscellaneous matching funds. 77.39.12.

MEATYARD, RALPH EUGENE
American, 1925-1972

Ralph Eugene Meatyard, Portfolio Three. Published by the Center for Photographic Studies, Louisville, Kentucky. 1974. Portfolio of 10 modern gelatin silver prints. Kate and Hall J. Peterson Fund. 73.57.1-10.
Madonna. 1964. 6⁹⁄₁₆ × 7⁷⁄₁₆ in. (16.7 × 18.9 cm.).
Untitled (Boy with Flag). 1959. 6¾ × 6¹³⁄₁₆ in. (17.2 × 17.3 cm.).
Untitled (Figure with Wall Detail). 1964. 6⁷⁄₁₆ × 6⅞ in. (16.4 × 17.5 cm.).

Romance of Ambrose Bierce No. 3. 1964. 6¹¹⁄₁₆ × 7 in. (17.0 × 17.8 cm.).
Untitled (Boy Making Gesture). 1959. 6⅞ × 7 in. (17.5 × 17.8 cm.).
Lucybelle Crater and Her 15-Year-Old Son's Friend. 1970-71. 7¹⁄₁₆ × 6⅞ in. (18.0 × 17.5 cm.).
Untitled (Figure and Boat). 1961. 7 × 7 in. (17.8 × 17.7 cm.).
Cranston Richie. 1964. 6¹⁵⁄₁₆ × 6¹⁵⁄₁₆ in. (17.7 × 17.7 cm.).
Untitled ("Motion-Sound" Landscape). 1969. 7 × 6¹⁵⁄₁₆ in. (17.8 × 17.6 cm.).
Untitled (Mask in Water). 1961. 7 × 7½ in. (17.8 × 19.0 cm.).

MELNICK, PHILIP
American, 1935-

[chaise lounge]. From *Silver See* portfolio. 1976. Gelatin silver print. 9 × 9 in. (22.9 × 22.9 cm.). National Endowment for the Arts purchase grant and miscellaneous matching funds. 77.39.13.

MERRILL, LAWRENCE J.
American, 1948-

Minneapolis. 1979. Color coupler print. 14⁷⁄₁₆ × 14⁵⁄₁₆ in. (37.0 × 36.5 cm.). Gift of the artist. 79.38.1.

Minneapolis. 1979. Color coupler print. 14¹¹⁄₁₆ × 14⅝ in. (37.4 × 37.2 cm.). Gift of the artist. 79.38.2.

Minneapolis. 1979. Color coupler print. 14⁷⁄₁₆ × 14⁵⁄₁₆ in. (36.8 × 36.4 cm.). Gift of the artist. 79.38.3.

Minneapolis. 1979. Color coupler print. 6¹¹⁄₁₆ × 6⅞ in. (17.0 × 16.9 cm.). Gift of the artist. 79.38.4.

Minneapolis. 1979. Color coupler print. 14½ × 14⁵⁄₁₆ in. (36.9 × 36.4 cm.). John R. Van Derlip Fund. 79.39.1.

Minneapolis. 1979. Color coupler print. 14⁷⁄₁₆ × 14⁵⁄₁₆ in. (36.8 × 36.3 cm.). John R. Van Derlip Fund. 79.39.2.

Minneapolis. 1979. Color coupler print. 14⁷⁄₁₆ × 14¼ in. (36.7 × 36.2 cm.). John R. Van Derlip Fund. 79.39.3.

Minneapolis. 1979. Color coupler print. 14¾ × 14⁹⁄₁₆ in. (37.6 × 37.0 cm.). John R. Van Derlip Fund. 79.39.4.

Railroad No. 11. From *Minnesota Photographers* portfolio. 1977. Gelatin silver print. 9⅛ × 9⅛ in. (23.2 × 23.2 cm.). John R. Van Derlip Fund. 79.48.9.

[New York City, no parking sign]. 1981. Color coupler print. 8 × 8 in. (20.4 × 20.4 cm.). Ethel Morrison Van Derlip Fund. 82.31.1.

[New York City, telephone booth]. 1981. Color coupler print. 7¹⁵⁄₁₆ × 7¹⁵⁄₁₆ in. (20.2 × 20.2 cm.). Ethel Morrison Van Derlip Fund. 82.31.2.

Woman with Umbrella, New York City. 1981. Color coupler print. 8 × 8 in. (20.4 × 20.4 cm.). Ethel Morrison Van Derlip Fund. 82.31.3.

[New York City, woman in fur coat]. 1981. Color coupler print. 8 × 8 in. (20.4 × 20.4 cm.). Ethel Morrison Van Derlip Fund. 82.31.4.

[New York City, truck]. 1982. Color coupler print. 8 × 8 in. (20.4 × 20.4 cm.). Gift of the artist. 82.32.1.

[New York City, mannequin and figures]. 1982. Color coupler print. 8 × 8 in. (20.4 × 20.4 cm.). Gift of the artist. 82.32.2.

[New York City, car and figures]. 1982. Color coupler print. 8 × 8 in. (20.4 × 20.4 cm.). Gift of the artist. 82.32.3.

[New York City, truck and figure]. 1982. Color coupler print. 8 × 8 in. (20.4 × 20.4 cm.). Gift of the artist. 82.32.4.

MERTIN, ROGER
American, 1942-

[woman holding mirror]. From *Plastic Love Dream* series. 1968. Gelatin silver print. 5⅛ × 7¾ in. (13.1 × 19.7 cm.). Kate and Hall J. Peterson Fund. 72.30.

[woman lying on mirror]. From *Plastic Love Dream* series. 1968. Gelatin silver print. 4⅞ × 7¼ in. (12.3 × 18.4 cm.). Kate and Hall J. Peterson Fund. 72.31.

[figure in grass with mirror]. From *Plastic Love Dream* series. 1968. Gelatin silver print. 4¹³⁄₁₆ × 7¼ in. (12.3 × 18.4 cm.). Kate and Hall J. Peterson Fund. 72.32.

Thousand Islands. 1971. Gelatin silver print. 8 × 11¹⁵⁄₁₆ in. (20.4 × 30.4 cm.). Kate and Hall J. Peterson Fund. 73.26.1.

[woman holding circular mirror]. From *Plastic Love Dream* series. 1968. Gelatin silver print. 5 × 7½ in. (12.7 × 19.1 cm.). Kate and Hall J. Peterson Fund. 73.26.2.

[female figures]. From *Plastic Love Dream* series. 1968. Gelatin silver print. 4¹¹⁄₁₆ × 7¹⁄₁₆ in. (12.0 × 18.0 cm.). Kate and Hall J. Peterson Fund. 73.26.3.

[clenched hand and field]. 1971. Gelatin silver print. 5 × 7⅜ in. (12.7 × 18.8 cm.). Kate and Hall J. Peterson Fund. 73.26.4.

[hand and aerial view]. 1971. Gelatin silver print, with sabattier effect. 4¾ × 7⅛ in. (12.1 × 18.1 cm.). Kate and Hall J. Peterson Fund. 73.26.5.

Penland Tree. 1971. Gelatin silver print. 5¹⁄₁₆ × 7⁹⁄₁₆ in. (12.9 × 19.2 cm.). Kate and Hall J. Peterson Fund. 73.26.6.

Conesus, New York. 1970. Gelatin silver print. 5¹⁄₁₆ × 7⁹⁄₁₆ in. (12.8 × 19.3 cm.). Kate and Hall J. Peterson Fund. 73.26.7.

Portrait, Aspen. 1971. Gelatin silver print. 8 × 11⅞ in. (20.3 × 30.3 cm.). Kate and Hall J. Peterson Fund. 73.26.8.

Rochester, New York. 1967. Gelatin silver print. 3⅜ × 6⅛ in. (8.6 × 15.6 cm.). National Endowment for the Arts purchase grant and miscellaneous matching funds. 76.54.1.

Rochester, New York. 1967. Gelatin silver print. 3⅞ × 5¹³⁄₁₆ in. (9.9 × 14.8 cm.). National Endowment for the Arts purchase grant and miscellaneous matching funds. 76.54.2.

Bridgeport, Connecticut. 1966. Gelatin silver print. 3¹⁵⁄₁₆ × 5⅞ in. (10.0 × 14.9 cm.). Gift of Frank Gaard. 76.55.

MEYEROWITZ, JOEL
American, 1938-

Truro, Cape Cod. 1976. Color coupler print (Ektacolor). 9⁹⁄₁₆ × 7⅝ in. (24.4 × 19.5 cm.). Mr. and Mrs. Harrison R. Johnston, Jr. Fund. 78.14.

Porch, Provincetown, Cape Cod. 1977. Color coupler print (Ektacolor). 9⅝ × 7⅝ in. (24.4 × 19.4 cm.). Mr. and Mrs. Harrison R. Johnston, Jr. Fund. 78.15.

Empire from Parking Pier in Hudson. 1978. Color coupler print. 15½ × 19½ in. (39.4 × 49.6 cm.). Gift of the American Telephone and Telegraph Co. 81.120.46.

29th Street and 12th Avenue. 1978. Color coupler print. 15⁷⁄₁₆ × 19½ in. (39.2 × 49.6 cm.). Gift of the American Telephone and Telegraph Co. 81.120.47.

12th Avenue and 39th Street. 1978. Color coupler print. 19½ × 15⁵⁄₁₆ in. (49.5 × 39.0 cm.). Gift of the American Telephone and Telegraph Co. 81.120.48.

MINICK, ROGER
American, 1944-

[highway through windshield]. From *New California Views* portfolio. 1977. Gelatin silver print. 8¹⁵⁄₁₆ × 13½ in. (22.7 × 34.4 cm.). Gift of funds from the Photography Council of The Minneapolis Institute of Arts. 80.24.11.

MISRACH, RICHARD
American, 1949-

[bush and palm trees with contrail]. From *New California Views* portfolio. 1979. Color coupler print (Ektacolor). 10½ × 10⅜ in. (26.7 × 26.5 cm.). Gift of funds from the Photography Council of The Minneapolis Institute of Arts. 80.24.12.

Hawaii VII. 1978. Color coupler print. 27¹⁄₁₆ × 32⅜ in. (68.8 × 82.2 cm.). Gift of the American Telephone and Telegraph Co. 81.120.49.

Hawaii XIV. 1978. Color coupler print. 26⅞ × 32⅛ in. (68.3 × 81.6 cm.). Gift of the American Telephone and Telegraph Co. 81.120.50.

Hawaii I. 1978. Color coupler print. 27⅜ × 33⅜ in. (69.5 × 84.8 cm.). Gift of the American Telephone and Telegraph Co. 81.120.51.

MITCHELL, GERALDINE K.
American, 1942-

[figure in grass with overlay]. 1974. Type R color print. 11¹⁵⁄₁₆ × 18⅞ in. (30.3 × 46.9 cm.). Kate and Hall J. Peterson Fund. 74.85.1.

[figure in grass with overlay]. 1974. Type R color print. 15¼ × 19½ in. (38.9 × 49.5 cm.). Kate and Hall J. Peterson Fund. 74.85.2.

[figure in grass with overlay]. 1974. Type R color print. 15⁷⁄₁₆ × 19½ in. (39.2 × 49.5 cm.). Kate and Hall J. Peterson Fund. 74.85.3.

[head and covers]. 1974. Type R color print. 11 × 13¼ in. (28.1 × 33.8 cm.). Kate and Hall J. Peterson Fund. 74.85.4.

Ishi Niwa, Berkeley, California. 1976. Dye bleach color print (Cibachrome). 3⁹⁄₁₆ × 2¹¹⁄₁₆ in. (9.0 × 6.9 cm.). National Endowment for the Arts purchase grant and miscellaneous matching funds. 76.26.1.

Fuya Niwa, Berkeley, California. 1976. Dye bleach color print (Cibachrome). 4 × 3¼ in. (10.2 × 8.8 cm.). National Endowment for the Arts purchase grant and miscellaneous matching funds. 76.26.2.

Hara Niwa, Berkeley, California. 1976. Dye bleach color print (Cibachrome). 2⅜ × 3½ in. (6.0 × 8.9 cm.). National Endowment for the Arts purchase grant and miscellaneous matching funds. 76.26.3.

Hana Niwa, Berkeley, California. 1976. Dye bleach color print (Cibachrome). 2¹¹⁄₁₆ × 3½ in. (6.9 × 8.9 cm.). National Endowment for the Arts purchase grant and miscellaneous matching funds. 76.26.4.

Chikya Niwa, Berkeley, California. 1976. Dye bleach color print (Cibachrome). 3 × 3⅝ in. (7.8 × 9.2 cm.). National Endowment for the Arts purchase grant and miscellaneous matching funds. 76.26.5.

Yabureteiru Niwa, Berkeley, California. 1976. Dye bleach color print (Cibachrome). 2¾ × 3½ in. (7.0 × 8.9 cm.). National Endowment for the Arts purchase grant and miscellaneous matching funds. 76.26.6.

Garasy Niwa, Berkeley, California. 1976. Dye bleach color print (Cibachrome). 3⁵⁄₁₆ × 4 in. (8.5 × 10.2 cm.). National Endowment for the Arts purchase grant and miscellaneous matching funds. 76.26.7.

MOLE, ARTHUR S. and JOHN D. THOMAS
American, 1888- American, died c. 1940

The Human U.S. Shield. 1918. Gelatin silver print. 12¹⁵⁄₁₆ × 10⁵⁄₁₆ in. (32.9 × 26.3 cm.). Kate and Hall J. Peterson Fund. 74.80.

MOSS, JOAN
American (b. Canada), 1931-

[figures at pool]. From *Two Women* series, Camelback, Arizona. 1977. Gelatin silver print. 12¹¹⁄₁₆ × 19³⁄₁₆ in. (32.3 × 48.7 cm.). Gift of the artist. 82.128.1.

Mother and Child, Wisconsin. 1981. Gelatin silver print. 12⁹⁄₁₆ × 18⅞ in. (32.0 × 47.9 cm.). Gift of the artist. 82.128.2.

Vegas, Caesar's Palace. 1980. Gelatin silver print. 12¹¹⁄₁₆ × 19¼ in. (32.3 × 48.9 cm.). Gift of the artist. 82.128.3.

Joanno Albino, Fort Lauderdale, Florida. 1980. Gelatin silver print. 12¹¹⁄₁₆ × 19³⁄₁₆ in. (32.3 × 48.8 cm.). Gift of funds from the Photography Council of The Minneapolis Institute of Arts. 82.129.1.

Carol at Her Mother's Kidney-Shaped Pool, Skokie, Illinois. 1981. Gelatin silver print. 12¹¹⁄₁₆ × 19⅛ in. (32.3 × 48.7 cm.). Gift of funds from the Photography Council of The Minneapolis Institute of Arts. 82.129.2.

Montmartre, Paris, France. 1977. Gelatin silver print. 12¹¹⁄₁₆ × 19¼ in. (32.3 × 49.0 cm.). Gift of funds from the Photography Council of The Minneapolis Institute of Arts. 82.129.3.

MUIR, WARD
See *Camera Work.*

MUXTER, RAMON J.
American, 1945-

[self-portrait at funeral]. 1972. Gelatin silver print. 5¹¹⁄₁₆ × 8½ in. (14.5 × 21.6 cm.). Anonymous gift. 72.110.1.

First Man on the Moon. 1970. Gelatin silver print. 5¾ × 8½ in. (14.6 × 21.6 cm.). Anonymous gift. 72.110.2.

[urinal]. 1972. Gelatin silver print. 5¹¹⁄₁₆ × 8½ in. (14.5 × 21.6 cm.). Anonymous gift. 72.110.3.

Fifteen Dollars, Hollywood. c. 1972. Gelatin silver print. 5¹³⁄₁₆ × 8¹¹⁄₁₆ in. (14.8 × 22.1 cm.). Kate and Hall J. Peterson Fund. 73.25.1.

[man on dock photographing woman]. 1972. Gelatin silver print. 5⁵⁄₁₆ × 8 in. (13.5 × 20.3 cm.). Kate and Hall J. Peterson Fund. 73.25.2.

[man holding child]. 1972. Gelatin silver print. 5⁵⁄₁₆ × 8 in. (13.5 × 20.3 cm.). Kate and Hall J. Peterson Fund. 73.25.3.

[woman on man's lap]. 1972. Gelatin silver print. 5⁵⁄₁₆ × 8 in. (13.5 × 20.4 cm.). Kate and Hall J. Peterson Fund. 73.25.4.

[people holding snapshots]. 1972. Gelatin silver print. 5⁵⁄₁₆ × 8 in. (13.5 × 20.3 cm.). Kate and Hall J. Peterson Fund. 73.25.5.

[group with lawn chairs]. 1972. Gelatin silver print. 5⁵⁄₁₆ × 8 in. (13.5 × 20.3 cm.). Kate and Hall J. Peterson Fund. 73.25.6.

[lake and dock with cowboy hat]. 1972. Gelatin silver print. 5⁵⁄₁₆ × 8 in. (13.5 × 20.4 cm.). Kate and Hall J. Peterson Fund. 73.25.7.

[family group on cement steps]. 1972. Gelatin silver print. 5⁵⁄₁₆ × 8 in. (13.5 × 20.4 cm.). Kate and Hall J. Peterson Fund. 73.25.8.

[man holding Polaroid camera]. 1972. Gelatin silver print. 8 × 5⁵⁄₁₆ in. (20.4 × 13.5 cm.). Kate and Hall J. Peterson Fund. 73.25.9.

[woman with sunglasses]. 1972. Gelatin silver print. 8 × 5⁵⁄₁₆ in. (20.3 × 13.5 cm.). Kate and Hall J. Peterson Fund. 73.25.10.

[man lying on back of car]. 1972. Gelatin silver print. 8 × 5⁵⁄₁₆ in. (20.4 × 13.5 cm.). Kate and Hall J. Peterson Fund. 73.25.11.

[woman sitting in lawn chair]. 1972. Gelatin silver print. 8 × 5⁵⁄₁₆ in. (20.3 × 13.5 cm.). Kate and Hall J. Peterson Fund. 73.25.12.

William Burroughs and Me. 1976. Gelatin silver print. 11³⁄₁₆ × 16⅝ in. (28.4 × 42.3 cm.). National Endowment for the Arts purchase grant and miscellaneous matching funds. 76.23.

Baltimore Street. 1976. Gelatin silver print. 12¹⁵⁄₁₆ × 18¹⁵⁄₁₆ in. (32.9 × 48.1 cm.). National Endowment for the Arts purchase grant and miscellaneous matching funds. 76.62.1.

Cat and Camel. 1976. Gelatin silver print. 11¾ × 17⁹⁄₁₆ in. (29.9 × 44.7 cm.). National Endowment for the Arts purchase grant and miscellaneous matching funds. 76.62.2.

[basketball hoop and horseshoe]. n.d. Gelatin silver print. 12⅜ × 18⁵⁄₁₆ in. (31.5 × 46.6 cm.). Gift of Jeff Petritch. 82.62.

[self-portrait with couple]. n.d. Gelatin silver print. 11¹³⁄₁₆ × 17⁹⁄₁₆ in. (30.0 × 44.6 cm.). Gift of the artist. 82.63.1.

[self-portrait at pool table]. n.d. Gelatin silver print. 11¹³⁄₁₆ × 17⅝ in. (30.0 × 44.8 cm.). Gift of the artist. 82.63.2.

[Richard Avedon at Ambassador Motel, Minneapolis]. 1970. Gelatin silver print. 8 × 12¼ in. (20.4 × 31.2 cm.). Gift of the artist. 82.63.3.

[photographer's father with basketball]. n.d. Color coupler print with accompanying negative. 7¹⁄₁₆ × 7⅛ in. (18.0 × 18.1 cm.). Gift of the artist. 82.63.4a and b.

MUYBRIDGE, EADWEARD
American (b. England), 1830-1904

Animal Locomotion (partial). Published under the auspices of the University of Pennsylvania, Philadelphia. 1887. Portfolio of 83 collotypes (of 781 total issued). Gift of S. C. Gale, William H. Hinkle, A. Loring, C. M. Loring, C. J. Martin, and Charles A. Pillsbury. 81.76.1-83.

Plate 14 [woman walking]. 7⁹⁄₁₆ × 15³⁄₁₆ in. (19.2 × 38.6 cm.).

Plate 31 [man carrying stone]. 9⁹⁄₁₆ × 12¹⁄₁₆ in. (24.4 × 30.7 cm.).

Plate 41 [woman with fan]. 8¹⁄₁₆ × 13¹³⁄₁₆ in. (20.5 × 35.1 cm.).

Plate 52 [woman walking with children]. 7⅝ × 14⅝ in. (19.4 × 37.2 cm.).

Plate 53 [woman scattering flowers]. 8¹⁄₁₆ × 14⁹⁄₁₆ in. (20.4 × 37.1 cm.).

Plate 55 [woman walking]. 7¼ × 15⅜ in. (18.4 × 39.0 cm.).

Plate 59 [man running]. 8½ × 13¹⁵⁄₁₆ in. (21.7 × 35.4 cm.).

Plate 60 [man running]. 9⁵⁄₁₆ × 12¹¹⁄₁₆ in. (23.6 × 32.2 cm.).

Plate 69 [boys running]. 8¹⁄₁₆ × 14⁵⁄₁₆ in. (20.6 × 36.3 cm.).

Plate 72 [woman and child walking]. 6¹⁵⁄₁₆ × 16⁵⁄₁₆ in. (17.7 × 41.5 cm.).

Plate 108 [woman ascending stairs]. 8¼ × 14½ in. (21.0 × 36.9 cm.).

Plate 114 [man descending incline]. 8¼ × 13¹¹⁄₁₆ in. (20.9 × 34.7 cm.).

Plate 128 [woman descending stairs]. 7¾ × 15³⁄₁₆ in. (19.7 × 38.6 cm.).

Plate 133 [woman descending stairs]. 9⅛ × 12³⁄₁₆ in. (23.2 × 31.0 cm.).

Plate 135 [woman descending stairs]. 8⅞ × 13⅛ in. (22.5 × 33.4 cm.).

Plate 137 [woman descending stairs]. 7¹¹⁄₁₆ × 14¹¹⁄₁₆ in. (19.5 × 37.4 cm.).

Plate 139 [woman descending stairs]. 8⅛ × 14⁵⁄₁₆ in. (20.6 × 36.4 cm.).

Plate 143 [woman descending stairs]. 7½ × 14¹⁵⁄₁₆ in. (19.1 × 38.0 cm.).

Plate 146 [woman descending stairs]. 10¹⁄₁₆ × 11¾ in. (25.5 × 29.9 cm.).

Plate 160 [man jumping]. 7½ × 16 in. (19.1 × 40.8 cm.).

Plate 167 [boys playing leapfrog]. 10⅛ × 11¹¹⁄₁₆ in. (25.8 × 29.7 cm.).

Plate 170 [woman jumping]. 6¹⁵⁄₁₆ × 16¹⁵⁄₁₆ in. (17.6 × 43.1 cm.).

Plate 177 [woman stepping from stone to stone]. 8⅛ × 15¹¹⁄₁₆ in. (20.6 × 39.9 cm.).

Plate 183 [woman walking on hands and feet]. 6⁷⁄₁₆ × 18³⁄₁₆ in. (16.4 × 46.2 cm.).

Plate 187 [woman dancing]. 7⅛ × 16⁹⁄₁₆ in. (18.2 × 42.1 cm.).

Plate 202 [woman picking up handkerchief]. 7¼ × 16 in. (18.5 × 40.7 cm.).

Plate 205 [woman stooping]. 7⁷⁄₁₆ × 14¾ in. (18.9 × 37.5 cm.).

Plate 214 [woman lifting child]. 7¾ × 14⅜ in. (19.7 × 36.6 cm.).

Plate 215 [woman putting child down]. 6⁹⁄₁₆ × 16¾ in. (16.6 × 42.6 cm.).

Plate 225 [woman putting jug down]. 6⁵⁄₁₆ × 17½ in. (16.0 × 44.5 cm.).

Plate 232 [woman lifting train]. 7 × 15¹⁵⁄₁₆ in. (17.8 × 40.6 cm.).

Plate 233 [woman picking up shawl]. 7 × 16⅞ in. (17.8 × 43.0 cm.).

Plate 241 [woman sitting down in chair]. 12½ × 10¹⁄₁₆ in. (31.7 × 25.5 cm.).

Plate 253 [woman kneeling]. 7¾ × 15⁵⁄₁₆ in. (19.7 × 38.9 cm.).

Plate 298 [woman playing tennis]. 9⅝ × 12 in. (24.5 × 30.5 cm.).

Plate 306 [woman throwing ball]. 7¹⁵⁄₁₆ × 15³⁄₁₆ in. (20.2 × 38.6 cm.).

Plate 313 [man throwing rock]. 8⁹⁄₁₆ × 13¹¹⁄₁₆ in. (21.7 × 34.8 cm.).

Plate 327 [man rowing]. 7¹¹⁄₁₆ × 14⁵⁄₁₆ in. (19.6 × 36.4 cm.).

Plate 334 [men boxing]. 11⅝ × 10¼ in. (29.6 × 26.0 cm.).

Plate 344 [man striking a blow]. 6¾ × 17⅜ in. (17.1 × 44.2 cm.).

Plate 349 [men fencing]. 7⅛ × 16⅝ in. (18.2 × 42.3 cm.).

Plate 356 [man firing rifle]. 9¹⁄₁₆ × 12⁹⁄₁₆ in. (23.1 × 31.7 cm.).

Plate 361 [man throwing spear]. 9³⁄₁₆ × 12⅝ in. (23.3 × 32.1 cm.).

Plate 368 [man descending stairs on hands]. 7¹³⁄₁₆ × 15¹⁄₁₆ in. (19.9 × 38.3 cm.).

Plate 374 [men blacksmithing]. 9 × 12⁹⁄₁₆ in. (22.8 × 32.0 cm.).

Plate 379 [man planing wood]. 8¹⁵⁄₁₆ × 13¼ in. (22.8 × 33.7 cm.).

Plate 386 [man using pick]. 10⁹⁄₁₆ × 10⅛ in. (26.9 × 25.8 cm.).

Plate 403 [woman emptying bucket]. 8¹³⁄₁₆ × 13⅜ in. (22.5 × 34.0 cm.).

Plate 411 [woman picking up towel]. 7⁷⁄₁₆ × 16¹⁄₁₆ in. (18.9 × 40.8 cm.).

Plate 432 [woman washing clothes in tub]. 7¼ × 16½ in. (18.4 × 41.9 cm.).

Plate 442 [woman rolling rock]. 7¹⁄₁₆ × 16¹⁄₁₆ in. (18.0 × 40.8 cm.).

Plate 454 [woman putting down basket]. 8⁹⁄₁₆ × 13¹⁄₁₆ in. (21.7 × 33.2 cm.).

Plate 461 [woman opening parasol]. 7¹¹⁄₁₆ × 15⅝ in. (19.6 × 39.8 cm.).

Plate 463 [woman reaching and stooping]. 8⅝ × 13½ in. (21.9 × 34.3 cm.).

Plate 466 [child walking to woman]. 9⅞ × 12⅛ in. (25.1 × 30.9 cm.).

Plate 467 [child walking]. 6 × 18³⁄₁₆ in. (15.2 × 46.2 cm.).

Plate 469 [child running]. 7¹⁵⁄₁₆ × 12⅞ in. (20.2 × 32.8 cm.).

Plate 471 [child crawling]. 7⁵⁄₁₆ × 15⅞ in. (18.7 × 40.4 cm.).

Plate 472 [child crawling upstairs]. 4⅞ × 17¹⁵⁄₁₆ in. (12.4 × 45.6 cm.).

Plate 475 [child getting in chair]. 9⅛ × 12⅞ in. (23.3 × 32.8 cm.).

Plate 481 [child lifting and walking with doll]. 7½ × 15 in. (19.0 × 38.1 cm.).

Plate 483 [woman lifting basket and waving handkerchief]. 12½ × 9¹¹⁄₁₆ in. (31.8 × 24.6 cm.).

Plate 496 [woman combing hair and washing face]. 8⅜ × 13¼ in. (21.3 × 33.8 cm.).

Plate 502 [woman pouring water and kneeling]. 8¹¹⁄₁₆ × 14¹⁄₁₆ in. (22.0 × 35.7 cm.).

Plate 508 [man shoeing horse]. 8½ × 12¾ in. (21.6 × 32.5 cm.).

Plate 519 [man throwing disk, ascending stairs, and walking]. 9½ × 12³⁄₁₆ in. (24.2 × 31.1 cm.).

Plate 528 [woman carrying and walking with child]. 12¹⁵⁄₁₆ × 9¹⁄₁₆ in. (33.0 × 23.1 cm.).

Plate 529 [man standing]. 6¹³⁄₁₆ × 17⅞ in. (17.3 × 45.5 cm.).

Plate 574 [horse walking]. 7¾ × 15⁵⁄₁₆ in. (19.8 × 38.9 cm.).

Plate 576 [horse walking]. 6¹³⁄₁₆ × 17¹⁄₁₆ in. (17.3 × 43.3 cm.).

Plate 581 [man riding horse]. 7⅝ × 15⁹⁄₁₆ in. (19.4 × 39.6 cm.).

Plate 637 [mounted horse jumping hurdle]. 10¹⁄₁₆ × 12⁷⁄₁₆ in. (25.6 × 31.6 cm.).

Plate 640 [mounted horse jumping hurdle]. 9¹⁵⁄₁₆ × 12¹⁄₁₆ in. (25.3 × 30.7 cm.).

Plate 643 [mounted horse jumping hurdle]. 5⅞ × 18⅛ in. (14.9 × 46.1 cm.).

Plate 658 [mule kicking]. 9¹³⁄₁₆ × 12⅛ in. (25.0 × 30.8 cm.).

Plate 670 [ox walking]. 6⅜ × 17⁹⁄₁₆ in. (16.2 × 44.6 cm.).

Plate 695 [elk galloping]. 9¼ × 12¹¹⁄₁₆ in. (23.5 × 32.3 cm.).

Plate 699 [buffalo walking]. 7⁷⁄₁₆ × 15¾ in. (19.0 × 40.1 cm.).

Plate 721 [lion walking]. 9¼ × 12¼ in. (23.6 × 31.2 cm.).

Plate 729 [tigress walking]. 7⁷⁄₁₆ × 15⁹⁄₁₆ in. (18.9 × 39.6 cm.).

Plate 730 [tigress walking]. 6⅝ × 17⁹⁄₁₆ in. (16.9 × 44.6 cm.).

Plate 770 [eagle flying]. 10⅜ × 11¹⁄₁₆ in. (26.5 × 28.2 cm.).

Plate 778 [storks and swans walking]. 6½ × 16⅝ in. (16.5 × 42.3 cm.).

MYERS, JOAN
American, 1944-

Monument Valley. 1979. Palladium print. 9⁹⁄₁₆ × 12⁷⁄₁₆ in. (24.4 × 31.6 cm.). Mr. and Mrs. Julius E. Davis Fund. 81.9.

NEIMANAS, JOYCE
American, 1944-

Some Females Have Daytime Fantasies. From *Underware* portfolio. 1976. Gelatin silver print, hand colored. 15¹⁵⁄₁₆ × 19¹³⁄₁₆ in. (40.5 × 50.3 cm.). National Endowment for the Arts purchase grant and miscellaneous matching funds. 76.64.12.

NEWHALL, BEAUMONT
American, 1908-

Edward Weston. From *The New Mexico Portfolio.* 1940. Gelatin silver print. 6⁹⁄₁₆ × 4¹⁵⁄₁₆ in. (16.7 × 12.5 cm.). National Endowment for the Arts purchase grant and miscellaneous matching funds. 76.61.13.

NEWMAN, ARNOLD
American, 1918-

Stieglitz and O'Keeffe, An American Place. 1944. Gelatin silver print. 9³⁄₈ × 7⁵⁄₈ in. (23.9 × 19.5 cm.). Kate and Hall J. Peterson Fund. 73.34.

Georges Rouault. 1957. Gelatin silver print. 9³⁄₄ × 7³⁄₄ in. (24.7 × 19.6 cm.). Anonymous gift of funds. 78.92.5.

NIXON, NICHOLAS
American, 1947-

Barbie Norman, Tennis Club of Albuquerque. 1973. Gelatin silver print. 7¹¹⁄₁₆ × 9¹¹⁄₁₆ in. (19.6 × 24.6 cm.). Kate and Hall J. Peterson Fund. 75.58.1.

View of the John F. Kennedy Federal Building, Boston. 1975. Gelatin silver print. 7¹¹⁄₁₆ × 9¹¹⁄₁₆ in. (19.6 × 24.6 cm.). Kate and Hall J. Peterson Fund. 75.58.2.

View of the Christian Science Church and Colonnade, Boston. 1975. Gelatin silver print. 7¹¹⁄₁₆ × 9¹¹⁄₁₆ in. (19.5 × 24.6 cm.). Kate and Hall J. Peterson Fund. 75.58.3.

View of Copley Square, Boston. 1974. Gelatin silver print. 7¹¹⁄₁₆ × 9¹¹⁄₁₆ in. (19.6 × 24.6 cm.). Kate and Hall J. Peterson Fund. 75.58.4.

East View, Tennis Club of Albuquerque. 1973. Gelatin silver print. 7¹¹⁄₁₆ × 9¹¹⁄₁₆ in. (19.6 × 24.6 cm.). Kate and Hall J. Peterson Fund. 75.58.5.

Mrs. Wheeler, Mrs. Norman, Mrs. Landy, Mrs. Jamison, Tennis Club of Albuquerque. 1973. Gelatin silver print. 7¹¹⁄₁₆ × 9⁵⁄₈ in. (19.6 × 24.6 cm.). Kate and Hall J. Peterson Fund. 75.58.6.

Mary Hughes, Tennis Club of Albuquerque. 1973. Gelatin silver print. 7¹¹⁄₁₆ × 9¹¹⁄₁₆ in. (19.6 × 24.6 cm.). Kate and Hall J. Peterson Fund. 75.58.7.

View of the Mother Church and the Christian Science Center, Boston. 1975. Gelatin silver print. 7¹¹⁄₁₆ × 9¹¹⁄₁₆ in. (19.6 × 24.7 cm.). Gift of the artist. 78.53.

New Orleans. 1978. Gelatin silver print. 7¹¹⁄₁₆ × 9¹¹⁄₁₆ in. (19.5 × 24.6 cm.). Gift of the American Telephone and Telegraph Co. 81.120.52.

West Springfield, Massachusetts. 1978. Gelatin silver print. 7¹¹⁄₁₆ × 9⁵⁄₈ in. (19.5 × 24.5 cm.). Gift of the American Telephone and Telegraph Co. 81.120.53.

New Orleans. 1978. Gelatin silver print. 7¹¹⁄₁₆ × 9⁵⁄₈ in. (19.5 × 24.5 cm.). Gift of the American Telephone and Telegraph Co. 81.120.54.

NOGGLE, ANNE
American, 1922-

Larry's Suit. From *The New Mexico Portfolio.* 1975. Gelatin silver print. 12 × 8¹⁄₁₆ in. (30.5 × 20.5 cm.). National Endowment for the Arts purchase grant and miscellaneous matching funds. 76.61.14.

NORQUIST, JOY
American (?), 20th century

[child and door]. From *What Ever Happened to Sexuality* portfolio. c. 1977. Gelatin silver print. 7⁷⁄₈ × 4¹⁵⁄₁₆ in. (20.0 × 12.5 cm.). Gift of the artist. 82.70.12.

NORTH, KENDA
American, 1951-

Coppertone Girl. From *Sun Bathers* series. 1976. Dye transfer print. 12³⁄₈ × 18¹⁄₁₆ in. (31.4 × 45.9 cm.). Gift of Christopher Cardozo. 79.40.1.

Steph on Boards. 1979. Dye transfer print. 12⁵⁄₈ × 18⁷⁄₁₆ in. (32.1 × 46.9 cm.). Gift of Christopher Cardozo. 79.40.2.

Ellen in Green. 1977. Dye transfer print. 18⁵⁄₁₆ × 12⁹⁄₁₆ in. (46.6 × 32.0 cm.). Kate and Hall J. Peterson Fund. 79.41.1.

Michaela, Hand over Face. 1977. Dye transfer print. 18⁷⁄₁₆ × 12⁹⁄₁₆ in. (46.9 × 32.0 cm.). Kate and Hall J. Peterson Fund. 79.41.2.

Untitled (Debo and I). 1979. Dye transfer print. 12½ × 18⁵⁄₁₆ in. (31.7 × 46.6 cm.). Kate and Hall J. Peterson Fund. 79.41.3.

OKUHARA, TETSU
American, 1942-

Susan. n.d. Gelatin silver prints, composite. 6¹⁵⁄₁₆ × 23⁷⁄₁₆ in. (17.7 × 59.6 cm.). Kate and Hall J. Peterson Fund. 78.101.

OLIN, JUDY
American (?), 20th century

[hand and breasts]. From *What Ever Happened to Sexuality* portfolio. c. 1977. Gelatin silver print. 5½ × 4³⁄₈ in. (14.0 × 11.1 cm.). Gift of the artist. 82.70.13.

OLLMAN, ARTHUR
American, 1947-

[mound of earth and bridge]. From *New California Views* portfolio. 1979. Color coupler print (Ektacolor). 8⁵⁄₈ × 12¹⁵⁄₁₆ in. (22.0 × 33.0 cm.). Gift of funds from the Photography Council of The Minneapolis Institute of Arts. 80.24.13.

OLSENIUS, RICHARD
American, 1946-

[couple]. From *High School* series. c. 1970. Gelatin silver print. 6 × 8¹⁵⁄₁₆ in. (15.3 × 22.7 cm.). Gift of the artist. 71.12.1.

[male with knife]. From *High School* series. c. 1970. Gelatin silver print. 5⁷⁄₈ × 8⁵⁄₈ in. (15.0 × 22.0 cm.). Gift of the artist. 71.12.2.

[black smoking in bathroom]. From *High School* series. c. 1970. Gelatin silver print. 5¹⁵⁄₁₆ × 8¹³⁄₁₆ in. (15.0 × 22.4 cm.). Gift of the artist. 71.12.3.

[empty classroom]. From *High School* series. c. 1970. Gelatin silver print. 6⅛ × 8¹⁵⁄₁₆ in. (15.5 × 22.8 cm.). Gift of the artist. 71.12.4.

[couple kissing]. From *High School* series. c. 1970. Gelatin silver print. 6¹⁄₁₆ × 8¹⁵⁄₁₆ in. (15.4 × 22.7 cm.). Gift of the artist. 71.12.5.

[teenage boy and girl at bottom of staircase]. From *High School* series. c. 1970. Gelatin silver print. 6¹⁄₁₆ × 8¹⁵⁄₁₆ in. (15.5 × 22.8 cm.). Kate and Hall J. Peterson Fund. 71.20.1.

[black girl in doorway]. From *High School* series. c. 1970. Gelatin silver print. 5³⁄₄ × 8¹¹⁄₁₆ in. (14.6 × 22.0 cm.). Kate and Hall J. Peterson Fund. 71.20.2.

[couple against brick wall]. From *High School* series. c. 1970. Gelatin silver print. 6 × 8¹³⁄₁₆ in. (15.3 × 22.4 cm.). Kate and Hall J. Peterson Fund. 71.20.3.

[teenagers on street]. From *High School* series. c. 1970. Gelatin silver print. 5¹³⁄₁₆ × 8⁵⁄₈ in. (14.9 × 22.0 cm.). Kate and Hall J. Peterson Fund. 71.20.4.

[blacks on staircase]. From *High School* series. c. 1970. Gelatin silver print. 5⁹⁄₁₆ × 8⅛ in. (14.1 × 20.7 cm.). Kate and Hall J. Peterson Fund. 71.20.5.

[couple kissing]. From *High School* series. c. 1970. Gelatin silver print. 6 × 8³⁄₄ in. (15.2 × 22.3 cm.). Kate and Hall J. Peterson Fund. 71.20.6.

[girl and couple in hallway]. From *High School* series. c. 1970. Gelatin silver print. 5¹¹⁄₁₆ × 8⁷⁄₁₆ in. (14.5 × 21.6 cm.). Kate and Hall J. Peterson Fund. 71.20.7.

O'NEAL, JANE L.
American, 1945-

[overturned shopping cart]. From *L. A. Issue* portfolio. 1978. Dye bleach color print (Cibachrome). 9½ × 14 in. (24.1 × 35.6 cm.). Gift of funds from the Photography Council of The Minneapolis Institute of Arts. 80.25.14.

ORLOVE, MARK
American, 1950-

Lollipops. 1977. Color coupler print. 11¹³⁄₁₆ × 9⁹⁄₁₆ in. (30.1 × 24.3 cm.). Kate and Hall J. Peterson Fund. 78.94.1.

The Dress. 1978. Color coupler print. 7³⁄₄ × 6⅛ in. (19.7 × 15.5 cm.). Kate and Hall J. Peterson Fund. 78.94.2.

Gangbusters. 1977. Color coupler print. 3¼ × 9¹⁄₁₆ in. (8.2 × 23.1 cm.). Kate and Hall J. Peterson Fund. 78.94.3.

PALFI, MARION
American (b. Hungary), 1917-1978

Wife of the Lynch Victim. From *Silver See* portfolio. Gelatin silver print. 13⁷⁄₁₆ × 10½ in. (34.3 × 26.8 cm.). National Endowment for the Arts purchase grant and miscellaneous matching funds. 77.39.14.

In the Shadow of the Capitol. From *L. A. Issue* portfolio. c. 1947. Gelatin silver print. 11⁹/₁₆ × 8⅝ in. (29.4 × 21.9 cm.). Gift of funds from the Photography Council of The Minneapolis Institute of Arts. 80.25.15.

PAPAGEORGE, TOD
American, 1940-

Ocean Front Walk, Venice No. 4. 1978. Gelatin silver print. 10¾ × 15¹¹/₁₆ in. (27.3 × 40.0 cm.). Gift of the American Telephone and Telegraph Co. 81.120.55.

Downtown Pasadena. 1978. Gelatin silver print. 10⅞ × 15⅞ in. (27.6 × 40.4 cm.). Gift of the American Telephone and Telegraph Co. 81.120.56.

Sunset Boulevard, Hollywood. 1978. Gelatin silver print. 10¹¹/₁₆ × 15¹¹/₁₆ in. (27.2 × 39.9 cm.). Gift of the American Telephone and Telegraph Co. 81.120.57.

New York Pier, July 5, 1976. Gelatin silver print. 10⅝ × 15⁹/₁₆ in. (27.0 × 39.6 cm.). Ethel Morrison Van Derlip Fund. 82.37.1.

Central Park. 1980. Gelatin silver print. 12⁹/₁₆ × 18¹⁵/₁₆ in. (31.9 × 48.2 cm.). Ethel Morrison Van Derlip Fund. 82.37.2.

PARKER, BART
American, 1934-

[landscape with colored pens]. From *Underware* portfolio. 1976. Color coupler print. 8⁷/₁₆ × 15¹/₁₆ in. (21.5 × 38.3 cm.). National Endowment for the Arts purchase grant and miscellaneous matching funds. 76.64.13.

PEEL, MICHAEL
English, 20th century

The Camera Never Lies. Book with color coupler print. Published by Circle Press, Surrey, England. 1979. Gift of Manfred Glucksman. 80.71.1-2.

PETERSON, DALE R.
American, 1934-

[arrow shadows on wall]. n.d. Gelatin silver print. 15¾ × 15⁹/₁₆ in. (40.1 × 39.6 cm.). Kate and Hall J. Peterson Fund. 71.14.1.

[farm buildings]. n.d. Gelatin silver print. 13¼ × 19⅝ in. (33.7 × 50.0 cm.). Kate and Hall J. Peterson Fund. 71.14.2.

PETERSON, MARGARET
American, 1946-

Untitled, Champaign. 1973. Gelatin silver print. 4¹³/₁₆ × 7¾ in. (12.3 × 19.7 cm.). Kate and Hall J. Peterson Fund. 74.82.1.

Untitled, Champaign. 1973. Gelatin silver print. 4¾ × 7⅝ in. (12.1 × 19.4 cm.). Kate and Hall J. Peterson Fund. 74.82.2.

Untitled, Champaign. 1973. Gelatin silver print. 4⅞ × 7¹¹/₁₆ in. (12.3 × 19.6 cm.). Kate and Hall J. Peterson Fund. 74.82.3.

Untitled, Champaign. 1973. Gelatin silver print. 4¾ × 7⁵/₁₆ in. (12.1 × 18.6 cm.). Kate and Hall J. Peterson Fund. 74.82.4.

PETROWIAK, BILL
American (?), 20th century

[reclining male]. From *What Ever Happened to Sexuality* portfolio. c. 1977. 6 gelatin silver prints. approx. 9 × 4½ in. (23.0 × 11.5 cm.) total. Gift of the artist. 82.70.14.

PFAHL, JOHN
American, 1939-

Blue Right Angle, Albright-Knox Art Gallery, Buffalo, New York. 1975. Color coupler print. 7⅝ × 9⅞ in. (18.6 × 24.1 cm.). Gift of funds from the Photography Council of The Minneapolis Institute of Arts. 80.20.1.

Lovelock Seed Company, Lovelock, Nevada. 1978. Color coupler print. 7½ × 9⁹/₁₆ in. (19.0 × 24.3 cm.). Gift of funds from the Photography Council of The Minneapolis Institute of Arts. 80.20.2.

PINKEL, SHEILA
American, 1941-

Lightwork. From *Silver See* portfolio. 1976. Gelatin silver print. 16 × 19¹⁵/₁₆ in. (40.7 × 50.6 cm.). National Endowment for the Arts purchase grant and miscellaneous matching funds. 77.39.15.

PINNELL, PAIGE
American, 1944-

Oddfellow's Eyes. From *The New Mexico Portfolio.* 1973. Gelatin silver print. 4⁵/₁₆ × 12³/₁₆ in. (11.0 × 31.0 cm.). National Endowment for the Arts purchase grant and miscellaneous matching funds. 76.61.15.

PIROU, EUGÈNE
French, 19th century

Gustave Eiffel. From *Galerie Contemporaine.* c. 1880. Woodburytype. 9¼ × 7⅜ in. (23.5 × 18.7 cm.). David Draper Dayton Fund. 75.59.1.

PLEASURE, FRED
American, 1932-

Sand Dune No. 4, Robert Moses State Park, New York. 1972. Color coupler print. 7½ × 9½ in. (19.1 × 24.2 cm.). Kate and Hall J. Peterson Fund. 74.84.1.

Traprock No. 1, Route I-84, New Britain, Connecticut. 1972. Color coupler print. 9⁹/₁₆ × 7 in. (24.3 × 17.9 cm.). Kate and Hall J. Peterson Fund. 74.84.2.

Three Stones, Gloucester, Massachusetts. 1972. Color coupler print. 6⅝ × 9½ in. (16.9 × 24.2 cm.). Kate and Hall J. Peterson Fund. 74.84.3.

Stones and Natural Breakwater, Gloucester, Massachusetts. 1972. Color coupler print. 6¹¹/₁₆ × 9⁹/₁₆ in. (17.1 × 24.3 cm.). Kate and Hall J. Peterson Fund. 74.84.4.

Figures in Rock, Gloucester, Massachusetts. 1973. Color coupler print. 7½ × 11¹¹/₁₆ in. (19.1 × 28.7 cm.). Kate and Hall J. Peterson Fund. 74.84.5.

POST, WILLIAM B.
See *Camera Work*

PRATT, FREDERICK H.
See *Camera Work*

PUTTERMAN, JAYDIE
American, 1945-

Provincetown, Rhode Island. 1968. Gelatin silver print. 6⅝ × 9⅞ in. (16.8 × 25.1 cm.). Kate and Hall J. Peterson Fund. 74.78.1.

Paul Smart, Loudon, New Hampshire, U.S.A. 1972. Gelatin silver print. 6⁹/₁₆ × 9¾ in. (16.7 × 24.9 cm.). Kate and Hall J. Peterson Fund. 74.78.2.

France. 1974. Gelatin silver print. 6⅝ × 9¹³/₁₆ in. (16.8 × 25.0 cm.). Kate and Hall J. Peterson Fund. 74.78.3.

U.S. Grand Prix, Watkins Glen, New York. 1972. Gelatin silver print. 6⁹/₁₆ × 9⅞ in. (16.7 × 25.0 cm.). Kate and Hall J. Peterson Fund. 74.78.4.

Laguna-Seca, California, U.S.A. 1972. Gelatin silver print. 6⅞ × 10⅛ in. (17.4 × 25.7 cm.). Kate and Hall J. Peterson Fund. 74.78.5.

St. Louis, U.S.A. 1969. Gelatin silver print. 9¹³/₁₆ × 6¹¹/₁₆ in. (25.0 × 17.0 cm.). Kate and Hall J. Peterson Fund. 74.78.6.

New York City Ballet, Lincoln Center, New York City. 1973. Gelatin silver print. 6⅝ × 9¹⁵/₁₆ in. (16.8 × 25.3 cm.). Kate and Hall J. Peterson Fund. 74.78.7.

Gainsville, Georgia. 1972. Gelatin silver print. 6⁹/₁₆ × 9¾ in. (16.7 × 24.8 cm.). Kate and Hall J. Peterson Fund. 74.78.8.

Dick Mann, Loudon, New Hampshire. 1972. Gelatin silver print. 6⁹/₁₆ × 9¾ in. (16.7 × 24.8 cm.). Kate and Hall J. Peterson Fund. 74.78.9.

Laguna-Seca, California, Gary Fisher. 1972. Gelatin silver print. 9¹¹/₁₆ × 6½ in. (24.6 × 16.6 cm.). Kate and Hall J. Peterson Fund. 74.78.10.

PUYO, E. J. CONSTANT
See *Camera Work*

QUESADA-BURKE, CARMEN
American, 1947-

Untitled (Minnesota Farmhouse). 1972. Platinum print. 6⁷/₁₆ × 4⁷/₁₆ in. (16.3 × 11.3 cm.). Kate and Hall J. Peterson Fund. 74.83.1.

Untitled (Vines, Upstate New York). 1972. Platinum print. 4¹¹/₁₆ × 3¹¹/₁₆ in. (11.9 × 9.4 cm.). Kate and Hall J. Peterson Fund. 74.83.2.

Untitled (near Kenisco Reservoir, New York). 1972. Platinum print. 4¹¹/₁₆ × 3¹¹/₁₆ in. (11.9 × 9.4 cm.). Kate and Hall J. Peterson Fund. 74.83.3.

Untitled (Pocono Snow, Pennsylvania). 1972. Platinum print. 4¹¹/₁₆ × 3¹¹/₁₆ in. (11.9 × 9.4 cm.). Kate and Hall J. Peterson Fund. 74.83.4.

RANALLI, DANIEL
American, 1946-

Photogram No. 57. 1978. Gelatin silver print. 13 × 10⁷/₁₆ in. (33.1 × 26.6 cm.). Kate and Hall J. Peterson Fund. 78.95.1.

Photogram No. 58. 1978. Gelatin silver print. 10¾ × 13⅞ in. (27.3 × 35.3 cm.). Kate and Hall J. Peterson Fund. 78.95.2.

RANKAITIS, SUSAN ANNE
American, 1949-

Chin/The Arousing (Shock Thunder) From *L. A. Issue* portfolio. 1979. Gelatin silver monoprint, solarized and toned. 10¹⁵⁄₁₆ × 13¹⁵⁄₁₆ in. (27.8 × 35.4 cm.). Gift of funds from the Photography Council of The Minneapolis Institute of Arts. 80.25.16.

REED, ROLAND
American, 1864-1934

The Pottery Maker, Hopi. n.d. Gelatin silver print. 14⅜ × 18⅝ in. (36.5 × 47.5 cm.). Gift of Mr. and Mrs. Patrick Butler. 78.52.

RENGER-PATZSCH, ALBERT
German, 1897-1966

[hands on steering wheel]. n.d. Gelatin silver print. 6⅝ × 8¹⁵⁄₁₆ in. (16.8 × 22.7 cm.). John R. Van Derlip Fund. 81.82.

RENNER, ERIC
American, 1941-

John Wood and Eric Renner, Santa Fe. From *The New Mexico Portfolio.* 1976. Gelatin silver print. 7⅞ in. (20.0 cm.) diameter. National Endowment for the Arts purchase grant and miscellaneous matching funds. 76.61.16.

RENWICK, WILLIAM W.
See *Camera Work*

REY, GUIDO
See *Camera Work*

REYNOLDS, JOCK
See Hellmuth, Suzanne and Jock Reynolds

RICE, LELAND
American, 1940-

Within You and without You. c. 1968. 2 gelatin silver prints. Each 6 × 6⅞ in. (15.5 × 17.5 cm.). Kate and Hall J. Peterson Fund. 71.21.16.

Fred Spratt Studio. From *Silver See* portfolio. 1977. Color coupler print. 9⅜ × 12¹³⁄₁₆ in. (23.9 × 32.5 cm.). National Endowment for the Arts purchase grant and miscellaneous matching funds. 77.39.16.

RICH, LINDA
American, 1949-

Capital City Riders. Published by the photographer, Madison, Wisconsin. n.d. Portfolio of 10 gelatin silver prints. Kate and Hall J. Peterson Fund. 74.16.1-10.
[motorcycles at Storybook Gardens]. 5⁵⁄₁₆ × 7¹³⁄₁₆ in. (13.5 × 19.9 cm.).
[Harley Davidson display]. 5⅜ × 8⅝ in. (13.7 × 21.9 cm.).
[man with hat with stars]. 5⁵⁄₁₆ × 5⁷⁄₁₆ in. (13.5 × 13.7 cm.).
[bearded man with hat]. 5⁷⁄₁₆ × 5⅜ in. (13.8 × 13.6 cm.).
[National Watermelon Queen with bikers]. 5⅜ × 6 in. (13.7 × 15.3 cm.).
[four men holding beer cans]. 5⅜ × 5⁷⁄₁₆ in. (13.7 × 13.8 cm.).
[bikers on capital steps]. 5⁵⁄₁₆ × 8 in. (13.6 × 20.3 cm.).

[bikers holding jackets]. 5⅜ × 8 in. (13.7 × 20.3 cm.).
[man standing with glass]. 7⅞ × 5¼ in. (20.1 × 13.4 cm.).
[biker riding motorcycle]. 5⁵⁄₁₆ × 7⅞ in. (13.5 × 20.1 cm.).
[seated man with wall of certificates]. 1974. Gelatin silver print. 7¹⁄₁₆ × 6¹⁵⁄₁₆ in. (17.9 × 17.7 cm.). Gift of the artist. 74.62.

Skin Deep. Published by the photographer, Madison, Wisconsin. 1973. Book of 19 gelatin silver prints. Kate and Hall J. Peterson Fund. 74.81.1-19.
[woman under chandelier]. 5 × 5 in. (12.7 × 12.7 cm.).
[man seated in front of clippings]. 5 × 5 in. (12.7 × 12.7 cm.).
[woman under hair dryer with dummies]. 5 × 5 in. (12.7 × 12.7 cm.).
[woman in front of mirror]. 5 × 5 in. (12.7 × 12.7 cm.).
[woman in front of mirror]. 5 × 5 in. (12.7 × 12.7 cm.).
[woman under hair dryer with painting]. 5 × 5 in. (12.7 × 12.7 cm.).
[woman being massaged]. 4¹⁵⁄₁₆ × 5 in. (12.6 × 12.7 cm.).
[woman receiving face massage]. 5 × 5 in. (12.7 × 12.7 cm.).
[woman with eyes covered]. 5 × 5 in. (12.7 × 12.7 cm.).
[woman with hair net under dryer]. 5 × 5 in. (12.7 × 12.7 cm.).
[woman in archway]. 5 × 5 in. (12.7 × 12.7 cm.).
[woman with fingernail polish]. 5 × 5 in. (12.7 × 12.7 cm.).
[man seated in front of mirror]. 5 × 5 in. (12.7 × 12.7 cm.).
[woman under picture of black nude]. 5¹⁄₁₆ × 5 in. (12.8 × 12.7 cm.).
[woman reading *Vogue*]. 5 × 5 in. (12.7 × 12.7 cm.).
[woman in black plastic gown]. 5 × 5 in. (12.7 × 12.7 cm.).
[seated woman with mask on]. 5 × 5 in. (12.7 × 12.7 cm.).
[standing woman in plastic gown]. 5 × 5 in. (12.7 × 12.7 cm.).
[self-portrait with mink coat on sofa]. 5 × 5 in. (12.7 × 12.7 cm.).

I Do. Published by the photographer, Madison, Wisconsin. 1975. Portfolio of 21 gelatin silver prints. Kate and Hall J. Peterson Fund. 77.8.1-21.
[self-portrait with husband: couple with pickle and bagel]. 6½ × 6½ in. (16.5 × 16.5 cm.).
[seated man with wall of certificates]. 6½ × 6½ in. (16.5 × 16.5 cm.).
[woman with cupid cutout]. 6⁹⁄₁₆ × 6⁷⁄₁₆ in. (16.7 × 16.3 cm.).
[bridesmaid and display case]. 6½ × 6⁷⁄₁₆ in. (16.5 × 16.4 cm.).
[civilian wedding party with arched candelabras]. 6⁷⁄₁₆ × 6½ in. (16.3 × 16.5 cm.).
[bride with garter]. 6½ × 6½ in. (16.5 × 16.5 cm.).
[man holding postcard]. 6⁷⁄₁₆ × 6½ in. (16.4 × 16.5 cm.).

[couple in front of Cupid Wedding Chapel]. 6½ × 6⁹⁄₁₆ in. (16.6 × 16.7 cm.).
[woman at desk]. 6½ × 6⁷⁄₁₆ in. (16.5 × 16.4 cm.).
[two seated women with ribbons on wall]. 6½ × 6⁷⁄₁₆ in. (16.5 × 16.3 cm.).
[couple with heart-shaped wreath]. 6½ × 6⁷⁄₁₆ in. (16.5 × 16.4 cm.).
[woman with pictures on wall]. 6⁷⁄₁₆ × 6⁷⁄₁₆ in. (16.4 × 16.4 cm.).
[woman with dress on hanger]. 6½ × 6½ in. (16.5 × 16.5 cm.).
[seated woman with wedding accessories]. 6⅜ × 6⅜ in. (16.2 × 16.2 cm.).
[couple on couch below wall of ribbons]. 6⁷⁄₁₆ × 6⅜ in. (16.4 × 16.2 cm.).
[woman standing with hymnal]. 6⅜ × 6⅜ in. (16.2 × 16.3 cm.).
[woman in pews of chapel]. 6½ × 6½ in. (16.5 × 16.5 cm.).
[woman behind flowers]. 6½ × 6⁷⁄₁₆ in. (16.5 × 16.4 cm.).
[elderly woman at podium]. 6⁷⁄₁₆ × 6⅜ in. (16.4 × 16.2 cm.).
[couple seated with picture mural]. 6⅜ × 6⅜ in. (16.2 × 16.2 cm.).
[iron bench with bell in yard]. 6⁷⁄₁₆ × 6⁷⁄₁₆ in. (16.4 × 16.4 cm.).

RISS, MURRAY
American (b. Poland), 1940-

Elly. 1967. Gelatin silver print. 6¹⁄₁₆ × 7¹³⁄₁₆ in. (15.5 × 19.8 cm.). Gift of the artist. 82.64.1.

Elly. 1967. Gelatin silver print. 5⅜ × 6¹⁵⁄₁₆ in. (13.7 × 17.6 cm.). Gift of the artist. 82.64.2.

Street Scene, Providence, Rhode Island. 1966. Gelatin silver print. 5⁷⁄₁₆ × 7¼ in. (13.8 × 18.4 cm.). Gift of the artist. 82.64.3.

ROOT, DAVID
American, 1942-

[sardines]. 1976. Color electrostatic print. 13¹³⁄₁₆ × 8½ in. (35.1 × 21.6 cm.). Gift of the artist. 82.65.

ROSSI, LINDA
American, 1952-

Mesa. n.d. Gelatin silver print, toned. 5¼ × 7⅝ in. (13.4 × 19.3 cm.). National Endowment for the Arts purchase grant and miscellaneous matching funds. 76.19.1.

Hand as Shell. n.d. Gelatin silver print, toned. 7 × 8⅜ in. (17.8 × 21.3 cm.). National Endowment for the Arts purchase grant and miscellaneous matching funds. 76.19.2.

Fossilized Night, May 3. n.d. Gelatin silver print, hand colored. 13¼ × 19⅛ in. (33.7 × 48.6 cm.). National Endowment for the Arts purchase grant and miscellaneous matching funds. 76.19.3.

Aerial View of a Garden II. n.d. Gelatin silver print, toned. 13⅛ × 19⅛ in. (33.5 × 48.6 cm.). National Endowment for the Arts purchase grant and miscellaneous matching funds. 76.19.4.

Deft Imperial. n.d. Gelatin silver print, toned. 11¾ × 16⅞ in. (29.9 × 42.9 cm.). National Endowment for the Arts purchase grant and miscellaneous matching funds. 76.19.5.

Galactic. n.d. Gelatin silver print, toned. 12½ × 18⅜ in. (31.8 × 46.8 cm.). National Endowment for the Arts purchase grant and miscellaneous matching funds. 76.19.6.

Woodlawn I. n.d. Gelatin silver print, toned and hand colored. 9³⁄₁₆ × 13⅛ in. (23.4 × 33.3 cm.). National Endowment for the Arts purchase grant and miscellaneous matching funds. 76.19.7.

Woodlawn II. n.d. Gelatin silver print, toned. 9¼ × 13¹⁄₁₆ in. (23.5 × 33.3 cm.). National Endowment for the Arts purchase grant and miscellaneous matching funds. 76.19.8.

RUBINCAM, HARRY C.
See *Camera Work*

RUBINSTEIN, MERIDEL
American, 1948-

Portrait from the Land of Enchantment (Silvinita Lopez, Cordova, New Mexico). From *The New Mexico Portfolio*. 1975. Gelatin silver print. 10¹⁄₁₆ × 7¾ in. (25.6 × 19.7 cm.). National Endowment for the Arts purchase grant and miscellaneous matching funds. 76.61.17.

RUSSELL, ANDREW JOSEPH
American, 1830-1902

Sun Pictures of Rocky Mountain Scenery. Published by Julius Bien, New York. 1870. Book by F. V. Hayden of 30 albumen prints. John R. Van Derlip Fund. 78.90.1-30.

Moore's Lake, Head of Bear River, Uintah Mountains. 6 × 8¹⁄₁₆ in. (15.3 × 20.6 cm.).

Granite Rock, Buford Station, Laramie Mountains. 6 × 8 in. (15.2 × 20.3 cm.).

Skull Rock (Granite), Sherman Station, Laramie Mountains. 6 × 7⅞ in. (15.2 × 20.1 cm.).

Malloy's Cut, Sherman Station, Laramie Range. 6 × 7⅞ in. (15.2 × 20.1 cm.).

Dial Rock, Red Buttes, Laramie Plaines. 6 × 8 in. (15.2 × 20.3 cm.).

Laramie Valley, from Sheephead Mountains. 6 × 8¹⁄₁₆ in. (15.3 × 20.5 cm.).

Snow and Timber Line, Medicine Bow Mountain. 6 × 8¹⁄₁₆ in. (15.3 × 20.5 cm.).

High Bluffs, Black Buttes. 5¹⁵⁄₁₆ × 7¹⁵⁄₁₆ in. (15.2 × 20.2 cm.).

Bitter Creek Valley, near Green River. 5¹⁵⁄₁₆ × 7⅞ in. (15.1 × 20.1 cm.).

Burning Rock Cut, Green River Valley. 6 × 7⅞ in. (15.2 × 20.1 cm.).

Citadel Rock, Green River Valley. 6 × 8 in. (15.3 × 20.3 cm.).

Castle Rock, Green River Valley. 6 × 8 in. (15.3 × 20.3 cm.).

Church Buttes, near Fort Bridger, Wyoming Territory. 5¹⁵⁄₁₆ × 7¹³⁄₁₆ in. (15.1 × 19.9 cm.).

Lake at the Head of Bear Lake, Uintah Mountains. 5¹⁵⁄₁₆ × 7¹⁵⁄₁₆ in. (15.1 × 20.2 cm.).

Conglomerate Peaks of Echo. 8¹⁄₁₆ × 6 in. (20.5 × 15.3 cm.).

Sentinel Rock, Echo Canyon. 8¹⁄₁₆ × 6 in. (20.5 × 15.3 cm.).

Hanging Rock, Echo Canyon. 6 × 8¹⁄₁₆ in. (15.3 × 20.5 cm.).

Coalville, Weber Valley, Utah. 6 × 8 in. (15.3 × 20.4 cm.).

Thousand Mile Tree, Wilhelmina's Pass. 6 × 7¹⁵⁄₁₆ in. (15.2 × 20.2 cm.).

Wilhelmina's Pass, Distant View of Serrated Rocks or Devil's Slide, Weber Canyon, Utah. 6 × 7¹⁵⁄₁₆ in. (15.2 × 20.2 cm.).

Serrated Rocks or Devil's Slide (Near View), Weber Canyon, Utah. 7¹⁵⁄₁₆ × 6 in. (20.3 × 15.3 cm.).

Tunnel No. 3, Weber Canyon, Utah. 5⅞ × 7¹⁵⁄₁₆ in. (14.9 × 20.2 cm.).

Devil's Gate, from below Weber Canyon, Wasatch Mountains. 5¹⁵⁄₁₆ × 8 in. (15.1 × 20.4 cm.).

City Creek Canyon, Wasatch Mountains, Salt Lake City. 7¹⁵⁄₁₆ × 6 in. (20.2 × 15.2 cm.).

Wasatch Range of Rocky Mountains, from Brigham Young's Woolen Mills. 6 × 7¹⁵⁄₁₆ in. (15.2 × 20.1 cm.).

Salt Lake City, Camp Douglas and Wasatch Mountains in the Background. 6 × 8 in. (15.2 × 20.4 cm.).

Great Mormon Tabernacle, Salt Lake City. 5¹⁵⁄₁₆ × 8 in. (15.1 × 20.3 cm.).

Trestle Work, Promontory Point, Salt Lake Valley. 6 × 8¹⁄₁₆ in. (15.3 × 20.4 cm.).

Summit of the Sierra Nevada, Snow Sheds in the Foreground, Donner Lake in the Distance, C.P.R.R. 6 × 8 in. (15.2 × 20.3 cm.).

Hydraulic Gold Mining, near Dutch Flats, California, C.P.R.R. 6 × 8 in. (15.2 × 20.3 cm.).

SAHLSTRAND, JAMES M.
American, 1936-

Nude No. 3838. 1965. Gelatin silver print. 23½ × 30¼ in. (59.7 × 76.9 cm.). Ethel Morrison Van Derlip Fund. 70.76.11.

SANDER, AUGUST
German, 1876-1964

Young Soldier, Westerwald. 1945. Gelatin silver print by Gunther Sander. 11¹¹⁄₁₆ × 9⅛ in. (29.8 × 23.2 cm.). Mr. and Mrs. Harrison R. Johnston, Jr. Fund. 77.68.1.

The Wife of the Painter Peter Abelen, Cologne. 1926. Gelatin silver print by Gunther Sander. 11⅝ × 8¼ in. (29.5 × 20.9 cm.). Mr. and Mrs. Harrison R. Johnston, Jr. Fund. 77.68.2.

Circus Artists, Cologne. 1926. Gelatin silver print by Gunther Sander. 8⁹⁄₁₆ × 11¹¹⁄₁₆ in. (21.8 × 29.8 cm.). Mr. and Mrs. Harrison R. Johnston, Jr. Fund. 77.68.3.

Boxers, Cologne. 1929. Gelatin silver print by Gunther Sander. 11⅜ × 9 in. (29.0 × 23.0 cm.). Mr. and Mrs. Harrison R. Johnston, Jr. Fund. 77.68.4.

Farm Girls, Westerwald. 1928. Gelatin silver print by Gunther Sander. 11¹⁵⁄₁₆ × 9 in. (30.4 × 22.9 cm.). Mr. and Mrs. Harrison R. Johnston, Jr. Fund. 77.68.5.

SAWYER, JOAN
American, 1948-

[umbrella]. From *The New Mexico Portfolio*. 1975. Gelatin silver print. 7¹³⁄₁₆ × 11¹¹⁄₁₆ in. (19.9 × 29.7 cm.). National Endowment for the Arts Purchase grant and miscellaneous matching funds. 76.61.18.

SCHEER, SHERIE
American, 1940-

[beach]. From *New California Views* portfolio. 1977. Gelatin silver print, hand colored. 12⅞ × 16¹⁵⁄₁₆ in. (32.7 × 43.1 cm.). Gift of funds from the Photography Council of The Minneapolis Institute of Arts. 80.24.14.

SCHMIDT, RICHARD
American (?), 20th century

A Day at the Beach. From *What Ever Happened to Sexuality* portfolio. c. 1977. Gelatin silver print. 7¾ × 7⁹⁄₁₆ in. (19.7 × 19.3 cm.). Gift of the artist. 82.70.15.

SCHWARM, LARRY W.
American, 1944-

Horses. 1975. Gelatin silver print. 7 × 7 in. (17.8 × 17.8 cm.). Gift of the artist. 76.84.1.

Laurie with Rocks. 1974. Gelatin silver print. 5⅞ × 8¹¹⁄₁₆ in. (14.9 × 22.2 cm.). Gift of the artist. 76.84.2.

Electric Lady. 1975. Gelatin silver print. 6¼ × 9¼ in. (15.8 × 23.6 cm.). Gift of the artist. 76.84.3.

John with Chicken. 1975. Gelatin silver print. 6⅝ × 6⅝ in. (16.8 × 16.9 cm.). Gift of the artist. 76.84.4.

Wheatfield in Snow. 1975. Gelatin silver print. 6¼ × 9⅜ in. (15.9 × 23.8 cm.). Gift of the artist. 76.84.5.

July 4, 1976, Topeka, Kansas. 1976. Gelatin silver print. 5⅝ × 8⅜ in. (14.3 × 21.3 cm.). Gift of the artist. 77.6.1.

Topeka, Kansas. 1976. Gelatin silver print. 5⅝ × 8⅜ in. (14.3 × 21.3 cm.). Gift of the artist. 77.6.2.

Lawrence, Kansas. 1976. Gelatin silver print. 7 × 7¹⁄₁₆ in. (17.8 × 17.9 cm.). Gift of the artist. 77.6.3.

Topeka, Kansas. 1976. Gelatin silver print. 5¹¹⁄₁₆ × 8⁷⁄₁₆ in. (14.4 × 21.4 cm.). Gift of the artist. 77.6.4.

Topeka, Kansas. 1976. Gelatin silver print. 5¹¹⁄₁₆ × 8⁷⁄₁₆ in. (14.4 × 21.5 cm.). Gift of the artist. 77.6.5.

SCOVILLE, SCOTT
American (?), 20th century

[rocks]. From *What Ever Happened to Sexuality* portfolio. c. 1977. Gelatin silver print. 9⅜ × 6½ in. (23.8 × 16.5 cm.). Gift of the artist. 82.70.16.

SEARS, SARAH C.
See *Camera Work*

SEELEY, GEORGE H.
See *Camera Work*

SELIGMANN, HERBERT J.
American, 1891-1984

Alfred Stieglitz and John Marin at An American Place, New York. 1931. Gelatin silver print. 4 × 3 in. (10.2 × 7.6 cm.). John R. Van Derlip Fund. 81.83.

[Chrysler Building]. n.d. Gelatin silver print. 4 × 2¹⁵⁄₁₆ in. (10.1 × 7.5 cm.). John R. Van Derlip Fund. 81.84a.

[New York building]. n.d. Gelatin silver print. 4 × 2¹⁵⁄₁₆ in. (10.1 × 7.5 cm.). John R. Van Derlip Fund. 81.84b.

SELKIRK, NEIL
British, 1947-

Neil Selkirk. Published by Baum/Marks Fine Arts, New York. 1979. Portfolio of 10 gelatin silver prints. Ethel Morrison Van Derlip Fund. 80.47.1-10.
Maurice Nadjari, New York City. 1977. 18½ × 18¹³⁄₁₆ in. (47.0 × 47.9 cm.).
H.E. Mr. Peter Jay and Mrs. Jay, Washington, D.C. 1978. 18⁵⁄₁₆ × 18½ in. (46.5 × 47.1 cm.).
Jim "Catfish" Hunter, New York City. 1975. 18⅜ × 18⁹⁄₁₆ in. (46.7 × 47.1 cm.).
Robert Wagner, Jr. and Robert Wagner, New York City. 1977. 18¼ × 18⁷⁄₁₆ in. (46.4 × 46.9 cm.).
Charles Colson, Washington, D.C. 1973. 18⅜ × 18⁹⁄₁₆ in. (46.7 × 47.2 cm.).
Zbigniew Brzezinski, Washington, D.C. 1978. 18⁵⁄₁₆ × 18½ in. (46.5 × 47.0 cm.).
Jimmy Hoffa, Lake Orion, Michigan. 1975. 18⁹⁄₁₆ × 12⁷⁄₁₆ in. (47.3 × 31.8 cm.).
Alger Hiss, New York City. 1977. 18¼ × 18½ in. (46.5 × 47.0 cm.).
Jerry Finkelstein and Andrew Stein, New York City. 1977. 18¾ × 18¹⁵⁄₁₆ in. (47.6 × 48.1 cm.).
I.F. Stone, New York City. 1977. 18⁵⁄₁₆ × 18½ in. (46.5 × 47.0 cm.).

SEVERSON, RITA
American (?), 20th century

[rain on screen]. From *What Ever Happened to Sexuality* portfolio. c. 1977. Gelatin silver print. 6³⁄₁₆ × 7½ in. (15.7 × 19.1 cm.). Gift of the artist. 82.70.17.

SHAW, GEORGE BERNARD
See *Camera Work*

SHORE, STEPHEN
American, 1947-

Coronado St., Los Angeles, California. From *New California Views* portfolio. 1975. Color coupler print (Ektacolor). 7¹¹⁄₁₆ × 9¹¹⁄₁₆ in. (19.5 × 24.6 cm.). Gift of funds from the Photography Council of The Minneapolis Institute of Arts. 80.24.15.

Fort Lauderdale Yankee Stadium, Fort Lauderdale, Florida. 1978. Color coupler print. 7¹¹⁄₁₆ × 9¹¹⁄₁₆ in. (19.5 × 24.7 cm.). Gift of the American Telephone and Telegraph Co. 81.120.58.

Sparky Lyle's Locker, Fort Lauderdale Yankee Stadium, Fort Lauderdale, Florida. 1978. Color coupler print. 7¹¹⁄₁₆ × 9¹¹⁄₁₆ in. (19.5 × 24.7 cm.). Gift of the American Telephone and Telegraph Co. 81.120.59.

Fort Lauderdale Yankee Stadium, Fort Lauderdale, Florida. 1978. Color coupler print. 7¹¹⁄₁₆ × 9¹¹⁄₁₆ in. (19.5 × 24.7 cm.). Gift of the American Telephone and Telegraph Co. 81.120.60.

SHUPER, KAY
American, 1947-

["Glossy"]. From *Silver See* portfolio. 1976. Serigraph. 15 × 19¹⁵⁄₁₆ in. (38.1 × 50.7 cm.). National Endowment for the Arts purchase grant and miscellaneous matching funds. 77.39.17.

SIMON, MICHAEL
American (b. Hungary), 1936-

By the Apple Tree. 1971. Gelatin silver print. 4¹⁄₁₆ × 6¹⁄₁₆ in. (10.3 × 15.4 cm.). Kate and Hall J. Peterson Fund. 74.90.1.

Shirland. 1971. Gelatin silver print. 4⅞ × 7⅜ in. (12.5 × 18.7 cm.). Kate and Hall J. Peterson Fund. 74.90.2.

Amy and Nicholas. 1971. Gelatin silver print. 4¹¹⁄₁₆ × 7 in. (11.9 × 17.8 cm.). Kate and Hall J. Peterson Fund. 74.90.3.

The Long Awaited Homecoming. 1971. Gelatin silver print. 4⁹⁄₁₆ × 6¹³⁄₁₆ in. (11.6 × 17.3 cm.). Kate and Hall J. Peterson Fund. 74.90.4.

The Flood. 1973. Gelatin silver print. 4⅜ × 6⅝ in. (11.1 × 16.9 cm.). Kate and Hall J. Peterson Fund. 74.90.5.

[tree in landscape]. 1973. Gelatin silver print. 4⁷⁄₁₆ × 6¾ in. (11.3 × 17.2 cm.). Kate and Hall J. Peterson Fund. 74.90.6.

[woman and two children in valley]. 1973. Gelatin silver print. 4⅜ × 6⁹⁄₁₆ in. (11.1 × 16.7 cm.). Kate and Hall J. Peterson Fund. 74.90.7.

[docks with figures]. 1973. Gelatin silver print. 4½ × 6¾ in. (11.3 × 17.2 cm.). Kate and Hall J. Peterson Fund. 74.90.8.

Amy. 1973. Gelatin silver print. 4⁷⁄₁₆ × 6⅝ in. (11.2 × 16.9 cm.). Kate and Hall J. Peterson Fund. 74.90.9.

[path with leaves]. 1974. Gelatin silver print. 5 × 7½ in. (12.8 × 19.1 cm.). Kate and Hall J. Peterson Fund. 74.90.10.

Beloit, Wisconsin from South Beloit, Illinois City Hall. From *Southern Wisconsin Vernacular Architecture* series. 1980. Gelatin silver print. 9¹³⁄₁₆ × 12½ in. (24.9 × 31.8 cm.). Gift of the artist. 81.20.

SISKIND, AARON
American, 1903-

Chicago 3. 1948. Gelatin silver print. 11¹⁄₁₆ × 16⁷⁄₁₆ in. (28.1 × 41.8 cm.). Ethel Morrison Van Derlip Fund. 69.25.1.

Mexico. 1955. Gelatin silver print. 13½ × 16⅜ in. (34.4 × 41.7 cm.). Ethel Morrison Van Derlip Fund. 69.25.2.

Rome 55. 1963. Gelatin silver print. 19⅝ × 15¼ in. (49.1 × 38.8 cm.). Ethel Morrison Van Derlip Fund. 69.25.3.

Rome 73. 1963. Gelatin silver print. 19¼ × 14⅞ in. (48.9 × 37.8 cm.). Ethel Morrison Van Derlip Fund. 69.25.4.

Rome, Appia Antica 4. 1967. Gelatin silver print. 10⁵⁄₁₆ × 13⅜ in. (26.2 × 34.1 cm.). Ethel Morrison Van Derlip Fund. 69.25.5.

Gloucester I. 1944. Gelatin silver print. 13⅜ × 10³⁄₁₆ in. (33.9 × 25.9 cm.). Ethel Morrison Van Derlip Fund. 70.76.10.

Rome Hieroglyph I. 1963. Gelatin silver print. 10⁷⁄₁₆ × 13⅜ in. (26.5 × 34.0 cm.). Kate and Hall J. Peterson Fund. 71.13.1.

Rome 76. 1963. Gelatin silver print. 19⁵⁄₁₆ × 15¹⁄₁₆ in. (49.1 × 38.2 cm.). Kate and Hall J. Peterson Fund. 71.13.2.

Chicago 2. 1948. Gelatin silver print. 13⁷⁄₁₆ × 16⁷⁄₁₆ in. (34.2 × 41.8 cm.). Kate and Hall J. Peterson Fund. 71.13.3.

[branch]. From *Underware* portfolio. n.d. Gelatin silver print. 9¹³⁄₁₆ × 9¹³⁄₁₆ in. (24.9 × 24.9 cm.). National Endowment for the Arts purchase grant and miscellaneous matching funds. 76.64.14.

SLOSBERG, KEN
American, 1944-

[green and yellow foliage]. From *L. A. Issue* portfolio. 1979. Color coupler print. 7½ × 11³⁄₁₆ in. (19.0 × 28.5 cm.). Gift of funds from the Photography Council of The Minneapolis Institute of Arts. 80.25.17.

SMITH, KEITH A.
American, 1938-

Orbiting into Space. From *Underware* portfolio. 1976. Etching. 11⁵⁄₁₆ × 15¾ in. (28.9 × 40.1 cm.). National Endowment for the Arts purchase grant and miscellaneous matching funds. 76.64.15.

[figures sitting]. 1967. Photoetching. 2⁹⁄₁₆ × 3¾ in. (6.6 × 9.6 cm.). Gift of Frank Gaard. 82.66.

SMITH, MICHAEL A.
American, 1942-

Twelve Photographs, 1967-1969. Published by the photographer. n.d. Portfolio of 12 gelatin silver prints. Kate and Hall J. Peterson Fund. 75.48.1-12.
Leaf under Ice, New Jersey. 1969. 7⁹⁄₁₆ × 9⁹⁄₁₆ in. (19.3 × 24.4 cm.).
Window, Philadelphia. 1969. 9⅝ × 6⁷⁄₁₆ in. (24.4 × 16.3 cm.).
Roots, Philadelphia. 1967. 7⁹⁄₁₆ × 9⁷⁄₁₆ in. (19.2 × 23.9 cm.).
Eroded Rocks, Colorado. 1967. 7⁹⁄₁₆ × 9½ in. (19.2 × 24.2 cm.).
Clouds, New Jersey. 1968. 7⅝ × 9⅝ in. (19.3 × 24.5 cm.).
Barn Wall, New Jersey. 1968. 7⁹⁄₁₆ × 9⁹⁄₁₆ in. (19.3 × 24.3 cm.).
Jawbones, New Jersey. 1969. 7½ × 9⁹⁄₁₆ in. (19.1 × 24.3 cm.).
Grasses, New Jersey. 1968. 9⁹⁄₁₆ × 7⁹⁄₁₆ in. (24.4 × 19.2 cm.).
Martha, New Jersey. 1969. 9⁹⁄₁₆ × 7⅝ in. (24.3 × 19.4 cm.).
Docks, Wenona, Maryland. 1967. 7½ × 9⁹⁄₁₆ in. (19.2 × 24.3 cm.).
Ice, New Jersey. 1969. 7⅝ × 9⁹⁄₁₆ in. (19.3 × 24.3 cm.).
Rock Pools No. 2, Colorado. 1967. 9⁹⁄₁₆ × 7⁹⁄₁₆ in. (24.3 × 19.2 cm.).

Ice on Trees, Virginia. 1974. Gelatin silver print. 7⁹/₁₆ × 9⅝ in. (19.3 × 24.5 cm.). Kate and Hall J. Peterson Fund. 75.48.13.

Rock Wall No. 1, New Jersey. 1973. Gelatin silver print. 7⁹/₁₆ × 9⅝ in. (19.3 × 24.5 cm.). Kate and Hall J. Peterson Fund. 75.48.14.

Trees, Great Smokey Mountains National Park, North Carolina. 1973. Gelatin silver print. 7⅝ × 9⁹/₁₆ in. (19.3 × 24.4 cm.). Kate and Hall J. Peterson Fund. 75.48.15.

Canyon de Chelly, Arizona. 1975. Gelatin silver print. 7⅝ × 9⁹/₁₆ in. (19.4 × 24.4 cm.). National Endowment for the Arts purchase grant and miscellaneous matching funds. 76.68.1.

Bryce Canyon, Utah. 1975. Gelatin silver print. 7⁹/₁₆ × 9⁹/₁₆ in. (19.3 × 24.3 cm.). National Endowment for the Arts purchase grant and miscellaneous matching funds. 76.68.2.

Blue Mesa, Arizona. 1975. Gelatin silver print. 7⅝ × 9⁹/₁₆ in. (19.4 × 24.3 cm.). National Endowment for the Arts purchase grant and miscellaneous matching funds. 76.68.3.

Yellowstone National Park, Wyoming. 1975. Gelatin silver print. 9⁹/₁₆ × 7⅝ in. (24.3 × 19.3 cm.). National Endowment for the Arts purchase grant and miscellaneous matching funds. 76.68.4.

Chino Valley, Arizona. 1975. Gelatin silver print. 7⅝ × 9⁹/₁₆ in. (19.4 × 24.4 cm.). National Endowment for the Arts purchase grant and miscellaneous matching funds. 76.68.5.

Canyon del Muerto, Arizona. 1975. Gelatin silver print. 7⁹/₁₆ × 9⁹/₁₆ in. (19.2 × 24.3 cm.). National Endowment for the Arts purchase grant and miscellaneous matching funds. 76.68.6.

Garapata Beach, California. 1975. Gelatin silver print. 7⅝ × 9⁹/₁₆ in. (19.3 × 24.4 cm.). National Endowment for the Arts purchase grant and miscellaneous matching funds. 76.68.7.

Shore Acres, Oregon. 1975. Gelatin silver print. 7⅝ × 9⁹/₁₆ in. (19.3 × 24.3 cm.). National Endowment for the Arts purchase grant and miscellaneous matching funds. 76.68.8.

Capital Reef, Utah. 1975. Gelatin silver print. 7⁹/₁₆ × 9⁹/₁₆ in. (19.2 × 24.3 cm.). National Endowment for the Arts purchase grant and miscellaneous matching funds. 76.68.9.

Mummy Ruins, Canyon del Muerto, Arizona. 1975. Gelatin silver print. 7⅝ × 9⁹/₁₆ in. (19.3 × 24.4 cm.). National Endowment for the Arts purchase grant and miscellaneous matching funds. 76.68.10.

Cedar Breaks, Utah. 1975. Gelatin silver print. 7⅝ × 9⅝ in. (19.4 × 24.5 cm.). National Endowment for the Arts purchase grant and miscellaneous matching funds. 76.68.11.

Yellowstone National Park, Wyoming. 1975. Gelatin silver print. 7⅝ × 9⁹/₁₆ in. (19.4 × 24.3 cm.). National Endowment for the Arts purchase grant and miscellaneous matching funds. 76.68.12.

Blue Mesa, Arizona. 1978. Gelatin silver print. 7½ × 19¹¹/₁₆ in. (19.1 × 50.0 cm.). John R. Van Derlip Fund. 79.42.1.

Bryce Canyon, Utah. 1978. Gelatin silver print. 7⅝ × 19⅝ in. (19.3 × 49.8 cm.). John R. Van Derlip Fund. 79.42.2.

Salt River Canyon, Arizona. 1978. Gelatin silver print. 7½ × 19⁹/₁₆ in. (19.1 × 49.7 cm.). Gift of Ron and Lucy Moody. 80.21.1.

Yellowstone National Park, Wyoming. 1975. Gelatin silver print. 7⁹/₁₆ × 9½ in. (19.3 × 24.1 cm.). Gift of Roger Palmer. 81.123.

Kitt Peak, Arizona. Frontispiece of *Landscapes 1975-1979* (vol. 1) book. 1978. Gelatin silver print. 7⁹/₁₆ × 9½ in. (19.2 × 24.2 cm.). Gift of funds from the Photography Council of The Minneapolis Institute of Arts. 82.92.

Blue Mesa, Arizona. 1978. Gelatin silver print. 9⁷/₁₆ × 7⁹/₁₆ in. (24.1 × 19.2 cm.). Gift of Frank Kolodny. 82.126.21.

Blue Mesa, Arizona. 1978. Gelatin silver print. 9½ × 7⁹/₁₆ in. (24.2 × 19.2 cm.). Gift of Frank Kolodny. 82.126.22.

Shores Acres, Oregon. 1979. Gelatin silver print. 7⅝ × 9⁹/₁₆ in. (19.4 × 24.3 cm.). Gift of Frank Kolodny. 82.126.23.

Shore Acres, Oregon. 1979. Gelatin silver print. 7⅝ × 9⁹/₁₆ in. (19.3 × 24.3 cm.). Gift of Frank Kolodny. 82.126.24.

Near Newcomb, New York. 1977. Gelatin silver print. 7⁹/₁₆ × 9½ in. (19.2 × 24.1 cm.). Gift of Frank Kolodny. 82.126.25.

Pebble Beach, California. 1975. Gelatin silver print. 7⁹/₁₆ × 9½ in. (19.2 × 24.2 cm.). Gift of Frank Kolodny. 82.126.26.

SNYDER, JOEL
American, 1940-

Rebo, Chester, Illinois. 1975. Gelatin silver print. 7⁹/₁₆ × 7½ in. (19.2 × 19.0 cm.). Gift of the artist. 76.83.1.

John-John, Chester, Illinois. 1974. Gelatin silver print. 10¹/₁₆ × 7 in. (25.6 × 17.7 cm.). Gift of the artist. 76.83.2.

Jimmy, Chester, Illinois. 1975. Gelatin silver print. 6 × 5⅞ in. (15.3 × 14.9 cm.). Gift of the artist. 76.83.3.

Sugar Bear Shaving Steve, Chester, Illinois. 1976. Gelatin silver print. 7⁹/₁₆ × 7¹³/₁₆ in. (19.3 × 19.9 cm.). Gift of the artist. 76.83.4.

Donald, Chester, Illinois. 1975. Gelatin silver print. 7½ × 7⅝ in. (19.1 × 19.3 cm.). Gift of the artist. 76.83.5.

After Drug Administration, State Asylum, Chester, Illinois. 1976. Gelatin silver print. 7⁹/₁₆ × 7½ in. (19.2 × 19.0 cm.). Gift of the artist. 76.83.6.

SOMMER, GIORGIO
Italian (b. Germany), 1834-1914

Pompei. Published by the photographer, Naples. n.d. Album of 40 albumen prints. Mr. and Mrs. Julius E. Davis Fund. 81.17.1-40.
Fòro Civile, Pompei. 7¹¹/₁₆ × 9⅝ in. (19.6 × 24.6 cm.).
Fòro Civile, Pompei. 7⅝ × 9¹³/₁₆ in. (19.4 × 24.9 cm.).
Basilica, Pompei. 6¹⁵/₁₆ × 9⁷/₁₆ in. (17.7 × 24.2 cm.).

Strada della Abbondanza, Pompei. 7¹/₁₆ × 9⅝ in. (18.0 × 24.6 cm.).
Casa di Cornelio Ruffo, Pompei. 6¹⁵/₁₆ × 9⁷/₁₆ in. (17.6 × 24.0 cm.).
Casa di Marco Oleonio, Pompei. 7⅛ × 9⁹/₁₆ in. (18.2 × 24.3 cm.).
Quartiere e dei Sold di Pompei. 7⁹/₁₆ × 9⅝ in. (19.2 × 24.5 cm.).
Teatro Greco, Pompei. 7¾ × 9¾ in. (19.6 × 24.8 cm.).
Tempio d'Ercole e Teatro Tragico, Pompei. 6⅞ × 9⅜ in. (17.6 × 23.9 cm.).
Teatro Tragico, Pompei. 6½ × 9⅜ in. (17.2 × 23.8 cm.).
Bagni Nuovi, Pompei. 6¹⁵/₁₆ × 9⁵/₁₆ in. (17.7 × 23.7 cm.).
Tèmpio d'Iside, Pompei. 7⅛ × 9⁷/₁₆ in. (18.2 × 24.0 cm.).
Strada di Stabbia, Pompei. 6¹⁵/₁₆ × 9⁷/₁₆ in. (17.7 × 24.0 cm.).
Casa di Marco Lucrezio, Pompei. 6¹⁵/₁₆ × 9⅜ in. (17.7 × 23.9 cm.).
Strada Mercurio, Pompei. 6⅞ × 9⁵/₁₆ in. (17.5 × 23.8 cm.).
Tèmpio della Fortuna, Pompei. 6⅝ × 9⁷/₁₆ in. (16.9 × 24.2 cm.).
Tèmpio di Mercurio, Pompei. 7 × 9⅝ in. (17.8 × 24.5 cm.).
Tèmpio di Giove, Pompei. 7¹/₁₆ × 9⅝ in. (18.0 × 24.5 cm.).
Tèmpio di Venere, Pompei. 7¹¹/₁₆ × 9¹³/₁₆ in. (19.5 × 24.9 cm.).
Tèmpio di Venere, Pompei. 7⅝ × 9¹⁵/₁₆ in. (19.4 × 25.3 cm.).
Casa del Poèta, Pompei. 6⅞ × 9⁷/₁₆ in. (17.6 × 24.0 cm.).
Casa del Fauno, Pompei. 7⁹/₁₆ × 9¹³/₁₆ in. (19.2 × 25.0 cm.).
Casa di Panza, Pompei. 9¾ × 7¹¹/₁₆ in. (24.8 × 19.6 cm.).
Casa della Nuova Fontana, Pompei. 9¹/₁₆ × 7¹/₁₆ in. (23.1 × 18.0 cm.).
Panorama di Pompei. 6¹³/₁₆ × 9⁵/₁₆ in. (17.3 × 23.8 cm.).
Strada di Salustio, Pompei. 6¹⁵/₁₆ × 9⅜ in. (17.6 × 23.8 cm.).
Casa di Salustio, Pompei. 6⅞ × 9⅜ in. (17.4 × 23.8 cm.).
Casa di Pornai, Pompei. 6⅞ × 9⁷/₁₆ in. (17.5 × 24.0 cm.).
Casa di Meleagro, Pompei. 7¹¹/₁₆ × 9¹¹/₁₆ in. (19.5 × 24.7 cm.).
Panorama di Pompei. 7¹/₁₆ × 9⅝ in. (17.9 × 24.5 cm.).
Porta d' Ercolano, Pompei. 6¹⁵/₁₆ × 9¹³/₁₆ in. (17.6 × 25.0 cm.).
Strada delle Tombe, Pompei. 7¹¹/₁₆ × 9¾ in. (19.5 × 24.7 cm.).
Casa di Diomede, Pompei. 6¹³/₁₆ × 9⁷/₁₆ in. (17.3 × 23.9 cm.).
Anfiteatro, Pompei. 6¹³/₁₆ × 9⁵/₁₆ in. (17.4 × 23.7 cm.).
Imprerte umane, Pompei, Scoverta. 7¹/₁₆ × 9⅝ in. (18.0 × 24.5 cm.).
[fresco of warriors]. 6¼ × 8¹⁵/₁₆ in. (15.9 × 22.7 cm.).
Freschi di Pompei. 6¹¹/₁₆ × 9⅝ in. (17.0 × 24.5 cm.).
[fresco of three figures]. 7¼ × 8¹⁵/₁₆ in. (18.5 × 22.7 cm.).

Fresco di Pompei. 7 × 7⁹⁄₁₆ in. (17.8 × 19.3 cm.).
Bacco ed Ariadne Fresco, Pompei. 9½ × 7³⁄₁₆ in. (24.2 × 18.3 cm.).

Napoli. Published by the photographer, Naples. n.d. Album of 48 albumen prints. Mr. and Mrs. Julius E. Davis Fund. 81.18.1-48.
Panorama, Napoli. 7 × 9⁵⁄₁₆ in. (17.8 × 23.7 cm.).
Panorama, Napoli. 6⁵⁄₁₆ × 9⁵⁄₁₆ in. (17.7 × 23.6 cm.).
Napoli dal Mele. 6⅞ × 9⅜ in. (17.5 × 23.8 cm.).
Palazzo Reale, Napoli. 6¹⁵⁄₁₆ × 9⁵⁄₁₆ in. (17.7 × 23.7 cm.).
Cavalli di Bronzo, Napoli. 6¹⁵⁄₁₆ × 9⅜ in. (17.7 × 23.8 cm.).
Teatro S. Carlo, Napoli. 6¹⁵⁄₁₆ × 8¾ in. (17.7 × 22.2 cm.).
S. Lueria e Hotel de Roma, Napoli. 7 × 9⁵⁄₁₆ in. (17.8 × 23.8 cm.).
Via Nazionale, Entrata, Napoli. 6¹³⁄₁₆ × 9⁵⁄₁₆ in. (17.3 × 23.7 cm.).
Posilippo, Napoli. 7 × 9¼ in. (17.8 × 23.6 cm.).
Piedigrotta, Napoli. 9¹⁄₁₆ × 7¼ in. (23.1 × 18.2 cm.).
Tèmpio di Serapide, Pozzuoli. 6¹⁵⁄₁₆ × 9¼ in. (17.7 × 23.5 cm.).
Anfiteatro di Pozzuoli. 6⅞ × 9⁵⁄₁₆ in. (17.6 × 23.6 cm.).
Castello di Baja. 7 × 9⁵⁄₁₆ in. (17.8 × 23.7 cm.).
Capri. 6¹⁵⁄₁₆ × 9⅜ in. (17.7 × 23.8 cm.).
[painting of cave interior]. 6¹⁵⁄₁₆ × 9⁵⁄₁₆ in. (17.6 × 23.8 cm.).
Sorrente da Capo di Monte, Napoli. 7 × 9³⁄₁₆ in. (17.7 × 23.4 cm.).
Amalfi dal Convento dei Capuccini. 9⅛ × 7⅛ in. (23.2 × 18.0 cm.).
Casta di Caserta. 6⅞ × 9⁵⁄₁₆ in. (17.6 × 23.7 cm.).
Lava del Vesuvio, Napoli. 7 × 9⁵⁄₁₆ in. (17.8 × 23.7 cm.).
L'Eruzione del Vesuvio, 26 Aprile 1872, ore 5 PM. 7⅛ × 9⅜ in. (18.1 × 23.9 cm.).
Tèmpio di Nettuao Pesto, Napoli. 7 × 9³⁄₁₆ in. (17.8 × 23.3 cm.).
Panorama di Ercolano. 6¹⁵⁄₁₆ × 9⅜ in. (17.6 × 23.9 cm.).
Panorama di Pompei. 6¹⁵⁄₁₆ × 9⁵⁄₁₆ in. (17.7 × 23.8 cm.).
Panorama Fòro Civile, Pompei. 7 × 9⁵⁄₁₆ in. (17.8 × 23.7 cm.).
Panorama di Pompei. 6¹⁵⁄₁₆ × 9¼ in. (17.7 × 23.6 cm.).
Strada di Stabbia, Pompei. 6¹⁵⁄₁₆ × 9⁵⁄₁₆ in. (17.7 × 23.7 cm.).
Strada delle Tombe, Pompei. 7 × 9⁵⁄₁₆ in. (17.8 × 23.7 cm.).
Casa del Fauno, Pompei. 6¹⁵⁄₁₆ × 9⁵⁄₁₆ in. (17.6 × 23.7 cm.).
Casa di Marco Lucrezio, Pompei. 7 × 9 ⅜ in. (17.7 × 23.8 cm.).
Casa di Marco Oleonio, Pompei. 6¹⁵⁄₁₆ × 9⁵⁄₁₆ in. (17.7 × 23.7 cm.).
Casa del Poèta, Pompei. 6⅞ × 9⁵⁄₁₆ in. (17.5 × 23.6 cm.).
Casa di Diomede, Pompei. 6¹⁵⁄₁₆ × 9⁵⁄₁₆ in. (17.6 × 23.8 cm.).

Casa di Cornelio Ruffo, Pompei. 6¹⁵⁄₁₆ × 9⁵⁄₁₆ in. (17.7 × 23.8 cm.).
Basilica, Pompei. 6¹⁵⁄₁₆ × 9⅛ in. (17.7 × 23.3 cm.).
Tèmpio di Mercurio, Pompei. 6⅞ × 9⅜ in. (17.5 × 23.8 cm.).
Casa di Pornai. 7 × 9⅜ in. (17.8 × 23.9 cm.).
Tèmpio di Venere, Pompei. 7 × 9⅜ in. (17.8 × 23.8 cm.).
Tèmpio d'Iside, Pompei. 9 × 7 in. (22.9 × 17.9 cm.).
Fontana Pella Casa del Gran Belcone, Pompei. 9⅛ × 7⅛ in. (23.2 × 18.0 cm.).
Anfiteatro, Pompei. 6¹⁵⁄₁₆ × 9⅜ in. (17.7 × 23.8 cm.).
Freschi di Pompei. 6⅞ × 9⅜ in. (17.4 × 23.8 cm.).
Tòro Farnese, Museo Napoli. 9¹⁄₁₆ × 7¼ in. (23.1 × 18.2 cm.).
Ercole Farnese, Museo Napoli. 9¹⁄₁₆ × 7⅛ in. (23.0 × 18.1 cm.).
[Museo Napoli]. 9⅛ × 6⅞ in. (23.2 × 17.5 cm.).
Psyche, Museo Napoli. 9¹⁄₁₆ × 7¹⁄₁₆ in. (23.1 × 18.0 cm.).
Sileno, Museo Napoli. 9¹⁄₁₆ × 7⅛ in. (23.0 × 18.1 cm.).
Mercurio, Museo di Napoli. 9¹⁄₁₆ × 7⅛ in. (23.1 × 18.1 cm.).
Fauno Ebbrio, Museo Napoli. 9⅛ × 7³⁄₁₆ in. (23.2 × 18.2 cm.).

SONNEMAN, EVE
American, 1946-

Kiva Seat, Aztec, New Mexico. 1974. Gelatin silver print. 4¾ × 13¹⁄₁₆ in. (12.1 × 33.2 cm.). Kate and Hall J. Peterson Fund. 74.91.1.

Light on Lead Street, New Mexico. 1968. Gelatin silver print. 4⅝ × 13³⁄₁₆ in. (11.8 × 33.6 cm.). Kate and Hall J. Peterson Fund. 74.91.2.

Portrait of My Lover, Central Park. 1971. Gelatin silver print. 4⅝ × 12¾ in. (11.7 × 32.4 cm.). Kate and Hall J. Peterson Fund. 74.91.3.

Parachute, Barcelona. 1970. Gelatin silver print. 4¾ × 13⁵⁄₁₆ in. (12.0 × 33.8 cm.). Kate and Hall J. Peterson Fund. 74.91.4.

Central Park Rock, New York. 1971. Gelatin silver print. 4⅝ × 13¼ in. (11.8 × 33.7 cm.). Kate and Hall J. Peterson Fund. 74.91.5.

Siesta, Isle Mujeres, Mexico. 1972. Gelatin silver print. 4¹¹⁄₁₆ × 13⁵⁄₁₆ in. (12.0 × 33.8 cm.). Kate and Hall J. Peterson Fund. 74.91.6.

Shoes in Hand, Coney Island. 1974. Gelatin silver print. 4¹¹⁄₁₆ × 13⅜ in. (11.9 × 33.9 cm.). Kate and Hall J. Peterson Fund. 74.91.7.

La Ciotat, France. 1970. Gelatin silver print. 4⁹⁄₁₆ × 12⅞ in. (11.6 × 32.7 cm.). Kate and Hall J. Peterson Fund. 74.91.8.

SPENCER, EMA
See *Camera Work*

SPENDER, HUMPHREY
English, 1910-

Madrid. 1934. Gelatin silver print. 6½ × 8¹³⁄₁₆ in. (16.5 × 22.4 cm.). John R. Van Derlip Fund. 81.85.

STEICHEN, EDWARD
American (b. Luxembourg), 1879-1973

Group of 100 photographs by Edward Steichen. Bequest of Edward Steichen by direction of Joanna T. Steichen and the George Eastman House. 82.28.1-100.

[abstraction]. c. 1921. Palladium print (?). 9⁹⁄₁₆ × 7⁹⁄₁₆ in. (24.4 × 19.3 cm.). 82.28.1.

[sunflower]. n.d. Gelatin silver print. 13¾ × 10¹¹⁄₁₆ in. (34.9 × 27.2 cm.). 82.28.2.

Dana Steichen. n.d. Gelatin silver print. 9⅝ × 7⅝ in. (24.4 × 19.3 cm.). 82.28.3.

Dana Steichen. n.d. Palladium print (?). 9⁹⁄₁₆ × 7⅝ in. (24.4 × 19.4 cm.). 82.28.4.

George Arliss in "Old English." Vanity Fair, April 1925. Gelatin silver print. 9⁹⁄₁₆ × 7⁹⁄₁₆ in. (24.3 × 19.3 cm.). 82.28.5.

Ethel Barrymore. c. 1925. Gelatin silver print. 9½ × 7⁹⁄₁₆ in. (24.1 × 19.2 cm.). 82.28.6.

John Barrymore. Vanity Fair, May 1930. Gelatin silver print. 9½ × 7⅝ in. (24.2 × 19.4 cm.). 82.28.7.

Captain Bob Bartlett. n.d. Gelatin silver print. 9½ × 7⅝ in. (24.2 × 19.3 cm.). 82.28.8.

Charlie Chaplin. Vanity Fair, December 1925. Gelatin silver print. 9½ × 7⁹⁄₁₆ in. (24.1 × 19.3 cm.). 82.28.9.

Charlie Chaplin. c. 1925. Gelatin silver print. 9½ × 7⁹⁄₁₆ in. (24.1 × 19.3 cm.). 82.28.10.

Winston Churchill. 1932. Gelatin silver print. 9½ × 7⅝ in. (24.1 × 19.4 cm.). 82.28.11.

Miguel Covarrubias. n.d. Gelatin silver print. 9½ × 7⁹⁄₁₆ in. (24.2 × 19.3 cm.). 82.28.12.

Joan Crawford. Vanity Fair, September 1932. Gelatin silver print. 9½ × 7⁹⁄₁₆ in. (24.2 × 9.2 cm.). 82.28.13.

Lily Damita. Vanity Fair, August 1928. Gelatin silver print. 9½ × 7⅝ in. (24.2 × 19.3 cm.). 82.28.14.

La Duchesse de Gramont, Paris. 1924. Gelatin silver print. 13¾ × 10¾ in. (34.9 × 27.3 cm.). 82.28.15.

The de Marcos. Vanity Fair, August 1935. Gelatin silver print. 9½ × 7⁹⁄₁₆ in. (24.2 × 19.3 cm.). 82.28.16.

Raymond Ditmars. Vanity Fair, August 1932. Gelatin silver print. 9⅜ × 7⁹⁄₁₆ in. (23.4 × 19.3 cm.). 82.28.17.

Jack Donahue. Vanity Fair, April 1928. Gelatin silver print. 9½ × 7⁹⁄₁₆ in. (24.1 × 19.3 cm.). 82.28.18.

Isadora Duncan at the Parthenon. 1921. Palladium print (?). 19½ × 13¾ in. (49.5 × 35.0 cm.). 82.28.19.

The Isadora Duncan Dancers of Moscow. Vanity Fair, April 1929. Gelatin silver print. 9½ × 7⅝ in. (24.2 × 19.3 cm.). 82.28.20.

Mrs. William Temple Emmet. Vogue, October 15, 1934. Gelatin silver print. 9⁹⁄₁₆ × 7⅝ in. (24.3 × 19.4 cm.). 82.28.21.

W. C. Fields. 1925. Gelatin silver print. 13¹¹⁄₁₆ × 10¹¹⁄₁₆ in. (34.8 × 27.2 cm.). 82.28.22.

Sidney Franklin. c. 1930. Gelatin silver print. 9½ × 7⁹⁄₁₆ in. (24.2 × 19.3 cm.). 82.28.23.

Eva Le Gallienne. Vanity Fair, December 1928. Gelatin silver print. 9½ × 7⁹⁄₁₆ in. (24.1 × 19.2 cm.). 82.28.24.

Greta Garbo and John Gilbert. c. 1928. Gelatin silver print. 16½ × 13⁹⁄₁₆ in. (42.0 × 34.5 cm.). 82.28.25.

Janet Gaynor. 1928. Gelatin silver print. 9½ × 7⁹⁄₁₆ in. (24.1 × 19.2 cm.). 82.28.26.

Janet Gaynor. Vanity Fair, April 1929. Gelatin silver print. 9⁷⁄₁₆ × 7½ in. (24.0 × 19.1 cm.). 82.28.27.

Lillian Gish in "Within the Gates." 1934. Gelatin silver print. 9½ × 7⁹⁄₁₆ in. (24.1 × 19.2 cm.). 82.28.28.

Martha Graham. 1931. Gelatin silver print. 13¾ × 10¾ in. (35.1 × 27.3 cm.). 82.28.29.

Frank M. Hawks. Vanity Fair, October 1931. Gelatin silver print. 9½ × 7⅝ in. (24.1 × 19.3 cm.). 82.28.30.

Edward Johnson. Vanity Fair, November 1935. Gelatin silver print. 9½ × 7⁹⁄₁₆ in. (24.1 × 19.3 cm.). 82.28.31.

Ruby Keeler. Vanity Fair, November 1932. Gelatin silver print. 9½ × 7⁹⁄₁₆ in. (24.1 × 19.2 cm.). 82.28.32.

Francine Larrimore. Vanity Fair, May 1929. Gelatin silver print. 9⁷⁄₁₆ × 7⁹⁄₁₆ in. (24.0 × 19.3 cm.). 82.28.33.

Beatrice Lillie. Vanity Fair, May 1931. Gelatin silver print. 7⁹⁄₁₆ × 9½ in. (19.2 × 24.1 cm.). 82.28.34.

Anita Loos. c. 1926. Gelatin silver print. 9½ × 7⁹⁄₁₆ in. (24.2 × 19.3 cm.). 82.28.35.

Lynn Fontanne. 1927. Gelatin silver print. 9⁹⁄₁₆ × 7⅝ in. (24.3 × 19.4 cm.). 82.28.36.

Alfred Lunt and Lynn Fontanne. c. 1925. Gelatin silver print. 9½ × 7⅝ in. (24.2 × 19.3 cm.). 82.28.37.

Marion Marsh. Vanity Fair, December 1932. Gelatin silver print. 7¹¹⁄₁₆ × 9⁷⁄₁₆ in. (19.5 × 24.1 cm.). 82.28.38.

Mei Lan-Fang. Vanity Fair, April 1930. Gelatin silver print. 9⁹⁄₁₆ × 7⅝ in. (24.2 × 19.4 cm.). 82.28.39.

Mei Lan-Fang. c. 1930. Gelatin silver print. 9½ × 7⅝ in. (24.2 × 19.4 cm.). 82.28.40.

Adolphe Menjou. Vanity Fair, March 1933. Gelatin silver print. 9⁷⁄₁₆ × 7⁹⁄₁₆ in. (24.0 × 19.2 cm.). 82.28.41.

Helen Menken. Vanity Fair, April 1930. Gelatin silver print. 9½ × 7⁹⁄₁₆ in. (24.1 × 19.2 cm.). 82.28.42.

Beth Merrill. Vanity Fair, August 1928. Gelatin silver print. 9⅜ × 7⁹⁄₁₆ in. (23.9 × 19.3 cm.). 82.28.43.

Agnes Ernst (Mrs. Eugene) Meyer. n.d. Gelatin silver print. 9⁷⁄₁₆ × 7⁵⁄₁₆ in. (24.0 × 18.7 cm.). 82.28.44.

Ferenc Molnár. Vanity Fair, January 1929. Gelatin silver print. 9½ × 7⁹⁄₁₆ in. (24.1 × 19.2 cm.). 82.28.45.

Carlotta Monterey (Mrs. Eugene O'Neill). 1932. Gelatin silver print. 13¾ × 10¾ in. (35.0 × 27.4 cm.). 82.28.46.

Carlotta Monterey (Mrs. Eugene O'Neill). 1932. Gelatin silver print. 9½ × 7⅝ in. (24.2 × 19.4 cm.). 82.28.47.

Lois Moran. Vanity Fair, February 1931. Gelatin silver print. 9½ × 7⁹⁄₁₆ in. (24.1 × 19.3 cm.). 82.28.48.

Merle Oberon in "I, Claudius." Vogue, March 1, 1937. Gelatin silver print. 10⁹⁄₁₆ × 13¹¹⁄₁₆ in. (26.9 × 34.8 cm.). 82.28.49.

Jane Fauntz. Vanity Fair, September 1932. Gelatin silver print. 9¼ × 7⅝ in. (23.5 × 19.4 cm.). 82.28.50.

Katherine Rawls. Vanity Fair, September 1932. Gelatin silver print. 9³⁄₁₆ × 7⅝ in. (23.4 × 19.4 cm.). 82.28.51.

Eugene O'Neill. Vanity Fair, October 1933. Gelatin silver print. 9⁹⁄₁₆ × 7⅝ in. (24.3 × 19.4 cm.). 82.28.52.

Ruth Bryan Owen. Vanity Fair, July 1933. Gelatin silver print. 9½ × 7⅝ in. (24.2 × 19.4 cm.). 82.28.53.

Douglas Fairbanks. Vanity Fair, February 1928. Gelatin silver print. 9½ × 7⁹⁄₁₆ in. (24.1 × 19.3 cm.). 82.28.54.

Paul Robeson. Vanity Fair, August 1930. Gelatin silver print. 9⁹⁄₁₆ × 7⅝ in. (24.2 × 19.3 cm.). 82.28.55.

Jack Sharkey. Vanity Fair, April 1932. Gelatin silver print. 9½ × 7⁹⁄₁₆ in. (24.2 × 19.3 cm.). 82.28.56.

Sylvia Sidney. Vanity Fair, April 1932. Gelatin silver print. 13¹¹⁄₁₆ × 10¾ in. (34.9 × 27.3 cm.). 82.28.57.

Fred Stone and Family. Vogue, March 29, 1930. Gelatin silver print. 9½ × 7⅝ in. (24.2 × 19.3 cm.). 82.28.58.

Sunburn, New York. 1925. Gelatin silver print. 9⅜ × 7⁹⁄₁₆ in. (23.8 × 19.2 cm.). 82.28.59.

In front of Lilyan Tashman's Beach House, Malibu. Vanity Fair, January 1932. Gelatin silver print. 9½ × 7⁹⁄₁₆ in. (24.1 × 19.3 cm.). 82.28.60.

Robert T. Vanderbilt. n.d. Gelatin silver print. 9½ × 7⁹⁄₁₆ in. (24.2 × 19.3 cm.). 82.28.61.

Lupe Velez. 1928. Gelatin silver print. 9⁹⁄₁₆ × 7⁹⁄₁₆ in. (24.1 × 19.2 cm.). 82.28.62.

Cosette (Mrs. Lucien) Vogel. n.d. Gelatin silver print. 9⁹⁄₁₆ × 7⁹⁄₁₆ in. (24.3 × 19.2 cm.). 82.28.63.

Dr. Richard Von Kühlmann. Vanity Fair, February 1933. Gelatin silver print. 9½ × 7⁹⁄₁₆ in. (24.1 × 19.3 cm.). 82.28.64.

Paul Warburg. n.d. Gelatin silver print. 9½ × 7⅝ in. (24.1 × 19.3 cm.). 82.28.65.

H. G. Wells. Vanity Fair, January 1932. Gelatin silver print. 9½ × 7⁹⁄₁₆ in. (24.2 × 19.2 cm.). 82.28.66.

Mae West. Vanity Fair, May 1933. Gelatin silver print. 9⁹⁄₁₆ × 7⅝ in. (24.3 × 19.4 cm.). 82.28.67.

Fanny Wickes. Vogue, December 1, 1924. Gelatin silver print. 9⁹⁄₁₆ × 7⁹⁄₁₆ in. (24.3 × 19.3 cm.). 82.28.68.

Helen Wills. Vogue, October 12, 1929. Gelatin silver print. 9½ × 7⁹⁄₁₆ in. (24.1 × 19.3 cm.). 82.28.69.

Frank Lloyd Wright. n.d. Gelatin silver print. 9⁹⁄₁₆ × 7⁹⁄₁₆ in. (24.4 × 19.2 cm.). 82.28.70.

Loretta Young. Vanity Fair, August 1930. Gelatin silver print. 9½ × 7⁹⁄₁₆ in. (24.1 × 19.2 cm.). 82.28.71.

Homeless Women: The Depression. 1932. Gelatin silver print. 13⁹⁄₁₆ × 10¹¹⁄₁₆ in. (34.5 × 27.1 cm.). 82.28.72.

Eastman Kodak Company Advertisement. c. 1935. Gelatin silver print. 13¼ × 10⁹⁄₁₆ in. (33.8 × 26.8 cm.). 82.28.73.

Eastman Kodak Company Advertisement. c. 1935. Gelatin silver print. 9⅜ × 7⅝ in. (23.9 × 19.3 cm.). 82.28.74.

Eastman Kodak Company Advertisement. c. 1935. Gelatin silver print. 13 × 10⁷⁄₁₆ in. (33.2 × 26.5 cm.). 82.28.75.

Eastman Kodak Company Advertisement. c. 1935. Gelatin silver print. 13⅜ × 10⁹⁄₁₆ in. (34.0 × 26.8 cm.). 82.28.76.

Eastman Kodak Company Advertisement. c. 1935. Gelatin silver print. 7⅝ × 9⅝ in. (19.4 × 24.4 cm.). 82.28.77.

Eastman Kodak Company Advertisement. c. 1935. Gelatin silver print. 13⅜ × 10⅝ in. (34.0 × 26.9 cm.). 82.28.78.

Eastman Kodak Company Advertisement. c. 1935. Gelatin silver print. 13¹¹⁄₁₆ × 10½ in. (34.8 × 26.6 cm.). 82.28.79.

Eastman Kodak Company Advertisement. c. 1935. Gelatin silver print. 7⅝ × 9⅝ in. (19.4 × 24.4 cm.). 82.28.80.

Eastman Kodak Company Advertisement. c. 1935. Gelatin silver print. 7⁹⁄₁₆ × 9½ in. (19.3 × 24.2 cm.). 82.28.81.

Eastman Kodak Company Advertisement. c. 1935. Gelatin silver print. 13½ × 10⁷⁄₁₆ in. (34.3 × 26.5 cm.). 82.28.82.

[man and woman in swimming suits]. n.d. Gelatin silver print. 9⁹⁄₁₆ × 7⁹⁄₁₆ in. (24.3 × 19.3 cm.). 82.28.83.

Mrs. James H. Van Alen. Vogue, October 26, 1929. Gelatin silver print. 9½ × 7⅝ in. (24.2 × 19.3 cm.). 82.28.84.

[bride]. *Vogue,* October 1, 1937. Gelatin silver print. 9⁹⁄₁₆ × 7⅝ in. (24.3 × 19.4 cm.). 82.28.85.

"Awake and Sing" with Jules Garfield, Morris Carnovsky, and Luther Adler. Vanity Fair, June 1935. Gelatin silver print. 9⁹⁄₁₆ × 7⅝ in. (24.3 × 19.4 cm.). 82.28.86.

"Ethan Frome" with Ruth Gordon, Raymond Massey, and Pauline Lord. Vanity Fair, February 1936. Gelatin silver print. 13⅝ × 10¹¹⁄₁₆ in. (34.7 × 27.1 cm.). 82.28.87.

"The Front Page" with Osgood Perkins and Lee Tracy. Vanity Fair, September 1928. Gelatin silver print. 13⁵⁄₁₆ × 10½ in. (33.8 × 26.8 cm.). 82.28.88.

"The Green Pastures." Vanity Fair, May 1930. Gelatin silver print. 11¾ × 9⅝ in. (29.9 × 24.5 cm.). 82.28.89.

"The Green Pastures." Vanity Fair, May 1930. Gelatin silver print. 9½ × 7⁹⁄₁₆ in. (24.1 × 19.2 cm.). 82.28.90.

James Hackett as "Macbeth." c. 1924. Gelatin silver print. 13¹³⁄₁₆ × 10¾ in. (35.2 × 27.3 cm.). 82.28.91.

"Processional" with June Walker. Vanity Fair, April 1925. Gelatin silver print. 9½ × 7⁹⁄₁₆ in. (24.1 × 19.2 cm.). 82.28.92.

"What Price Glory?" with Fuller Mellish, George Tobias, and Brian Donlevy. Vanity Fair, February 1925. Gelatin silver print. 13¹³⁄₁₆ × 10¹³⁄₁₆ in. (35.1 × 27.5 cm.). 82.28.93.

Brancusi's Studio. 1927. Gelatin silver print. 13¹¹⁄₁₆ × 10¹¹⁄₁₆ in. (34.8 × 27.2 cm.). 82.28.94.

Mask of Goethe and Spiral. 1932. Gelatin silver print. 13¹¹⁄₁₆ × 10¹¹⁄₁₆ in. (34.9 × 27.2 cm.). 82.28.95.

[autumn trees]. n.d. Dye transfer print. 9⁹⁄₁₆ × 7⅜ in. (24.3 × 18.8 cm.). 82.28.96.

[sunflowers]. n.d. color coupler print (?). 15³⁄₁₆ × 16¹⁄₁₆ in. (38.6 × 40.8 cm.). 82.28.97.

"Strange Interlude" with Lynn Fontanne. 1928. Gelatin silver print. 9⅜ × 7½ in. (23.9 × 19.0 cm.). 82.28.98.

"Strange Interlude" with Lynn Fontanne. 1928. Gelatin silver print. 8⁹⁄₁₆ × 7⁹⁄₁₆ in. (21.8 × 19.2 cm.). 82.28.99.

"Strange Interlude" with Lynn Fontanne. 1928. Gelatin silver print. 9⅛ × 7⁹⁄₁₆ in. (23.2 × 19.2 cm.). 82.28.100.

See also *Camera Work*

STEIGER-MEISTER, CARLA
American, 1951-

[starfish glass and bird]. From *Minnesota Photographers* portfolio. 1978. Color coupler print. 6½ × 9¹⁵⁄₁₆ in. (16.5 × 25.3 cm.). John R. Van Derlip Fund. 79.48.10.

STEINER, RALPH
American, 1899-

Ten Photographs from the Twenties and Thirties and One from the Seventies. Published by the photographer, Thetford Hill, Vermont. n.d. Portfolio of 11 gelatin silver prints. Mr. and Mrs. Harrison R. Johnston, Jr. Fund. 78.18.1-11.
Typewriter as Design. c. 1922. 8 × 5¹⁵⁄₁₆ in. (20.4 × 15.1 cm.).
Lollipop. 1922. 4⁹⁄₁₆ × 3⁹⁄₁₆ in. (11.6 × 9.1 cm.).
Always—Camel Cigarettes. 1922. 3⅝ × 4¹¹⁄₁₆ in. (9.3 × 12.0 cm.).
Ford. 1928. 9⁷⁄₁₆ × 7⁹⁄₁₆ in. (24.1 × 19.2 cm.).
Nehi Sign. 1928. 9½ × 7½ in. (24.2 × 19.1 cm.).
Row of Albany Houses. 1928. 4⁵⁄₁₆ × 9⁵⁄₁₆ in. (11.0 × 23.7 cm.).
Wicker Chair. 1928. 7½ × 9½ in. (19.1 × 24.2 cm.).

Ham and Eggs. n.d. 9½ × 7½ in. (24.1 × 19.1 cm.).
The Coconut Factory. n.d. 9⁹⁄₁₆ × 7⁵⁄₁₆ in. (24.0 × 18.7 cm.).
After the Rehearsal. 1936. 9½ × 7½ in. (24.1 × 19.1 cm.).
[fence in snow]. n.d. 4⅞ × 6⅝ in. (12.4 × 16.8 cm.).

Saratoga Coal Company. 1929. Gelatin silver print. 7⅝ × 9⅝ in. (19.3 × 24.4 cm.). John R. Van Derlip Fund. 81.86.

STIEGLITZ, ALFRED
American, 1864-1946

The Steerage. From *291,* September-October, 1915. Photogravure. 13¹⁄₁₆ × 10⅜ in. (33.3 × 26.4 cm.). Transfer from reference collections. 82.71.6a.

From the Shelton, West. 1935. Gelatin silver print. 9½ × 7⁷⁄₁₆ in. (24.2 × 18.9 cm.). Gift of funds from Harry Drake. 83.151.

Equivalent. 1929. Gelatin silver print. 4⅝ × 3⅝ in. (11.8 × 9.2 cm.). Gift of funds from Harry Drake. 83.152.

See also *Camera Work*

STOCKWELL, SHARON
American, 1949-

The Act of Exposing a Sensitive Surface. From *Minnesota Photographers* portfolio. 1978. Gelatin silver print with needle and thread. 10¹¹⁄₁₆ × 7⁵⁄₁₆ in. (27.1 × 18.6 cm.). John R. Van Derlip Fund. 79.48.11.

STRAND, PAUL
American, 1890-1976

The Mexican Portfolio. Published by Da Capo Press, New York. 1967. Portfolio of 20 photogravures. John R. Van Derlip Fund. 68.23.1-20.
Near Saltillo. 1932. 4¹⁵⁄₁₆ × 6¼ in. (12.5 × 15.8 cm.).
Church, Coapiaxtla. n.d. 6⅜ × 4⅞ in. (16.2 × 12.5 cm.).
Virgin, San Felipe, Oaxaca. n.d. 10⁵⁄₁₆ × 7¹⁵⁄₁₆ in. (26.2 × 20.3 cm.).
Women of Santa Anna, Michoacan. n.d. 5 × 6¼ in. (12.7 × 15.8 cm.).
Men of Santa Anna, Michoacan. 1933. 6⁵⁄₁₆ × 4⅞ in. (16.0 × 12.4 cm.).
Woman, Patzcuaro. 1933. 6⅜ × 5 in. (16.2 × 12.7 cm.).
Boy, Uruapan. n.d. 6⁵⁄₁₆ × 4⅞ in. (16.0 × 12.4 cm.).
Cristo, Oaxaca. n.d. 10³⁄₁₆ × 7⅞ in. (26.0 × 20.0 cm.).
Woman and Boy, Tenancingo. n.d. 6⅜ × 5 in. (16.3 × 12.7 cm.).
Plaza, State of Puebla. n.d. 5 × 6¼ in. (12.7 × 15.9 cm.).
Man with a Hoe, Los Remedios. 1933. 6¼ × 4⅞ in. (15.9 × 12.3 cm.).
Calvario, Patzcuaro. 1933. 10¹⁄₁₆ × 7¹³⁄₁₆ in. (25.6 × 19.9 cm.).
Cristo, Tlacochoaya, Oaxaca. 1933. 9⅞ × 7¾ in. (25.2 × 19.7 cm.).
Boy, Hidalgo. n.d. 10¹⁄₁₆ × 7¹⁵⁄₁₆ in. (25.6 × 20.2 cm.).

Woman and Baby, Hidalgo. n.d. 4¹⁵⁄₁₆ × 6³⁄₁₆ in. (12.6 × 15.7 cm.).
Girl and Child, Toluca. n.d. 6⅜ × 5 in. (16.3 × 12.7 cm.).
Cristo with Thorns, Huexotla. 1933. 10¼ × 7⅞ in. (26.0 × 20.1 cm.).
Man, Tenancingo. 1933. 6⁷⁄₁₆ × 5 in. (16.3 × 12.7 cm.).
Young Woman and Boy, Toluca. n.d. 5 × 6⅛ in. (12.7 × 15.7 cm.).
Gateway, Hidalgo. n.d. 10⅛ × 7¹⁵⁄₁₆ in. (25.7 × 20.1 cm.).

Rebecca Strand, New York City. 1922. Platinum print. 7⅝ × 9⅝ in. (19.5 × 24.5 cm.). William Hood Dunwoody Fund. 82.88.1.

Window, Red River, New Mexico. 1931. Platinum print. 9¹¹⁄₁₆ × 7⅝ in. (24.6 × 19.4 cm.). William Hood Dunwoody Fund. 82.88.2.

Fisherman, Banyuls, Pyrénées-Orientales, France. 1950. Gelatin silver print. 5⅞ × 4⅝ in. (15.0 × 11.8 cm.). William Hood Dunwoody Fund. 82.88.3.

Driftwood, Dark Roots, Maine. 1928. Platinum print. 7⁹⁄₁₆ × 9½ in. (19.3 × 24.2 cm.). William Hood Dunwoody Fund. 82.88.4.

See also *Camera Work*

STRAUSS, JOHN FRANCIS
See *Camera Work*

STRUSS, KARL F.
See *Camera Work*

SUTTON, GARY L.
American, 1944-

Peach. 1977. Color coupler print. 7 × 9 in. (17.8 × 22.9 cm.). Paul J. Schmitt Fund. 78.38.1.

Blue. 1977. Color coupler print. 7 × 9 in. (17.8 × 23.0 cm.). Paul J. Schmitt Fund. 78.38.2.

M-4. 1977. Color coupler print. 7 × 9 in. (17.8 × 22.9 cm.). Paul J. Schmitt Fund. 78.38.3.

Motion 1. 1978. Color coupler print. 7¹⁄₁₆ × 9¹⁄₁₆ in. (17.9 × 23.0 cm.). Paul J. Schmitt Fund. 78.38.4.

Chicago. 1977. Color coupler print. 7¹⁄₁₆ × 9⅛ in. (17.9 × 23.2 cm.). Paul J. Schmitt Fund. 78.38.5.

Krissy's Room. 1977. Color coupler print. 7 × 9¹⁄₁₆ in. (17.8 × 23.1 cm.). Gift of the artist. 78.39.1.

Rose Stance. 1977. Color coupler print. 7 × 9⅛ in. (17.8 × 23.1 cm.). Gift of the artist. 78.39.2.

Reception. 1979. Gelatin silver print. 6¹⁄₁₆ × 8 in. (15.4 × 20.4 cm.). Gift of the artist. 79.43.1.

Six-Sided Table. 1979. Gelatin silver print. 6 × 8¹⁄₁₆ in. (15.3 × 20.5 cm.). Gift of the artist. 79.43.2.

Backyard Birch. 1979. Gelatin silver print. 6¹⁄₁₆ × 8⅛ in. (15.4 × 20.6 cm.). John R. Van Derlip Fund. 79.44.1.

Silver Weeds. 1979. Gelatin silver print. 6¹⁄₁₆ × 8⅛ in. (15.4 × 20.6 cm.). John R. Van Derlip Fund. 79.44.2.

SWEDLUND, CHARLES
American, 1935-

[geyser]. From *Underware* portfolio. 1976. Dye transfer print. 7⁵/₈ × 9³/₈ in. (18.6 × 23.9 cm.). National Endowment for the Arts purchase grant and miscellaneous matching funds. 76.64.16.

Three Graces. 1969. Gelatin silver print. 7³/₈ × 7³/₈ in. (18.8 × 18.8 cm.). Kate and Hall J. Peterson Fund. 83.11.

SWEETMAN, ALEX
American, 1946-

A Photograph of a Half-tone Diagram of a Hologram of Underware that Resembles a Woman's Face. 1976. Gelatin silver print. 15¹⁵/₁₆ × 19¹⁵/₁₆ in. (40.6 × 50.7 cm.). National Endowment for the Arts purchase grant and miscellaneous matching funds. 76.64.17.

SWERDLOWE, ALLEN
American, 1948-

[tree shadow]. 1979. Vandyke brown print. 2¹⁵/₁₆ × 4³/₈ in. (7.6 × 11.2 cm.). Gift of the artist. 79.45.1.

[streetlight shadow on snow]. 1978. Vandyke brown print. 2¹⁵/₁₆ × 4⁵/₁₆ in. (7.4 × 11.0 cm.). Gift of the artist. 79.45.2.

[chute with shadow over dumpster]. 1978. Vandyke brown print. 2¹⁵/₁₆ × 4³/₈ in. (7.6 × 11.2 cm.). John R. Van Derlip Fund. 79.46.1.

[sidewalk with awning]. 1978. Vandyke brown print. 2¹⁵/₁₆ × 4³/₈ in. (7.5 × 11.2 cm.). John R. Van Derlip Fund. 79.46.2.

[tree shadows on brick facade]. 1978. Vandyke brown print. 2⁷/₈ × 4⁵/₈ in. (7.3 × 11.0 cm.). John R. Van Derlip Fund. 79.46.3.

Flores, Untitled No. 2. 1981. Color coupler print. 30¹/₈ × 46¹/₂ in. (76.6 × 118.2 cm.). Gift of funds from the Photography Council of The Minneapolis Institute of Arts. 81.42.

SZÉKESSY, KARIN
German, 1939-

Mental Exercise. 1967. Gelatin silver print. 19⁹/₁₆ × 23¹/₂ in. (49.8 × 59.7 cm.). Gift of Russell Cowles II. 81.100.1.

TAIT, DAVID B.
American, 1946-

[woman with cigarette and man with glass]. From *Social Dancing* series. 1976. Gelatin silver print. 14 × 17¹⁵/₁₆ in. (35.6 × 45.6 cm.). Christina N. and Swan J. Turnblad Memorial Fund. 78.55.1.

[woman with arm extended]. From *Social Dancing* series. 1977. Gelatin silver print. 14 × 17⁷/₈ in. (35.6 × 45.5 cm.). Christina N. and Swan J. Turnblad Memorial Fund. 78.55.2.

[woman with beer bottle]. From *Social Dancing* series. 1976. Gelatin silver print. 14 × 17¹⁵/₁₆ in. (35.6 × 45.6 cm.). Christina N. and Swan J. Turnblad Memorial Fund. 78.55.3.

[couple dancing]. From *Social Dancing* series. 1976. Gelatin silver print. 14 × 17¹⁵/₁₆ in. (35.6 × 45.6 cm.). Christina N. and Swan J. Turnblad Memorial Fund. 78.55.4.

TALBOT, WILLIAM HENRY FOX
English, 1800-1877

[roof and chimneys of Lacock Abbey]. c. 1836. Calotype. 3⁷/₈ × 4¹/₁₆ in. (9.9 × 10.4 cm.). Kate and Hall J. Peterson Fund. 73.33.1.

[portrait of a lady]. n.d. Calotype. 6 × 4 in. (15.3 × 10.2 cm.). Kate and Hall J. Peterson Fund. 73.33.2.

Cloisters of Lacock Abbey. 1844. Calotype. 6¹/₂ × 8¹/₁₆ in. (16.4 × 20.6 cm.). John R. Van Derlip Fund. 74.12.

TAMAMURA, K.
Japanese, active 1890-1910

Untitled. c. 1891. Album of 30 albumen prints. Gift of Mrs. Charles Sumner Gale. 82.67.1-30.
Tokyo. 7³/₄ × 10¹/₈ in. (19.7 × 25.7 cm.).
[figures and dwelling]. 7⁵/₈ × 9⁵/₈ in. (19.3 × 24.5 cm.).
[figures]. 9⁵/₈ × 7⁵/₈ in. (24.5 × 19.4 cm.).
Bentendori, Yokohama. 7⁹/₁₆ × 10¹/₈ in. (19.2 × 25.7 cm.).
[woman playing musical instrument]. 9⁵/₈ × 7⁵/₈ in. (24.5 × 19.3 cm.).
Stone Idol at Nikko. 7⁹/₁₆ × 10¹/₁₆ in. (19.1 × 25.7 cm.).
Nikko. 9¹⁵/₁₆ × 7¹³/₁₆ in. (25.3 × 19.8 cm.).
[woman with musical instrument]. 9⁵/₈ × 7⁵/₈ in. (24.5 × 19.3 cm.).
[figures with parasol]. 9⁵/₈ × 7⁵/₈ in. (24.5 × 19.4 cm.).
[village]. 7³/₄ × 10¹/₈ in. (19.7 × 25.8 cm.).
Lotus Blossom Uyeno, Tokyo. 7⁹/₁₆ × 10¹/₈ in. (19.2 × 25.7 cm.).
[figures with rickshaw]. 9⁵/₈ × 7⁵/₈ in. (24.5 × 19.3 cm.).
[parade]. 9⁵/₈ × 7⁹/₁₆ in. (24.5 × 19.3 cm.).
Cherry Blossoms at Uyeno Park. 7⁵/₈ × 10¹/₁₆ in. (19.3 × 25.6 cm.).
Wysteria Vine. 7³/₄ × 10¹/₈ in. (19.7 × 25.7 cm.).
[man with pipe]. 9⁵/₈ × 7⁹/₁₆ in. (24.5 × 19.3 cm.).
Bluff Gardens, Yokohama. 7¹/₂ × 10¹/₈ in. (19.1 × 25.7 cm.).
Nagasaki. 7⁹/₁₆ × 10¹/₈ in. (19.2 × 25.8 cm.).
Suwa Temple. 7¹/₂ × 10¹/₈ in. (19.0 × 25.7 cm.).
Nagoya Town. 7¹³/₁₆ × 10¹/₁₆ in. (19.9 × 25.6 cm.).
Nagoya Castle. 7¹¹/₁₆ × 10¹/₈ in. (19.5 × 25.8 cm.).
Nagasaki. 7¹³/₁₆ × 10¹/₁₆ in. (19.8 × 25.6 cm.).
Arashi Yama at Kyoto. 7¹¹/₁₆ × 10¹/₁₆ in. (19.6 × 25.6 cm.).
Lake of Biwa from Ishiyama. 7⁵/₈ × 10¹/₁₆ in. (19.4 × 25.6 cm.).
Kiyomizu at Kyoto. 7¹³/₁₆ × 10¹/₈ in. (19.8 × 25.8 cm.).
Harbor of Kobe. 7⁵/₈ × 10¹/₁₆ in. (19.3 × 25.6 cm.).
Moon Temple at Mayasan Kobe. 7¹/₂ × 10¹/₈ in. (19.0 × 25.7 cm.).
Kyoto Town from Maruyama. 7³/₄ × 10¹/₁₆ in. (19.8 × 25.5 cm.).
Chioin at Kyoto. 7¹³/₁₆ × 10¹/₁₆ in. (19.8 × 25.6 cm.).
Large Pinetree at Karasaki. 7⁹/₁₆ × 10¹/₁₆ in. (19.2 × 25.6 cm.).

TAUSSIG, ARTHUR
American, 1941-

Oakland, California. 1975. Color coupler print. 12¹⁵/₁₆ × 8³/₄ in. (32.9 × 22.3 cm.). Gift of the artist. 77.9.1.

Los Angeles, California. 1976. Color coupler print. 8³/₄ × 13¹/₁₆ in. (22.3 × 33.2 cm.). Gift of the artist. 77.9.2.

Newport Beach, California. 1975. Color coupler print. 8¹³/₁₆ × 13¹/₁₆ in. (22.3 × 33.2 cm.). Gift of the artist. 77.9.3.

San Diego, California. 1975. Color coupler print. 8³/₄ × 13 in. (11.2 × 33.1 cm.). Gift of the artist. 77.9.4.

Panama City, Florida. From *Silver See* portfolio. 1977. Color coupler print. 8¹³/₁₆ × 13¹/₁₆ in. (22.4 × 33.2 cm.). National Endowment for the Arts purchase grant and miscellaneous matching funds. 77.39.18.

Guerrero, Mexico. 1979. Color coupler print. 18¹/₁₆ × 23 in. (45.9 × 58.5 cm.). Gift of the artist. 79.47.

Artesia, California. From *New California Views* portfolio. 1979. Color coupler print (Ektacolor). 8³/₄ × 13¹/₁₆ in. (22.3 × 33.2 cm.). Gift of funds from the Photography Council of The Minneapolis Institute of Arts. 80.24.16.

Arco Tower, Los Angeles, California. 1976. Color coupler print. 8³/₄ × 13¹/₁₆ in. (22.3 × 33.1 cm.). Gift of the artist. 82.68.1.

Interior, Newport Beach, California. 1975. Color coupler print. 8³/₄ × 13 in. (22.3 × 33.0 cm.). Gift of the artist. 82.68.2.

Hotel, Costa Mesa, California. 1975. Color coupler print. 8³/₄ × 13 in. (22.3 × 33.1 cm.). Gift of the artist. 82.68.3.

TELBERG, VAL
American (b. Russia), 1910-

Self-Portrait, St. Marks Place. c. 1947. Gelatin silver print. 13⁷/₈ × 11 in. (35.4 × 27.9 cm.). Ethel Morrison Van Derlip Fund. 81.97.1.

Fire in the Snow (The City No. 3). c. 1948. Gelatin silver print. 13¹³/₁₆ × 11 in. (35.1 × 28.0 cm.). Ethel Morrison Van Derlip Fund. 81.97.2.

TESKE, EDMUND
American, 1911-

[nude male]. From *Silver See* portfolio. n.d. Gelatin silver print, solarized. 9¹⁵/₁₆ × 7⁷/₈ in. (25.3 × 20.0 cm.). National Endowment for the Arts purchase grant and miscellaneous matching funds. 77.39.19.

THOMPSON, DODY W.
American, 1923-

[pine cones and twigs in ice]. From *L. A. Issue* portfolio. 1979. Gelatin silver print. 11³/₁₆ × 8¹³/₁₆ in. (28.5 × 22.4 cm.). Gift of funds from the Photography Council of The Minneapolis Institute of Arts. 80.25.18.

THOMSON, JOHN
Scottish, 1837-1921

The London Boardmen. From *Street Life in London,* 1877-78. Woodburytype. 4⁹/₁₆ × 3⁵/₁₆ in. (11.6 × 8.5 cm.). John R. Van Derlip Fund. 78.91.

THORSEN, TORE
American, 1945-

[tree and field]. n.d. Gelatin silver print. 5⁷/₁₆ × 9³/₁₆ in. (13.9 × 23.4 cm.). Ethel Morrison Van Derlip Fund. 70.76.8.

TICE, GEORGE A.
American, 1938-

The Amish Portfolio. Published by the photographer. 1968. Portfolio of 12 gelatin silver prints. John R. Van Derlip Fund. 69.51.1-12.
Haywagon. 1961. 2⅛ × 6⁷/₁₆ in. (5.4 × 16.4 cm.).
Two Amish Boys. 1962. 5¹³/₁₆ × 4⁷/₁₆ in. (14.7 × 11.3 cm.).
Planting Tobacco. 1963. 6 × 4⁷/₁₆ in. (15.2 × 11.3 cm.).
Three Amish Girls. 1963. 4½ × 5⅝ in. (11.4 × 14.3 cm.).
Barn and Covered Bridge. 1964. 4³/₁₆ × 6⁷/₁₆ in. (10.7 × 16.3 cm.).
Amish Boy with Straw Hat. 1965. 4⁷/₁₆ × 5⅞ in. (11.3 × 15.0 cm.).
Tree and Meeting House. 1965. 4⅜ × 4⅜ in. (11.1 × 11.2 cm.).
Buggy, Farmhouse, and Windmill. 1965. 3¹/₁₆ × 6⁷/₁₆ in. (7.8 × 16.4 cm.).
Pump and Shuttered Windows. 1965. 4⁷/₁₆ × 5¹⁵/₁₆ in. (11.3 × 15.2 cm.).
Horse and Buggy in Farmyard. 1965. 2⅛ × 6³/₁₆ in. (5.4 × 15.7 cm.).
Old Amish Men. 1966. 4⁷/₁₆ × 6 in. (11.3 × 15.3 cm.).
Buggies, Sunday Meeting. 1966. 5¹¹/₁₆ × 4⁷/₁₆ in. (14.5 × 11.3 cm.).
Portfolio V. Published by the photographer. n.d. Portfolio of 10 prints. Kate and Hall J. Peterson Fund. 77.7.1-10.
Deborah, Carteret, New Jersey. 1976. Gelatin silver print. 10⁷/₁₆ × 13⅛ in. (26.6 × 33.4 cm.).
Ice No. 1, Clark, New Jersey. 1967. Gelatin silver print. 3¹¹/₁₆ × 4¹¹/₁₆ in. (9.4 × 11.9 cm.).
Rooftops, Paterson, New Jersey. 1969. Gelatin silver print. 7⅝ × 9⁹/₁₆ in. (19.4 × 24.3 cm.).
Shared Closet, Rahway, New Jersey. 1967. Gelatin silver print. 7⅝ × 6 in. (19.4 × 15.2 cm.).
Aquatic Plants No. 1, Saddle River, New Jersey. 1967. Gelatin silver print. 7⅝ × 9⅝ in. (19.4 × 24.4 cm.).
Shore in Fog, Mount Desert Island, Maine. 1970. Gelatin silver print. 9⁹/₁₆ × 7⁹/₁₆ in. (24.2 × 19.3 cm.).
Russ Island, Maine. 1971. Palladium print. 5¹⁵/₁₆ × 6 in. (15.1 × 15.2 cm.).
Joe's Barber Shop, Paterson, New Jersey. 1970. Gelatin silver print. 7⁹/₁₆ × 9⅝ in. (19.3 × 24.4 cm.).
Roaring Fork River, Aspen, Colorado. 1969. Platinum print. 9⁹/₁₆ × 7⁹/₁₆ in. (24.4 × 19.3 cm.).
White Castle, Route No. 1, Rahway, New Jersey. 1973. Gelatin silver print. 10½ × 13⅛ in. (26.7 × 33.5 cm.).

Roaring Fork River, Aspen, Colorado. 1969. Platinum print. 9⁹/₁₆ × 7⁹/₁₆ in. (24.4 × 19.3 cm.). Gift of the artist. 82.69.

TICHICH, RICHARD
American, 1947-

Soloman Arroyo Vasquez, Xuchapa, Puebla. 1979. Gelatin silver print. 6¹³/₁₆ × 7³/₁₆ in. (17.3 × 18.2 cm.). Gift of the artist. 80.22.

TORBERT, STEPHANIE B.
American, 1945-

[sky reflection in self-service unit]. 1969. Color coupler print. 10⅞ × 13⅞ in. (27.7 × 35.3 cm.). Kate and Hall J. Peterson Fund. 73.27.1.

[cars and neon lights]. 1969. Color coupler print. 9⁵/₁₆ × 13⅞ in. (23.7 × 35.3 cm.). Kate and Hall J. Peterson Fund. 73.27.2.

[530 Hennepin Avenue doorway with neon]. 1969. Color coupler print. 9⁵/₁₆ × 13¹³/₁₆ in. (23.7 × 35.2 cm.). Kate and Hall J. Peterson Fund. 73.27.3.

[light fixture reflection with branches]. n.d. Color coupler print. 9¹/₁₆ × 13⁷/₁₆ in. (23.0 × 34.3 cm.). Kate and Hall J. Peterson Fund. 75.46.1.

[metal poles in landscape]. n.d. Dye bleach color print (Cibachrome). 9⁵/₁₆ × 13⁹/₁₆ in. (23.7 × 34.5 cm.). Kate and Hall J. Peterson Fund. 75.46.2.

[reflections with blue ceiling]. n.d. Dye bleach color print (Cibachrome). 9¼ × 13⁹/₁₆ in. (23.5 × 34.5 cm.). Kate and Hall J. Peterson Fund. 75.46.3.

[steeple scenes]. n.d. 2 dye bleach color prints (Cibachromes). 4¾ × 7¼ in. (12.0 × 18.5 cm.) and 5 × 7⁷/₁₆ in. (12.7 × 19.0 cm.). Kate and Hall J. Peterson Fund. 75.46.4 a and b.

TOURTIN, EMILE
French, 19th century

Sarah Bernhardt. From *Galerie Contemporaine.* 1877. Woodburytype. 4½ × 3⅜ in. (11.4 × 8.6 cm.). David Draper Dayton Fund. 75.59.2.

TRAUBE, CHARLES
American, 1945-

Edge to Edge. Published by Christopher Cardozo, Inc. 1983. Portfolio of 10 gelatin silver prints. Gift of Frank Kolodny. 82.126.27-36.
Kentucky 1970, Fall Creek. 8⅞ × 11 in. (22.6 × 28.0 cm.).
England 1972, Wavy Grass. 8⅞ × 10¹⁵/₁₆ in. (22.5 × 27.9 cm.).
Kentucky 1970, Dancing Trees. 8¹³/₁₆ × 10¹⁵/₁₆ in. (22.5 × 27.9 cm.).
Mexico 1972, Vines and Rocks. 8⅞ × 11 in. (22.6 × 27.9 cm.).
Kentucky 1970, Creek Bed. 8⁹/₁₆ × 11⅛ in. (21.8 × 28.3 cm.).
Venezuela 1973, Folded Landscape. 8¹³/₁₆ × 10¹⁵/₁₆ in. (22.5 × 27.9 cm.).
Kentucky 1970, Trees and Vines. 8⅞ × 10⅞ in. (22.6 × 27.7 cm.).
Wisconsin 1971, Hillside. 8⅝ × 11¹/₁₆ in. (21.9 × 28.2 cm.).
Venezuela 1973, Lacy Trees. 8¾ × 10¹⁵/₁₆ in. (22.3 × 27.9 cm.).
Kentucky 1971, Two Trees and River. 8⅞ × 10⅞ in. (22.6 × 27.7 cm.).

TRAUBE, ALEX
American, 1946-

American Hero. From *The New Mexico Portfolio.* 1974. Gelatin silver print. 10 × 11¹⁵/₁₆ in. (25.5 × 30.4 cm.). National Endowment for the Arts purchase grant and miscellaneous matching funds. 76.61.19.

TROTTER, CLAIRE
American, 1913-

[rocks in sand]. 1974. Gelatin silver print. 13⁵/₁₆ × 10⁹/₁₆ in. (33.8 × 26.8 cm.). Gift of Dr. Carl Sheppard. 76.13.

TRUAX, KAREN
American, 1946-

Whoosis. From *The New Mexico Portfolio.* 1975. Dye transfer print. 5¾ × 8⁷/₁₆ in. (14.6 × 21.5 cm.). National Endowment for the Arts purchase grant and miscellaneous matching funds. 76.61.20.

[two women in red with shell]. From *L. A. Issue* portfolio. n.d. Dye bleach color print (Cibachrome). 13 × 8¹⁵/₁₆ in. (33.0 × 22.7 cm.). Gift of funds from the Photography Council of The Minneapolis Institute of Arts. 80.25.19.

TUCKERMAN, JANE
American, 1947-

[knees and water]. 1976. Gelatin silver print. 19⅝ × 14⅛ in. (49.9 × 35.9 cm.). Kate and Hall J. Peterson Fund. 78.96.

Vachon Ferry. 1980. Gelatin silver print. 12⅛ × 17¹¹/₁₆ in. (30.8 × 44.9 cm.). Kate and Hall J. Peterson Fund. 81.43.1.

[aerial view of shore with birds]. 1980. Gelatin silver print. 18⁵/₁₆ × 12⅝ in. (46.5 × 32.1 cm.). Kate and Hall J. Peterson Fund. 81.43.2.

291

Periodical published by "291," New York City. Edited by Alfred Stieglitz, Paul B. Haviland, and others. 1915-1916. Transfer from reference collections. 82.71.1-9.

UELSMANN, JERRY N.
American, 1934-

Jerry N. Uelsmann Portfolio. Published by Witkin-Berley Limited, Roslyn Heights, New York. 1972. Portfolio of 10 gelatin silver prints. Kate and Hall J. Peterson Fund. 72.39-48.
Enigmatic Figure. 1959. 7⁵/₁₆ × 9½ in. (18.6 × 24.2 cm.).
Bless Our Home and Eagle. 1962. 13⁵/₁₆ × 10¼ in. (33.9 × 26.1 cm.).
Room No. 1. 1963. 9 × 13⅝ in. (22.9 × 34.6 cm.).
[leaf and tree]. 1964. 13½ × 9¹⁵/₁₆ in. (34.3 × 25.2 cm.).
Apocalypse II. 1967. 10⅝ × 13⁵/₁₆ in. (27.1 × 33.8 cm.).
Forgotten Heritage. 1969. 13¾ × 10¾ in. (34.9 × 27.3 cm.).
[sky and water]. 1969. 9⅜ × 6¹³/₁₆ in. (23.8 × 17.2 cm.).
[daguerrotype and house]. 1969. Sensitized aluminum plate. 7½ × 6⁵/₁₆ in. (19.0 × 16.0 cm.).

All-American Sunset. 1971. 6¹⁵⁄₁₆ × 8 in. (17.6 × 20.3 cm.).

[old house and car with shadow rock]. 1971. 13 × 9¹⁵⁄₁₆ in. (33.1 × 25.2 cm.).

Sky House. 1967. Gelatin silver print. 13⅝ × 8¹⁵⁄₁₆ in. (34.7 × 22.8 cm.). Gift of Mr. and Mrs. Russell Cowles II. 79.12.9.

UPHAM, GEORGE
American, 1946-

[woman in chair, the photographer's mother]. n.d. Color coupler print. 10¹⁵⁄₁₆ × 13¹⁵⁄₁₆ in. (27.7 × 35.5 cm.). Gift of the artist. 77.40.1.

[man in kitchen, the photographer's father]. n.d. Color coupler print. 10¹⁵⁄₁₆ × 13¹⁵⁄₁₆ in. (27.7 × 35.5 cm.). Gift of the artist. 77.40.2.

[mountain range, California]. n.d. Color coupler print. 10¹⁵⁄₁₆ × 13¹⁵⁄₁₆ in. (27.7 × 35.5 cm.). Gift of the artist. 77.40.3.

[cactus]. n.d. Color coupler print. 10¹⁵⁄₁₆ × 13¹⁵⁄₁₆ in. (27.8 × 35.4 cm.). Gift of the artist. 77.40.4.

[oval rock, California]. n.d. Color coupler print. 10⅞ × 13⅞ in. (27.7 × 35.3 cm.). Gift of the artist. 77.40.5.

[rocks with white sky, California]. n.d. Color coupler print. 13¹¹⁄₁₆ × 10⅞ in. (34.8 × 27.8 cm.). Gift of the artist. 77.40.6.

[shaped rock and shadow, California]. n.d. Color coupler print. 13½ × 10¹⁵⁄₁₆ in. (34.3 × 27.7 cm.). Gift of the artist. 77.40.7.

[autumn leaves on dark pool, northern Minnesota]. n.d. Color coupler print. 14 × 10¹⁵⁄₁₆ in. (35.5 × 27.7 cm.). Gift of the artist. 77.40.8.

[waterfall, northern Minnesota]. n.d. Color coupler print. 13¾ × 10⅝ in. (35.0 × 27.0 cm.). Gift of the artist. 77.40.9.

[creek among green foliage, northern Minnesota]. n.d. Color coupler print. 13¹⁵⁄₁₆ × 10⅞ in. (35.5 × 27.7 cm.). Gift of the artist. 77.40.10.

[small waterfall, northern Minnesota]. n.d. Color coupler print. 14 × 10¹⁵⁄₁₆ in. (35.6 × 27.7 cm.). Gift of the artist. 77.40.11.

[steaming lake with island, northern Minnesota]. n.d. Color coupler print. 10¹⁵⁄₁₆ × 14 in. (27.8 × 35.6 cm.). Gift of the artist. 77.40.12.

[trees and water, northern Minnesota]. n.d. Color coupler print. 10¹⁵⁄₁₆ × 14¹⁄₁₆ in. (27.7 × 35.7 cm.). Gift of the artist. 77.40.13.

[cascades, northern Minnesota]. n.d. Color coupler print. 10¹⁵⁄₁₆ × 14 in. (27.7 × 35.7 cm.). Gift of the artist. 77.40.14.

[faceted rocks with water, northern Minnesota]. n.d. Color coupler print. 10½ × 14¹⁄₁₆ in. (26.6 × 35.7 cm.). Gift of the artist. 77.40.15.

[two pine trees against white sky, northern Minnesota]. n.d. Color coupler print. 10⅞ × 13 in. (27.7 × 33.1 cm.). Gift of the artist. 77.40.16.

[faceted rocks on coastline, northern Minnesota]. n.d. Color coupler print. 10¹⁵⁄₁₆ × 13¹⁵⁄₁₆ in. (27.8 × 35.4 cm.). Gift of the artist. 77.40.17.

[multicolored waterfall, northern Minnesota]. n.d. Color coupler print. 10¹⁵⁄₁₆ × 14⁵⁄₁₆ in. (27.8 × 36.4 cm.). Gift of the artist. 77.40.18.

[water and rocks]. n.d. Color coupler print. 14 × 10⅞ in. (35.5 × 27.7 cm.). Kate and Hall J. Peterson Fund. 82.93.1.

[stream in autumn]. n.d. Color coupler print. 10⅞ × 14⅜ in. (27.7 × 36.5 cm.). Kate and Hall J. Peterson Fund. 82.93.2.

[water and rocks in forest]. n.d. Color coupler print. 10⅝ × 13¹⁵⁄₁₆ in. (27.0 × 35.5 cm.). Kate and Hall J. Peterson Fund. 82.93.3.

[rocks and autumn trees]. n.d. Color coupler print. 10¹³⁄₁₆ × 14⅛ in. (27.5 × 35.9 cm.). Kate and Hall J. Peterson Fund. 82.93.4.

[tree trunks]. n.d. Color coupler print. 10¹⁄₁₆ × 13⅜ in. (25.6 × 34.0 cm.). Kate and Hall J. Peterson Fund. 82.93.5.

VAN DERZEE, JAMES
American, 1886-1983

Eighteen Photographs. Published by Graphics International Ltd., Washington, D.C. 1974. Portfolio of 18 modern gelatin silver prints. Stanley Hawks Memorial Fund. 74.36.1-18.
Mrs. Turner, Lenox, Massachusetts. 1905. 7¹⁄₁₆ × 5½ in. (17.9 × 14.0 cm.).
Whittier Preparatory School, Phoebus, Virginia. 1907. 15¹³⁄₁₆ × 7⅜ in. (14.7 × 18.7 cm.).
The Van DerZee Men, Lenox, Massachusetts. 1908. 6¼ × 5 in. (15.9 × 12.7 cm.).
Kate and Rachel Van DerZee, Lenox, Massachusetts. 1909. 7¼ × 6¼ in. (18.4 × 15.9 cm.).
Miss Suzie Porter, Harlem. 1915. 7⁷⁄₁₆ × 6⅛ in. (18.9 × 15.6 cm.).
Nude, Harlem. 1923. 9⁷⁄₁₆ × 7⁹⁄₁₆ in. (24.0 × 19.2 cm.).
Marcus Garvey and Garvey Militia, Harlem. 1924. 9¹¹⁄₁₆ × 7¹³⁄₁₆ in. (24.6 × 19.8 cm.).
Garveyite Family, Harlem. 1924. 9½ × 7¾ in. (24.1 × 19.6 cm.).
Dancer, Harlem. 1925. 6⅝ × 4¹¹⁄₁₆ in. (16.8 × 11.9 cm.).
Portrait of an Actor, Harlem. 1929. 6½ × 4⅝ in. (16.6 × 11.8 cm.).
Swimming Team, Harlem. 1925. 2⁹⁄₁₆ × 9⁵⁄₁₆ in. (6.5 × 23.7 cm.).
Wedding Day, Harlem. 1926. 9⅜ × 6⅞ in. (23.9 × 17.5 cm.).
Black Jews, Harlem. 1929. 7⁷⁄₁₆ × 9⅜ in. (19.0 × 23.8 cm.).
Atlantic City. 1930. 6⁵⁄₁₆ × 3¹³⁄₁₆ in. (16.1 × 9.7 cm.).
Portrait of Two Brothers and Their Sister, Harlem. 1931. 7³⁄₁₆ × 9⁷⁄₁₆ in. (18.3 × 24.0 cm.).
Couple, Harlem. 1932. 7⅜ × 9⁷⁄₁₆ in. (18.7 × 24.1 cm.).
The Heiress, Harlem. 1938. 7⅜ × 9⁷⁄₁₆ in. (18.8 × 23.9 cm.).
Daddy Grace, Harlem. 1938. 9⁵⁄₁₆ × 7⁷⁄₁₆ in. (23.7 × 18.9 cm.).

VAN DYKE, WILLARD
American, 1906-

Antique Store with Car, New York. 1937. Gelatin silver print. 9¼ × 7⁹⁄₁₆ in. (23.6 × 19.2 cm.). Anonymous gift of funds. 78.16.

VERBURG, JOANN
American, 1950-

Dine Drawing. 1982. 5 gelatin silver prints. 26 × 90 in. approx. total. Gift of funds from the Photography Council of The Minneapolis Institute of Arts. 82.131.1-5.

VOGEL, ROSALEE
American, 1918-

New York City. 1966. Gelatin silver print. 10⁹⁄₁₆ × 10⅝ in. (26.9 × 27.1 cm.). Mr. and Mrs. Julius E. Davis Fund. 81.10.1.

New York City. 1966. Gelatin silver print. 13⁹⁄₁₆ × 10⅝ in. (34.5 × 27.1 cm.). Mr. and Mrs. Julius E. Davis Fund. 81.10.2.

New York City. 1966. Gelatin silver print. 10¹¹⁄₁₆ × 13⁹⁄₁₆ in. (27.2 × 34.5 cm.). Mr. and Mrs. Julius E. Davis Fund. 81.10.3.

New York City. 1966. Gelatin silver print. 11¹¹⁄₁₆ × 10¹¹⁄₁₆ in. (29.7 × 27.2 cm.). Gift of the artist. 81.11.1.

New York City. 1966. Gelatin silver print. 13⁹⁄₁₆ × 10¹¹⁄₁₆ in. (34.5 × 27.2 cm.). Gift of the artist. 81.11.2.

VON STERNBERG, ROBERT
American, 1939-

[palm trees at night]. From *Silver See* portfolio. 1977. Gelatin silver print. 10⁹⁄₁₆ × 13⅜ in. (26.8 × 34.0 cm.). National Endowment for the Arts purchase grant and miscellaneous matching funds. 77.39.20.

WAGNER, CATHERINE
American, 1953-

Petaluma, California. From *New California Views* portfolio. 1978. Gelatin silver print. 9⁷⁄₁₆ × 12¾ in. (24.0 × 32.4 cm.). Gift of funds from the Photography Council of The Minneapolis Institute of Arts. 80.24.17.

WALKER, TODD
American, 1917-

[nude with bars]. 1970. Gelatin silver print. 9⅞ × 6¹³⁄₁₆ in. (24.5 × 17.4 cm.). Kate and Hall J. Peterson Fund. 72.28.

[grey draped figure]. 1969. Gelatin silver print. 9¼ × 7¼ in. (23.5 × 18.5 cm.). Kate and Hall J. Peterson Fund. 72.29.

[fragments of nude woman]. From *L. A. Issue* portfolio. 1979. Serigraph. 8⅞ × 14⅝ in. (22.6 × 37.2 cm.). Gift of funds from the Photography Council of The Minneapolis Institute of Arts. 80.25.20.

WARREN, JOEL
American, 1948-

[boy with drawing]. From *Central High School, St. Paul* series. c. 1975. Gelatin silver print. 5¼ × 7¹³⁄₁₆ in. (13.3 × 19.9 cm.). National Endowment for the Arts purchase grant and miscellaneous matching funds. 76.67.1.

[students outdoors]. From *Central High School, St. Paul* series. c. 1975. Gelatin silver print. 5¼ × 7⅞ in. (13.4 × 20.0 cm.). National Endowment for the Arts purchase grant and miscellaneous matching funds. 76.67.2.

[two black girls in restroom]. From *Central High School, St. Paul* series. c. 1975. Gelatin silver print. 5⅝₁₆ × 7¹⁵⁄₁₆ in. (13.5 × 20.2 cm.). National Endowment for the Arts purchase grant and miscellaneous matching funds. 76.67.3.

[black male and female seated]. From *Central High School, St. Paul* series. c. 1975. Gelatin silver print. 5¼ × 7⅞ in. (13.3 × 20.0 cm.). National Endowment for the Arts purchase grant and miscellaneous matching funds. 76.67.4.

[man in shaft of light]. From *Central High School, St. Paul* series. c. 1975. Gelatin silver print. 5⁵⁄₁₆ × 7¹⁵⁄₁₆ in. (13.6 × 20.3 cm.). National Endowment for the Arts purchase grant and miscellaneous matching funds. 76.67.5.

[two male students on chairs]. From *Central High School, St. Paul* series. c. 1975. Gelatin silver print. 5³⁄₁₆ × 7⅞ in. (13.3 × 20.0 cm.). National Endowment for the Arts purchase grant and miscellaneous matching funds. 76.67.6.

[two black men in shadows]. From *Central High School, St. Paul* series. c. 1975. Gelatin silver print. 5¼ × 7⅞ in. (13.3 × 20.0 cm.). National Endowment for the Arts purchase grant and miscellaneous matching funds. 76.67.7.

[black boys in front of blackboard]. From *Central High School, St. Paul* series. c. 1975. Gelatin silver print. 5¼ × 7⅞ in. (13.3 × 19.9 cm.). National Endowment for the Arts purchase grant and miscellaneous matching funds. 76.67.8.

[black man against blackboard]. From *Central High School, St. Paul* series. c. 1975. Gelatin silver print. 5¼ × 7⅞ in. (13.4 × 20.0 cm.). National Endowment for the Arts purchase grant and miscellaneous matching funds. 76.67.9.

[black couple]. From *Central High School, St. Paul* series. c. 1975. Gelatin silver print. 5³⁄₁₆ × 7¾ in. (13.2 × 19.7 cm.). National Endowment for the Arts purchase grant and miscellaneous matching funds. 76.67.10.

WATANABE, JOAN
American, 1952-

[hands over cracked earth]. From *L. A. Issue* portfolio. n.d. Gelatin silver print. 4 × 5¹⁵⁄₁₆ in. (10.2 × 15.0 cm.). Gift of funds from the Photography Council of The Minneapolis Institute of Arts. 80.25.21.

WATKINS, CARLETON E. (attribution)
American, 1829-1916

[Pulpit Rock, Utah]. n.d. Albumen print. 4¹⁵⁄₁₆ × 6⅜ in. (12.6 × 16.2 cm.) oval. Gift of anonymous funds. 78.12.

WATSON-SCHÜTLE, EVA
See *Camera Work*

WATZEK, HANS
See *Camera Work*

WEEGEE
American, 1899-1968

Eva Gabor and Mama Gabor. n.d. Gelatin silver print. 8⅞ × 7⅝ in. (22.6 × 19.5 cm.). Ethel Morrison Van Derlip Fund. 82.89.3.

WELLS, ALICE
American, 1929-

Young Man with Flags. n.d. Gelatin silver print. 4⅝ × 13⁷⁄₁₆ in. (11.7 × 34.7 cm.). Ethel Morrison Van Derlip Fund. 70.76.2.

Untitled, from *Found Moments Transformed* sequence. From *The New Mexico Portfolio.* 1972. Gelatin silver print. 8¹³⁄₁₆ × 11¹⁵⁄₁₆ in. (22.4 × 30.4 cm.). National Endowment for the Arts purchase grant and miscellaneous matching funds. 76.61.21.

WELLS-WITTEMAN, ALISA
See *Wells, Alice*

WELPOTT, JACK
American, 1923-

The Farmer Twins, Stinesville, Indiana. n.d. Gelatin silver print. 7¼ × 9⁵⁄₁₆ in. (18.4 × 23.6 cm.). Kate and Hall J. Peterson Fund. 71.21.17.

[painted panel truck]. From *New California Views* portfolio. 1979. Gelatin silver print. 8⁷⁄₁₆ × 12³⁄₁₆ in. (21.5 × 31.0 cm.). Gift of funds from the Photography Council of The Minneapolis Institute of Arts. 80.24.18.

WESSEL, HENRY, Jr.
American, 1942-

[man watching birds]. From *New California Views* portfolio. 1977. Gelatin silver print. 11¹⁄₁₆ × 16¹¹⁄₁₆ in. (28.1 × 42.4 cm.). Gift of funds from the Photography Council of The Minneapolis Institute of Arts. 80.24.19.

WEST, EDWARD
American, 1949-

[tree trunks]. From *Underware* portfolio. 1976. Gelatin silver print. 9⅞ × 9¹³⁄₁₆ in. (25.2 × 24.9 cm.). National Endowment for the Arts purchase grant and miscellaneous matching funds. 76.64.18.

WESTON, BRETT
American, 1911-

California. 1958. Gelatin silver print. 9⁹⁄₁₆ × 7⅝ in. (24.4 × 19.4 cm.). Gift of Arnold M. Gilbert. 74.61.9.

Oregon. 1970. Gelatin silver print. 9⅝ × 7⅝ in. (24.4 × 19.4 cm.). Gift of Arnold M. Gilbert. 74.61.10.

Japan. 1971. Gelatin silver print. 7¹¹⁄₁₆ × 9⅝ in. (19.5 × 24.4 cm.). Gift of Arnold M. Gilbert. 74.61.11.

Utah. 1972. Gelatin silver print. 11 × 10⁷⁄₁₆ in. (28.0 × 26.5 cm.). Gift of Arnold M. Gilbert. 74.61.12.

Utah. 1972. Gelatin silver print. 10⅝ × 13³⁄₁₆ in. (27.1 × 33.6 cm.). Gift of Arnold M. Gilbert. 74.61.13.

Mendenhall Glacier, Alaska. 1973. Gelatin silver print. 10¾ × 12⁹⁄₁₆ in. (27.3 × 32.0 cm.). Gift of Arnold M. Gilbert. 74.61.14.

WESTON, EDWARD
American, 1886-1958

Fiftieth Anniversary Portfolio. Published by the photographer. 1951. Portfolio of 12 gelatin silver prints. John R. Van Derlip Fund. 68.22.1-12.
Cabbage Leaf. 1931. 7⁹⁄₁₆ × 9⁷⁄₁₆ in. (19.3 × 24.1 cm.).
Eel River. 1937. 7⁷⁄₁₆ × 9⅜ in. (18.9 × 23.8 cm.).
David H. McAlpin, New York. 1941. 9⁹⁄₁₆ × 7⅝ in. (24.3 × 19.4 cm.).
Eroded Rock, Point Lobos. 1930. 9⁷⁄₁₆ × 7⁹⁄₁₆ in. (24.0 × 19.3 cm.).
Nude. 1936. 9½ × 7½ in. (24.1 × 19.1 cm.).
Wall Scrawls, Hornitos. 1940. 7⁹⁄₁₆ × 9½ in. (19.3 × 24.2 cm.).
Guadalupe, Mexico. 1924. 8³⁄₁₆ × 7 in. (20.7 × 17.7 cm.).
Church Door, Hornitos. 1940. 7⅝ × 9½ in. (19.4 × 24.2 cm.).
North Dome, Point Lobos. 1946. 9½ × 7⁹⁄₁₆ in. (24.1 × 19.2 cm.).
William Edmondson, Sculptor, Nashville. 1941. 7⁷⁄₁₆ × 9⁷⁄₁₆ in. (19.0 × 23.9 cm.).
"Willie," New Orleans. 1941. 9½ × 7½ in. (24.2 × 19.2 cm.).
Dunes, Oceano. 1936. 7⁷⁄₁₆ × 9½ in. (18.9 × 24.2 cm.).

Shell. 1931. Gelatin silver print by Cole Weston. 7½ × 9⅜ in. (19.0 × 23.8 cm.). Kate and Hall J. Peterson Fund. 71.21.18.

Dunes, Oceano. 1936. Gelatin silver print by Cole Weston. 7½ × 9⁷⁄₁₆ in. (19.0 × 24.0 cm.). Kate and Hall J. Peterson Fund. 72.20.

Nudes on Dunes. 1939. Gelatin silver print by Cole Weston. 7½ × 9½ in. (19.1 × 24.3 cm.). Kate and Hall J. Peterson Fund. 72.21.

Pepper No. 30. 1930. Gelatin silver print by Cole Weston. 9⅝ × 7⁹⁄₁₆ in. (23.7 × 18.9 cm.). Kate and Hall J. Peterson Fund. 72.22.

White Radish. 1933. Gelatin silver print by Cole Weston. 9⅜ × 7⅜ in. (23.9 × 18.7 cm.). Kate and Hall J. Peterson Fund. 72.123.

Nude. 1934. Gelatin silver print by Cole Weston. 3⁹⁄₁₆ × 4⁹⁄₁₆ in. (9.1 × 11.7 cm.). Kate and Hall J. Peterson Fund. 72.124.

Pepper No. 30. 1930. Gelatin silver print by Cole Weston. 9⁷⁄₁₆ × 7½ in. (24.0 × 19.2 cm.). Kate and Hall J. Peterson Fund. 78.33.

WHITE, CLARENCE H.
See *Camera Work*

WHITE, MINOR
American, 1908-1976

Peeled Paint. 1959. Gelatin silver print. 9½ × 7⅜ in. (24.2 × 18.8 cm.). Ethel Morrison Van Derlip Fund. 70.76.9.

Jupiter Portfolio. Published by Light Gallery, New York. 1975. Portfolio of 12 gelatin silver prints. John R. Van Derlip Fund. 81.40.1-12.
Sun over the Pacific, Devil's Slide. 1947. 7⅜ × 9¹⁵⁄₁₆ in. (18.8 × 25.3 cm.).
Nude Foot, San Francisco. 1947. 8⁷⁄₁₆ × 10⅝ in. (21.4 × 27.1 cm.).
Sand Blaster, San Francisco. 1949. 8½ × 9⅞ in. (21.6 × 25.2 cm.).

Birdlime and Surf, Point Lobos, California. 1951. 9³⁄₁₆ × 10⁷⁄₈ in. (23.4 × 27.6 cm.).

Two Barns, Dansville, New York. 1955. 9¼ × 11⁷⁄₈ in. (23.6 × 30.2 cm.).

Windowsill Daydreaming, Rochester, New York. 1958. 11¹¹⁄₁₆ × 9¹⁄₈ in. (29.7 × 23.2 cm.).

Peeled Paint, Rochester, New York. 1959. 12¼ × 9 in. (31.1 × 22.9 cm.).

Beginnings, Rochester, New York. 1962. 11⁷⁄₈ × 9 in. (30.2 × 22.9 cm.).

Ritual Stones, Notom, Utah. 1963. 11⅝ × 9 in. (29.6 × 22.8 cm.).

Ivy, Portland, Oregon. 1964. 11⁷⁄₈ × 8¾ in. (30.2 × 22.2 cm.).

Navigation Markers, Cape Breton, Nova Scotia. 1970. 8⁷⁄₁₆ × 11¼ in. (21.5 × 28.5 cm.).

Dock in Snow, Vermont. 1971. 12³⁄₁₆ × 8⁷⁄₈ in. (30.9 × 22.6 cm.).

WILCOX, ROBERT GENE
American, 1925-1970

[winding country road]. n.d. Gelatin silver print. 4⅝ × 6½ in. (11.8 × 16.5 cm.). Ethel Morrison Van Derlip Fund. 70.76.6.

York, England. 1956. Gelatin silver print. 10⁵⁄₁₆ × 10¼ in. (26.3 × 26.1 cm.). Miscellaneous purchase funds. 74.72.1.

York, England. 1956. Gelatin silver print. 7½ × 9⁹⁄₁₆ in. (19.1 × 24.3 cm.). Miscellaneous purchase funds. 74.72.2.

[fence detail]. n.d. Gelatin silver print. 19⅜ × 15¼ in. (49.2 × 38.8 cm.). Miscellaneous purchase funds. 74.72.3.

Cemetery, Salzburg, Austria. 1957. Gelatin silver print. 13⁷⁄₁₆ × 10½ in. (34.2 × 26.8 cm.). Miscellaneous purchase funds. 74.72.4.

[village street with sheep]. n.d. Gelatin silver print. 10⅝ × 13⅜ in. (27.1 × 34.0 cm.). Miscellaneous purchase funds. 74.72.5.

Burgos, Spain. 1956. Gelatin silver print. 7½ × 9⁹⁄₁₆ in. (19.2 × 24.3 cm.). Miscellaneous purchase funds. 74.72.6.

Marbella Malaga, Spain. 1957. Gelatin silver print. 7½ × 9⁷⁄₁₆ in. (19.0 × 24.0 cm.). Miscellaneous purchase funds. 74.72.7.

[Spanish street with Barberia sign]. n.d. Gelatin silver print. 9½ × 7³⁄₁₆ in. (24.2 × 18.3 cm.). Miscellaneous purchase funds. 74.72.8.

Malaga, Spain. 1957. Gelatin silver print. 13⁷⁄₁₆ × 10⁹⁄₁₆ in. (34.1 × 26.9 cm.). Miscellaneous purchase funds. 74.72.9.

Naples, Italy. 1957. Gelatin silver print. 13⁷⁄₁₆ × 13¹⁄₁₆ in. (34.2 × 33.2 cm.). Miscellaneous purchase funds. 74.72.10.

Minneapolis. 1959. Gelatin silver print. 15⁷⁄₁₆ × 19⁷⁄₁₆ in. (39.3 × 49.5 cm.). Miscellaneous purchase funds. 74.72.11.

Minneapolis, Minnesota. n.d. Gelatin silver print. 10⁹⁄₁₆ × 13⁷⁄₁₆ in. (26.9 × 34.3 cm.). Miscellaneous purchase funds. 74.72.12.

Minneapolis, Minnesota. 1960. Gelatin silver print. 16½ × 13⁹⁄₁₆ in. (42.0 × 34.5 cm.). Miscellaneous purchase funds. 74.72.13.

Washington Avenue, Gateway District. c. 1961. Gelatin silver print. 13⁷⁄₁₆ × 10⁹⁄₁₆ in. (34.2 × 26.9 cm.). Miscellaneous purchase funds. 74.72.14.

Minneapolis, Minnesota. 1960. Gelatin silver print. 13⅜ × 16⅜ in. (33.9 × 41.7 cm.). Miscellaneous purchase funds. 74.72.15.

[Metropolitan Building interior, Minneapolis]. n.d. Gelatin silver print. 13½ × 10⁹⁄₁₆ in. (34.3 × 26.9 cm.). Miscellaneous purchase funds. 74.72.16.

[Metropolitan Building interior, Minneapolis]. n.d. Gelatin silver print. 18¹⁵⁄₁₆ × 15⅛ in. (48.1 × 38.5 cm.). Miscellaneous purchase funds. 74.72.17.

[Metropolitan Building, Minneapolis]. n.d. Gelatin silver print. 13⁷⁄₁₆ × 10⁷⁄₁₆ in. (34.2 × 26.6 cm.). Miscellaneous purchase funds. 74.72.18.

[Herb's Barber Shop, Minneapolis]. n.d. Gelatin silver print. 14¹⁵⁄₁₆ × 19⅛ in. (38.0 × 48.6 cm.). Miscellaneous purchase funds. 74.72.19.

Store Window. c. 1960. Gelatin silver print. 11⁷⁄₈ × 9¹³⁄₁₆ in. (30.2 × 25.0 cm.). Miscellaneous purchase funds. 74.72.20.

Portrait of a Blacksmith, Audobon, Minnesota. 1960. Gelatin silver print. 13½ × 10½ in. (34.3 × 26.8 cm.). Miscellaneous purchase funds. 74.72.21.

Near Stillwater, Minnesota. 1960. Gelatin silver print. 7⁹⁄₁₆ × 7⁹⁄₁₆ in. (19.2 × 19.2 cm.). Miscellaneous purchase funds. 74.72.22.

Fountain City, Wisconsin. c. 1960. Gelatin silver print. 15⅜ × 19⅜ in. (39.1 × 49.2 cm.). Miscellaneous purchase funds. 74.72.23.

Near Moosonee, Ontario. 1963. Gelatin silver print. 13½ × 16⁷⁄₁₆ in. (34.3 × 41.8 cm.). Miscellaneous purchase funds. 74.72.24.

The Forest, St. Croix Falls, Wisconsin. 1961. Gelatin silver print. 15⅝ × 15⁹⁄₁₆ in. (39.8 × 39.6 cm.). Miscellaneous purchase funds. 74.72.25.

St. Croix Falls. 1961. Gelatin silver print. 10⁵⁄₁₆ × 10³⁄₁₆ in. (26.2 × 26.0 cm.). Miscellaneous purchase funds. 74.72.26a.

St. Croix Falls. 1961. Gelatin silver print. 10³⁄₁₆ × 10³⁄₁₆ in. (26.0 × 26.0 cm.). Miscellaneous purchase funds. 74.72.26b.

St. Croix Falls. 1961. Gelatin silver print. 19³⁄₁₆ × 15⅝ in. (48.8 × 39.7 cm.). Miscellaneous purchase funds. 74.72.27.

Copper River. 1961. Gelatin silver print. 16 × 15½ in. (40.7 × 39.4 cm.). Miscellaneous purchase funds. 74.72.28.

Trees No. III. 1961. Gelatin silver print. 10½ × 13½ in. (26.7 × 34.4 cm.). Miscellaneous purchase funds. 74.72.29.

St. Croix Falls, Wisconsin. 1962. Gelatin silver print. 9¹⁵⁄₁₆ × 8⅝ in. (25.3 × 21.9 cm.). Miscellaneous purchase funds. 74.72.30.

St. Croix Falls, Wisconsin. 1962. Gelatin silver print. 10⁹⁄₁₆ × 13⅜ in. (26.8 × 34.1 cm.). Miscellaneous purchase funds. 74.72.31.

Minneapolis, Minnesota. 1962. Gelatin silver print. 13⁷⁄₁₆ × 10½ in. (34.2 × 26.8 cm.). Miscellaneous purchase funds. 74.72.32.

The Oval Window, Two Harbors, Minnesota. 1962. Gelatin silver print. 17⅜ × 15⁹⁄₁₆ in. (44.2 × 39.6 cm.). Miscellaneous purchase funds. 74.72.33a.

The Oval Window, Two Harbors, Minnesota. 1962. Gelatin silver print. 7½ × 7½ in. (19.1 × 19.0 cm.). Miscellaneous purchase funds. 74.72.33b.

Near Nipigon, Ontario. 1963. Gelatin silver print. 16⅜ × 13⁷⁄₁₆ in. (41.7 × 34.2 cm.). Miscellaneous purchase funds. 74.72.34.

Backwater, Central Ontario. 1963. Gelatin silver print. 16½ × 13½ in. (41.8 × 34.3 cm.). Miscellaneous purchase funds. 74.72.35.

Near Moosonee, Ontario, Canada. 1963. Gelatin silver print. 13⁹⁄₁₆ × 16½ in. (34.5 × 41.9 cm.). Miscellaneous purchase funds. 74.72.36.

Church, Manitoulin Island. n.d. Gelatin silver print. 19⁷⁄₁₆ × 15⁷⁄₁₆ in. (49.4 × 39.3 cm.). Miscellaneous purchase funds. 74.72.37.

Grace, Longlac, Ontario. 1963. Gelatin silver print. 13½ × 10½ in. (34.4 × 26.7 cm.). Miscellaneous purchase funds. 74.72.38.

Longlac, Ontario. 1963. Gelatin silver print. 13½ × 10½ in. (34.3 × 26.8 cm.). Miscellaneous purchase funds. 74.72.39.

Longlac, Ontario. 1963. Gelatin silver print. 10¹¹⁄₁₆ × 10⁷⁄₁₆ in. (27.2 × 26.6 cm.). Miscellaneous purchase funds. 74.72.40.

Face, Longlac, Ontario. 1963. Gelatin silver print. 13½ × 10½ in. (34.4 × 26.7 cm.). Miscellaneous purchase funds. 74.72.41.

Indian Youth, Longlac, Ontario. 1963. Gelatin silver print. 13⅜ × 10⅜ in. (34.0 × 26.5 cm.). Miscellaneous purchase funds. 74.72.42.

Longlac, Ontario. 1963. Gelatin silver print. 19⁹⁄₁₆ × 15½ in. (49.7 × 39.3 cm.). Miscellaneous purchase funds. 74.72.43.

Longlac, Ontario. 1963. Gelatin silver print. 10½ × 13⁷⁄₁₆ in. (26.7 × 34.2 cm.). Miscellaneous purchase funds. 74.72.44.

Sonon Springs, Wisconsin. 1963. Gelatin silver print. 13½ × 10½ in. (34.3 × 26.7 cm.). Miscellaneous purchase funds. 74.72.45.

St. Croix Falls. 1964. Gelatin silver print. 15¹⁄₁₆ × 19¼ in. (38.3 × 49.0 cm.). Miscellaneous purchase funds. 74.72.46.

St. Croix River. 1964. Gelatin silver print. 15⁷⁄₁₆ × 19⅜ in. (39.3 × 49.2 cm.). Miscellaneous purchase funds. 74.72.47.

Ciudad Real de Catorce. 1964. Gelatin silver print. 19⁹⁄₁₆ × 15¼ in. (49.1 × 38.4 cm.). Miscellaneous purchase funds. 74.72.48.

Mexican Church. 1964. Gelatin silver print. 19⅜ × 15⁹⁄₁₆ in. (49.2 × 39.7 cm.). Miscellaneous purchase funds. 74.72.51.

Mexican Church. 1964. Gelatin silver print. 19³⁄₁₆ × 15¹⁄₁₆ in. (48.8 × 38.4 cm.). Miscellaneous purchase funds. 74.72.52.

[Virgin Mary figure]. n.d. Gelatin silver print. 13½ × 10⁷⁄₁₆ in. (34.2 × 26.6 cm.). Miscellaneous purchase funds. 74.72.53.

British Columbia. 1965. Gelatin silver print. 19⅜ × 15½ in. (49.2 × 39.4 cm.). Miscellaneous purchase funds. 74.72.54.

Brule River, Wisconsin. 1965. Gelatin silver print. 7⁹⁄₁₆ × 7⁹⁄₁₆ in. (19.2 × 19.2 cm.). Miscellaneous purchase funds. 74.72.55a.

Brule River. 1963. Gelatin silver print. 15½ × 15⅜ in. (39.3 × 39.1 cm.). Miscellaneous purchase funds. 74.72.55b.

Roslyn, Washington. 1966. 19¼ × 15⁹⁄₁₆ in. (49.0 × 39.6 cm.). Miscellaneous purchase funds. 74.72.56.

[ice-covered bush under sun]. n.d. Gelatin silver print. 17¹³⁄₁₆ × 15 in. (45.2 × 38.2 cm.). Miscellaneous purchase funds. 74.72.57.

[plant and rock]. n.d. Gelatin silver print. 7⁹⁄₁₆ × 7⁹⁄₁₆ in. (19.2 × 19.2 cm.). Miscellaneous purchase funds. 74.72.58.

[vine pattern]. n.d. Gelatin silver print. 8¾ × 6⅜ in. (22.2 × 16.2 cm.). Miscellaneous purchase funds. 74.72.59.

[hills and tree]. n.d. Gelatin silver print. 10⁹⁄₁₆ × 13½ in. (26.9 × 34.3 cm.). Miscellaneous purchase funds. 74.72.60.

Moosonee, Ontario. 1963. Gelatin silver print. 13⁷⁄₁₆ × 10½ in. (34.2 × 26.8 cm.). Miscellaneous purchase funds. 74.72.61.

Spain. 1957. Gelatin silver print. 10⁹⁄₁₆ × 10⁹⁄₁₆ in. (26.8 × 26.8 cm.). Miscellaneous purchase funds. 74.72.62.

[pebbles and sand]. 1953. Gelatin silver print. 13⅝ × 10½ in. (33.9 × 26.8 cm.). Miscellaneous purchase funds. 74.72.64.

St. Croix Falls, Wisconsin. 1955. Gelatin silver print. 7¼ × 9¹⁄₁₆ in. (18.5 × 23.0 cm.). Miscellaneous purchase funds. 74.72.65.

Burial Ground of the Clan MacNab, Killin, Scotland. 1956. Gelatin silver print. 15½ × 15½ in. (39.5 × 39.5 cm.). Miscellaneous purchase funds. 74.72.66.

Portrait of a Seaman, Freighter Cairnesk, North Atlantic. 1956. Gelatin silver print. 16½ × 13½ in. (42.0 × 34.4 cm.). Miscellaneous purchase funds. 74.72.67.

San Sebastian, Spain. 1956. Gelatin silver print. 13⁷⁄₁₆ × 10½ in. (34.2 × 26.8 cm.). Miscellaneous purchase funds. 74.72.68.

Vienna, Austria. 1957. Gelatin silver print. 15⁹⁄₁₆ × 19½ in. (39.6 × 49.6 cm.). Miscellaneous purchase funds. 74.72.69.

Spanish Doors. 1957. Gelatin silver print. 19⁷⁄₁₆ × 15½ in. (49.4 × 39.5 cm.). Miscellaneous purchase funds. 74.72.70.

Trieste, Italy. 1957. Gelatin silver print. 10⁷⁄₁₆ × 10⁹⁄₁₆ in. (26.6 × 26.8 cm.). Miscellaneous purchase funds. 74.72.71.

Near Trieste, Italy. 1957. Gelatin silver print. 13½ × 10½ in. (34.3 × 26.8 cm.). Miscellaneous purchase funds. 74.72.72.

Trieste, Italy. 1957. Gelatin silver print. 13½ × 10⁹⁄₁₆ in. (34.4 × 26.9 cm.). Miscellaneous purchase funds. 74.72.73.

Delft, Holland. 1957. Gelatin silver print. 10⁹⁄₁₆ × 10⅜ in. (26.9 × 26.4 cm.). Miscellaneous purchase funds. 74.72.74.

Marbella Malaga, Spain. 1957. Gelatin silver print. 10½ × 10½ in. (26.7 × 26.7 cm.). Miscellaneous purchase funds. 74.72.75.

Marbella Malaga, Spain. 1957. Gelatin silver print. 9⅞ × 9⅞ in. (25.1 × 25.2 cm.). Miscellaneous purchase funds. 74.72.76.

Fisherman, Marbella Malaga, Spain. 1957. Gelatin silver print. 13⁹⁄₁₆ × 10⁹⁄₁₆ in. (34.4 × 26.8 cm.). Miscellaneous purchase funds. 74.72.77.

Marbella Malaga, Spain. 1957. Gelatin silver print. 10⁹⁄₁₆ × 13⁹⁄₁₆ in. (26.9 × 34.4 cm.). Miscellaneous purchase funds. 74.72.78.

Church Entrance, River Falls, Wisconsin. 1959. Gelatin silver print. 13⁷⁄₁₆ × 10⁷⁄₁₆ in. (34.2 × 26.5 cm.). Miscellaneous purchase funds. 74.72.79.

Birches, Asron. 1960. Gelatin silver print. 15½ × 19½ in. (39.5 × 49.6 cm.). Miscellaneous purchase funds. 74.72.80.

Trees No. II, Minneapolis, Minnesota. 1962. Gelatin silver print. 10¼ × 10³⁄₁₆ in. (26.1 × 26.0 cm.). Miscellaneous purchase funds. 74.72.81a.

Minneapolis. 1960. Gelatin silver print. 10¼ × 10¼ in. (26.1 × 26.0 cm.). Miscellaneous purchase funds. 74.72.81b.

St. Paul. 1960. Gelatin silver print. 13⁹⁄₁₆ × 16⁷⁄₁₆ in. (34.5 × 41.8 cm.). Miscellaneous purchase funds. 74.72.82.

Valhalla Cafe, Minneapolis, Minnesota. 1960. Gelatin silver print. 19⁷⁄₁₆ × 15⅜ in. (49.4 × 39.2 cm.). Miscellaneous purchase funds. 74.72.83.

St. Croix Falls. 1961. Gelatin silver print. 10½ × 10⁹⁄₁₆ in. (26.8 × 26.8 cm.). Miscellaneous purchase funds. 74.72.84.

St. Paul, Minnesota. 1961. Gelatin silver print. 10½ × 13½ in. (26.8 × 34.4 cm.). Miscellaneous purchase funds. 74.72.85.

Mahtomedi, Minnesota. c. 1961. Gelatin silver print. 15 × 15⁹⁄₁₆ in. (38.1 × 39.5 cm.). Miscellaneous purchase funds. 74.72.86.

St. Croix Falls. 1961. Gelatin silver print. 19⅜ × 15⁷⁄₁₆ in. (49.3 × 39.3 cm.). Miscellaneous purchase funds. 74.72.87.

St. Croix Falls, Wisconsin. 1961. Gelatin silver print. 15½ × 19⁷⁄₁₆ in. (39.4 × 49.4 cm.). Miscellaneous purchase funds. 74.72.88.

Minneapolis, Minnesota. 1961. Gelatin silver print. 19¼ × 15⅜ in. (48.9 × 39.1 cm.). Miscellaneous purchase funds. 74.72.89.

Minneapolis, Minnesota. 1961. Gelatin silver print. 15⁹⁄₁₆ × 19⁷⁄₁₆ in. (38.9 × 49.4 cm.). Miscellaneous purchase funds. 74.72.90.

Northern Wisconsin. 1962. Gelatin silver print. 10⅜ × 10¼ in. (26.4 × 26.0 cm.). Miscellaneous purchase funds. 74.72.91.

North Shore. 1962. Gelatin silver print. 13½ × 13¼ in. (34.3 × 33.6 cm.). Miscellaneous purchase funds. 74.72.92.

Indian Woman, Longlac, Ontario. 1963. Gelatin silver print. 19⁷⁄₁₆ × 15⁹⁄₁₆ in. (49.4 × 39.6 cm.). Miscellaneous purchase funds. 74.72.93.

Old Cree Indian Man, near Moosonee, Ontario. 1963. Gelatin silver print. 19½ × 15⁷⁄₁₆ in. (49.6 × 39.3 cm.). Miscellaneous purchase funds. 74.72.94.

Manitoulin Island, Ontario. 1963. Gelatin silver print. 11 × 10⁹⁄₁₆ in. (28.0 × 26.9 cm.). Miscellaneous purchase funds. 74.72.95.

South Central Ontario. 1963. Gelatin silver print. 16½ × 13½ in. (41.9 × 34.4 cm.). Miscellaneous purchase funds. 74.72.96.

St. Croix Falls. 1963. Gelatin silver print. 15¹⁵⁄₁₆ × 15½ in. (40.6 × 39.4 cm.). Miscellaneous purchase funds. 74.72.97.

Church, Sheguindah, Ontario. 1963. Gelatin silver print. 16⁷⁄₁₆ × 13⅜ in. (41.8 × 34.0 cm.). Miscellaneous purchase funds. 74.72.98.

The Dance, Minneapolis, Minnesota. 1963. Gelatin silver print. 9⁹⁄₁₆ × 6¼ in. (24.3 × 16.0 cm.). Miscellaneous purchase funds. 74.72.99.

The Dance, Minneapolis, Minnesota. 1963. Gelatin silver print. 9⁹⁄₁₆ × 6⁵⁄₁₆ in. (24.3 × 16.0 cm.). Miscellaneous purchase funds. 74.72.100.

Shell Lake, Wisconsin. 1963. Gelatin silver print. 10⁹⁄₁₆ × 13⁷⁄₁₆ in. (26.8 × 34.3 cm.). Miscellaneous purchase funds. 74.72.101.

Ciudad, Real de Catorce. 1964. Gelatin silver print. 19⅛ × 15½ in. (48.7 × 39.4 cm.). Miscellaneous purchase funds. 74.72.102.

Mexican Church. 1964. Gelatin silver print. 19 × 15⁹⁄₁₆ in. (48.3 × 39.6 cm.). Miscellaneous purchase funds. 74.72.103.

Mexican Church. 1964. Gelatin silver print. 19⁵⁄₁₆ × 15⁹⁄₁₆ in. (49.0 × 39.6 cm.). Miscellaneous purchase funds. 74.72.104.

Mexican Church. 1964. Gelatin silver print. 18⅞ × 14¹³⁄₁₆ in. (48.0 × 37.7 cm.). Miscellaneous purchase funds. 74.72.105.

Mexican Church. 1964. Gelatin silver print. 19⁹⁄₁₆ × 15⁹⁄₁₆ in. (49.4 × 39.6 cm.). Miscellaneous purchase funds. 74.72.106.

Mexican Church. 1964. Gelatin silver print. 19⅜ × 15½ in. (49.3 × 39.5 cm.). Miscellaneous purchase funds. 74.72.107.

[church exterior]. n.d. Gelatin silver print. 18¹⁄₁₆ × 14¾ in. (45.9 × 37.5 cm.). Miscellaneous purchase funds. 74.72.108.

White Bear Lake, Minnesota. 1965. Gelatin silver print. 10½ × 13⅜ in. (26.7 × 34.0 cm.). Miscellaneous purchase funds. 74.72.109a.

Tree and Snow. 1965. Gelatin silver print. 15½ × 19⁹⁄₁₆ in. (39.4 × 49.7 cm.). Miscellaneous purchase funds. 74.72.109b.

Near White Bear Lake, Minnesota. 1965. Gelatin silver print. 15⁵⁄₁₆ × 15³⁄₁₆ in. (49.2 × 38.6 cm.). Miscellaneous purchase funds. 74.72.110.

Vantage, Washington. 1966. Gelatin silver print. 19⁵⁄₁₆ × 15½ in. (49.1 × 39.4 cm.). Miscellaneous purchase funds. 74.72.111.

White Bear Lake. 1966. Gelatin silver print. 13⁷⁄₁₆ × 10⁹⁄₁₆ in. (34.2 × 26.9 cm.). Miscellaneous purchase funds. 74.72.112.

White Bear Lake, Minnesota. 1966. Gelatin silver print. 13⁷⁄₁₆ × 10½ in. (34.1 × 26.8 cm.). Miscellaneous purchase funds. 74.72.113.

Cle Elun, Washington. 1966. Gelatin silver print. 19⅜ × 15½ in. (49.2 × 39.4 cm.). Miscellaneous purchase funds. 74.72.114.

Roslyn, Washington. 1966. Gelatin silver print. 19⅛ × 15¼ in. (48.5 × 38.4 cm.). Miscellaneous purchase funds. 74.72.115.

Roslyn, Washington. 1966. Gelatin silver print. 15⅛ × 19³⁄₁₆ in. (38.4 × 48.7 cm.). Miscellaneous purchase funds. 74.72.116.

Roslyn, Washington. 1966. Gelatin silver print. 19⁵⁄₁₆ × 15⅜ in. (49.1 × 39.1 cm.). Miscellaneous purchase funds. 74.72.117.

[old man by fence]. n.d. Gelatin silver print. 13⅝ × 10⅝ in. (34.7 × 27.1 cm.). Miscellaneous purchase funds. 74.72.118.

[farm structures]. n.d. Gelatin silver print. 15⁷⁄₁₆ × 19³⁄₁₆ in. (39.3 × 48.7 cm.). Miscellaneous purchase funds. 74.72.119.

[wooden fence and plants]. n.d. Gelatin silver print. 7½ × 9½ in. (19.1 × 24.2 cm.). Miscellaneous purchase funds. 74.72.120.

[sun and clouds]. n.d. Gelatin silver print. 7½ × 9⅜ in. (19.1 × 23.8 cm.). Miscellaneous purchase funds. 74.72.121.

Brownsville, Minnesota. n.d. Gelatin silver print. 10³⁄₁₆ × 13½ in. (25.8 × 34.3 cm.). Miscellaneous purchase funds. 74.72.122.

[dead branches and moss]. n.d. Gelatin silver print. 16⁵⁄₁₆ × 11⅝ in. (41.6 × 29.6 cm.). Miscellaneous purchase funds. 74.72.123.

[broken ice]. n.d. Gelatin silver print. 16½ × 13⁹⁄₁₆ in. (41.8 × 34.5 cm.). Miscellaneous purchase funds. 74.72.124.

Abstraction in Nature. n.d. Gelatin silver print. 16⁵⁄₁₆ × 11⁹⁄₁₆ in. (41.5 × 29.4 cm.). Miscellaneous purchase funds. 74.72.125.

Basalt Formations, Washington. 1965. Gelatin silver print. 9⁷⁄₁₆ × 7½ in. (24.0 × 19.1 cm.). Miscellaneous purchase funds. 74.72.126.

Bricks. n.d. Gelatin silver print. 10⁷⁄₁₆ × 13⁷⁄₁₆ in. (26.5 × 34.2 cm.). Miscellaneous purchase funds. 74.72.127.

[building facade with reflection]. n.d. Gelatin silver print. 13⁹⁄₁₆ × 10⅝ in. (34.4 × 27.0 cm.). Miscellaneous purchase funds. 74.72.128.

[trees, house, and mountains]. n.d. Gelatin silver print. 10⁵⁄₁₆ × 10³⁄₁₆ in. (26.2 × 25.9 cm.). Miscellaneous purchase funds. 74.72.129.

[men sitting on ledge]. n.d. Gelatin silver print. 19½ × 15⁹⁄₁₆ in. (49.5 × 39.6 cm.). Miscellaneous purchase funds. 74.72.130a.

[trees]. n.d. Gelatin silver print. 15¾ × 19⅜ in. (40.0 × 49.3 cm.). Miscellaneous purchase funds. 74.72.130b.

[facade, Sourdough and Senate Bar signs]. n.d. Gelatin silver print. 13⅝ × 10⅝ in. (34.7 × 27.0 cm.). Miscellaneous purchase funds. 74.72.131.

[Minneapolis Revival Mission]. n.d. Gelatin silver print. 19⅛ × 15⁹⁄₁₆ in. (48.6 × 39.6 cm.). Miscellaneous purchase funds. 74.72.132.

Spring, St. Croix. 1962. Gelatin silver print. 15⁹⁄₁₆ × 19⁷⁄₁₆ in. (39.6 × 49.4 cm.). Miscellaneous purchase funds. 74.72.133.

Near Trieste, Italy. 1957. Gelatin silver print. 10½ × 10⁹⁄₁₆ in. (26.7 × 26.9 cm.). Miscellaneous purchase funds. 74.72.134.

[rock formation]. n.d. Gelatin silver print. 4⅝ × 4⅝ in. (11.8 × 11.8 cm.). Miscellaneous purchase funds. 74.72.135.

[bell tower]. n.d. Gelatin silver print. 6⁹⁄₁₆ × 4½ in. (16.7 × 11.5 cm.). Miscellaneous purchase funds. 74.72.136.

WILCOX, ROBERT GENE (attribution)
American, 1925-1970

[elevator, Metropolitan Building, Minneapolis]. n.d. Gelatin silver print. 13⅞ × 9½ in. (35.3 × 24.1 cm.). Gift of Sheldon and Rhoda Karlins. 81.124.2.

[central court and skylight, Metropolitan Building, Minneapolis]. n.d. Gelatin silver print. 13⅞ × 10½ in. (35.3 × 26.7 cm.). Gift of Sheldon and Rhoda Karlins. 81.124.3.

[elevator doors, Metropolitan Building, Minneapolis]. n.d. Gelatin silver print. 13⅞ × 10⅜ in. (35.4 × 26.3 cm.). Gift of Sheldon and Rhoda Karlins. 81.124.4.

WILMERDING, WILLIAM E.
See *Camera Work*

WINOGRAND, GARRY
American, 1928-1984

Albuquerque, New Mexico. 1958. Gelatin silver print. 8⅝ × 12¹⁵⁄₁₆ in. (21.9 × 32.9 cm.). Anonymous gift of funds. 78.92.6.

[swimming pool deck]. From *New California Views* portfolio. 1964. Gelatin silver print. 17⅜ × 11⅝ in. (44.3 × 29.5 cm.). Gift of funds from the Photography Council of The Minneapolis Institute of Arts. 80.24.20.

Garry Winogrand. Published by Hyperion Press. 1978. Portfolio of 15 gelatin silver prints. Gift of Ivor Massey. 82.127.1-15.
Cape Kennedy, Florida. 1969. 9 × 13⁷⁄₁₆ in. (22.9 × 34.2 cm.).
New York City. 1968. 9 × 13⅜ in. (22.9 × 34.1 cm.).
Utah. 1964. 9 × 13⅜ in. (22.9 × 34.1 cm.).
New York City. 1967. 9 × 13⁷⁄₁₆ in. (22.9 × 34.1 cm.).
New York City. 1969. 9 × 13⅜ in. (22.8 × 34.1 cm.).
New York City. 1968. 9 × 13⁷⁄₁₆ in. (23.0 × 34.1 cm.).
New York City. 1964. 13⁵⁄₁₆ × 9 in. (33.9 × 22.8 cm.).
New York City. 1971. 8¹⁵⁄₁₆ × 13⁷⁄₁₆ in. (22.7 × 34.1 cm.).
New York City. 1963. 9¹⁄₁₆ × 13⁷⁄₁₆ in. (23.0 × 34.1 cm.).
Toronto. 1969. 9 × 13⁷⁄₁₆ in. (22.9 × 34.1 cm.).
New York City. 1972. 9 × 13⅜ in. (22.9 × 34.1 cm.).

Austin, Texas. 1974. 8⅞ × 13¼ in. (22.5 × 33.7 cm.).
Fort Worth, Texas. 1974. 9 × 13⁷⁄₁₆ in. (22.9 × 34.1 cm.).
Castle Rock, Colorado. 1960. 8¹³⁄₁₆ × 13⁷⁄₁₆ in. (22.4 × 34.1 cm.).
New York City. 1968. 13⅜ × 9 in. (34.0 × 22.9 cm.).

WOLFF, PAUL and E. HASE
German, German,
1895-1951 dates unknown

Fortuna. c. 1935. Gelatin silver print. 12⁷⁄₁₆ × 9 in. (31.6 × 22.8 cm.). Ethel Morrison Van Derlip Fund. 82.38.1.

Yᴀᴠɴᴏ, ᴍᴀx
American, 1921-

[nude with rock wall]. From *Silver See* portfolio. n.d. Gelatin silver print. 10½ × 13⅜ in. (28.8 × 34.1 cm.). National Endowment for the Arts purchase grant and miscellaneous matching funds. 77.39.21.

Zᴡᴀʀᴛ, ᴘɪᴇᴛ
German, 1885-1977

Locomotief. c.1928. Gelatin silver print. 6¹¹⁄₁₆ × 4¹³⁄₁₆ in. (17.0 × 12.3 cm.). Ethel Morrison Van Derlip Fund. 82.38.2.

Uɴᴋɴᴏᴡɴ ᴘʜᴏᴛᴏɢʀᴀᴘʜᴇʀ
English (?), 19th century

[moth]. n.d. Salted paper print. 4 × 4¼ in. (10.1 × 10.8 cm.). Anonymous gift of funds. 78.11.

UNKNOWN PHOTOGRAPHER
French (?), 19th century

[church facade]. September 4, 1852. Paper negative. 8⅜ × 6¾ in. (21.2 × 17.2 cm.). Anonymous gift of funds. 78.13.

UNKNOWN PHOTOGRAPHER
French (?), 19th century

[trees]. n.d. Albumen print. 7¹⁄₁₆ × 9¹⁵⁄₁₆ in. (18.0 × 25.3 cm.). Kate and Hall J. Peterson Fund. 80.16.2.

UNKNOWN PHOTOGRAPHER
American (?), 20th century

[front facade of The Minneapolis Institute of Arts]. n.d. Gelatin silver print. 8⅛ × 13¼ in. (20.7 × 33.7 cm.). Gift of Robert Kurtz. 80.70.1.

[Minnesota State Capitol Building, St. Paul]. n.d. Gelatin silver print, hand colored. 8¼ × 12¹⁄₁₆ in. (20.9 × 30.7 cm.). Gift of Robert Kurtz. 80.70.2.

[Third Avenue Bridge, Minneapolis]. n.d. Gelatin silver print. 7 × 10¹⁵⁄₁₆ in. (17.8 × 27.8 cm.). Gift of Robert Kurtz. 80.70.3.

UNKNOWN PHOTOGRAPHER
American (?), 19th century

The Monitor Onondaga. n.d. Albumen print. 4⁹⁄₁₆
× 7⁵⁄₁₆ in. (11.7 × 18.6 cm.). John R. Van Derlip
Fund. 81.79.

UNKNOWN PHOTOGRAPHER
Middle Eastern (?), 19th century

[women with water jugs]. n.d. Albumen print. 10⁵⁄₁₆
× 8 in. (26.2 × 20.4 cm.). Kate and Hall J. Pe-
terson Fund. 82.90.1.

[woman with facial coverings]. n.d. Albumen print.
10¼ × 8 in. (26.2 × 20.4 cm.). Kate and Hall J.
Peterson Fund. 82.90.2.

Group portfolios

L. A. ISSUE
Published by the Los Angeles Center for Photo-
graphic Studies. 1979. 21 prints by 21 photogra-
phers. Gift of funds from the Photography Council
of The Minneapolis Institute of Arts. 80.25.1-21.
Laurie Brown. John Brumfield. Jerry Burchfield.
Grey Crawford. Vida Freeman. Anthony Enton
Friedkin. Jeff Gates. Suda House. De Ann Jen-
nings. Phillip T. Jones. Barbara Kasten. Gary Krue-
ger. Michael G. Levine. Jane L. O'Neal. Marion
Palfi. Susan Anne Rankaitis. Ken Slosberg. Dody
W. Thompson. Karen Truax. Todd Walker. Joan
Watanabe.

MINNESOTA PHOTOGRAPHERS
Published by the artists, Minneapolis. 1978. 11
prints by 11 photographers. John R. Van Derlip
Fund. 79.48.1-11.
Will Agar. Linda Brooks. Linda Gammell. James
Henkel. Patricia Horner. David Husom. Leah John-
son. Jerome D. Mathiason. Lawrence J. Merrill.
Carla Steiger-Meister. Sharon Stockwell.

NEW CALIFORNIA VIEWS
Published by Landweber/Artists, Los Angeles.
1979. 20 prints by 20 photographers. Gift of funds
from the Photography Council of The Minneapolis
Institute of Arts. 80.24.1-20.
Jerry Burchard. Linda S. Connor. Robert Cum-
ming. Joe Deal. John Divola. Steve Fitch. Wanda
Lee Hammerbeck. Graham Howe. Victor Land-
weber. Kenneth McGowan. Roger Minick. Rich-
ard Misrach. Arthur Ollman. Sherie Scheer.
Stephen Shore. Arthur Taussig. Catherine Wag-
ner. Jack Welpott. Henry Wessel, Jr. Garry Win-
ogrand.

THE NEW MEXICO PORTFOLIO
Published by the Center of the Eye Photography
Collaborative, Santa Fe, New Mexico. 1976. 21
prints by 21 photographers. National Endowment
for the Arts purchase grant and miscellaneous
matching funds. 76.61.1-21.
Thomas F. Barrow. Van Deren Coke. Robert D'A-
lessandro. Helen Doroshow. Betty Hahn. Cheri
Hiser. Alan Hoffman. Ernie Knee. Rolf Koppel. Ar-
thur Lazar. Wayne R. Lazorik. Michael D. Mc-
Loughlin. Beaumont Newhall. Anne Noggle. Paige
Pinnell. Eric Renner. Meridel Rubinstein. Joan
Sawyer. Alex Traube. Karen Truax. Alisa Wells.

SILVER SEE
Published by the Los Angeles Center for Photo-
graphic Studies. 1977. 21 prints by 21 photogra-
phers. National Endowment for the Arts purchase
grant and miscellaneous matching funds. 77.39.1-
21.
Jo Ann Callis. Eileen Cowin. Darryl Curran. Robert
W. Fichter. Robbert Flick. Judith Golden. Robert
Heinecken. Claire Henze. Steve Kahn. Robert Glenn
Ketchum. Victor Landweber. Jerry McMillan. Phil-
ip Melnick. Marion Palfi. Sheila Pinkel. Leland Rice.
Kay Shuper. Arthur Taussig. Edmund Teske. Rob-
ert Von Sternberg. Max Yavno.

UNDERWARE
Published by the School of the Art Institute of
Chicago. 1976. 18 prints by 18 photographers.
National Endowment for the Arts purchase grant
and miscellaneous matching funds. 76.64.1-18.
Harold Allen. Frank Barsotti. Linda S. Connor. Bar-
bara Crane. Bonnie Donohue. Fred Endsley. Rob-
ert W. Fichter. Robert Heinecken. Joseph D.
Jachna. Kenneth Josephson. William G. Larson.
Joyce Neimanas. Bart Parker. Aaron Siskind. Keith
A. Smith. Charles Swedlund. Alex Sweetman. Ed-
ward West.

WHAT EVER HAPPENED TO SEXUALITY
Published at Bemidji State University under the
guidance of Sandi Fellman. 1977. 17 prints by 17
photographers. Gift of the artists. 82.70.1-17.
Leslie Baughn. Corey Bernat. Karl Bremer. Susan
Busse. Larry Eels. Randy Hodson. Pat Janashak.
Carolyn Jensen. Nancy Lambert. Pam Lins. Terry
McGrath. Joy Norquist. Judy Olin. Bill Petrowiak.
Richard Schmidt. Scott Scoville. Rita Severson.

Design by Wendy Byrne. Composition by World Composition
Services, Inc., New York. Duotone printing by Meriden Gravure,
Inc., Meriden, Connecticut. Color printing by Beck Offset Color Co.,
Pennsauken, New Jersey. Bound by Publishers Book Bindery, Long
Island City, New York. Printed in the United States.

Library of Congress Catalogue Card Number: 84-70445.
ISBN: 0-89381-157-2 cloth edition; 0-89381-163-7 catalogue edition.

Aperture publishes books, portfolios, and a periodical to
communicate with serious photographers and creative people
everywhere. A complete catalogue will be mailed upon request.
Address: Millerton, New York 12546.